Significant Others

EDITED BY WHITNEY CHADWICK AND ISABELLE DE COURTIVRON

Creativity & Intimate Partnership

With 76 illustrations

THAMES AND HUDSON

We dedicate this book to significant others: Bob Bechtle Michèle Respaut and Michèle Sarde

Illustration Acknowledgments

References are to page numbers; b = below, l = left, r = right, t = top

Photo Richard de Combray 187; photo Deigh-Navin 168; Peggy Guggenheim Collection, Venice (The Solomon R. Guggenheim Foundation, New York) 38, 117 l, 146 l; The Wadsworth Atheneum, Hartford, CT 117 r; photo Lillian Hellman 176 l; Trustees of the Edward James Foundation 115; Karlsruhe, Staatliche Kunsthalle 109; London: BFI Stills, Posters and Designs 26, Courtauld Institute Galleries 74, National Portrait Gallery 73, courtesy National Portrait Gallery (photo Lenare) 82 (inset), Tate Gallery 77; Tate Gallery Archive (Vanessa Bell Photograph Collection) 64, 78, 81; Mexico City: Education Ministry 133 l, Hotel del Prado 131; Lee Miller Archives 96; photo Nickolas Muray 118; New York: The Solomon R. Guggenheim Museum 35, courtesy Robert Miller Gallery 235 tl, 235 b, 237, Collection, The Museum of Modern Art, New York. Kay Sage Tanguy Bequest 146 r, Collection, The Museum of Modern Art, New York. Fractional gift of Leo Castelli in honor of Alfred H. Barr, Jr. 207, Collection, The Museum of Modern Art, New York. Gift of Peggy Guggenheim 235 tr; Paris: Assurances Générales de France 29 r, Archives Clara Malraux 50, 63, Musée National d'Art Moderne, Centre Georges Pompidou 37, 43; Musée Rodin 21, 22, 25, 29 l; The Art Museum, Princeton University, Princeton, NJ. Gift of the Estate of Kay Sage Tanguy 149 l; Private Collection: 99 l, 99 r, 103, 104, 111, 127, 128, 134, 149 r, 201, 203 l, r; photo Robert Rauschenberg 188 t, 188 b, 193; photo John Reed/Lee Krasner Papers, Archives of American Art, Smithsonian Institution, Washington, D.C. 243; photo Roger-Viollet 59, photo René Saint Paul 56; City College of San Francisco 133 r; copyright Seuil (photo J. P. Ducatez) 208, (courtesy Ubu Repertory Theater, New York) 220; photo Bernard G. Silberstein 125; photo Marlis Schwieger 171; photo Wilfred Zogbaum 222; photo Wilfred Zogbaum/Lee Krasner Papers, Archives of American Art, Smithsonian Institution, Washington, D.C. 241.

Any copy of this book issued by the publisher as a paperback is sold subject to the condition that it shall not by way of trade or otherwise be lent, resold, hired out or otherwise circulated without the publisher's prior consent in any form of binding or cover other than that in which it is published and without a similar condition including these words being imposed on a subsequent purchaser.

© 1993 Thames and Hudson Ltd, London Text © 1993 Whitney Chadwick and Isabelle de Courtivron, and the several authors appearing in the Contents list opposite

First published in the United States of America in 1993 by Thames and Hudson Inc., 500 Fifth Avenue, New York, New York 10110

Library of Congress Catalog Card Number 92-62321

All Rights Reserved. No part of this publication may be reproduced or transmitted in any form or by any means, electronic or mechanical, including photocopy, recording or any other information storage and retrieval system, without prior permission in writing from the publisher.

Printed and bound in Slovenia

Contents

	Introduction Whitney Chadwick and Isabelle de Courtivron	7
I	Myths of Creation: Camille Claudel & Auguste Rodin Anne Higonnet	15
2	Living Simultaneously: Sonia & Robert Delaunay Whitney Chadwick	3 I
3	Of First Wives and Solitary Heroes: Clara & André Malraux Isabelle de Courtivron	51
4	The "Left-handed Marriage": Vanessa Bell & Duncan Grant Lisa Tickner	65
5	"Tinder-and-Flint": Virginia Woolf & Vita Sackville-West Louise DeSalvo	83
6	The Bird Superior meets the Bride of the Wind: Leonora Carrington & Max Ernst Susan Rubin Suleiman	97
7	Beauty to his Beast: Frida Kahlo & Diego Rivera Hayden Herrera	119
8	Separate Studios: Kay Sage & Yves Tanguy Judith D. Suther	137
9	The Literate Passion of Anaïs Nin & Henry Miller, Noël Riley Fitch	155
10	Non-negotiable Bonds: Lillian Hellman & Dashiell Hammett Bernard Benstock	173
11	The Art of Code: Jasper Johns & Robert Rauschenberg Jonathan Katz	189

12	Significantly Other: Simone & André Schwarz-Bart	
	Ronnie Scharfman	209
13	Fictions: Krasner's Presence, Pollock's Absence	
	Anne M. Wagner	223
	Notes and Selected Bibliographies	244
	Notes on the Contributors	254
	Index	255

Acknowledgments

The idea for this book originally took shape in conversations between Shari Benstock and Isabelle de Courtivron. Shari's vision has remained indispensable to its successful completion and we would like to acknowledge with deep appreciation her invaluable support and advice.

Our contributors—friends and colleagues—stayed faithful to the project throughout its sometimes rocky history. Without their commitment, their hard work, and their unswerving belief in the value of collaboration and partnership, there would be no book.

Many others have supported and aided us in this venture. Much of the final MS preparation took place at the Massachusetts Institute of Technology during the summer of 1992. Kim Reynolds, Zachary Knight, and Bob Aiudi in the Department of Foreign Languages and Literatures were invaluable to us. Special thanks go to Bob who tirelessly and cheerfully led us through the labyrinthine passageways of computer technology. Philip Khoury, Dean of Humanities and Social Sciences at MIT, provided financial support at a critical moment. Ruth Perry and Susie Sutch read and commented on early drafts of the introduction.

Finally, our experience of working together on this book has reconfirmed our belief in collaborative endeavor as both fruitful and fun.

WHITNEY CHADWICK AND ISABELLE DE COURTIVRON

 $T_{\text{HIS BOOK}}$ is a collective attempt to tackle the questions of gender and creativity from a different vantage point. Traditional biographies and monographs have typically described creativity as an extraordinary (usually male) individual's solitary struggle for artistic self-expression. We decided, instead, to explore the complexities of partnerships and collaborations, painful as well as enriching. We chose to focus on couples (whether different or same-sex) because couples are endlessly fascinating in the diversity of their interactions. And we further chose to limit ourselves to couples in which both partners were either visual artists or writers in order to have a shared creative context within which to explore differences arising from gender, sexuality, age, race, and class. Finally, we wanted to be restricted by neither the anecdotal nor the theoretical. With these parameters in mind, we asked the following question of the thirteen contributors to this book: if the dominant belief about art and literature is that they are produced by solitary individuals, but the dominant social structures are concerned with familial, matrimonial, and heterosexual arrangements, how do two creative people escape or not the constraints of this framework and construct an alternative story?1

We expected the answers to this question to establish a decipherable pattern of constraint and prejudice, of male genius and female absence. But the essays that came back to us from our contributors surprised us. While fully taking into account the limitations of gender stereotyping, their essays provided us with a renewed sense of wonder at the endless complexities of partnership itself.

These stories can be told anew today as a result of a generation of theoretical writings that have taught us to view gender and creativity through new "frames." The work of many scholars has been crucial in this respect. For over twenty years, literary and art critics have been motivating us to read with fresh eyes. More recently, a new wave of

writings has focused on groups, interactions, friendships and mutually enriching influences, which blur our existing notions of heroic individuality. Literary scholars Ruth Perry and Martine Brownley, for example, have explored a process that they call "mothering the mind," which retrieves from silence and absence those who helped create the conditions, the inspiration, and the atmosphere for their partner's artistic production.² Another mode of investigation has led to a closer scrutiny of those creative women who were formerly considered disciples and imitators of "great men," and it has brought their stories and their art to life, at times with persuasive subtlety, at others accompanied by powerful indictments. Setting the record straight, which began with Nancy Milford's poignant biography of Zelda Fitzgerald in 1970, has more recently liberated Frida Kahlo, Camille Claudel, Berthe Morisot, and others, from the shadows of their spouses, teachers, lovers and mentors. A new generation of biographers has asked unprecedented questions about the reciprocal influence of couples such as Simone de Beauvoir and Jean-Paul Sartre, or Georgia O'Keeffe and Alfred Stieglitz and in doing so, has taken us a long way toward the dismantling of earlier stereotypes. Phyllis Rose's discussion of five Victorian couples in Parallel Lives (1983), and Shari Benstock's account of a community of women writers in Paris in the early years of the twentieth century, Women of the Left Bank (1986), opened our eyes to the complex social formations that shape creative lives. More recently, Patricia O'Toole's The Five of Hearts: An Intimate Portrait of Henry Adams and His Circle (1990) and Humphrey Carpenter's The Brideshead Generation: Evelyn Waugh and His Friends (1990) are among the works which have extended our awareness of the rewards and costs of intimate friendships. In that same spirit, a number of the contributors here point to the ways that couples like Anaïs Nin and Henry Miller, Vanessa Bell and Duncan Grant, Virgina Woolf and Vita Sackville-West, Jasper Johns and Robert Rauschenberg, Simone and André Schwarz-Bart, Lillian Hellman and Dashiel Hammett, and Robert and Sonia Delaunay redefine previous gender and sexual stereotypes, and point toward models of far more fluid, equitable and enriching partnership.

The essays in *Significant Others* suggest that although most of the artists and writers concerned have not escaped social stereotypes about masculinity and femininity and their assumed roles within partnership, many have negotiated new relationships to those stereotypes. Perhaps because as feminist scholars we have until

recently focused on the social constraints, we have not fully understood the richness of the private interactions that operate within relationships. Our contributors pay equal attention to the theory underlying the social concepts of masculinity and femininity and to the real social and material conditions which enable, or inhibit, the creative life. The lives of Camille Claudel and Auguste Rodin, for example, remind us that in assessing their careers we must pay attention to social constructions of sexual potency or madness, and to the familial and companionate structures that enabled or disabled their capacities to function as artists. Nor do these thirteen authors ignore the predominantly male intellectual systems of support (teachers, critics, journalists, publishers, curators), complemented by female systems of domestic support, which nourished the endeavors of a Rodin, Malraux, Ernst or Tanguy, but inhibited those of their companions. They also look at the cultural and social evaluations that assign "masculine" or "feminine" characteristics to certain kinds of art and certain artists, and in so doing compelled artists like Johns and Rauschenberg to live a secret life within the art world, and removed Sonia Delaunay's productions from the realm of "modern" art. Yet the intricate stories of mutual respect and support, even within the most painful failures, emerge as one of the innovative aspects of the partnerships explored in this collection of essays.

Investigating notions of collaboration or, as Shari Benstock puts it, "the partners' struggle in search of fulfillment and self-expression within bonds,"3 offers one way that we can move toward untangling the myths from the realities, the images from the lives, the singular achievement from the collaborative processes. At the same time, we are aware of the limitations of a focus on couples. After all, the couple is only one among many configurations that provide human companionship. These may include circles of friends and lovers that do not reduce easily to pairings. We have, for example, chosen to omit couples in which one person-however influential on the other-is a "silent" (that is, unrecognized) partner. We have also avoided discussing those artists or writers whose relationship is intellectual and/or artistic, but not sexual (for example, Ernest Hemingway and Gertrude Stein). For the sake of coherence, we have limited ourselves to couples who have shared a sexual as well as creative partnership. This, of course, does not necessarily imply marriage or heterosexual bonding. However, the conflicts of two people who lead creative lives within the context of sexual/affective bonds, and who therefore are always confronting the pleasures and terrors of "being geniuses

together," provide, we believe, a useful starting point. For if the myth of solitariness prevails, can only one be a genius? And if the reality of community prevails, how is genius to define itself? We started with the assumption that, given our culture's emphasis on solitary creation, one is always constructed as Significant, and the partner as Other, and concluded with the realization that although this schema remains powerful, the truths which we are learning to decipher are indeed much more interesting.

In the following essays, the contributors explore the matches and mis-matches between myths about creativity and partnership that artists and writers have inherited and the realities of living creative lives in partnership. These myths include the idea that if only one can be Genius, and if in our culture that role is usually assigned to men, all attempts at competition (actual or imagined) by women defeminize her and are considered potential threats to "his" productivity. The story of Zelda Fitzgerald serves as a poignant example here, but Clara and André Malraux also correspond to the much-maligned pair of cultural hero and resentful wife who, though considered second-rate, cannot accept her role as an enabler of male genius. If not a direct competitor, then women are often seen as pale copies, imitators with little originality of their own, as in the cases of Jackson Pollock and Lee Krasner, Yves Tanguy and Kay Sage, Max Ernst and Leonora Carrington, and it is up to her to decide whether she will survive by accepting that role, or dispute it and risk ostracism. Whereas he transcends his sources, goes the stereotype, she remains limited and/ or defined by hers. Such is woman who, according to Simone de Beauvoir, "does not passionately lose herself in her projects," is unable to "forget herself" and in this inability to transcend her human condition is unable to create incandescent works of art.⁴ With models such as these in mind, our contributors remain keenly aware of the difficulty that women-and, although less often, men-have experienced as they have struggled to create within traditional forms, or struggled to change the terms of creativity and the terms of partnership.

Links between productivity and creativity are gender-bound at a deep level. Reproductive metaphors appear widely in the work of both male and female artists and writers, but they are qualified by Western culture's tendency to associate productivity for women with childbearing, with biological reproduction. Scholar Nancy Huston has written convincingly about the mutilating effects of a binary construction which attributes to women the body and to men the

mind, and in the process destroys both.⁵ Yet although the histories of art and of literature have been profoundly shaped by such beliefs, the lives of Vanessa Bell and Duncan Grant, among others, reveal far more complex and intricate interweavings of the spheres of production and reproduction than those suggested by this stereotype.

The hierarchy that is often assumed to be the "natural" order reinforces the notion that women do not do "serious" work, that they paint when they are "bored in bed," as in the case of Frida Kahlo (whose marriage portrait of the couple portrays Diego Rivera as the one who holds the paintbrushes) or Kay Sage (who always denied any formal artistic training and was vigorously rejected as an artist by the Surrealists until she endorsed the socially acceptable role of widow of Tanguy). Through the examples of couples like Kahlo and Rivera, or the Delaunays, we can begin to understand the opposition between those who do, and those who do and also create a theory about what they do, and in the process structure meaning. From these essays we also learn about the intersection of esthetics and sexual politics: for example, that historical contexts and intellectual conditions also encourage (or discourage) diversity and new paradigms. Bloomsbury, with its emphasis on a sensibility defined partly in feminist and homosexual terms, created a space for Vanessa Bell to be respected as a painter; the McCarthy era of the 1950's in North America closed the doors on any feminine presence in order to keep literature and art within the pure, safe, and virile fraternity of the pen and the brush.

The stereotypes, myths, and images which we have inherited are impoverished ones. But if they are rooted in our culture, and continue to exert such a strong hold over our expectations, how can partners break free? Many of the couples here managed to transcend these constraints, despite often paying a high price, and to create for themselves alternative arrangements both creative and affective. The cases of Nin and Miller, Hellman and Hammett, Bell and Grant, and Woolf and Sackville-West demonstrate that—if we know how to read their stories with fresh eyes—the realities of exchange and influence in these partners are unexpectedly strong and innovative. The Schwarz-Barts, for example, provide a striking departure from a stereotype in which he creates out of political context, she out of personal context.

The realities of artistic partnership also include domestic arrangements which are not bound by the model of heterosexual union. Here the complexities, and the possibilities for rethinking notions of partnership and of creativity, are even more challenging in

that gendered roles are often blurred, and the partners are called upon to reinvent, to refigure the myths into new realities. In the case of Woolf and Sackville-West, those new realities were eased by the social freedom that accompanied upper-class status and by a social perception that saw lesbianism as less threatening than homosexuality. Is it because Virginia and Leonard Woolf corresponded to narrow but acceptable gender roles (she the physically sterile, frigid, creative, mad female; he the logical, rational, political male) that she is always paired with him, despite considerable evidence of the creative benefits of casting aside such limited, and limiting, roles in her relationship with Sackville-West? Cultural differences also come into play in shaping partnerships. Frida Kahlo introduces us to gender stereotypes in Latin cultures that may make it easier for a woman to gain an acknowledgment and acceptance as an artist if she conforms to firmly defined social constructions of femininity in her life. Kahlo surrounded her person with the social attributes of femininity in dress and embellishments, and then stripped them away in her paintings to reveal other, less easily categorized realities.

What we found most interesting in these essays was not the limitations of partnership, although they provided the starting point for this book, but the innovations that are not always apparent in traditional catalogs, biographies, or monographs. Our contributors, however, were not called upon to offer new models. "Rewriting history around the issue of gender," art historian Anne Wagner has written, "is not about reversing the 'facts,' whatever they may be; it is about taking both public and private representations and estimations of women's place in art among the determinants both of the artist's self, and of her art."6 Exploring the diversity of models already present may, we hope, be sufficient to resist the tendency to invent new myths about creativity and intimate partnership. These essays do, however, point toward a rupture with any reductive notion of couples altogether, and toward resistance to the inflexibility of existing gender definitions when examining their impact on artistic creation. What we can learn from these thirteen couples, both in their positive and negative legacies, is the importance of inventing new roles and/or renegotiating the old ones. What we can also learn is that it is up to us to reach toward multiple definitions of creativity and, in so doing, to rethink worn-out concepts of autonomy, compromise, and success. It is not our intention to underestimate, or oversimplify, the exquisite complications of leading creative lives and leading affective lives; nor do we in any way mean to belittle the agonizing loneliness of artistic

and literary production. All of us involved in this book know the wrenching pain of sitting alone in front of a blank page or a blank canvas. But we also know that the story doesn't end—or for that matter doesn't begin—there.

We therefore propose thirteen stories about relationships, some of which remain imprisoned, some of which break free from the conventions and the stereotypes. The players in these stories are imaginative and courageous, and they have chosen creative, colorful, and difficult solutions. Although for the sake of coherence we have chosen to focus on twentieth-century Western Europe and the United States, and on literature and the plastic arts, we imagine there to be hundreds, thousands of such narratives, in our cultural heritage as well as in our own experiences, waiting to be deciphered by those prepared to read between the lines and between the lives.

Camille Claudel, ca. 1883

MYTHS OF CREATION

I

Camille Claudel & Auguste Rodin

ANNE HIGONNET

ALL AROUND him he saw the masterpieces of his tradition. Rodin had traveled to Florence from Paris in 1875 to pay homage to sculpture's past, to find his place in a lineage, and to learn what he called "secrets" from "magicians."¹ There on the Piazza della Signoria, great works by Donatello, Michelangelo, and Cellini faced each other, marking out across time and space the standards against which Rodin could measure himself.

Of all the works with which Rodin could identify himself, Cellini's *Perseus and Medusa* (1554) most explicitly told a story of sight and sculpture. Perseus and Medusa were, each in their own way, archetypal sculptors, able to transform what they saw into inanimate matter by harnessing a magical power of vision.

Medusa had once been a beautiful woman. Having incurred the wrath of the gods, however, she became a vision of horror with snakes for hair, and a gaze which turned all living things to stone. A young man, aided by the same gods who had cursed Medusa, would appropriate her powers and make better use of them. Perseus armed himself with useful tools in advance, planned a strategy, cut off Medusa's head, and flew away to further triumphs. The judicious display of her head at crucial moments supplemented his own prowess by petrifying his enemies. The power of sight that made Medusa a monster made Perseus a hero.

Stylistic innovation in sculpture since Cellini had left the old myths intact. If anything their message was renewed through formal reinterpretation. The tale of Perseus and Medusa, for instance, was brilliantly retold in a glacially erotic Neo-Classical style by Antonio Canova, one of the few sculptors since the late Renaissance whose reputation and influence Rodin needed to match. Canova's 1797–1801 *Perseus Triumphant*² ushered into the nineteenth century a myth that by the twentieth would be validated anew. Sigmund Freud used the story of Perseus and Medusa, as he used other myths, to lend the credibility of cultural lineage to his psychoanalytic theories of vision and

sexuality, in much the same way that Rodin had made his pilgrimage to Florence. By 1922, only five years after Rodin's death, and twentyone years before Camille Claudel's, Freud had written "Medusa's Head," which grounded the ancient myth in anatomical fact and made it relevant to a modern middle-class society. In this man's story, Medusa's head represents a female threat of castration, and Perseus's possession of her powers the apotropaic act that fetishistically reaffirms male invulnerability. Freud had spelled out the masculinity of Perseus and the femininity of Medusa.

When Camille Claudel and Auguste Rodin met in 1882 or 1883, she had already demonstrated artistic talent. Born in 1864, she had begun to model clay around 1876 without any encouragement. Since then, she had enlisted the support of her father, Louis-Prosper, and her brother Paul, and antagonized both her mother Louise and her sister, also called Louise. She had been noticed by a local sculptor, Alfred Boucher, and had managed to get herself to Paris, center of the European art world, in order to obtain the training necessary for a career in sculpture. She knew what she wanted, but the professional art world offered few opportunities for women. The École des Beaux-Arts, that most prestigious school of all, did not admit women. They were also excluded in practice, if not in theory, from full participation in the raucous, bawdy life of productive sculpture studios. Undaunted, Claudel joined other ambitious young women who rented their own studios and attended the respectable but cloistered Académie Colarossi. There was no tradition of women sculptors to inspire them; they didn't even imagine one, so fully did they believe in their ability to belong to the art world as they knew it.

Rodin, meanwhile, had ample experience behind him. In 1883, he was 43 years old and knew his business. A graduate of the national School of Decorative Arts, he had not been admitted to the École des Beaux-Arts, but he had a marketable skill which enabled him to earn a living doing decorative pieces and assisting the very successful and well-connected sculptor Albert-Ernest Carrier-Belleuse. It wasn't glorious work but it paid well by contemporary standards: for one bust, called *The Little Manon*, Rodin received 600 francs in the mid-1870's, a time when the average worker earned 3 francs a day.³ He had parlayed his talent and his contacts into exhibition at the Salon, plentiful if mixed critical reviews, and, not long before meeting Claudel, an extremely lucrative and prestigious commission. The national Museum of Decorative Arts had offered him 8,000 francs in 1880 to make the Museum's portal; in 1881, they raised the price to

10,000.⁴ By that year, Rodin knew key members of the Parisian intelligentsia and had been welcomed into artistic, literary, and political salons. He had been allowed to do portrait busts of many influential men and thus link his name with theirs, including Victor Hugo who, in Rodin's own words, was "the giant of the century."⁵

No one wonders, therefore, why Claudel was attracted to Rodin. He represented not only the success she desired, but also the success of desire. She wanted to be a sculptor in her own right, and every young artist then took the interest of an eminent senior artist as a good sign that one day he or she too would be famous. In the case of a woman, however, it was also a form of success in itself to be sexually desired by a successful man, so much so that feminine desire consisted at least partly in the desire to be desired. Nor does anyone wonder why Rodin was drawn to Claudel, although for different reasons. She was a beautiful young woman who was willing to have an affair without demanding the usual bourgeois feminine rewards of marriage, a household, children, and social status. She freely gave herself as the object of his desire.

Yet of course we have wondered, though not enough to revise our initial interpretations. We would not be fascinated with Claudel and Rodin's banal sexual liaison if we did not suspect that Rodin was also seduced by Claudel's artistic gifts, and his mind as well as his emotions engaged over the years by an intellectual dialogue with her. Nor could we suppose such a thing if we did not believe that Claudel had a will of her own and the potential to become a sculptor in her own right. On the question of whether Claudel did, or even could, realize that potential, hangs the balance of opinion. Certainly at first she played the pupil's role, albeit, along with Bourdelle, his most challenging pupil. How long did Claudel and Rodin remain in this pedagogic relationship? Until she made her own sculptures in the late 1880's, according to some. For the rest of her career, according to others. We will never know with certainty. The facts of Claudel's and Rodin's professional relationship have been almost completely obscured by the personal circumstances of their ten years together.

Banished from her parents' home when they discovered the sexual aspect of her ties to Rodin, Claudel lived and worked for much of this time in a decrepit villa called the Folie Neubourg on the boulevard d'Italie. Apparently Rodin paid the rent and her expenses. No trace of any regular salary survives even though she was performing exactly the same kind of tasks with which he had earned his living in earlier years. She modeled parts of the works that he

signed, probably some of the small figures in his *Gates of Hell* (still unfinished at his death), almost certainly the hands and feet of his 1886 *Burghers of Calais*: two of the monumental projects that made him famous. She carved some of his marbles, for she had the gift of the craft, which he did not. In addition, she posed for several of his sculptures, an extremely time-consuming task that was normally a paid profession, and that kept her away from her own sculpture. No records were kept of how she spent her time, or who was working on which pieces at exactly what stage of their completion. The striking resemblance between some of their works from this period—like her *Young Girl with Sheaf* (ca. 1890) and his *Galatea* (ca. 1890)—increases the confusion. All we know with certainty is that their decade together was the most innovative and the most productive of both their careers.

Nevertheless, we have now-and their contemporaries had then-a mode of interpretation to fall back on by default. In the absence of evidence, art historians have assumed that she imitated him, and that her achievement consisted in executing his ideas. The absence in Claudel's case has been extreme. For a very long time most of Claudel's surviving works remained in private, uncatalogued collections. The few traces of her production were scattered, if not lost, whereas Rodin hoarded every conceivable bit of information pertinent to himself and passed it directly on to a permanently staffed institution. The profession of art history has always measured the chronology and value of the unknown by the scale of what it does know. On occasion, this attitude has taken the extreme form of automatically attributing works produced during the period of Rodin's and Claudel's affair to Rodin; one piece, Brother and Sister (1890), was simply assumed to be Rodin's on the basis of its similarity to his Maternal Kiss (1885) until external evidence proved that Claudel had modeled it. Claudel's retreat to the private world of the Folie Neubourg allowed the public to imagine her work according to its habits.

In Ovid's version of the Perseus and Medusa myth, we only learn Medusa's whole story when Perseus recounts his triumph over her during a banquet honoring his conquests.⁶ Her story is his to tell because he controls the kind of public space in which words are listened to and believed. Claudel worked in seclusion on the assumption—shared at least theoretically by all her contemporaries—that artistic genius came from within an individual and would be recognized in proportion to its intrinsic merit. It was perhaps the

surest sign of Claudel's provincial and feminine upbringing that she could not gauge how fully, in practice, any artistic career depended on institutions, social connections, financial self-promotion, and a strategically chosen stylistic position. Nor did she understand that for the men who controlled a public art world, her professional reputation would never emerge from under their interpretation of her private life. In their eyes, her sexuality eclipsed her work because she was a woman and therefore, according to their acquired expectations, an innately sexual rather than intellectual being. They had become aware of her sexuality as the object of Rodin's desire; therefore her story could exist only as a part of his story.

During Claudel and Rodin's years together, Claudel did exhibit a few works, never more than three in a year. Some critics voiced admiration for her sculpture in print, notably Mathias Morhardt. She received an "honorable mention" for her Cacountala at the Salon des Artistes Français in 1888. These public footholds dwindle to insignificance, however, in comparison with Rodin's conquests. He had a studio of his own in the state's Dépôt des Marbres, another on the boulevard de Vaugirard, a storehouse on the Ile des Cygnes, and, of course, the Folie Neubourg was in his name. His work was published regularly in a magazine called L'Art. In 1885, he was given the public commission for the Burghers of Calais. In 1886, a Rothschild Baron paid him 6000 francs for a marble group, setting the pace for private commissions. In 1887, Rodin was awarded the Légion d'Honneur, an event celebrated several times over at banquets organized by his many admirers. In 1889, he not only exhibited to critical acclaim in the Exposition Universelle, but also, with Claude Monet, delighted the art world at the fashionable Galerie Georges Petit. Already critics and friends compared him with the great geniuses of the past: Dante, Delacroix, Phidias, Hugo, Donatello, ceaselessly with Michelangelo. It would be tedious to continue the list of all the commissions, alliances, decorations, studios, visitors, banquets, and intellectual exchanges Rodin enjoyed on his own between 1883 and about 1893.

Rodin shared a tiny part of this public life with Claudel, introducing her to Morhardt, to critics like Gustave Geffroy and Roger Marx, taking her with him to soirées at the Daudets', the Goncourts', at Octave Mirbeau's.⁷ She herself felt ill at ease in public: provincial, awkward with her limp, seeing in the power-brokers of the art world only "badly dressed men."⁸ "I don't understand theoretical questions about art," she said, consigning herself to the

role of mere artisan.⁹ She remained confident that in time her talent would be publicly recognized. Time, though, was running out. At her age, Rodin hadn't made much more progress socially, nor acquired many more graces. But women reached a social zenith that lasted as long as their youthful beauty; men seemed ever more attractive as they aged. The asset Claudel might have parlayed into professional opportunities was diminishing, while Rodin's artistic success was beginning to glow with a sexual aura.

Once he had learned the lessons of Old Masters like Rubens and Delacroix, Rodin explained later in his life, "I had the courage de me servir de mon sexe and to become a man at last."10 The French phrase allows several translations, among them, "to take advantage of my gender" and "to use my penis." As Anne Wagner has so clearly demonstrated, Rodin's identity after the 1880's merged esthetics with sexuality.¹¹ He believed that his art and his virility came from the same source, and so did his contemporaries. Wagner uses Arthur Symons's comment of 1900—"The principle of Rodin's work is sex, a sex aware of itself, and expending energy desperately to reach an impossible goal"-as her epigraph¹² and continues: "Rodin's subjectivity . . . was constructed as essentially elementally male-and as such, a self that returned to a first, primitive engagement with the world's materiality."13 Rodin's Balzac (1898) thrusts up from the earth like a roughly hewn primeval stone marker, the artist's energies and the man's forms furled in the column of his cloak. In the last years of his career, Rodin created another kind of monument that elicited a technique with equally elemental connotations. Each drawing and watercolor may have been modest in scale and intention, but seven thousand of them added up to a massive project. According to contemporary witnesses, Rodin barely looked down at his work, so rapidly was his pencil moving in apparently automatic response to what he saw, and what he saw was usually the part of a woman he identified as the origin of life.

The marks of vigorous modeling Rodin left in clay, or the swift signs on paper, his ability to combine human figures in endlessly new permutations, the sheer quantity of his output and, above all, the erotic themes of his sculpture, all became indistinguishable from his personal sexuality. No one seemed able to write about Rodin's work, least of all Rodin himself, without using sexual metaphors. Language conflated nature, masculinity, and creativity. Bourdelle called his teacher "the great penetrator of human forms;"¹⁴ the different ways we might read that epithet today all meant the same thing then.

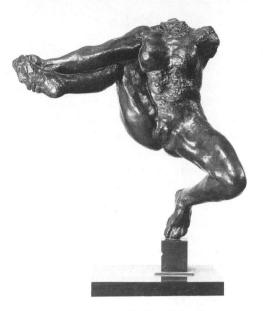

Auguste Rodin, Iris, 1890

Rodin's genius endowed a late nineteenth-century interpretation of femininity and masculinity with a beauty that absolved shame. He refused coy references, snickering citations, and abstruse exegesis; his figures acted on their impulses, played out their passions, embraced, strained, coupled, exulted, suffered. Beneath his cloak Balzac grasped an engorged penis and his entire abstracted form, never more evocatively represented than by the American photographer Edward Steichen in 1908, described an unabashedly phallic silhouette. No one could draw or model female labia, vulvae, or vaginas as unselfconsciously as Rodin. Thousands of times over, he returned to this subject with evident admiration and pleasure, in drawings but also, earlier, in sculptures like *Iris* (1890). Rodin's work seemed all the more exhilaratingly liberating because it so adamantly rejected the highly polished and classicizing esthetic standards of previous generations.

This sexuality which Rodin at once embodied and represented with such freedom satisfied the ideological aspirations of his primary audience—an increasingly powerful if informal coalition of patrons, publishers, politicians, art dealers, and professional intellectuals (both female and male). As Wagner concludes about Rodin's art: "Its impact lay not so much in anatomical truth or accuracy... as in the way it was seen to give explicit sculpted form to a particular understanding of the modern sexual condition."¹⁵ This understanding did provide a crucial margin of difference, however slim, from

what Wagner calls "the dominant sexual economy of his day,"¹⁶ and Rodin's attribution to women of a genital sexuality did offer some women the glimmering of a "female sexuality reclaimed as bourgeois."¹⁷ Rodin's meanings empowered this avant-garde audience, enhanced their identity, freed them from ordinary bourgeois social constraints, and gave women—among them, of course, Camille Claudel—a newly positive belief in their own potential.

Rodin's work, however, carried different sexual meanings to other audiences. Nor were the formal messages of his sculpture immune, even among their intended audience, from the social values then prevailing in Europe. To anyone not versed in the elaborate terminology and sophistication of the art world, and to more than a few intellectuals once they stopped talking esthetics, the figure of a headless, limbless woman with her legs splayed was nothing but a cunt. Meanwhile, Rodin called his most important, and most reproduced, male nude The Thinker (1880), and endowed his figure of the writer Balzac with a phallic sexuality that rendered his prowess total. Both of these masterpieces by Rodin offered the vision of a masculine power that fused the intellectual with the physical to make mind and body one. When he represented women, however, Rodin sedulously separated all signs of agency, individuality, or thought from any signs of sexuality. Far from guaranteeing a complete potency, women's gender was understood as a biological limitation. In Rodin's work, sexuality promises to unite men, but differentiates among women. Rodin treated upper-class women as portraits and his hired models as anonymous sexual creatures. Of course, what woman would pay to be represented by her genitalia? But isn't that the point? No woman whose class or economic situation allowed her any control over Rodin's production would tolerate his interpretations of other women for herself, because she understood the current derogatory implications of those representations all too clearly, despite their formal beauty. And no amount of social power then available to any woman could make her into a Thinker.

Rodin did sculpt a female *Thought* (1893-5). She was Claudel. Not the one who thinks, but the incarnation of thought's abstraction, her face emerges from his material, the rough stone. Inspired by Claudel, using her as his model, Rodin did create a small third category of female images. *France* (ca. 1904), *Dawn* (1885), *Farewell* (1892), each in Claudel's likeness, offer women viewers—as they much more personally and actually offered Claudel—the possibility of being a mind, an idea. Certainly this provided some alternative to the

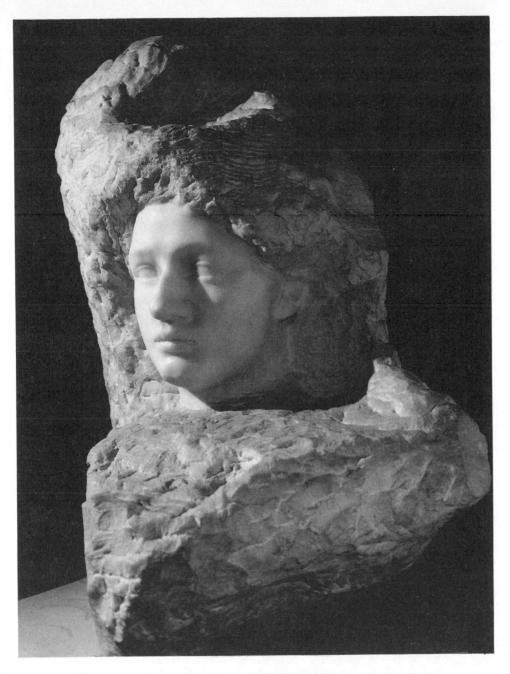

Auguste Rodin, Dawn, 1885

tediously familiar but implacably enforced dichotomy between face and body, between social status and sexuality. Rodin himself fully acknowledged Claudel's talent and encouraged her career in every way he could imagine. "I have showed her where she could find gold, but the gold that she finds is entirely hers."¹⁸ He denied allegations that he had sculpted works she signed, and even defended her right to represent sexuality. As Claudine Mitchell has discovered, Claudel solicited a state commission for her *The Waltz* (1892-5), which depicted a man and a woman swept away in an erotic movement unconcealed by drapery. Dismayed, an Inspector from the Ministry of Fine Arts, Armand Dayot, consulted Rodin, who responded: "Mademoiselle Claudel only wants to do the nude, so we should let her, for it is right and as she does not want drapery she would only do it badly."¹⁹

Dayot refused Claudel's nude on grounds of indecency, citing its "violent accent of reality" and its "surprising sensuality of expression."²⁰ Rodin could not fundamentally alter Claudel's problem. Both in her professional career and in her personal life, she still had to choose between the rigidly distinct options of respectability or sexuality. But she refused to choose. Unwilling or unable to understand her situation, Claudel persisted in her utopian desire to live outside the matrimonial laws of patriarchy and, at the same time, to practice the traditionally elite art of sculpture with perfect liberty.

Rodin's example suggested emulation. Since his youth he had enjoyed a free union with Rose Beuret and had refused any external restraints on his imagination. He himself wrote to Bourdelle in about 1905 on the subject of his latest work:

Finally, I have attained naturalness which carries in itself all the schools molten together. Consequently my drawings are freer, they will cultivate liberty in the artists who study them, not by telling them to do as I do, but by revealing their own genius to them and by pushing them toward its full sway by showing them the immense expanse in which they may evolve.²¹

This immensity, however, was not accessible to women artists.

Rodin's new representations of women as subjects did not entail, encourage, or imply a corresponding change in social attitudes toward women as makers of art. If the sight of women's sexuality sometimes disturbed his contemporaries, the spectacle of women's economic or intellectual control over their sexuality terrified them. Only the truly exceptional woman in the late nineteenth century—a

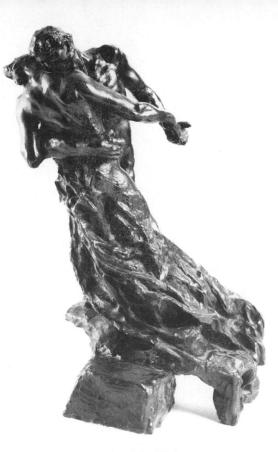

Camille Claudel, The Waltz, 1892-5

Sarah Bernhardt, for instance—managed, through deft concessions, financial calculations, and sheer willpower, to shape a successful artistic career outside masculine regulations. Rodin himself, so supportive of a dependent Claudel, reacted differently when Bernhardt aspired to sculpture from her autonomous position of power. He is said to have responded to her portrait of her sister Regina, exhibited in the Salon of 1875, that "the bust is rubbish and the public is stupid to linger over it."²²

This social situation was not Rodin's personal responsibility; nor were Claudel's individual decisions. On the contrary, no one artist, not even the world's greatest living artist (as he began to be so often called) could affect gender roles in any significant way. Both Rodin and Claudel played out mythic roles they could neither determine nor alter. Rodin's role nurtured his talent. Émile Zola, Maurice Rollinat, Joris-Karl Huysmans, Octave Mirbeau, Félicien Rops, and many

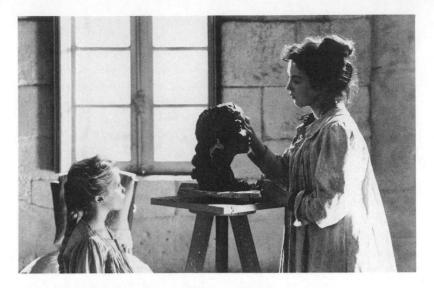

Isabelle Adjani as Camille Claudel in the 1989 movie

others, shared Rodin's most daring interests in the redefinition of eroticism. He sealed his friendships with these men by offering them his erotic statuettes, giving one to Mirbeau, for instance, another to Geffroy.²³ He could work on the assumption of his gender, and forget about it. Hers overwhelmed her. The most sympathetic critics put her gender in conflict with her talent. Mirbeau called her "A revolt against nature: the woman of genius."²⁴ Morhardt assigned her a masculine gender: "She is of the race of heroes."²⁵

Only in her sculpture itself did she maneuvre around social expectations. Even in her work she seemed preoccupied with her own gender inasmuch as the majority of her figures represent women.²⁶ Yet her version of gender is different-different from Rodin's, from that of his more sexually conservative peers, and from the work of earlier notable women sculptors, such as Marcello, or Harriet Hosmer. Most importantly, in her sculptures of women we can discern no clear boundary between sexual and asexual. Claudel refused to divide women into the proverbial virgins and whores. She did produce some heterosexually erotic pieces, like The Waltz, as well as one heterosexually autobiographical work, Maturity (1898), in which, on the basis of comparisons with drawings that explicitly depict the relationship between Rodin and Rose Beuret, it becomes clear that Claudel is narrating her break with Rodin in conventional terms. She begs him not to leave her for another, older, woman. Even in these pieces, however, her treatment of the female body-by

contemporary standards corporeally unidealized yet expressively highly charged-shifts it from the visual status of passive object to that of desiring subject. It is impossible to see these women, as Rodin's women were so often seen, as essentially sexual creatures. Meanwhile, when handling ostensibly more spiritual themes, like the several variants of The Little Châtelaine (1893-6) or The Prayer (1889), female figures, no matter what their evident intellectual absorption, also appear intensely physical. In the most developed of the Little Châtelaines (1896), the bust of the child who gazes solemnly upward with complete concentration is connected to its base by rootlike coils of hair which stream back, out, and down through space, a masterpiece of spatially intricate marble carving. The Little Châtelaine also demonstrates the range of Claudel's female subjects. She represented the very young and the very old, the exultant and the despairing, the destitute and the wealthy. She sculpted women alone and in groups, meditative or addressing each other. None is the object of pity, sentimentality, or jest.

Claudel, whose work escaped the rules of femininity, succumbed to their retributions in her life. After her break with Rodin around 1893, she became increasingly reclusive and paranoid. Although critics like Gustave Kahn and the ever-loyal Morhardt, along with her brother, the poet Paul Claudel, wrote in her favor, and though the dealer Eugène Blot promoted what she produced as best he could through exhibitions and editions, she produced less and less, especially after 1905. She shut herself in an unkempt studio, collected cats, annoyed the neighbors. She raved about Rodin, accused him of stealing her ideas, of maligning her, of spying on her. The imbalance in their relationship had been magnified into madness. She had become merely an episode in his private life, whereas he had become a specter that haunted her and made her unable to distinguish between past and present, between her career and her psyche.

On March 2, 1913, Claudel's father died. His support of her had never wavered. Three days later, her brother Paul obtained a certificate from a doctor that authorized him, under an 1839 French law, to incarcerate his sister against her will. On March 10, Camille Claudel was seized in her studio and confined to an asylum for the insane. In asylums she remained for the rest of her life, first at Ville-Evrard and then at Montdevergues, near Avignon. She pleaded by letter to be released, to no avail. Her mother answered one letter by writing to Claudel's doctor, "She has all the vices, I don't want to see her again."²⁷ Claudel died in 1943 after thirty years of imprisonment.

Meanwhile, Rodin went on to worldwide adulation, enjoyed the extremely rare honor of seeing a museum dedicated entirely to his work during his lifetime, and died at home in 1917.

Rodin made formal innovations within accepted social limits, corroborating class and gender models, while working brilliantly far out on their most progressive edge. Claudel, who introduced few stylistic changes into the history of sculpture, worked just barely beyond those same social limits. The margin of difference between her work and his was infinitesimal, but unforgivable.

At the same time that Rodin made his perenially popular image of heterosexual love, *The Kiss*, around 1886, Claudel made her first version of the same subject, variously called *Abandon*, *Vertumnus and Pomona*, or *Cacountala*. Not only was Claudel daring to model both female and male nudes, she also undertook to represent erotic desire from a woman's point of view. If Rodin expressed desire's power, Claudel explored its reciprocity. Her marble carving balances the muscled strength of her female figure against a more slender male figure. He reaches for her, but she gives herself. They merge gently into one curve, flesh melting into flesh. Without violence and without demands, they succumb by mutual consent. The moment elides desire and fulfillment as both slip together toward the ecstasy of pleasure.

In 1902, Claudel took her turn at the theme of Perseus and Medusa. She made Medusa's head a self-portrait. How should we interpret this profoundly ambivalent act of self-representation? Does Claudel submit to the charge of monstrosity, or revel in it? Has she abandoned or reclaimed the power of her art, her gaze? Or does she suggest that a woman cannot answer these questions, though she can pose them? At least here we know who Medusa was, and her story as well as Perseus's has been heard. The myths of the gods retain their power. But when we see the individual faces in them, we can begin to rethink the myths as history.

And history twists unexpectedly. In the last two decades, Claudel's story has been retold. Feminist-inspired rediscoveries of forgotten women artists led to Claudel's work being exhumed, catalogued, and exhibited. Bitterly rival authors, and their monographs, fueled public interest in France. Claudel's story has even become a commercial French motion picture. Directed by Bruno Nuytten, and starring Isabelle Adjani, it was nominated for American Academy Awards in 1989. Publicity surrounding the movie made Claudel well known on both sides of the Atlantic. The professional fame she longed for is now hers.

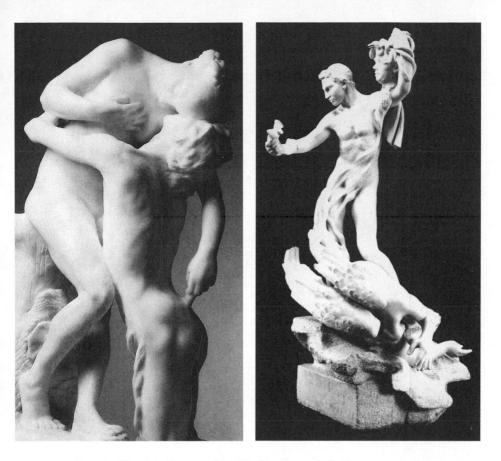

Camille Claudel, Cacountala, 1888; Perseus and the Gorgon, 1902

Fame has come with a price. Now the name Camille Claudel embodies another feminine stereotype: the victim. Nor has her professional reputation been disentangled either from Rodin's or from their sexual relationship. Two out of the last three exhibitions of her work (in which labels consistently referred to him as Rodin and to her as Camille) were held at the Musée Rodin. As the description on the back of the *Camille Claudel* video cassette puts it, the movie is "both an inspiring saga of artistic vision and the haunting story of a doomed romance." Are we rehearsing once again the ancient myths? Or are we looking Medusa straight in the eye in order to see her differently?

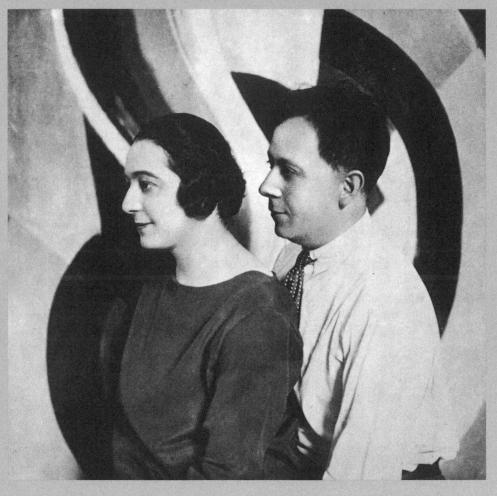

Sonia and Robert Delaunay in front of his painting Propeller, 1923

LIVING SIMULTANEOUSLY Sonia & Robert Delaunay

2

WHITNEY CHADWICK

WHETHER in the studios of Cubist painters, or in the public dance halls of Montparnasse, cultural life in pre-First World War Paris often appeared as a canvas of abrupt rhythms and fragmented shifting surfaces. Modernity was embodied in a restless desire for change and innovation, for newness in all its forms. Sonia and Robert Delaunay (both born in 1885) were among the artists and writers who would give new verbal and visual form to the dynamism and dislocations of the twentieth-century urban landscape. In 1913, they were also among the crowd which flocked to dance halls like the Bal Bullier, where he danced to the intricate patterns and staccato rhythms of the tango and the foxtrot and she, disguised in the colors and shapes of an abstract painting, sat quietly absorbing the flow of movement and light.

The Delaunays' desire to shed the conventions of the past and embrace the modern in every aspect of their lives and work extended to their costumes. Dressed in fashions designed by Sonia, which employed the same palette of colors and shapes evident in their paintings of these years, the young couple seemed to have absorbed the multi-faceted rhythms of everyday life into their very persons. Their frequent companion, the poet and art critic Guillaume Apollinaire, spoke admiringly of Robert Delaunay's red coat with its blue collar, his red socks, yellow and black shoes, black pants, green jacket, sky-blue vest, and tiny red tie. Sonia was no less resplendent in a purple dress with a wide purple and green belt. Under the dress's jacket, she wore a large corsage divided into brightly colored zones of fabric in which antique rose, yellow-orange, Nattier blue and scarlet appeared on different materials, juxtaposing wool, taffeta, tulle, watered silk, and peau de soie. So much variety, Apollinaire concluded, could not escape notice and must surely transform fantasy into elegance.

By 1913, the Delaunays' project of capturing the tempo of modern urban life by integrating sensations of movement and

immobility on a two-dimensional surface was well advanced. Using strident juxtapositions of color, they evoked volume and depth. Employing a vocabulary of color and curved forms without recognizable subject matter, they produced lyrical compositions whose content was bound up in impressions and associations. They called the result simultaneity—the term derived from the color theories of Henri Chevreul which underlay the Impressionists' and Neo-Impressionists' elaboration of the structural and spatial properties of color—and its principles would dominate the work of both for the remainder of their lives.

Sonia Terk's arrival in Paris in 1905 coincided with a widespread international migration of artists to the French capital during the first decade of the twentieth century. The daughter of a Ukrainian factory worker, she had been adopted by a wealthy uncle and raised in luxury in St. Petersburg. The tradition of educating upper-class women in Russia-which dated to the nineteenth century-insured her training in literature, philosophy, and mathematics. A female drawing teacher, recognizing the young girl's talent, advised the family to send her abroad for further study. It was ambition and commitment, however, that kept her in Paris in the face of growing familial disapproval over her decision to pursue art as a profession rather than as the amateur accomplishment considered suitable to a young woman of her class and background. Robert Delaunay, on the other hand, the son of the Countess Berthe-Félicie de Rose, a supporter of modern art, was raised in the world of the French avant-garde and spoke its language from an early age.

The meeting between Sonia and Robert Delaunay in 1908 marks the beginning of one of the most productive and, in some though not all ways, mutually enriching artistic exchanges of the twentieth century. Yet modern art histories, with their almost exclusive focus on individual production, provide little in the way of a model with which to evaluate creative exchange within partnerships like that of the Delaunays. For the most part, they are content to project the Delaunays' working relationship (when acknowledging Sonia's presence at all, that is) as an artistic variant of the perfect marriages of popular fiction, stressing a complementarity secured by difference and by untroubled relations of dominance and subordination. He, Parisian-born and upper middle class, mercurial and ambitious, a selfdeclared "genius," painted and wrote theoretical treatises on modern art, sometimes extending his ideas to other media and other projects. "I was carried away by the poet in him, the visionary, the fighter,"

Sonia herself later confessed.¹ She, a Russian Jewish expatriate, all warmth and generosity, quietly adjusted herself to his needs, setting aside her own career as a painter and instead devoting herself to applying his esthetic theories to the decorative arts, and to the creation of a welcoming environment for the couple's many friends. Cheerfully shouldering the responsibility for the family's financial well-being, she also assumed the care (with paid help) of the son born in 1911, thus freeing Robert to follow the dictates of genius.

The problem with this version of reality is not that the facts don't fit, but that it originates almost entirely in the minds of men. We know how Apollinaire, Tristan Tzara, André Breton, and other male modernists viewed the Delaunays. We do not know how Marie Laurencin, Fernande Olivier, or Simone Breton experienced life *chez* Delaunay, if indeed they did. Gertrude Stein's rather curt dismissal of the couple in her *Autobiography of Alice B. Toklas* is of little help in sifting reality out of vanguard myth; and few historians have been willing to accept Sonia's characterization: "We were two moving forces. One made one thing and one made the other."¹²

Feminism has contributed mightily to disentangling Sonia and her work from Robert and his, and contesting that all too familiar assumption that he made art and she made craft. Like Sophie Taeuber-Arp, Marie Laurencin, Lee Krasner, and other productive female modernists, she now stands alone when necessary-with her own exhibitions, catalogs, monographs, even a biography. The problem is that underlying many of them is the assumption that she can be neatly fitted into the mold that he forged, that his modernism and her modernism are for all intents and purposes the same; they were after all a couple. Once again one is left wondering where to put a life and a production as intricate as those of Sonia Delaunay, that both shaped and defied familiar categories and forms of expression. Clearly it is modernism itself-particularly those aspects of it relating to the intersection of abstract painting and design-which demands refashioning around a figure like Sonia Delaunay. I want to suggest here that not only should we be wary of attempts to insert Sonia Delaunay too neatly into the lineage which has secured Robert's place in modern art histories, but that we must continue to chip away at the notion that the parameters of modern art are fixed and monolithic. To acknowledge the territory of early twentieth-century modernism as unstable rather than fixed, as shifting in focus and definition, is to concede that a single couple in the Paris of the 1910's and 20's might indeed experience, and shape, different versions of what we now call

modern art. If Sonia Delaunay is at the margins of modern art—as her exclusion from many books on the subject suggests—then it is the margins that must be seen as defining the center.

The terms of the Delaunays' artistic relationship were less fixed, more subject to negotiation, to unconscious if not conscious reworking, than art history leads us to believe. Artistic hierarchies, which establish the predominance of painting and sculpture by asserting their difference from the decorative arts, are of little help in evaluating a creative outpouring in all media like that of Sonia Delaunay. And social constructions of sexual difference within bourgeois marriage as complementary but separated into distinct spheres of influence color both the Delaunays' and our own understanding of their creative relationship. Sonia Delaunay did not publicly contest society's, and Robert's, positioning of her: "From the day we started living together, I played second fiddle and I never put myself first until the 1950's. Robert had brilliance, the flair of genius. As for myself, I lived in greater depth."3 To live a secret life in "greater depth," or to assume what feminists have theorized as a public masquerade of masculinity-"'I'm against women's work being seen apart. I think I work like a man"4-are but two of the many strategies often adopted by women, perhaps unconsciously, when confronted with the difficulty of reconciling art and femininity.

The woman who "lived in greater depth" was sensitive to the complexities of a union between two artists, one of whom had a wellknown antipathy to competition, and was secure in her knowledge of herself. Her words also reveal something of the unfolding pattern of the creative lives of this couple; it is a pattern rich in loops and circles—like the prisms and discs of the Delaunays' painting—loops which sometimes parallel each other, sometimes intersect, only to swirl away again, always returning to a central point.

The initial moment of confluence and diversion came during the summer of 1909. While Picasso and Braque struggled toward the new relationship of form and space that would define Cubism—one working in a small Spanish hill town, the other in Cézanne country the Delaunays spent hours walking in the countryside near Paris, exploring nature with an eye to breaking down its forms and using them as the basis for a new pictorial language. Despite Robert Delaunay's relative lack of formal training in art, he already displayed a characteristic desire to understand its complexities through study and analysis. A series of Neo-Impressionist canvases, their broken brushstrokes and juxtapositions of primary colors signalling his

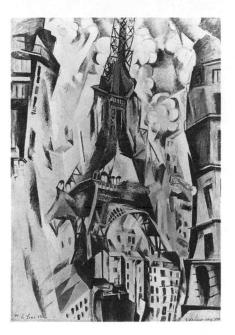

Robert Delaunay, Eiffel Tower, 1910

familiarity with Cézanne's landscapes and Chevreul's color theories, was followed by a speedy but methodical sweep through Fauve and Cubist painting. Robert Delaunay's paintings of 1909, which include the first study for the groundbreaking series *Eiffel Towers*, reveal his growing commitment to the interplay of color patches and curved forms, and to a structural use of color and brushstroke strongly influenced by Cézanne.

It was at this point that Sonia temporarily abandoned painting and turned to embroidery. The paintings included in her first oneperson exhibition at the art dealer Wilhelm Uhde's gallery the previous year had included powerful figurative canvases in which forms were simplified and organized into flat areas of intense color, often bounded by strong black outlines. Influenced by the work of Matisse and Gauguin, these early paintings established her professional reputation and revealed her allegiance to the principles of an expressionist avant-garde that included a group of fellow Russians, among them Alexandra Exter and Natalia Goncharova.

The reasons for Sonia Delaunay's sudden change in medium in 1909, when she produced an embroidery of foliage patterns similar to Robert's flower studies of the same year, remain obscure. There are no extant paintings by her from that year and she has offered no

explanations. Robert, on the other hand, clearly encouraged her to find her direction through the applied arts, and in so doing reaffirmed a gendered creative tradition in which men produce the masterpieces, women embellish the home. "The break," he later noted, "was to come in 1909. Delaunay-Terk made some satin wall-hangings which, by means of their expressiveness, were to bring into view the prospect of liberation."⁵

Was it Robert's criticism of her reliance on drawing as a scaffolding for her imagery that led her toward a new kind of surface elaboration? Or a growing awareness of her young lover's insecurity in the face of competition? Or simply a renewed fascination with satin stitch embroidery? It was an unusual step for an ambitious young woman who had battled with her family for the right to remain in Paris and become an artist and whose first exhibition had recently opened to positive reviews. We may never know the true reason and Sonia would not exhibit her paintings alone again until after Robert's death—but the decision meant that the Delaunays moved toward pure abstraction along related, but distinct, paths and into art history in different, but unequal, categories.

In 1910, Sonia and Uhde (with whom she had enterprisingly arranged a marriage of convenience in 1908 in order to remain in Paris and paint) agreed to an amicable separation so that she and Robert could marry. After a sojourn in the country while they waited for Sonia's divorce to become final, the young couple settled into an apartment with a studio on the rue des Grands Augustins. It was during this period that Sonia produced her first collaged and painted designs for book covers, and Robert began his first Cubist-derived paintings on the theme of the modern city.

Moving toward an art of abstraction in which color and form were liberated from representation, Sonia and Robert Delaunay first analyzed forms in nature. Robert referred to the process as "deconstruction;" Sonia thought in terms of the constructed surfaces of textile design. Although the routes they followed toward their goal of pure abstraction were not identical, both would come to conceptualize painting as a structural activity. And both used the word *craft* to describe their interest in the materiality of paint. Sonia's utilization of the vocabulary of textiles, however, no doubt contributed to later critical dismissals of her work as craft rather than "fine" art. "There is really a flagrant injustice toward us two," she later noted. "I was classified in the decorative arts and they didn't want to admit me as a fully fledged painter."⁶ Robert's adherence to Cubism,

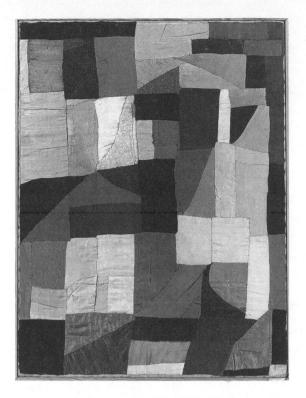

Sonia Delaunay, appliquéd quilt, 1911

on the other hand, placed him squarely within the theoretical framework that rooted modernist painting in that movement's conceptual and stylistic innovations.

It is not surprising that Sonia Delaunay's first purely abstract work was not a painting at all, but a pieced and appliquéd quilt of brightly colored geometric blocks and arcs made shortly after the birth of the couple's son in 1911. The quilt's geometries and extravagant mix of colors—reds, yellows, greens, purples, pinks, black and white—originated in her memories of quilts she had seen in Russian peasant homes. But while Robert identified the quilt with Russian folk art, the couple's artist friends were quick to note its debt to Sonia's knowledge of early Cubist painting. The bed covering produced at a moment when Robert's paintings were also moving toward greater abstraction, rectangular fragmentation, and a stronger surface patterning—shares its vertical orientation with the upwardly sweeping geometries of his *Eiffel Tower* paintings of 1909–11, but the color sense is pure Sonia.

Robert Delaunay, Windows Open Simultaneously, 1st Part, 3rd Motif, 1912

The quilt's rich surface of liberated forms and colors is imprinted in Robert Delaunay's groundbreaking series of paintings titled Windows, begun in 1912. His return to a more highly keyed palette in subsequent paintings is inseparable from Sonia's increasingly free use of color at this time. To unravel the directional flow of influences in 1912 might satisfy an art historian's need to know who did what first, but it is of little help in understanding the Delaunavs' synergistic creativity. However indebted Robert may have been to Sonia's more spontaneous and uninhibited expressions of color-or she to his years of studying and analyzing form-the two understood their sources quite differently. She attributed her new compositions to Robert's understanding of Chevreul's color theories: "And his construction in turn helped me. It was the backbone of my painting. It enabled me to arrange colors without drawing."7 He was quick to connect the surface orientation of Sonia's painting to the traditions of the decorative arts: "the colors are dazzling. They have the look of enamels or ceramics, of carpets ... "8 If her surfaces were decorative in his eyes, her color sensibility was "atavistic," rooted in her Russian Jewish heritage, a sensitivity to color that, in Robert's words, "went far beyond academic and official instruction because of an innate need that was incompatible with established formulas, because of an anarchic spirit that would eventually be turned into a regulated force."9

The identification of a woman artist's creativity with the innate and powerful generative forces of nature places women's productions outside the mediated sphere of male cultural activity. Men study and

think; women feel and generate instinctively. In the Western polarizing of mind and body, men are rewarded for being intellectual and theoretical, women for being intuitive and procreational. Constructions such as these reinforce powerful and widely held cultural beliefs that women and their actions are inexplicable and unknowable, and they are widely internalized. "My life was more physical," Sonia would later explain. "He would think a lot while I would always be painting. We agreed in many ways, but there was a fundamental difference. His attitude was more scientific than mine when it came to pure painting, because he would search for a justification of theories."¹⁰

Sonia, although she did not share Robert's interest in intellectual and theoretical analysis, understood her ability to translate sensation into coherent expression as a result, not of intuition or mystical origin, but of the disciplined training she had received as an art student in Karlsruhe between 1903 and 1905. Describing those years in a biographical sketch written later and in the third person, she remarked that: "He [the professor] not only taught drawing, with severe discipline, but the structure of plastic expression as well. . . . This discipline has marked her work thereafter, forcing it to have a constructive basis which imparts force to plastic expression and *eliminates chance, indecision, and mere facility* [my italics]."¹¹

The year 1912—the year that both Delaunays fully realized the implications of simultaneity in their work—was a major turning point for them. While he formulated his theory—based on light as a unifying force among contrasting colors—she produced lampshades and curtains, colored surfaces penetrated by actual light. Robert's first abstract compositions, *Windows*, *Discs*, and *Circular Forms* (all of which would become series), appeared and many of them were included in his first one-person exhibition that year at the Galerie Barbazanes. Sonia executed her first studies of light (*Study of Light*, *Boulevard Saint Michel*) and painted her first completely abstract oil, *Simultaneous Contrasts*.

At the moment that Robert assumed a public position in the modernist vanguard—traditionally measured by one-person exhibitions of paintings or sculpture and critical recognition—Sonia's career began to diverge from this familiar model. Her return to painting in 1912 was not accompanied by a return to public exhibitions. And although her reputation spread rapidly throughout Western Europe after 1912, it did so primarily among art world initiates or, after the War, as a commercial designer rather than an

"artist." As Robert Delaunay's work became more firmly situated within esthetic debates, Sonia Delaunay began to apply the principles of simultaneity to a wide range of materials and objects, producing collages, pastels, fabrics, household items, and bookbindings.

Sonia and Robert Delaunay shared a remarkably similar esthetic vision. Yet that vision would be inscribed very differently across the geographies of modernism. While Robert and his work, along with his growing reputation, remained closely tied to the "art for art's sake" esthetics of Cubism and geometric abstraction, Sonia soon identified with those artists-including the Futurists and Dadaistswho sought to demolish the hegemony of easel painting, to take art out of the studio and into the streets. It was during this period that Sonia and Robert Delaunay met the two writers whose work came closest to theirs in feeling and attitude, and whose influence would prove decisive in shaping the relationship of both to an emerging modernist art history. Guillaume Apollinaire and Blaise Cendrars would find poetic inspiration in simultaneity, that embrace of multiple and coincident events and sensations that signified contemporaneity to the Delaunays. Both would make of it an experimental poetic language; both would, like the Delaunays, be assigned very different positions in the modernist pantheon. It was Apollinaire, the intellectual and theorist, whose writings would define the new modern art in Paris and situate Robert Delaunay within it, but it was Cendrars who remained for Sonia "the truest and greatest poet of our time."12

It was while staying with the Delaunays in November and December of 1912 that Apollinaire composed "Zone," a simultaneous poem that has been called the first truly modernist piece of writing. Today Apollinaire is as well known for his passionate and persuasive defense of modern artists like Picasso, Braque and Robert Delaunay as for his modernist verse. His writings on Robert Delaunay, and his critical support at a key moment in the young artist's career proved crucial. Sonia and Robert Delaunay's first collaborative book project was an album of orange and indigo blue sheets designed for a poem of Apollinaire's inspired by Robert's painting Windows. The project provided a powerful impetus toward their subsequent experiments with verbal and visual combinations. Cendrars, colorful French-Swiss vagabond and self-invented personality, arrived in Paris in 1912, bringing with him an explosive poetic hymn to what Apollinaire would call l'esprit nouveau. "Easter in New York" erupted in a stream of confrontations and condensations: "The

steam whistles raucously jeer and choke. The city trembles. Fire, cries, and smoke." The poem so moved Sonia Delaunay that she immediately designed a cover for it: "On suede I placed motifs of paper collage. Inside I did the same with big, colored paper squares. It was a tangible response to the beauty of the poem."¹³

The following year Cendrars and Sonia Delaunay collaborated in designing a format for his epic Prose of the Transsiberian and of Little Jeanne of France. Determined not to "illustrate" the poem, Sonia instead experimented with new arrangements of color, images and words. The results found their way into the paintings of both Delaunays, as well as the writing of Apollinaire and Cendrars. To accommodate the text, a long poem evoking a train journey from Moscow to Nikolskoye on the Sea of Japan, the two chose a single sheet of paper which, folded lengthwise and then refolded, opens like an accordion to a length of about seven feet. The parallel columns of painted and typographic imagery flow from panel to panel through a series of interlacing arcs, arabesques, spirals, squares, and triangles of color. The work's verbal and visual equivalences marked a major innovation in twentieth-century graphic design; it also signalled the fully developed articulation of a new, pure language of color in Sonia Delaunay's work.

Blaise Cendrars, who often called himself "the poet of the Simultaneous," enjoys no position in the chronicles of modern art comparable to that held by the cerebral Apollinaire. Indeed, if Sonia has often been projected as "other" to Robert, something similar might be said of the position assigned to Cendrars by critics and historians of modernism. His literary reputation, his biographer Jay Bochner tells us, is often cast as that of a "gifted outsider;" he is frequently dismissed as more intuitive than intellectual, more connected to lived experience than to art. Just as Robert Delaunay produced Sonia's "otherness" through the gendered attributes of "exoticism" and "atavism," so also did critics project Cendrars as the irrational "feminine" to Apollinaire's measured intellectualism.¹⁴

The year 1913 was one of extraordinary production in avantgarde circles. In Paris, Apollinaire published Les Peintres cubistes: méditations esthétiques (The Cubist Painters: Aesthetic Meditations), the book which would be accepted for many years as the first serious analysis of Cubist painting as understood by its original practitioners, and Stravinsky's Rite of Spring made its explosive debut. In New York, Marcel Duchamp's Nude Descending a Staircase outraged audiences at the Armory Show, while in Moscow, Natalia Gonchar-

ova exhibited 761 works and signed the Ravonist and Futurist manifesto. Sonia Delaunay's paintings of that year included major works like The Bal Bullier, a three-by-ten-foot painting in which brilliantly colored shapes and rich juxtapositions of warm and cool, acid and mellow hues evoke the five couples dipping and turning to rhythms of the tango, and the first of Electric Prisms, paintings based on the effects of electric lighting on the streets of Paris. An explosion of works in a wide variety of media accompanied the paintings as Sonia and Cendrars turned their attention to commercial images. producing advertisements and posters for lectures and exhibitions marked by luminous arcs of pure color. There is no evidence that Sonia sought to realize any of these projects commercially at this time, or to profit by them. Rather they served as a fertile ground for her ongoing attempt to define the modern through a poetics of color and word.¹⁵ Having fully liberated her esthetic from a reliance on the easel picture, it was no longer possible to arrange her productions in any recognizable hierarchy based on media.

In 1913, Sonia and Robert Delaunay were invited to exhibit in the Herbstsalon at Der Sturm Gallery in Berlin. Robert's works on display, including canvases like The Cardiff Team (1913) and the series Circular Forms (begun in 1912), reveal the richness and complexity of artistic exchange between the Delaunays at this time. His large canvas The City of Paris, when exhibited in Paris, had moved Apollinaire to proclaim it the most important work in that year's Salon. ""The City of Paris' is more than an artistic manifesto," he assured his audience. "This picture marks the advent of a concept of art which has not been seen since the great Italian painters."16 The painting combines themes familiar to Robert-views of urban Paris, the Eiffel Tower-and adds to them the Classical image of the three Graces, as seen through the distorting lens of Picasso's proto-Cubist masterpiece Les Demoiselles d'Avignon (1907). Robert's City of Paris represents a kind of summing up of his own history as a modern artist, but its selfconscious grandeur also reveals the beginnings of his later struggle to locate subjects worthy of his ambitious desire to shape modern art.

Sonia's contributions to the Berlin exhibition ranged from bookcovers and posters to lampshades, curtains, and cushions, and included her collaboration with Cendrars on *Prose of the Transsiberian* which they planned to publish in an edition of 150 copies. Sonia Delaunay's Berlin works reveal no indecision about her future direction, no agonizing over medium or subject. Many of the items she sent to the Herbstsalon had already found homes with artists and

Sonia Delaunay, Electric Prisms, 1914

other friends of the couple, but her work was now circulating without the intermediary of gallery, art dealer, or critical press.

While Robert's painting moved between the poles of pure abstraction and a simplified Cubist-derived figuration, always stressing the interplay of color and form, Sonia began to apply the principles of simultaneity to new enterprises. Both Delaunays maintained a firm belief in movement and the dynamic interplay of shapes and colors as signifiers of modern life, but it was Sonia who first acknowledged the limitations of painting as an essentially static medium, one in which motion could be depicted or implied, but never actualized. During the summer of 1913, she began to make "simultaneous" dresses and fabrics, organizing their patterns of abstract forms to enhance the natural movement of the body and produce a moving surface of shimmering color. Cendrars was quick to remark on the new identification of the female body in motion with

modern life, noting in a poem inspired by Sonia's new fashions, "colors undress you through contrast; On her dress she wears her body."¹⁷ In the early twentieth century, women's fashions would become an important medium through which the principles of abstraction were translated to a broad public as the Victorian legacy of clothing as a means of defining class and occupation gave way to the modern preoccupation with clothing as a means of creating identity. Sonia Delaunay's experiments with color and design contributed mightily—along with those of the Bloomsbury group in London to an early forging of what would become a long and uneasy marriage between modern art and fashion in the twentieth century.

News of Sonia's simultaneous dresses spread swiftly. In Italy the Futurists, equally committed to producing their own esthetic rupture with the past, also began to exploit the idea of clothing as a signifier for a revolutionary modernism. Although Futurism's virulent antifeminism would lead to costumes designed almost exclusively for men, it is worth noting that Giacomo Balla's 1914 manifesto, "The Anti-Neutral Dress," owed much to Sonia's pioneering experiments. The avant-garde designs by artists for fabrics and fashions which flowed from Paris, Milan and, after the October Revolution, Moscow, marked the beginning of a new era in fashion and a challenge to critical constructions of modernism as primarily rooted in the stylistic innovations of vanguard painting.

Sonia and Robert Delaunay were in Spain when war broke out in 1914. Word of the Revolution in Russia reached them in Barcelona in 1917, bringing with it news of the certain loss of Sonia's income, on which they had depended since their marriage. It was during this period that she began to seek commercial applications for her designs. Costumes which she created for Serge Diaghilev's production of *Cléopatre* in 1918 (with sets designed by Robert) established the couple's reputation as innovative designers. A subsequent commission for costumes for the Barcelona Opera Company's production of *Aida* led to the first requests from wealthy Spanish women for modern dresses designed by Sonia Delaunay. In 1919, the "Casa Sonia," a boutique specializing in simultaneous dresses, scarves and fabric, opened in Madrid. With Sonia now launched on a commercial design career, Robert began to draft a chronology of her work in the various media she now employed.

The Delaunays returned to Paris in 1921 and quickly reestablished themselves at the center of a group of writers and artists which included members of the Paris Dada group, among them the poets

Breton, Philippe Soupault, and Tzara. Now, however, it was Sonia's extension of the principles of abstraction in painting to the objects of daily life which attracted others determined to abolish hierarchies of media, artists whose radical stance included a critique of the conventions of painting and sculpture and a desire to break down the barriers between art and life.

She turned the interior of the couple's Paris apartment into a dazzling display of simultaneous fabrics, screens, embroideries and geometrically patterned rugs. The poet René Crevel described walls covered with multi-colored poems to which fellow poets and painters added their own notes and greetings. Determined to disrupt at every point the conventions of artistic expression, the Dada poets were quick to enter into the spirit of creative freedom that prevailed in the Delaunay household. "The master of the house," Crevel noted, "invited every new guest to go to work and made them admire the curtain of gray *crêpe de Chine* on which his wife, Sonia Delaunay had through a miracle of inexpressible harmonies deftly embroidered in linen arabesques the impulsive creation of Philippe Soupault with all his humor and poetry."¹⁸

The Delaunays' first encounters with Dada had probably taken place in Madrid at the time Robert contributed to the second issue of the periodical Dada. By 1922, Tzara, Soupault, Joseph Delteil, and others were writing poems on Sonia's creations and wearing clothes that she had designed and made. Although her name appears infrequently in Dada histories, her achievement in freeing abstraction from the conventions of easel painting helped shape a new esthetic, or anti-esthetic, depending on who was employing the pen or the brush. A series of "dress-poems" brought colors and words into everchanging relationships through the movements of the body. "When receiving her friends," wrote one admirer, "she wears a tea-gown.... But in the evening she wears the coat that is worthy of the moon and that was born of a poem; for the geometric forms of the alphabet were used by Sonia Delaunay as an unexpected ornament, so that now instead of saying that a dress is a poem we can say: This poem is a dress."19

Dada took art out of the studio and into the cabaret as artists contributed compositions, musical scores, and performances—as well as paintings, objects, and poems—to Dada events. When in 1923 Tzara revived his theatrical work *The Gas Heart* in a production at the Théâtre Michel, it was with costumes designed by Sonia Delaunay. The play, a complicated parody on nothing, featured the characters

Neck, Eye, Nose, Mouth, and Ear. Sonia's cardboard costumes retained the planes and geometries of her earlier costumes for the ballet, but their scale and absurdity were pure Dada.

Sonia's willingness to continue funding the family through the commercial application of her talents may have relieved the impractical Robert, but it doesn't appear to have liberated his work. If the Dada revolt against traditional esthetic values found sympathetic spirits in the Delaunays, it also may have contributed to Robert's crisis over what to paint during the 1920's, for it struck at the heart of his commitment to painting as central to the modernist project. The vears during which Sonia extended the principles of abstraction to a flourishing design business correspond to a period in which Robert's painting vacillated stylistically and his career languished. His 1922 exhibition at the Paul Guillaume Gallery received positive notice from artists but was a commercial failure, and he sold practically nothing for the next ten years. His paintings of these years include reworkings of earlier subjects-including the Eiffel Tower-as well as a number of portraits of prominent poets and writers in which volumes are simplified and the palette monochrome. In several of these works, abstraction is present only in the bold geometric shapes and colors of the simultaneous scarves and vests designed by Sonia and worn by the sitters.

Sonia Delaunay's notorious booth of modern fashions at the Bal Bullier in 1923—with its scarves, ballet costumes, embroidered vests, appliquéd coats, and wealthy clients—and her Future of Fashion show at Claridge's Hotel in London, featuring models draped in simultaneous fabric, led to an invitation to design fabrics for a textile manufacturing firm in Lyon. Sonia Delaunay would become the bestknown of a number of twentieth-century artists—from Raoul Dufy to Varvara Stepanova—whose designs found their way into the world of commercial fashion.

Meanwhile, Robert Delaunay designed the display for the fabrics which Sonia presented at the Autumn Salon in 1924, and patented her invention of a "fabric pattern" which, when sold with a length of material, allowed middle-class women to produce Sonia Delaunay designs at home. By 1925, Sonia's design work represented the most significant extension of the Delaunays' concept of modernity into the everyday world and her name had become synonymous with "modern style." As her experiments in design spread to furniture, carpets, the movies, and even the decoration of a Citroen automobile, Robert began to orchestrate her contacts with potential clients.

Robert Delaunay, portrait of Madame Mandel in one of Sonia Delaunay's simultaneous dresses, 1923

"When success literally assailed me," she commented later, "he pretended to be envious of my luck and to believe that the money was easily earned. 'You don't realize, you are not doing anything, you don't make the slightest effort and people climb up five flights of stairs to come and buy.'"²⁰

By the end of the 1920's, it was apparent that the Delaunays' esthetics were inseparable from a Western European modernism in which they both played formative roles. The couple's final decade together saw a series of collaborative efforts and, much to Sonia's relief, the collapse of her business in the worldwide recession of the 1930's: "I was capable of being a woman manager, but I had other purposes in life. I have always felt horror and disgust for the business world... the heap of orders, the mundane intrigues... in the end I was employing thirty workers... all of it devoured me."²¹ It was also a period during which Robert's reputation was further institutiona-

lized through major museum exhibitions like the New York Museum of Modern Art's "Cubism and Abstract Art," organized by Alfred Barr in 1936. For Sonia, there was no such institutionalization. though the elaboration of her designs in architectural contexts seems to have contributed to Robert's return to abstraction in painting around 1930 in a series of works called Rhythm Without End, whose circular forms and half circles originate in Sonia's earlier paintings of dancers. The exchange of motifs and colors between the Delaunays was once more open and reciprocal, connected in Sonia's mind to the filtering of a shared esthetic through different temperaments: "He would ask me at the end of the day: 'Are the colors exact?' We worked a lot together on these rhythms since they were closer to me. Robert's work is more scientifically simplified than my painting. I used to tell him at the time that it was too dry. Over the years, I realize that it was done on purpose. . . . it was really our two temperaments expressing themselves differently."22

Robert Delaunay died in Montpellier in 1941 and Sonia did not return to Paris until 1945. Once there, she was instrumental in arranging a retrospective of Robert's paintings in 1946, and in organizing and documenting his work for a complete catalog. Robert Delaunay: du cubisme à l'art abstrait (Robert Delaunay: From Cubism to Abstract Art), with a text by Pierre Francastel, appeared in 1957. Robert's death released her from her long-held belief that only one public career as an artist was possible for this couple. A major retrospective of Sonia's work-250 pieces in all-was held at the Kunsthalle in Bielfeld, Germany, in 1958; it was followed by a remarkable string of more than fifty one-person exhibitions by the early 1980's. At the end of her life, she again recalled the shared vision that bound her esthetic to that of Robert. In the closing lines of the autobiography published in 1978 she noted: "In my most recent research, I have had the feeling of being very close to touching what Robert had felt and what was the 'solar source' of his work.... I am sure that there is, behind it all, something fundamental, which will be the basis of painting in the future. The sun rises at midnight."²³ Yet not until 1987 were the productions of Sonia and Robert Delaunay joined together in a major exhibition at the Musée d'Art Moderne de la Ville de Paris.

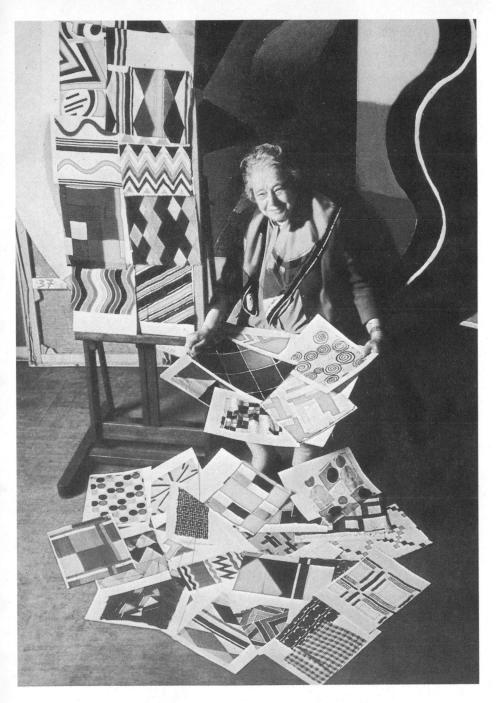

Sonia Delaunay selecting fabric samples for her 1965 retrospective exhibition at the Musée des Arts Décoratifs, Paris

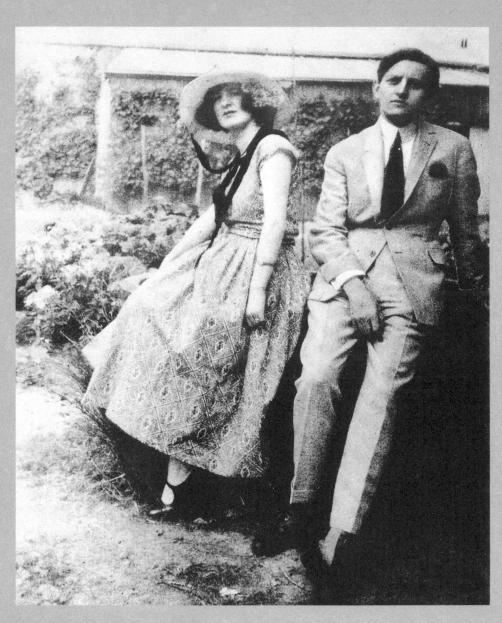

Clara and André Malraux in Indochina, 1923

OF FIRST WIVES AND SOLITARY HEROES

Clara & André Malraux

ISABELLE DE COURTIVRON

ANDRÉ MALRAUX built his legend on the strength of his remarkable intelligence, on the hypnotic quality of his monologues, on his uncanny ability to anticipate the spirit of his times, and on his innovative literary style. He also built his legend on the solitary courage of men and on the collective silence of women. Clara Malraux wrote three novels and six volumes of memoirs to remind the world—but mostly him—that in the beginning, she was there also; that during the formative fifteen years of their life together, when he laid the foundations for his work and fame, he was not the solitary adventurer he and his biographers liked to project.

In 1923, André and Clara, both in their twenties, sailed to what was then called Indochina on a quest reminiscent of Rimbaud's to Abyssinia: to "appropriate" some Khmer statues in order to sell them to American dealers. The money would allow the Malrauxs to continue the lifestyle to which they had become accustomed since their marriage two years earlier. It was a marriage which had been an act of passion, of rebellion, but also of convenience. When they met, both stood impatiently on the threshold of adult life. Clara Goldschmidt (born in 1897) was older by five years, wealthier-her German Jewish family had prospered in the leather trade-and more sophisticated. Her childhood had been spent between her comfortable Parisian home and her maternal grandparents' house in Magdeburg, Germany. Though she had no formal education, her father's death when she was 13, her mother's weak and dependent character (a model she would make certain never to emulate), and a premature inheritance, had freed her to read voraciously without fear of parental censorship, to visit museums, take lessons, and travel. She spoke several languages, had spent time alone in Italv. was thoroughly familiar with German Romanticism and Italian art, and projected the self-assurance that the combination of a comfortable income and an unusual intelligence can insure. Vivacious, elegant, headstrong, and, on her own admission, "not pretty enough for

silence," Clara thrived on her love of literature and on her fascination for avant-garde thinking. The major obstacle she faced was that, as a woman alone, the life of an intellectual which she wanted to lead was closed to her. Even in the most avant-garde Parisian circles whose members claimed liberation from bourgeois ideology, the idealization of Woman in the cultural imaginary, as Susan Suleiman has pointed out, was intimately connected to the exclusion of women from cultural practices.1 From courtly love to Surrealism, the tradition of mixité (heterosociality) so predominated in France that French women had rarely succeeded, unlike Anglo-Saxon women, in creating alternative spheres. The "Women of the Left Bank" who made major contributions to the modernist movement in the Paris of the 1920's were, on the whole, American and British expatriates with a more established tradition of separatism; and, more often than not, they were also lesbians. Their counterparts, heterosexual women firmly constrained by tradition, who gravitated toward predominantly French or European movements such as Surrealism, were "unable (even unwilling) to establish any power base within the masculine culture," as Shari Benstock has observed.² An intelligent and creative French woman, like Clara, could most easily accede to existing intellectual and artistic circles, therefore, by sharing the life of one of its members. Clara was not unaware of these realities. Moreover, pressure was being placed on her by her older brother, too conventional to appreciate the freedom of her mind and of her choices: "get married and make mistakes under another name," he warned. Clara had resisted this option for several years, though she was not opposed to companionship (she was, indeed, quite taken with the idea of romantic love). But she wanted to translate, to write, to become involved in art and politics, and she was determined to share all those new ideas she found so exhilarating with an intellectual partner. Meanwhile, she had begun working part-time for one of the many small avant-garde reviews being published in Paris in 1921. Some said she was helping to finance Action, whose first issues were filled with the works of Max Jacob, Jean Cocteau, Antonin Artaud, Eric Satie, Maxim Gorky and Guillaume Apollinaire. But in the spring she had also published in this review her first translation of German poetry. Perhaps because of her brother's concern about their family's reputation, however, she signed the translation only with her initials, C. G.

The childhood of André Malraux could not have been more different from hers. So much so that he at first decided to embellish it,

then opted for an attitude of contempt for the traditional autobiographical gesture (that "miserable little pile of secrets") which reveals only what a man hides. As he wrote in Antimémoires (1967), a man is not what he hides but what he does. He also stated that he hated his childhood. No one is quite sure of the reasons for such dark memories; even his most authoritative biographer, Jean Lacouture, has questioned the reasons for these negative associations. Was it because he had been raised in Bondy, a modest suburb of Paris, inhabiting a small place over the grocery store run by his mother and grandmother who, by all accounts, were extremely loving? Or was it simply because he had been raised by women? Was it because he was part of the generation that had been too young to participate in the First World War and carried the guilt of their elder brothers' deaths? Or because he was a fragile youngster whose only way out of his drab environment was by combining a precocious intelligence and something of a hustler's mentality? A true autodidact, he had fashioned for himself an impressive cultural baggage based on an iron intellectual discipline, and soon found that his strength lay in the exceptional way in which he communicated his ideas—with bravado, flourish, self-assurance, and a dazzling monologic style that he learned to cultivate when he understood its power over others. Like Clara, he hovered on the periphery of the literary effervescence that was Paris in the post-war period, in the world of bookstores, publishers, reviews, and literary groups.

When they first met, at a banquet given by the director of Action for its contributors-in which the nineteen-year-old André had just published his first prose poem-Clara immediately saw through the awkwardness, insecurity, and the modest origins of the young man. More importantly, she grasped the extraordinary potential of one who was still a boy, but in whom she recognized a fellow spirit. They started talking, and never stopped. They talked about their readings, about art, about poetry, about their common rebellion against bourgeois complacency, about their thirst for adventure and travel. He was surprised by this independent, provocative, intelligent young woman; he was impressed by her knowledge, attracted by the fact that she was Jewish-an identity which nineteenth-century French literature had marked erotically-and, let us not underestimate it, by her money. She saw in him a potential future "Great Writer" that she could help mold, the ideal companion with whom she could share books (those they would read and those they would write), and long journeys. He would enable her to escape the stifling bourgeois

environment to which her gender confined her; she would help him break out of drabness and indecision into a more cosmopolitan and refined sphere. They fell in love.

Theirs was not an unconventional union. In the early part of the century, a number of French intellectuals chose Jewish companions who had grown up in progressive milieus in which the world of the intellect was not considered with suspicion. These young women, freer in their ideas, less conventional in their mores, made more daring and intellectually challenging companions than their bourgeois Catholic contemporaries (whose stifling adolescence has been so painfully documented by Simone de Beauvoir in her autobiography. Memoirs of a Dutiful Daughter). Often, they were also wealthier, enabling budding young writers or painters to devote themselves to building the foundations for their future greatness. Jean Paulhan's wife, Salomea Prusak, a young Polish Jew, was studying to be a doctor. (Did he speak for some of his friends when in 1905 Paulhan wrote in his journal: "Ever since I have begun to love her, I have gained contempt for her ideas"?).³ Drieu la Rochelle married Colette Jeramec, also Jewish and also a doctor; Louis Aragon, on the rebound from Nancy Cunard, married Elsa Triolet who was Russian and Jewish, as was Sonia Terk who became Robert Delaunay's wife. When they were first married, Paul Nizan went to live with his wife Henriette's wealthy Jewish family, in the same way that André cohabited with the Goldschmidts. Nizan did not see any contradiction between this comfortable arrangement and his fierce Communist sensibilities. Breton's first wife, Simone Kahn, who greeted Clara on her return from her first harrowing Indochina expedition, was also Jewish and one of the rare women who was allowed in the Surrealist circles though not, it seems, to participate in the creative aspects of their enterprises. Some of these "first wives" had disappeared by the time their companions became recognized. Others pursued their creative itineraries in exchange for a public acknowledgment of their companion's greater talent.

Clara fell in love not only with the man but with the idea of the couple they would (and in fact didn't) become. An ideal fashioned from both traditional romantic notions and from the progressive concepts of the New Woman of which she was an exemplar. One month after they met, they left together for Italy unbeknownst to her family. It was during this trip, when they were recognized sharing the same wagon-lit by a family friend of the Goldschmidts, that the issue of marriage was decided. The wedding took place that fall. They took

their first plane trip together, visited Europe and North Africa, spent afternoons and Sundays with their intellectual friends the Delaunays, the Chagalls, and the Golls in bohemian apartments, but returned to the convenience of her family home. There the conversation may have been limited to the vagaries of the leather trade but the meals were conveniently prepared and the laundry freshly ironed. But mostly, rebels in spirit if not in lifestyle, they explored together the new world that their generation inherited, the world of Cubism, Surrealism, and socialism. Clara was more alert than André to the great rumblings in the Soviet Union, to the discontent of the labor movement, to the first stirring of Freudianism. André, who was trying his hand at art and literary criticism and had published a slim volume of *farfelu* prose, *Lunes en papier*, spent entire nights forming opinions, devising philosophical hypotheses, trying out his inimitable formulas.

Until 1923, that is. That year, the stocks in which André had invested Clara's generous dowry failed. Suddenly, they had no more money. In answer to her question "What do we do now?" he waxed indignant: "You don't think I'm going to start working, do you?" She had to admit that she didn't. It was at that point he thought up the Indochina scheme.

The legend of André Malraux begins with this first adventure. True, it was in keeping with the exotic temptation that seduced young French intellectuals to turn away from a tired European civilization during the early part of the century, and both young people must have been as much in love with their image as with the material goal of their expedition. The trip was captivating and so rich in discoveries that they did not have time to weigh its risks. They travelled first class and, inappropriately equipped with fashionable Parisian colonial outfits, made their way from Djibouti to Singapore, Saigon, and Phnom Penh, André talking his way—but not altogether successfully as we shall see—into an official archeological mission.

The few days in the jungle, riding on small horses, camping in hot, mosquito-infested grounds and surrounded by suspicious Indochinese, were undoubtedly arduous. This expedition may strike us today as more *farfelu* than dangerous, but each had to prove his or her valor. They did reach the temple of Banteai Srey, they did dig up the frescoes, and they were feeling quite the conquerors as they returned to Phnom Penh. There they were promptly arrested. Suddenly, the heroes turned into three (they had been accompanied by a school friend of André's) frightened young tourists stranded in a hostile environment. They were to be confined in Phnom Penh until

André Malraux in the Resistance, ca. 1943-4

their trial; the French colonial authorities, put off by André's arrogant attitude and Clara's German Jewish origins, threatened to lock them up in an Indochinese jail. The adventure was over.

The Malraux legend has it that, upon learning of this arrest, a group of distinguished Parisian writers were moved to mobilize and draft a petition to have André Malraux, young writer of talent and great promise, freed on the basis of his future oeuvre. And had Clara not set the record straight in her memoirs, the legend would have remained intact. In fact, it was she who, having feigned a suicide attempt and bouts of madness, then staged a hunger strike, and having finally been allowed to return to France-ironically, because of a French law stipulating that a wife had to follow her husband everywhere, she was not considered responsible for her whereabouts; the Napoleonic Code cuts both ways-was able to get the petitionwriting process in motion. Penniless (her family wanted nothing more to do with her), ridden with malaria, and desperate at the thought of André's confinement in an Indochinese jail, she alerted first the Surrealists (who, enamored of André's "surrealist" gesture in Indochina, were only too happy to support it), then the Pontigny

crowd of more respectable mainstream writers, drafted a petition and gathered signatures, then sent it off. When André was released, he liked to attribute this decision to the pressure placed on the colonial authorities by this distinguished petition, which ushered him into the circles of established writers. Clara, on the other hand, attributed it to her courageous and persistent actions on his behalf. Whether the petition had much to do with the release of André Malraux, regardless of its genesis, is not really known. There were other ways to put pressure on the colonial regime, and different measures were taken, economic and political. But the symbolism of the petition remains ingrained in the French literary imagination. André Malraux's (and his numerous biographers') insistence that this plea was spontaneously drafted by a number of literary lions impressed with his talent and assured of his potential, and Clara's repeated claim that without her tireless work and pressure the petition would never have existed in the first place, signals the first major dissonance in their marriage. It also points to André's early investment in solitary heroism and in masculine solidarity. This particular conflict became obscured by the fact that Clara had an affair on the ship which took her back to France. an avowal which crushed André. "If you hadn't saved my life, I would leave you now," he admitted. Which was more humiliating to André: the infidelity? Or having been "saved by a woman"-something that his fictional protagonists would never allow?

André Malraux had been raised by women, though his heroes would always include nostalgic patriarchal figures. He had married a woman who was older, richer and more self-assured, and he would never forgive her for his initial dependence on her. Now she had saved his life. This humiliation would inform an ethic of virile camaraderie that finds its roots in men's dignity in the face of torture and death. Clara never understood why he considered this debt to be so humiliating. Had it been the other way around, she thought, she would have been excited and grateful. But the asymmetry is such that while it adds a surplus of femininity for a woman to be "saved" by a man, the reverse is also true, and it was not in Malraux's plans to let himself be feminized. If his debt to Clara could not be erased completely in reality, at least in his novels it would. When he integrated, in La Voie royale (1930), fictional aspects of his Cambodian experience, the two adventurers were men. The only women in the text were prostitutes.

France's investment in the solitary hero of the 1930's who combines literary productivity and political action can be gauged by

the inflated rhetoric of the many biographies of André Malraux which perpetuate a succession of flamboyant images rather than the more pedestrian realities. First, the petition sui generis. Then, after his return to Indochina the following year to start an anti-colonialist newspaper, his revolutionary activities in China-which never occurred. The expedition to the ruins of the queen of Sheba-which he never found. Leading a group working for the release of the Communists Dimitrov and Thälmann (accused by the Nazis of having set fire to the Reichstag) to meet with Goebbels-whom he missed. Piloting in the Spanish Civil War-with differing assessments of what he accomplished though no one questions his courage. And the Resistance which he joined very late-though his participation received disproportionate attention. The writer in uniform was important to French culture of the 1930's, it signaled a revirilization of French letters and of French men. The 20's may have been the decade of the "New Woman"-with its attendant sexual connotations-but the 30's and not coincidently so, was to be the decade of the "New Man," which has a very different signification indeed. In 1930 Drieu la Rochelle, voicing his increasing concern with the decadence of French society and of its intellectuals, consecrated André Malraux as "l'homme nouveau." André's personal fear of feminization, a response to childhood dependence on women and to his later debt to Clara, coincided with growing societal resistance to what was perceived as women's emancipatory gestures during the First World War and in the postwar period. It also converged with a number of associations that gained currency during this period: of writers with homosexuality, intellectuals with passivity, and France with decadence. What he accomplished not only in his texts, which underscored the themes of violence, revolution, and dignity, but also as writeradventurer, was to free the French male writers from the image bequeathed them by the preceding generation of intellectuals bent on self-analysis, introspective brooding, and homosexual sincerity (what Malraux, alluding to Gide in the Antimémoires, scoffed at as the mere "pursuit of secrets"). He established in its place an ethic of action grounded in the pure space of male pursuits, whether revolutionary or philosophical, to which women had no access and thus which they could not weaken or dilute. Thus, and almost singlehandedly at first (Saint-Exupéry, Drieu la Rochelle, Montherlant, Brasillach, Céline and others, although quite different from each other in political and literary directions, added to this particular momentum), he rejuvenated and revirilized French literature while preserving its all-male

André Malraux, early 1930's

enclave. His novels—Les Conquérants (The Conquerors) in 1928, La Voie royale (The Royal Way) in 1930, La Condition humaine (The Human Condition) in 1933, L'Espoir (Man's Hope) in 1937-offered the most effective combination of thought and action. He showed that intellectuals could be pilots, and terrorists could be philosophers. His protagonists, confronted with the absurdity of the human enterprise, discovered meaning in revolutionary action in the Far East or in Europe. His conquerors left scars on maps, found commitment in the face of humiliation, emprisonment, torture and death, and transcended their alienation through revolution. But despite the fact that the novel that exemplified these values, and for which he won the Goncourt prize in 1933, was entitled La Condition humaine, the heroes who found collective purpose in his works did so within a fraternity. Having led a generation of young French students to the doorsteps of the Communist party-which he never joined-he discovered that he could put his dazzling monologic talents at the service of his causes and he hypnotized the crowds in the name of the anti-Fascist struggle. By the late 30's, André Malraux had turned himself into a

consummate cultural hero. But it is important to remember that much of his appeal lay in the mystery which shrouded each episode in his colorful and turbulent life.

The thorn in his side was the woman who witnessed the embellishments, the self-promotion, the mythomania. And who also witnessed-and resisted-his continuing claim to a solitary stance. As it is for the protagonists in his early novels, language was for André Malraux an acknowledgment of the failure of human communication. It became a way to seek the reassurance of solitude, the power of domination through the construction of an intricate verbal architecture. Uncomfortable with the messiness, the unpredictability of human emotions, he walled himself in the safe pure space of abstract ideas. Clara, excluded from the story and from the discourse, dedicated much of her energy to correcting his version of the facts. After all, she had been at his side in Phnom Penh, in Saigon, in Moscow, in Madrid. She insisted that she had read and discussed with him each of his texts and provided incisive feedback. And indeed, memoirs of the German émigré writers who fled the Nazi regime and sought refuge in France in the early 30's attest to the tour de force she achieved in her role of translator and mediator. Just as she had contributed in important ways to L'Indochine, the anti-colonial newspaper they published from 1923 to 1925 in Saigon, she was also instrumental in the establishment of their rue du Bac apartment as one of the centers of the anti-Fascist intellectual resistance. André saw Clara's attempts to correct his version of the facts and to integrate herself in his narrative as an attack on the image he was fashioning, as a constant put-down, a series of belittling gestures. He could no longer live under the perpetual eyes of a judge, he finally told her. Nor live with a rival in his bed, he could have added when she started writing. She kept this activity secret at first and then one day showed him her text. He was adamant: "Better to be my wife than a secondrate writer." Perhaps we can attribute this reaction less to André's self-avowed suspicion of women writers than to the fact that Clara's text was autobiographical and had their couple as its primary subject. She was therefore guilty not only of revealing the more private aspects of a life which he wanted kept open to more noble interpretations, but also of the "exclusive preoccupation with the minor" which he dismisses with such scorn in Antimémoires. So although he wrote his best work when she was at his side, she could only begin to take hers seriously when he was no longer at hers.

Would André have become a writer without Clara? Undoubtedly,

though perhaps his work would not have been as resonant, for he clearly owes a great deal to the doors she opened for him, culturally as well as humanly ("If I had not met you, I would have become a bookworm," he once admitted), and to the way she provided the most intelligent of sounding boards when he was forging his style and his ideas. What would Clara have written if she had not met André? Or if he had encouraged and supported her in this enterprise? It is hard to say: virtually all that she wrote in terms of fiction was produced after they had separated, and those books are haunted by the presence (and loss) of the looming figure that had so obsessed her. It is impossible to imagine what she would have produced had she not become mired in the repeated attempt to write herself out of invisibility. As the legend took hold, she published several novels trying to rectify the truth of their earlier years together; they are, let us admit it, naive attempts at trying to recreate her admiration for the younger man, her complete belief in him, and her crushing disappointment in his growing distortions of their shared past as well as in his elimination of her presence. Her memoirs (which end after the war although she lived for another forty years, almost as if her life, once he was no longer in it, had lost interest for the reader, or even for her) are much more impressive: clever, humorous, poignant, well-written, convincing. The writing in these volumes is at its strongest. Clearly Clara was more talented in writing autobiography than fiction, or at least she could tell her story better that way. In asserting the "preoccupation with the minor," she found a way to counter André's complex philosophical propounding with a rhetoric of naiveté, a voice clearly aimed at subverting his authoritative and exclusionary discourse.

Despite her repeated claim to independence, André Malraux constituted Clara's lifelong obsession and, until the end of her life, the center of her writing. This combination of unquenchable lifelong passion for one being and relentless anger with him clearly distorted her ability to create. Virginia Woolf, whose *Room of One's Own* she translated into French after the war, would have speculated that anger marred her work. Once they had separated, in the late 30's, he never spoke to her again; his family and friends insisted that he never read a word she published in spite of the fact that he was the constant center of reference of her narrative. Although there were to be three more women after Clara to share his life, a major retrospective of the life and work of André Malraux at the Fondation Maegth in 1973, three years before his death, contained not a single woman's face or name. His private life had not been free from pain—he lost his two brothers in

the Resistance, his second wife in an accident, his two teenage sons in a car crash. But it was only his public self which he wanted acknowledged, his actions, his conversations with other great men and the "encounters with ideas which are to permeate or guide [one's] life." The legend of the solitary hero remained intact until, and indeed, after his death. When André left her, Clara did not go mad, she did not commit suicide, though she admits that had the war not made it necessary for her to act, she might have. Separated from André, who was now living with a more decorative, more restful companion and writing books on art, she hid with their daughter Florence in the Toulouse area and joined the Resistance, acting courageously much earlier than he. She gathered around her an odd mixture of refugees from the Spanish Civil War and Eastern Europe, Jews, Communists, pacifists, socialists, and intellectuals for whom she created a form of underground salon. Every knock on the door could mean death, but Benjamin Constant, the Princesse de Clèves, and Stendhal were the subjects of long passionate conversations. After the war, she began anew a life for herself. This was not easy when every day in the newspapers one could see André Malraux's name. He became the acclaimed Minister of Culture and de Gaulle's closest adviser, thereby reneging on what she thought had been a shared lifelong commitment to leftist causes. They were on opposite sides of the Algerian conflict, of May 1968. He traveled around the world in style and decorum while she, still looking for political utopias, camped out in Israeli kibbutzim. But then, bohemian and unconventional as she was, an energetic, frumpy and irreverent old lady, she would have made a terrible minister's wife.

André Malraux's work stands canonized and anthologized. It is not my purpose to quarrel with the criteria that make it so. But Clara's struggle illuminates the more obscure itineraries of those "first wives" of the 20's whose names have been erased. It offers a counterpoint to those unbreakable male relationships which resisted even the most serious political divergences (Malraux the almost-Communist and Drieu the almost-Fascist were friends until the latter's death), and which became glorified as fraternity. But more importantly perhaps, trying to understand Clara's trajectory helps us think more widely than the narrow definition of art and of creativity that André's name evokes. Clara Malraux's creativity was elsewhere. She may not have been a writer in the same terms. But she was a woman of letters, in the same way that Adrienne Monnier or Victoria Ocampo were, in Paris and Buenos Aires; or that her alter ego Rahel

Clara Malraux, late 1920's

Varnhagen (whose biography she wrote three years before her death) had been, a century earlier in Germany. She lived for literature, spent much of her life translating, creating literary and political reviews, wrote volumes of memoirs, nourished young writers in whom she sensed real promise (and was never wrong). She was a woman whose creativity was other and therefore hard to define; it can be found in her numerous translations, in the memory of her vibrant conversations, the astute observations in her memoirs, her international commitments and relationships, her talent for bringing people together, her curiosity in human beings, her passion for literature and her profound knowledge and transmission of this literature. Next to André's monumental reputation, the grandeur of his texts, his political stature, his encounters with "great men," Clara at first appears to cut a small figure. From the beginning he knew how to discipline his thoughts, maintain his separateness, and reserve his best for the blank page; she dissipated her immense vitality in collaborative enterprises. Like the adventurer Perken in La Voie royale, André Malraux wanted to leave a scar-in his case, on the map of French literature. Like her heroine Monique, in Par de plus longs chemins (Taking the Longest Roads, 1953), Clara Malraux hoped to leave traces. But while scars are indelible, traces are intangible-unless they are discovered, recorded, and preserved.4

Vanessa Bell and Duncan Grant, Asheham, ca. 1913-14

THE "LEFT-HANDED MARRIAGE" Vanessa Bell & Duncan Grant

LISA TICKNER

IN JUNE 1926 Virginia Woolf dashed off a warm response to her sister's paintings, on show in the Leicester Galleries, London, praising the "flashing brilliance" of a Charleston landscape and the "pigeon breast radiance" of Bell's color. "Indeed I am amazed, a little alarmed (for as you have the children, the fame by rights belongs to me) by your combination of pure artistic vision and brilliance of imagination... I mean, people will say, What a gifted couple! Well: it would have been nicer had they said: Virginia had all the gifts: dear old Nessa was a domestic character – Alas, alas, they'll never say that now."¹

"Perfection of the life or of the work" Yeats wrote, and it's been a stark choice often enough, even as we've tried to refuse it. (Dora) Carrington chose life—sunlight on painted walls and the smell of quince cheese at Tidmarsh or Ham Spray—and painting was squeezed thin. Woolf chose work ("I had a day of intoxication when I said Children are nothing to this: when I sat surveying the whole book complete"). Only Bell appeared to manage both—"the unwobbling pivot of Bloomsbury" as Cyril Connolly called her—so that a picture emerges from memoirs and photographs of this daughter of Sir Leslie Stephen (that eminent Victorian) with Duncan Grant, her homosexual lover, in the studio at Charleston (the house that was also in a sense their masterpiece and joint memorial). There is a smell of turpentine in the air, a still life on the table, bees humming in the walled garden, naked children playing in the orchard, Clive Bell (her husband) secreted in his study and the "Woolves" bicycling over for lunch.

Of course this is much too simple. It diminishes Carrington's paintings, Woolf's sociability and the considerable constraints of Bell's practical and emotional life. It leaves out Sophie and Lottie and Grace, whose cooking and childcare made studio-time possible (as we think of it, for the woman, but of course equally, for the men). But we are nevertheless drawn to what Woolf admired as Bell's "handling of life as if it were a thing one could throw about," and wonder what can be learnt from it, and what it might tell us about her art.

In Germaine Greer's *The Obstacle Race* (1980) one of the obstacles for women artists is love. Love for women means betrayal and dependency; their talent is compressed and their reputations limited, both by their involvement in the decorative arts and by their voluntary adoption of secondary roles. Bell and Grant's "left-handed marriage" (as Woolf called it) emerges in Greer's dismal picture as "one of the greatest love stories of our time": a creative and emotional partnership with a shared interest in decorative environments and a "feminine" irreverence for monuments.

The reputations of Vanessa Bell and Duncan Grant have been overshadowed within Bloomsbury by the prominence of its literary members, and in British art history by accounts that have taken their cue from Wyndham Lewis and John Rothenstein and left the Bloomsbury painters marginal to the development of early twentiethcentury modernism. (Of course it all depends on what is meant by modernism and that, in turn, has been not just an esthetic question but a matter of sexual politics as well.)

Both Bell and Grant were influenced by the French paintings which Roger Fry first termed "Post Impressionist" in the context of his "Manet and the Post Impressionists" exhibition of 1910. Both were selected by Clive Bell for the British section of the "Second Post Impressionist Exhibition" in 1912. Both were directors of Roger Fry's Omega Workshops, opened in 1913, and designed for them.

Wyndham Lewis walked out of Omega in October 1913, less than six months after it opened, in a bitter but obscure quarrel now known as the "Ideal Home Rumpus." He and his fellow secessionists accused Fry of manipulating the *Daily Mail's* commission of a room for the Ideal Home Exhibition, and in an open letter to *The Observer* they distanced themselves from Fry's "party of strayed and dissenting aesthetes" as the boys who would do "the rough and masculine work" of British modernism.²

Lewis was bitter and intransigent and convinced that the quarrel with Fry had blighted his whole career. He associated Bloomsbury with a cult of mutual admiration and widespread influence (an exaggerated claim, but not a groundless one), and with homosexuality (and Lewis, like D. H. Lawrence, was notoriously homophobic). Lewis's views were repeated and endorsed by Rothenstein in the second volume of *Modern English Painters* (1956); nevertheless he included a chapter on Duncan Grant and exempted him from the "vendettas and intrigues so ruthlessly pursued by certain of his friends . . ." Vanessa Bell, whose work had been illustrated and

discussed in earlier surveys of British painting, was included only as the subject of Grant's 1942 portrait in the Tate Gallery. (Rothenstein had visited Charleston to gather information for his chapter on Grant, and Bell told their daughter that "he threatens to do the same by me, but I dislike him so much that I could hardly be polite . . .").³ When the book was published Grant felt obliged to send a letter of protest, and the remarks about Lewis and Bloomsbury were modified in the 1976 edition as "misleading" and "too categorical." But the quarrel rumbled on as subsequent historians felt called upon to take sides; or, in less personalized terms, as "Bloomsbury" came to embody a domestic, decorative and Francophile "traditional modernism," throwing into relief the "radical" (and implicitly more "virile") modernism of Lewis, Vorticism and the machine esthetic.⁴

Bloomsbury's artistic reputation fluctuated, partly according to which camp the critic was in (to put it rather too crudely, in Lewis's or Fry's), and partly according to period. Grant's reputation was at its high point between the wars (an exhibition at Agnews in 1934 was entitled "from Gainsborough to Grant"); but Rothenstein was right to suggest in the 1950's that although his name commanded respect, interest in his work had declined. Within this admittedly shifting profile. Bell on the whole fared worse. Grant's first solo exhibition was at the Carfax Gallery in 1920; hers was at the Independent Gallery in 1922 (and she was six years older). Fry's monograph Duncan Grant was published by the Woolfs' Hogarth Press in 1923, and Raymond Mortimer's in the Penguin Modern Painters series in 1948. Grant exhibited regularly and his paintings entered galleries all over the world; he was selected for the Venice Biennale and commissioned more consistently for theatrical and decorative schemes before his Tate Gallery retrospective in 1959. Bell had nothing like this prominence, although her work was often bracketed with his and sometimes mistaken for it, usually to her disadvantage. (Mortimer is an exception; he goes out of his way-perhaps at Grant's instigation-to stress her independence and distinction.)

From about the 1970's this began to change: a renewed interest in Bloomsbury (focusing on biographies of Grant's lover Lytton Strachey and Bell's sister Virginia Woolf) was extended to the artists in *Bloomsbury Portraits* (1976) by Richard Shone. In 1964 the Tate had owned 15 works by Grant and 4 by Bell. By 1984 it owned 26 works by Grant and 11 by Bell: 7 new Bell canvases, all dating from 1912–17, were acquired between 1969 and 1976. Richard Morphet of the Tate Gallery, Anthony d'Offay of the d'Offay Gallery, and Simon Watney

(author of English Post Impressionism, 1980, and more recently The Art of Duncan Grant, 1990) all knew Grant well but were too committed to the distinctiveness of Vanessa Bell to lose her in his shadow. Bell emerged as a powerful if elusive presence, both in Woolf's biography and in the Diaries and Letters, and subsequently, as a figure in The Omega Workshops (Judith Collins, 1983) and as the heroine of her own narrative in Frances Spalding's substantial Vanessa Bell (1983). What began as a predominantly formalist attempt to reassess the role of Bloomsbury in early British modernism was extended by homosexual perspectives and the interests of feminism. Both sought to map the tensions and overlaps between gender, sexuality and modernism that shaped the Bloomsbury oeuvre but had gone largely unremarked (except vituperatively by Wyndham Lewis).

Grant and Bell themselves, of course, believed that there was no one worth considering as a painter in England: no one like Katherine Mansfield or E. M. Forster "even with whom it's worth discussing one's business." And Bell was disparaging about her own work in relation to Grant's but resigned, working beside him in 1912: "as I have come to the conclusion that I didn't see it like that I no longer try to think I did." Woolf complained that it was "like putting a necklace of daisies round the neck of an elephant, praising you."5 She constantly sought reassurance, perhaps because she believed in Grant's strengths and didn't see her own-her aptness for the "blunt" and the plastic against his decorative exuberance-and perhaps (it has been suggested), because his "genius" was the justification for her investment in the painful asymmetry of their relationship.6 She was nevertheless delighted when the French artist André Dunoyer de Segonzac described her as "the best painter in England" and "fundamentally quite different" from Grant. Fry knew she would be amused that when Henry Tonks hung her Visit prominently in the "Nameless Exhibition" of 1921 he didn't know who it was by: "He's got you and D[uncan] exactly inverted and gave a little lecture on what a pity that women always imitated men."7 Clive Bell praised Grant in 1920 as an English painter that Europe might at last take seriously ("Nothing of the sort has happened since the time of Constable"). S. P. Rosenbaum, in The Bloomsbury Group (1975). accounts Grant in passing "the most distinguished painter" of his circle.8 Grant himself, it is touching to remark, showing visitors round Charleston in his old age, neglected his own canvases to draw their attention to the various paintings "by Mrs Bell."

Both Vanessa Bell and Duncan Grant escaped into art from the

more likely outcomes of their family backgrounds. Grant, a scion of the lairds of Rothiemurchus who spent his early years in India with his father's regiment, was rescued from the "army class" at St. Paul's School, London, by his aunt, Lady Strachev, who persuaded his parents to let him go to the Westminster School of Art. A legacy of f.100 allowed him to spend 1907 in Paris, studying at La Palette. Vanessa Bell was expected after her mother's death both to take her place in running the household and to make her debut in Society as the prelude to a good marriage. She took lessons with Arthur Cope and studied at the Royal Academy, but she was obliged to turn back at 4.30 into the vestal of the tea-table, to pass the spiced buns in the pink china shell and entertain her father's guests. (Woolf put her into Night and Day as Katherine Hilbery: "But try thinking of Katherine as Vanessa, not me," she wrote to Janet Case, "and suppose her concealing a passion for painting and forced to go into society by George [Duckworth, her half-brother]-that was the beginning of her.") Nevertheless their opportunities also derived from their class and station: there were few working-class men and no working-class women at the Academy or the Slade at the turn of the century. Bell was part of a great upswell of women who studied in the ateliers and public art schools of Europe in this period. She might have gone to Paris too, where the life of "lady art students" had been vividly described in an article in the Studio in 1903,9 and where Grant in 1907 knew women like Constance Lloyd and her friend Gwen John.

Bell and Woolf, as Vanessa and Virginia Stephen, had decided on their professions in the nursery. Woolf was educated at home while her brothers went to Cambridge and was permanently embitteredbut perhaps also emancipated—by this exclusion from university life. Bell was the beneficiary of what Woolf called in Three Guineas "the battle of the Royal Academy" (one among many-the battle of Westminster, the battle of Whitehall, the battle of Harley Street-all fought by the same combatants), "that is by professional men v. their sisters and daughters." But that was not the whole story. Women got into the Academies just as the men were getting out. (Woolf wrote to her brother in 1901, when Bell was in the middle of the entrance examination at the Royal Academy Schools, "she has a good model and a good place, certainly if there is an Artist or a gentleman on the Council the result is certain. Privately I don't think anyhow there can be much doubt. The Schools are very empty, so they will let in bad people.") And whatever opportunities they enjoyed there were often compromised by the prejudices of their teachers. Both Grant and Bell

studied briefly at the Slade. Grant told the story of how he worked out with an amused but disaffected cynicism what kind of drawing would win the approval of the formidable Professor Tonks and delivered it. Bell, on the other hand, found Tonks "a most depressing master." He was known to reduce his female students to tears, and once wrote that women "do what they are told, if they don't you will generally find they are a bit cracked.... They improve rapidly from about 16 to 21, then the genius that you have discovered goes off, they begin to take marriage seriously."10 It was Bell's strength that although she did, for a time, take marriage seriously, she never gave up her work. She removed herself from polite society, living as Woolf put it in 1917 "like an old hen wife among ducks, chickens and children . . . [she] never wants to put on proper clothes again." It wasn't exactly bohemianism-of the sort that distracted and debilitated artists like Nina Hamnett and Augustus John-but a kind of ruthless focusing on love and work that preserved her independence and her capacity for both.

"Bloomsbury" began twice, first at Cambridge in October 1899 when five freshmen went up to Trinity College; and then, decisively, in London in 1904. After the death of her father, Vanessa removed her siblings from Hyde Park Gate to Gordon Square. Kensington had been fashionable but gloomy and constrained. Bloomsbury was close to the British Museum and the Slade, distant from prying relatives, elegantly shabby, airy, and emancipated for two women in their 20's living unchaperoned with their brothers. When Thoby Stephen came down from Cambridge he proposed to keep in touch with his friends through regular Thursday "at homes." He probably had not thought of including his sisters but then there they were: two beautiful, gifted and completely independent young women with a house of their own. So "Bloomsbury," as Raymond Williams has described it, was in class terms a particular formation within the professional and administrative fraction of the now dominant bourgeoisie; but it was a dissident grouping, both because it insisted on open intellectual inquiry and tolerance and because it was based in and expressed the paradox of women's exclusion from the formative educational experiences of the men. Bloomsbury was not just inflected, but actually precipitated, by the inclusion of (informally educated but intelligent and articulate) women and the impact of feminism. In this and other respects, including its socialism, pacifism and anti-imperialism-another paradox-it played a reforming and hence modernizing role in the history of the class to which it seemed to be opposed.¹¹

No one reading the newspapers, letters, or diaries of the period can fail to be struck by the proximity of references to feminism and to art. In adjacent columns we read of suffrage processions or militant arson, and of Marinetti's London visits, the Post-Impressionist exhibitions, or Lewis's Blast. A photograph of Clive Bell, Desmond MacCarthy and Lytton's sister Marjorie Strachey on the beach at Studland in 1911 (the subject of one of Bell's best-known paintings) shows Marjorie reading an issue of Votes for Women. Pippa and Pernel Strachey were suffragists and Pernel became Principal of Newnham College, Cambridge. Fry's sister Marjorie went to Somerville College, Oxford. Virginia Woolf addressed envelopes for the suffrage campaign in 1910 and the local branch of the Women's Cooperative Guild met in her house from 1916 to 1920. Vanessa Bell, who was not involved in organized feminism, and did not subscribe to the cropheaded new-woman look of Carrington and the "Bloomsbury bunnies," nevertheless led a sexually and professionally emancipated life which it is hard to think of as other than "feminist." What is at issue is precisely the relationship at this point between sexual and professional emancipation.

"On or about December 1910, human character changed," as Woolf famously put it, meaning life in general, but significantly choosing as her benchmark the public impact of "Manet and the Post Impressionists."12 Frank Rutter's Revolution in Art, a pamphlet in defence of Post-Impressionism published in 1910, is dedicated on behalf of "their painter-comrades" to "Rebels of either sex all the world over who in any way are fighting for freedom of any kind." Bell wrote of this first Post-Impressionist exhibition that "it was as if one might say things one had always felt instead of trying to say things that other people told one to feel."¹³ It is true that the liberation she responded to as an artist was that of strong color, rhythmic line, and a spirited rejection of narrative and naturalistic subject matter; she does not mention the fact that there were no women in the 1910 exhibition (Bell and six others contributed in 1912), or as we might now argue that its representations of femininity were conventional in all but a strictly pictorial sense. But it is worth focusing on this combination of expressive feeling and free speech.

Virginia Woolf, in her notes for the original speech which became "Professions for Women," wrote that "the future of fiction depends very much upon what extent men can be educated to stand free speech in women."¹⁴ In a paper read to the Memoir Club about 1922, she claimed to have pinpointed the moment that precipitated free speech

at Gordon Square-open season on any topic however sensitive, however explicit—sometime around 1908. "It was a spring evening. Vanessa and I were sitting in the drawing room. The drawing room had greatly changed its character since 1904. The Sargent-Furse age was over. The age of Augustus John was dawning. His Pyramus filled one entire wall. The Watts portraits of my father and my mother were hung downstairs if they were hung at all. Clive had hidden all the match boxes because their blue and yellow swore with the prevailing color scheme. At any moment Clive might come in and he and I should begin to argue - amicably, impersonally at first; soon we should be hurling abuse at each other and pacing up and down the room. Vanessa sat silent and did something mysterious with her needle or her scissors. I talked egotistically, excitedly, about my own affairs no doubt. Suddenly the door opened and the long and sinister figure of Mr Lytton Strachey stood on the threshold. He pointed his finger at a stain on Vanessa's white dress. 'Semen?' he said. Can one really say it? I thought and we burst out laughing. With that one word all the barriers of reticence and reserve went down. A flood of the sacred fluid seemed to overwhelm us. Sex permeated our conversation. The word bugger was never far from our lips. We discussed copulation with the same excitement and openness that we had discussed the nature of good. It is strange to think how reticent, how reserved we had been and for how long."15 "[We] seemed to be a company of the young," Bell wrote, "all free, all beginning life in new surroundings without elders to whom we had to account in any way for our doings and behaviour, and this was not then common in a mixed company of our class." Leonard Woolf was astonished, on his return from Ceylon in 1911, to find that whereas to have "discussed some subjects or to have called a (sexual) spade a spade" in the presence of Miss Strachey or Miss Stephen would have been unimaginable in 1904, there was now "a much more intimate (and wider) circle in which complete freedom of thought and speech was extended to Vanessa and Virginia, Pippa and Marjorie." Indeed Duncan Grant recalled that these "Apostolic young men found to their amazement that they could be shocked by the boldness and scepticism of two young women."16 Bloomsbury was held together not only by a delicate web of affective ties (ties of blood or marriage or passion, homosexual and heterosexual) but by a common commitment to candor, clarity, and verve, in life as in art.

This is the context—the "conversational community"—summoned up in paintings like Bell's *Conversation Piece* (1912) or A

Duncan Grant, Vanessa Bell, ca. 1918

Conversation (Three Women) (1913-16). It is present implicitly in paintings of the studio-Bell's companionable portraits of Frederick and Jessie Etchells Painting (1912) and The Studio (Duncan Grant and Henri Doucet at Asheham) (1912) and less obviously in the portraits by Grant and Bell of themselves and each other. It is extended and explained by two other groups of paintings: the strongly Fauve portraits of independent, creative or professional women such as Iris Tree (1915) and Woman in Furs (1919), a portrait of Dr Marie Moralt, on the one hand and Bell's paintings of her children with the women who helped look after them, including Julian Bell and Nanny (ca. 1909-10) and Nursery Tea (1911) on the other. To throw this into historical relief we need recall only Sickert's exclusion of women, as the Fitzroy Society transformed itself into the Camden Town Group in 1911-"the Camden Town Group is a male club, and women are not eligible. There are lots of two sex clubs and several one sex clubs, and this is one of them"17-or Lewis's assertion that handing round the tea at The Rebel Art Centre was a job for women and not for artists.

Vanessa Bell, A Conversation (Three Women), 1913-16

A Conversation shows, in Post-Impressionist mode, three women in animated conversation against a sunlit flowerbed beyond the window. More precisely, at this moment, the woman who does not wear a hat (and is perhaps therefore at home here in a "room of her own") leans forward to engage her visitors. Three heads lean together and the brilliant color and energetic brushwork of the flowers obtrudes into the space between them, a floral speech-bubble, a visual metaphor for concentrated and uninhibited talk. (The speaker's pose, at once elegant and intense, is reminiscent of Grant's Queen of Sheba [1912], painted originally as part of a decorative scheme at Newnham College, Cambridge, where Pernel Strachey had been a student, and with the figures of Grant's cousins Lytton and Pernel very much in mind.) Virginia Woolf saw the picture exhibited in 1928 and wrote to Bell about it: "O and then I went to your show and spent an hour making some extremely interesting theories . . . I had forgotten the extreme brilliancy and flow and wit and ardour of these works ... I think you are a most remarkable painter. But I maintain you are into the bargain, a satirist, a conveyer of impressions about human life: a short story writer of great wit and able to bring off a situation in a way that rouses my envy. I wonder if I could write the Three Women in prose? Would Roger let me have it here for a week or so?"

Bell did not write about her art as Woolf did about hers, but

Bell & Grant

cautiously, we might take Lily Briscoe in To the Lighthouse (1927) as representing something of them both. Lily Briscoe struggles to balance her composition and subdue "all her impressions as a woman to something much more general." But "in that chill and windy way, as she began to paint . . . there forced themselves upon her other things, her own inadequacy, her insignificance, keeping house for her father off the Brompton Road, Mr Tansley whispering in her ear, 'Women can't paint, women can't write'." Nevertheless, "as if some juice necessary for the lubrication of her faculties were spontaneously squirted, she began precariously dipping among the blues and umbers, moving her brush hither and thither, losing consciousness of outer things. And as she lost consciousness of outer things, and her name and her personality and her appearance, and whether Mr Carmichael was there or not, her mind kept throwing up from its depths, scenes, and names, and sayings, and memories and ideas, like a fountain spurting over that glaring, hideously difficult white space, while she modelled it with greens and blues."

Lily Briscoe is a subject-like Bell or Woolf-who struggles with her medium, her circumstances, and herself to act creatively. She must transcend or efface these struggles in her work because she is committed, like Bell, to the Bloomsbury doctrine of "significant form." She dips her brush into the blues and umbers of Cézanne, described by Fry as "the type of the artist in its purest most unmitigated form."¹⁸ Her view of painting demands that she subdue "all her impressions as a woman to something much more general," but as she dips into the blue paint she dips also into the past. Lily Briscoe believes in-and aspires to-the androgynous integrity of a work of art. So did Woolf, on the whole, despite her sharp regard to the material constraints on women's creativity, and so did Bell. This was partly the corollary of her painterly ambition, which was, ostensibly, to produce a transcendant and generalized image of formal relationships, and partly the consequence of a desire to escape gender, not to be bound and delimited by femininity as a "woman-artist" but to enter into pictorial activity with the vigor and seriousness of any of her peers.

Bloomsbury, long before its interest in Freud, assumed a certain mobility of gendered identities and desires, even a necessary suspension of them in the course of creative work. (Woolf resented "the irruption of Sydney" (a friend) because to write it was necessary to become "very, very concentrated, all at one point, not having to draw upon the scattered parts of one's character, living in the brain.

Bell & Grant

Sydney comes and I'm Virginia; when I write I'm merely a sensibility.") Being a woman, being a homosexual, was a fact of life, embraced in some ways (Bell's passionate maternity, Grant's "never be ashamed") but art was not determined by it or something to be reduced to it. It wasn't an inspiration or a platform. But we could recognize its presence none the less as those scenes and sayings and memories and ideas that constitute subjectivity spurt like a fountain over the canvas's "hideously difficult white space."

To the end of her life, as her son Quentin Bell points out, Bell painted pictures, "replete with psychological interest while at the same time firmly denying that the story of the picture had any importance whatsoever."19 The irony is that life, even a woman's life, returns in this apparently formalist scenario to the benefit of her work and the confusion of her critics. Bell puts it best herself, writing to Woolf in 1931 about a painting she has been working on for two years, and which (she hopes this doesn't seem too absurd or conceited) seems to have some sort of analogous meaning to The Waves. "How can one explain, but to me painting a floor covered with toys and keeping them all in relation to each other and the figures and the space of the floor and the light on it means something of the same sort that you seem to me to mean." The spare reduction of paintings like Studland Beach (1912), which Shone calls one of the most radical paintings in England for its date, or Nursery Tea (1912), or the painting Fry owned of a woman after childbirth, combine new modernist moves with what is, ultimately and unexpectedly, maternal, "feminine" and domesticated subject matter.

Artists like Augustus John, Henri Gaudier-Brzeska and Wyndham Lewis expected women to live with them, to bear their children out of wedlock or to help support their art financially. None of these men was wedded to traditional ideas of womanliness. All of them believed women could be talented and independent. But an imperious and often promiscuous egoism ran through their relations with women and women themselves were often divided or insecure. Few had Gwen John's presence of mind and passionate selfishness. (Carrington felt she was "not strong enough to live in this world of people and paint.")²⁰ Life drained talent, often enough in the interests of men and with women's blessing. Bloomsbury was an exception, at least for Vanessa Bell. Its homosexual component ironized hearty masculinity and, for all the intricacies of its sexual relationships, sexual conquest and a sense of virility did not permeate its work (which was, of course, precisely Lewis's complaint).

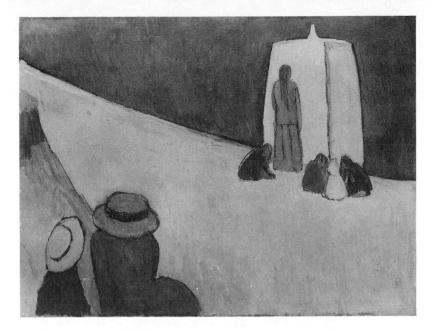

Vanessa Bell, Studland Beach, 1917

Vanessa Bell first met Duncan Grant at a meeting of the Friday Club (founded by her as a lecture and exhibition society) in 1905. The Bells dined with Grant on their honeymoon in Paris in 1907 and soon knew him well. After the birth of their two sons in 1908 and 1910 the Bell's marriage began a slow transmutation into something like a negotiated companionship. Clive resumed relations with a former mistress and Vanessa was first drawn to the quick sympathies of Roger Fry, who nursed her (with more attentiveness than Clive) on the way back from a serious miscarriage in Turkey in 1911. Her affair with Fry, much to his distress, was ended by her in favor of Duncan Grant in 1914.

Grant had been the lover of her brother Adrian Stephen, of Lytton Strachey, and of the economist Maynard Keynes. During the First World War, working on the land as a conscientious objector, he pursued a relationship with David Garnett in a ménage à trois with Vanessa Bell, first at Wissett in Suffolk and then at Charleston in Sussex. "Sometimes it is difficult," she wrote to Fry, "for I couldn't help minding some things and feeling out of it and in the way but that was less so lately and we seemed to have settled down to a possible relationship." Patiently, as Frances Spalding puts it, she "plaited their three lives into a single, binding cord of affection."²¹ From the beginning she had wanted to have a child by Grant: Angelica Bell (as

Duncan Grant, Asheham, ca. 1912

she was always called) was born on Christmas Day 1918. From this point their sexual relations ceased but their artistic and emotional partnership—hinted but unspoken by the paired slate gravestones in Firle churchyard—lasted until Bell's death in 1961.

Grant was loved by his friends for his idiosyncratic charm, his utter lack of pretension, his capacity for friendship, and for living in the present. Angelica Garnett (his daughter married David Garnett in 1942) described him as considerate and good-mannered: "He was never didactic, he never bullied, and seldom offered advice unless it was asked . . . So long as he was able to paint, he seemed to have no egotistical impulses, and yet one always felt that he did exactly what he wanted."²²

The picture is dramatically distinct, not only from the contemporary masculinity of the British avant-garde as figured by Lewis or John, but from the monstrous egoism and self-pity of Sir Leslie Stephen (suffered by Vanessa Bell), which Woolf described so eloquently in *Moments of Being*. "It never struck my father, I believe, that there was any harm in being ill to live with. I think he said unconsciously as he worked himself up into one of those violent outbursts, 'This is a sign of my genius', and he... let himself fly. It was part of the convention that after these outbursts, the man of genius

Bell & Grant

became 'touchingly apologetic'; but he took it for granted that his wife or sister would accept his apology." By contrast Woolf complimented the men she knew in 1931 "who have triumphed over all the difficulties of their very lopsided education... men with whom a woman can live in perfect freedom, without any fear."

Unlike Mr Ramsay in *To the Lighthouse* with his mind like a scrubbed board table, or Mr Tansley his admirer, "like a steel engraving, without colour, or warmth or body,"²³ Grant—forever hitching his trousers up in an almost parodic disowning of adult, masculine, middle-class decorum—radiated immense charm and insouciance. "I never saw a more remarkable figure than that adorable man—dressed in a nonconformist minister's coat; but under that an astonishing mixture of red waistcoats and jerseys, all so loose that they had to be hitched together by a woollen belt, and braces looping down somewhere quite useless. He is more and more like a white owl perched upon a branch and blinking at the light, and shuffling his soft furry feet in the snow—a wonderful creature, you must admit, though how he ever gets through life—but as a matter of fact he gets through it better than any of us."

No one ever seems to have heard Grant say anything that suggested his homosexuality had ever been a problem to him. To his daughter "it always seemed he'd known about it from the word go, and just accepted it."24 He was very frank with Michael Holroyd when Holroyd was researching his biography of Lytton Strachey. Holroyd put an enormous typescript down in front of him, with revelations about his homosexual affairs. After some time he gave the go-ahead to use the material about him, asking only, with a smile, if he would be arrested. (By the time the 1967 Sexual Offences Act decriminalized sex in private between two consenting males over 21, Grant was 82.) Fry, in his 1923 monograph, found a correlation between Grant's personality and his work. He praised its elegance and fluency and decorativeness and charm and a "peculiar, fantastic element" reminiscent of the conceits of Elizabethan poetry (none of these conventionally "masculine" attributes). Grant's fondness for Byzantine and Mediterranean motifs, for sporting themes, and subjects from Classical mythology, has recently been interpreted—by Christopher Reed and Simon Watney²⁵—as linked to a homosexual sensibility in this period. More specifically, it seems that Grant gave Douglas Turnbaugh the collection of explicitly erotic drawings reproduced in Private, the Erotic Art of Duncan Grant 1885-1978 (1989) with the promise that he would see it published. Further than that we

Bell & Grant

cannot go, without great delicacy of feeling and interpretation: to reduce Grant's oeuvre to his sexuality would be as arid, as diminishing a move as reducing Bell's to her gender.

We need to be equally circumspect on the question of Vanessa's "choice": its origins, function, and cost. It has been suggested that she chose a relationship with a younger and homosexual man because she was sexually abused as a child (the evidence for George Duckworth's "interference" with his half-sisters is compelling but ambiguous). We might guess that there were pleasures and constraints in her situation and that these were mirrored, in some form and some measure, by Duncan Grant's. The (largely uncharted) complexities of a lifetime's relationship between two people are not reducible to the question of whose sexual pathology was served by the unconventional arrangement of a "left-handed marriage." We should not underestimate what Grant gave Bell as an artist, which was not least, given her sometimes shaky self-esteem, the daily and confident assumption that she was one; a worthy collaborator, one with whom day after day on equal terms he would leave the breakfast table for the studio. What is perhaps more interesting is the combination of "masculine" attributes in the maternal Bell-her son wrote that "Leslie had bred a daughter who possessed just those qualities which he would have prized in a son: honesty, courage, firmness and tenacity"26-and the "feminine" gendering of Bloomsbury by contrast with Vorticist machismo: its lack of stridency, its female and homosexual membership, its interest in decoration as much as easel painting, its esthetic vocabulary and domestic subject matter. Bell's creativity may spring directly from this productive encounter between a modernist painter in flight from the category "woman artist" (what she called "the usual female fate") and a conversational community interested in women and unafraid of "femininity." It could be figured-perhaps overcrudely but metaphorically-as an encounter between femininity and homosexuality, or between a modern gender (a twentieth-century femininity) and a gendered modernism (as in Studland Beach or Virginia Woolf or Nursery Tea).

The early paintings (before 1920) are astonishingly radical, vibrant, and austere. Some of the later works are very beautiful but that sparse intensity is somehow lost. Is it that feminism fades, the avant-garde fades, youth fades or sex fades? (They all do after 1920, in general or for Vanessa Bell.) But the work goes on, for more than fifty years. There is "Charleston"—at once a place and a work of art—and the studio where their relations are closest: "Where Vanessa was timid

Angelica and Vanessa Bell, 1928

and tentative Duncan would be audacious, and when he was disorientated she would be authoritative. She would straighten out his muddles, laugh at his perplexities, and when, as so often happened, her self-confidence failed her, he would support and reassure her."²⁷

The enterprise was never "art" at the cost of a life lived, or "life" at the expense of a woman's oeuvre. Vanessa Bell was both Lily Briscoe, seeking that final touch that will make the whole composition fall into place and also (when she chose) Mrs Ramsay, who seeing her guests distressingly "separate" at the dinner party exerts all her energies to make them "merge" and cohere. Walking into Vanessa's room in Gordon Square, Woolf found "that astonishing brightness in the heart of darkness. Julian coming in with his French lesson; Angelica hung with beads, riding on Roger's foot; Clive claret colored and yellow like a canary; Duncan vague in the background, sitting astride a chair..." "I suppose you are, as Lytton once said, the most complete human being of us all ..."

Vita Sackville-West, with a photograph of Virginia Woolf on her desk, Sissinghurst Castle, 1930's; inset, Virginia Woolf, late 1920's

"TINDER-AND-FLINT"

Virginia Woolf & Vita Sackville-West

LOUISE DESALVO

ON JANUARY 16, 1923, a week after the death of the writer Katherine Mansfield, Virginia Woolf wrote an entry in her diary that shows how important Mansfield had been to her. Woolf admitted a "shock of relief" at having one less rival, then "confusion at feeling so little." Gradually, though, she became depressed, thinking that "there was no point in writing" any longer: "Katherine won't read it. Katherine's my rival no longer." Over the next few days, Woolf came to understand that her best writing was fueled by competing with a woman writer, an equal rival: "Yes—Go on writing of course; but into emptiness. There's no competitor. I'm . . . a lonely cock whose crowing nothing breaks—of my walk. For our friendship had so much that was writing in it."¹

A few months before Mansfield's death, Woolf had published Jacob's Room, her breakthrough vanguard novel, to mixed reviews, though her friends thought it her masterpiece. It was inspired in part by Mansfield's experiments with style and form. Woolf was also sketching early versions of Mrs Dalloway, "a study of insanity & suicide," and preparing a Greek chapter for her book on reading, which became The Common Reader. But she was taking no pleasure in her abilities or accomplishments. In reading proof, she had found her novel "thin & pointless," and she thought she was past her prime. Approaching her 41st birthday, Woolf felt herself becoming "elderly." Compared with her sister Vanessa's full, bohemian life with children and as a painter and lover to Duncan Grant, her life with Leonard Woolf seemed bare, settled, and trivial.

Before Virginia Woolf and Vita Sackville-West met, Clive Bell, Virginia's brother-in-law, reported to Virginia that Sackville-West thought her the best woman writer in England. This praise from Vita, a well-known, bestselling writer (her *Dragon in Shallow Waters* had been first of fiction bestsellers in the summer of 1921, outranking D. H. Lawrence's *Women in Love*), came at an opportune moment, for Woolf believed her powers were diminishing. Clive Bell arranged a

dinner party on December 14, 1922 so the two could meet. Virginia was captivated; she became "muzzy headed" from meeting Vita, though she was reluctant to get involved with her immediately, as was Vita's habit and inclination.

According to Leonard Woolf, Vita was "in the prime of life, an animal at the height of its powers, a beautiful flower in full bloom. She was handsome, dashing, aristocratic, lordly, almost arrogant."² Throughout dinner, Virginia studied Vita's manner. Though she found Vita "florid, moustached, parakeet coloured," she admired her "supple ease," the "aristocratic manner" that came from Vita's being a member of an ancient aristocratic Kent family, whose ancestral home, Knole, with its 365 rooms, was among the finest in England.

Virginia felt herself "virgin, shy, & schoolgirlish" in Vita's magnetic sexual presence: "She is a grenadier," Virginia wrote, "hard; handsome, manly." Always ill at ease in society, Virginia admired how Vita could drop a bead into her plate, then scoop it up with a grand gesture, and present it to Clive in remembrance of their evening together. Always the slow, patient, careful writer herself, eking out but two unrevised pages of prose a day, Virginia marveled at Vita's admission that she could toss off fifteen pages in a single sitting.

A few days later, Vita invited Virginia to dine at her London home in Ebury Street with Clive Bell and Desmond MacCarthy. She admitted to her husband, Harold Nicolson, that she already adored Virginia, finding her to be a paradox, "simple," "utterly unaffected," yet giving the impression that she was larger than life. She possessed a "spiritual beauty," though she dressed "quite atrociously"; she was "both detached" and interested in others. "I've rarely taken such a fancy to anyone," Vita admitted: "I have quite lost my heart."³

In a few years, Vita would fill the gap created in Virginia's life by Mansfield's death, though in a far different way. In a letter to Woolf about how she read books to inspire her work, she wrote: "I know just what to pick out of the shelf in order to strike sparks off myself, don't you? Or are you tinder-and-flint in one? I suspect so."⁴ Virginia and Vica would become as tinder-and-flint to one another, striking through their intimacy the sparks of love, sexuality, friendship, support, and literary inspiration. Their relationship became the most significant and longlasting in each of their lives.

When the two met, Vita was 30 years old, a few years past her passionate love affair with Violet Trefusis, which had almost ruined her marriage. Her affair with Violet, though it began when they were

young, was taken up anew by Vita in adulthood only after Harold could no longer hide his infidelities and the truth about his life as a homosexual. He had contracted a venereal infection and had to tell his wife so she could undergo medical examination and treatment. Vita was shattered by the news; she believed Harold had betrayed her, that her marriage was founded on duplicity.

After that shock, Vita completely rewrote the ground rules of their marriage. She had tried to be a good and faithful wife. She had accompanied Harold to Constantinople where he had a diplomatic post. After his admission of infidelity, traditional domestic life and the sexual part of their marriage were abandoned. The most important component of Vita's being, long buried in her marriage—her *Wanderlust*, her thirst for new experiences, for adventure, for seeing new places—now emerged. She would continue to protest her love for Harold and declare that Harold was her emotional center even as she plunged into the affair with Violet, careless of the consequences.

Violet and Vita eloped to France, their husbands pursuing them in an airplane, and putting a stop to their plan to abandon their families to live together. In time, Vita decided that never again would she let another grand, consuming passion threaten her home life and her marriage, and the peace, serenity, and solitude she required to do her work. Yet she knew that Harold's homosexuality and her sexual needs, primarily for lesbian relationships, required that she and Harold find sexual fulfillment outside marriage. Henceforth they led separate lives, she as a writer and gardener at Long Barn and later at Sissinghurst Castle in Kent, he as a diplomat in France, Persia, and Germany, and, later, in London as a Member of Parliament and writer. They maintained their relationship, founded upon honesty about their extramarital affairs, by letters, visits, and joint holidays.

Soon after Vita and Virginia's first meeting, Woolf heard from a friend that Vita "is a pronounced Sapphist, & may... have an eye on me, old though I am."⁵ Vita confessed to her husband that she loved Virginia. He cautioned restraint, citing the latter's precarious mental health. Vita promised that with Virginia she would exert self-control and there would be no complications.

Virginia, though she confessed that women alone stirred her imagination, was not a declared lesbian. None the less, she had had important intimacies with women before her marriage, the most significant, lasting several years, with Violet Dickinson. Her marriage to Leonard Woolf in 1915 had soon settled into an asexual relationship, and she believed herself to be frigid. Virginia, too, had

experienced a betrayal by her husband early in their marriage when he wrote of her as frigid in his novel *The Wise Virgins*, begun while the couple were on their honeymoon. For several years after that, Virginia's health was precarious. She attempted suicide, entered a nursing home, then was cared for in their home, Hogarth House, in Richmond, by a team of nurses. Leonard, shaken by Virginia's neardeath, became her caretaker and a champion of her work, founding The Hogarth Press as a shared venture to rebuild their troubled marriage.

Vita and Virginia's affair progressed slowly. What made Virginia change her mind after her initial resistance to Vita's charms? There was, of course, Vita's body, which initially attracted Virginia and which she believed was perfection. But Virginia also came to admire Vita's breeding, her ancestry, her pride, her independence, and her self-assurance, all very different from her own lifelong insecurity, humility, and dependence upon Leonard Woolf. She began to see Vita's friendship as a catalyst for change in her life and Vita's manner as a model to emulate. Though Virginia Woolf's work was well respected when she met her new friend, she never felt herself to be a success. Her Bloomsbury circle rarely praised her. Often, under the guise of honesty, they mocked and derided her so severely that she suffered anguish and feelings of self-hatred. Vita, instead, gave her the praise and respect that she both longed for and deserved.

Virginia's resistance to Vita evaporated completely when, in September 1925, she delivered her novel, *Seducers in Ecuador*, to Virginia at Monks House, Rodmell, in Sussex. Virginia had requested a novel for The Hogarth Press and Vita agreed. It was a coup for the press to have a bestselling author on its list, even for one book.

The novel that Vita turned out in no time at all earned Virginia's respect. She had written twenty thousand words in a fortnight, on a walking tour of the Dolomites with Harold, on mountaintops and beside lakes. The quality of the work showed that Vita had learned from Virginia, that she had tried to create a work of art fashioned similarly to Virginia's *Jacob's Room*. After reading *Seducers in Ecuador*, Virginia wrote in her diary that she saw her own influence. Vita had tightened her prose. There was "some sort of glimmer of art" in the novel; "indeed," she admitted, "I rather marvel at her skill, & sensibility; for is she not mother, wife, great lady, hostess, as well as scribbling."⁶

Virginia's praise was important. She was the first friend Vita had who was a committed writer, who took her work seriously. To

acknowledge her gratitude, Vita dedicated *Seducers* to Virginia; Virginia responded that she was "touched, with my childlike dazzled affection for you."

By the end of 1925, Virginia had declared her love, and she and Vita had entered a "soul-friendship" that Vita believed was very good for each of them. They became lovers at Long Barn on December 18, 1925. It was Virginia who was the seducer. Later, Vita described what transpired as an "explosion on the sofa in my room when you behaved so disgracefully and acquired me for ever." Virginia acted, knowing that by the end of January, Vita was embarking on a four-month journey to see Harold in Teheran, and the threat of separation fueled her ardor. Awarc of Vita's sexual needs, Virginia feared that if she did not take this opportunity, their intimacy would founder and Vita would be lost to her.

During their separation, they missed one another "horribly": Vita described herself as "reduced to a thing that wants Virginia." The separation gave them an opportunity to immortalize their love in letters. On the journey out, Vita addressed her letters "My darling Virginia," and added paragraphs at each stop of the Orient Express. She described the beauty of Crete, Egypt, the Indian Ocean, India, Baghdad, Persia. She described how she had been stuck in a river, crawled between ramparts of snow, attacked by a bandit, baked and frozen alternately, traveled alone with ten men (all strangers), slept in odd places, eaten wayside meals, crossed high passes, seen Kurds and Medes in caravans, and running streams, and black lambs skipping under blossom, seen hills of porphyry stained with copper sulphate, snow-mountains in a great circle, endless plains, with flocks on the slopes.7 Writing her finest prose for such a demanding recipient pushed Vita to new powers of description. Realizing she could make a distant place come alive for Virginia, she told her she could now write a travel book. Her letters were the raw material from which she fashioned Passenger to Teheran (1926), a classic of travel literature.

Virginia, writing "dearest Vita," had nothing but the familiar to describe. She assured her lover that she was "missing the loveliest spring there has ever been in England." She described a trip she had taken to Oxfordshire, where she had seen "a walled garden; flagged path; turf; a woman walking reading a book." Jealous of Vita's exotic life, but not wanting to journey so far herself, Virginia believed that the desert that Vita was traversing could not be "lovelier or stranger" than England.

When Vita returned, they took up their relationship at Rodmell,

in the long and warm June nights, with "roses flowering; and the garden full of lust and bees."⁸ Through the summer of 1926, they spent time together at one another's country homes: at Long Barn, with exquisite, priceless furnishings and carpets that Vita had inherited or brought back from her journeys abroad, "surrounded by the gardens—blazes of primulas, anemones, tulips, azaleas, irises, polyanthus" which she and Harold had created; and in the austerity of Monks House (where, to Vita, the Woolfs lived in "squalor"), with its view across water-meadows, the South Downs and its buttercups, clovers, and larks. Vita and Virginia continued to be lovers, perhaps for a year, into the spring of 1927.

After a time, though, Vita began describing this affair as primarily "a mental thing, a spiritual thing." Her lust had turned to "tenderness." Virginia was not sexual enough for Vita's needs. By June 1927, Vita and Mary Campbell had become lovers. Vita told Virginia, wanting to share with her the explosive quality of her newfound love. Virginia, wisely, refused to hear descriptions of Vita's entanglement with the woman who replaced her: "I hate being bored," she told her ex-lover. Unable to be as passionate as Vita desired, Virginia was none the less upset at the withdrawal of sexual love, though the affair settled into a strong, enduring friendship that lasted until 1934 when Vita took up with her sister-in-law Gwen St. Aubyn, whom Virginia detested.

During the ten years of the most important phase of their relationship, Vita Sackville-West published Seducers in Ecuador, Passenger to Teheran, The Land, Aphra Behn, Twelve Days, "King's Daughter," Andrew Marvell, The Edwardians, All Passion Spent, Family History, "Sissinghurst," Thirty Clocks Strike the Hour, Collected Poems, and The Dark Island. Virginia Woolf in that time wrote "Mr Bennett and Mrs Brown," Mrs Dalloway, To the Lighthouse, Orlando, A Room of One's Own, The Waves, Flush, and A Letter to a Young Poet; published The Common Reader and The Common Reader: Second Series; and began The Years, while working as usual on scores of reviews and essays. It was the most productive period of each of their lives. Neither had ever before written so much so well. Neither would ever again reach this peak of accomplishment. They wrote with each other in mind, and they learned from each other. Vita became more highly skilled, more concerned with style and form. Virginia became more playful in her prose, and could write more quickly and for a far wider audience. During their relationship, Virginia became a bestselling writer, with each of her works earning increasingly more money. Vita's work

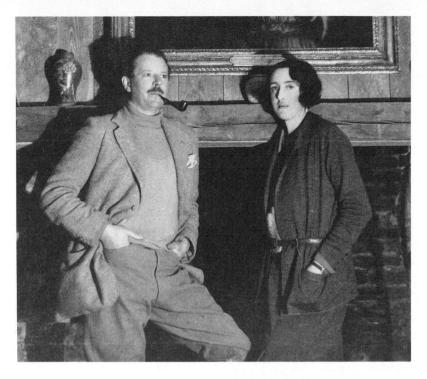

Harold Nicolson and Vita Sackville-West, 1932

continued to be commercially successful but began to be praised for its skill; she won the Hawthornden Prize in recognition of the artistry of her poem *The Land*.

When apart, they wrote frequently, and their correspondence is one of the great love duets of contemporary letters. Memories of their times together filled their letters. Word-paintings of places they saw, impressions they wished they could have shared. Talk of their work in progress. Descriptions of the trivia of their days that lovers require from one another. Advice for problems encountered. Concern for their husbands. Admonishments from one to the other to take very good care of themselves. Agony that they were apart.

Vita provided something for Virginia that Leonard Woolf did not—an agreeable companion for her social life, for attending the opera, concerts, the ballet, and parties. Leonard monitored his wife's emotional health, telling her it was time to leave just as a party was becoming exciting, because he thought she had had enough. He believed Virginia should curtail her social life; he thought it affected her health adversely. There is no doubt that while Vita and Virginia were friends, Virginia believed herself to be far more vital than when

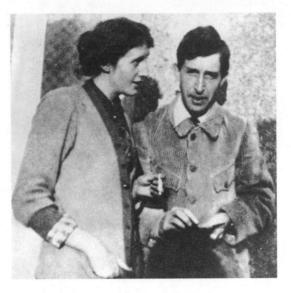

Virginia and Leonard Woolf, 1930's

she was under Leonard's influence alone. Indeed, Vita knew that Virginia needed to see people, and she provided the support, care, and calming influence her friend required when she became overexcited in company. Vita realized that her friend's art required her to be in society, something that Leonard did not understand. She realized that Virginia based her fiction primarily upon observation, not upon imagination.

Vita went with Virginia into society and learned from her the art of seizing upon the telling detail that signified meaning. She practiced this new technique in her letters to Harold. She described how she and Virginia had overtaken Duncan Grant on a way to a party, "hatless, and very carefully carrying one hard-boiled egg." One can easily see the difference in her correspondence before and after this friendship. Then she incorporated this skill into her fiction and travel books, which became far more vividly realized than they were before.

Like all lovers, they were curious about each other's history. Soon after Woolf met Sackville-West, she asked for a copy of her recent *Knole and the Sackvilles*, tracing the history of the house. "There is nothing I enjoy more than family histories, so I am falling upon Knole the first moment I get." Once they became lovers, each became more interested in, and able to address unresolved problems from, their childhoods. They realized, together, that their early lives had not been as wonderful as they had previously believed. Their friendship

enabled them to break through the idealized version each had held of her family. Virginia learned that the Stephen family household was far from idyllic; Vita learned that privilege does not necessarily entail happiness.

In conversation, letters, and in their novels, they explored their own and each other's pasts and came to far more realistic assessments of their family histories. Woolf wrote *To the Lighthouse*, *The Waves*, and *The Years*, novels that examined her childhood in the Stephen family, a childhood riddled with violence, sexual abuse, and emotional neglect. She wrote *Orlando*, which examined Vita's. Sackville-West wrote *The Edwardians*, based upon her childhood, and *Family History*, which to some extent examined Virginia's.

In Leonard Woolf's opinion, no one could have been more different from his wife than Vita: "She belonged indeed to a world which was completely different from ours, and the long line of Sackvilles, Dorsets, De La Warrs, and Knole with its 365 rooms had put into her mind and heart an ingredient which was alien to us and at first made intimacy difficult."⁹ Leonard was mistaken. Apart from the not inconsiderable difference of class, Virginia's and Vita's lives as children had been compromised in similar ways, resulting in similar character traits—insecurity, shyness, a need for solitude.

Woolf tried to explain her character, and the causes of her behavior, to Sackville-West:

Then there's my character. . . . I agree about the lack of jolly vulgarity. But then think how I was brought up! No school; mooning about alone among my father's books; never any chance to pick up all that goes on in schools—throwing balls; ragging; slang; vulgarity; scenes; jealousies only rages with my half brothers, and being walked off my legs round the Serpentine by my father.¹⁰

Sackville-West responded:

But indeed my bringing-up wasn't so very different from yours: I moved about too, at Knole mostly, and hadn't even a brother or a sister to knock the corners off me. And I never went to school. [She was lying; she had attended a school run by a Miss Woolff in South Street, where she did very well.] If I am jolly and vulgar, you can cry quits on another count, for you have that interest in humanity which I never can manage,—at least, I have the interest, but not the diabolical skill in its practice which is yours. And as I get older . . . I find I get more and more disagreeably solitary.¹¹

Both had been emotionally neglected or abused by their parents in

their childhood: Virginia, by her mother's withdrawal and depression, and her father's self-absorbed grief: Vita, by her father's insularity and her mother's infantile narcissism. Both were denied easy access to children their age: one because of her illness, the other because Knole was so far from any other household. Both had parents they idealized who were mercurial, difficult to please, lovable, yet maddening, who inflicted deep emotional wounds: Vita's mother frequently told her "she couldn't look at me because I was so ugly;" Virginia described life with her father as living in a cage with a lion. unable to escape to safety. They each had lived through childhood with constant reminders of history and the weighty sense of their family's place in it, wondering if their achievements would match those of their forebears: Virginia, because of her father's central place in British culture as editor of the Dictionary of National Biography, and her mother's Pattle family history; Vita, because of the inhabitants of Knole, which, she concluded, "were a rotten lot, and nearly all stark staring mad." Each felt conflict about the separate strains in her character: Vita, by the contrast between her Spanish grandmother Pepita, and her exalted English past; Virginia, by the tug between the flamboyant Pattles and the sober Stephens.

Most significantly, each had been the victim and the survivor of sexual abuse. Virginia had been subjected to the incestuous assaults of her two half-brothers, Gerald and George Duckworth, from the age of 6 through her 20's. This, she believed, spoiled her life before it had even begun. She shared this information with Vita on the journey they made together to France in 1928. Virginia "talked alot about her brother" and read Vita her memoir describing her incestuous abuse by George Duckworth, about how he would climb into her bed at night and abuse her.

When Vita was 11, a local farmer's son had forced her to watch him masturbate. He had made her masturbate a dog, which squirted "semen all over my shoes, and I was alarmed." At 16, and after, she had been the victim of frequent attempted rapes by her godfather, The Honourable Kenneth Hallyburton Campbell, who was her mother's age. He was a family intimate, a frequent overnight guest at Knole. His actions would be termed incestuous abuse by contemporary standards—unwanted sexual attention from a family member or trusted family friend. With him around, Vita could never feel safe from assault. "Perhaps," she pondered, "it accounts for much." She was too ashamed, too afraid to tell her parents; she feared what her father might say, feared that she would be held responsible for her

assailant's behavior. Knole was a hotbed of sexual infidelity and Vita watched her parents' exploits, and their intimates'.

Despite these painful sexual histories, Vita gave Virginia a precious and enabling gift in her maturity—the knowledge that, with the right partner, and in the right circumstances, she, too, could experience sexual pleasure. Though Virginia suffered from Vita's sexual withdrawal, this knowledge made a difference in her sense of herself; her fiction, too, in *Orlando* and *The Waves*, began to deal with physical passion.

Vita Sackville-West provided Virginia Woolf with a different appraisal of her character from the one that she had lived with for years—the reclusive semi-invalid who had to watch herself at all times and at all costs. Instead of emphasizing sickliness, Vita dwelled upon Virginia's health, her energy, her vitality, her accomplishments, her generosity in dealing with others, her gregariousness. "You are," she wrote, "a very, very remarkable person."

You see, you accomplish so much. You are one perpetual Achievement; yet you give the impression of having infinite leisure. One comes to see you: you are prepared to spend two hours of Time in talk. One may not, for reasons of health, come to see you: you write divine letters, four pages long. You read bulky manuscripts. You advise grocers. You support mothers, vicariously. You produce books which occupy a permanent place on one's bedside shelf next to Gerard MANLY [*sic*] Hopkins and the Bible. You cast a beam across the dingy landscape of the Times Literary Supplement. You change people's lives. You set up type. You offer to read and criticise one's poems.... How is this done?¹²

Vita's view helped Virginia arrive at a more realistic appraisal of the breadth of her accomplishments, not despite the faults of her character but because of its strengths, and gave her the verification of self-worth necessary to do even more.

It was Vita who also saw clearly the limitations of certain aspects of Virginia's marriage to Leonard. By her example, she showed Virginia what changes she could make, how she could be both married and independent. Vita earned her own money and she controlled her own income. It was her money, and not Harold's, that sent their sons, Ben and Nigel, to school, that bought Sissinghurst, that ran the household, that made their famous garden. Virginia's earnings from criticism and from her novels were essential to the running of her household. Yet she gave all her earnings to Leonard, keeping nothing for herself, asking Leonard for money when she needed to buy something. She required his permission to spend even the smallest sum, and his inclination, born of an impoverished childhood, was to spend nothing.

Although they were hardly well-to-do, Vita recognized that Leonard's stranglehold on the purse strings was damaging to Virginia. While she did not call herself a feminist, Vita found Leonard's control of the family finances abominable. Under Vita's influence, Virginia vowed, first, to earn more money, second, to keep a sum to spend as she pleased, and third, to use her money for pleasure and beauty. She bought household furnishings, rugs, paintings, a cooker, indoor plumbing, new clothing, and, in time, helped finance an automobile.

From Vita, Virginia learned to write more quickly, to be less obsessive about her art, and to take more time for relaxation, travel, and excursions that she could then use to enrich her art. She spent time on bowling, needlepoint, knitting, bread-baking, and listening to music.

Virginia helped Vita in ways that pushed her talent to the utmost. She gave "sudden discourse[s] on literature" to Vita who was "appalled" by her "ignorance" about literature, and requested "a synopsis of solid reading" to help prepare herself for fiction writing. After meeting Virginia, Vita wrote the most highly skilled work of her career: *The Edwardians, All Passion Spent*, and *Family History*. When their love affair ended, the quality of her fiction—*Grand Canyon*, for example—dimished considerably.

Virginia Woolf's friendship with Vita Sackville-West was most eloquently celebrated in Orlando. It owed much to Vita's own Knole and the Sackvilles, and their trips to Knole. On July 5, 1924, Virginia visited Knole with Vita and wrote of seeing it and meeting Vita's father, in her diary. She described walking through "miles of galleries," past "endless treasures—chairs that Shakespeare might have sat on—tapestries, pictures, floors made of the halves of oaks" to see Lord Sackville, sitting, alone, "lunching by himself." She was fascinated, but also outraged: "There is Knole, capable of housing all the desperate poor of Judd Street, & with only that one solitary earl in the kernel."¹³ Woolf wrote both her fascination and her outrage with the aristocracy into Orlando.

Orlando also rewrote English history. The loss of Knole because of Kent law that prevented Vita from inheriting it because she was female was the greatest pain she endured in her life. With her pen, Virginia remade Vita as Orlando, inheritor of Knole, born male, transmuting into female midway through the work. Through the act

of fiction, she gave Knole to Vita, and secured a part in the history of that house, previously identified with swashbuckling male heroes, for two women, who were lesbian lovers, one of whom—Vita—was herself a swashbuckler.

On March 10, 1935, Virginia and Leonard drove through a snowstorm to see Vita at Sissinghurst on the "bitterest Sunday for 22 years." "My friendship with Vita is over," Virginia wrote. "Not with a quarrel, not with a bang, but as ripe fruit falls. . . ."¹⁴ She felt an emptiness. She was at work on *The Pargiters*, her early version of *The Years*, and it was giving her difficulty. After their friendship ended and Virginia no longer felt in control of her art, Vita became increasingly solitary, depressed, and alcoholic.

When Virginia Woolf killed herself in March 1941, Vita experienced "the most awful shock." "I simply can't take it in—that lovely mind, that lovely spirit," she wrote Harold. They had seen each other for the last time for lunch in late February. Motor trips from Kent to Sussex were difficult to arrange during wartime because of petrol rationing. Vita thought Virginia had "seemed so well." But Virginia expressed in her diary "a churn in my mind" and wondered "shall I ever write again one of those sentences that gives me intense pleasure?"

Eight years later, in 1949, Vita told Harold that of the people she had known, Virginia was the person she missed most. She wondered if she "might have saved her if only I had been there and known the state of mind she was getting into. I think she would have told me, as she did on previous occasions."¹⁵

While the fire of Virginia Woolf and Vita Sackville-West's love flared, the ability they gave one another to look inward and backward in concert, to reexamine a past that was difficult to deal with alone, was an important aspect of their friendship. The record of that gift is preserved in their correspondence, private diaries, and the score of literary works they wrote while they were lovers and loving friends.

95

Max Ernst and Leonora Carrington, St. Martin d'Ardèche, 1939

THE BIRD SUPERIOR MEETS THE BRIDE OF THE WIND

Leonora Carrington & Max Ernst

SUSAN RUBIN SULEIMAN

It would make a wonderful movie.

Max, 46, handsome, brilliant, a famous artist of the Parisian avantgarde and renowned ladies' man, arrives in London for an exhibition of his paintings and meets Leonora, 20, a dark-eved beauty with flowing black hair, rebellious daughter of a wealthy English industrialist and an aspiring artist herself. It's love at first sight, "mad love" as the Surrealists called it: tempestuous, irresistible, sweeping all obstacles before it, a melding of souls and minds as well as bodies. We are in June 1937, the civil war is raging in Spain and a sense of impending catastrophe hangs over the rest of Europe. All the more reason to cling to love: Max and Leonora run off for a vacation in Cornwall with friends, then "elope" to Paris. Max is married—horrible scenes of confrontation with his abandoned wife (his second). He and Leonora travel south; he leaves her in a small village, but soon calls her back to Paris, he can't live without her. She becomes part of the Surrealist circle, her paintings are included in their big exhibition in Paris. But the atmosphere is full of petty squabbles, and she and Max want tranquility above all. They move back to their southern village, buy an old farmhouse together. Idyll: he paints and decorates the house with frescoes, sculptures, sculpted reliefs on the walls; she paints and writes stories that he illustrates with his collages, published in limited editions in Paris. They receive visits from friends, fellow artists from Paris, London-scenes of feasts and merrymaking, outlandish costumes, games, dances. They work and they love. He does a painting he calls A Moment of Calm: it is the summer of 1939.

Then the screen darkens: September 1, 1939, war is declared between France and Germany. Max, an exiled German who has lived in France for over fifteen years and is a committed anti-Nazi,

is nevertheless rounded up by French police as an "enemy alien." Leonora visits him at the detainment camp, where he continues to paint and draw; at Christmas he is released, thanks to the intervention of French friends alerted by Leonora. Return to their farmhouse in St. Martin; she paints his portrait, dressing him in striped socks and a merman's cloak in an icy landscape. The "phony war" drags on. In May, Max is denounced by a villager who claims he is in communication with the enemy. (In reality, if the Nazis found him they would not be nice: they have long considered him a "degenerate" artist, a menace to the Reich.) He is interned again, shuttled back and forth between camps; escapes and returns to St. Martin, but is taken away again. Leonora, anguished, starves herself and begins to hallucinate.

Meanwhile, the Germans occupy Paris: it's the real war this time. Leonora, in a state close to mental breakdown, is persuaded by friends to flee from St. Martin to Spain; in order to obtain the necessary travel permit, she signs over the deed of the house to a local official. When Max returns a few weeks later, he finds Leonora gone, the house no longer his. He stays for a while, painting her portrait over and over in mythical landscapes; he begins one of his greatest paintings, a cry of despair, *Europe after the Rain.* Then he leaves St. Martin, travels to Marseilles where he meets Surrealist friends and is introduced to the rich American Peggy G., who is on her way back to the United States and takes him under her wing: he must leave Europe. They go to Lisbon, to await the Clipper plane with a whole entourage: Peggy's children, her ex-husband, the ex-husband's estranged second wife.

Cut to Santander, Spain, where Leonora, having been diagnosed by Spanish doctors as incurably insane (she will later write about this experience in a work called *Down Below*), is shut up in a mental hospital: delusions, mistreatment by the doctors and nurses, physical and mental torture. Finally, her parents send her old nanny from England to take care of her; she is released, taken to Madrid, then shipped off to Lisbon from where they plan to send her to a sanitorium in South Africa. She succeeds in escaping from her jailer and seeks protection at the Mexican embassy in Lisbon, where she knows a diplomat. Renato, the Mexican diplomat, is Max's age: he will protect her, but in order to get her to America they will have to marry. She agrees. (They divorce amicably a few years later.)

Then Max and Peggy and their entourage arrive in Lisbon in

Leonora Carrington, Portrait of Max Ernst, ca. 1939; Max Ernst, Leonora in the Morning Light, 1940

spring 1941. Leonora is reunited with Max and spends long, intense days of reading and drawing with him, but their love affair is over. Max is now Peggy's lover, although he does not love her and she knows it. Peggy, although desperately in love with him and jealous, realizes that he and Leonora have a relationship nobody else can share: "Leonora was the only woman Max had ever loved." According to Peggy, who narrates this part of the story, Max begs Leonora not to marry Renato, to fly to New York with him and the rest of their group. She refuses, explaining that "her life with Max was over."

It is not completely over, for Leonora and Max are both in New York during a whole year and they see a lot of each other, along with other exiled Surrealists. He lives with Peggy and she with Renato. But he continues to work on his paintings of her, and she continues to write about him and to paint pictures like the ones she did when they were together. An avant-garde journal in New York devotes a whole issue to Max, to which she contributes a story, "The Bird Superior, Max Ernst," accompanied by the portrait she painted of him in St. Martin; one of his large portraits of her, *Leonora in the Morning Light*, is also reproduced in that issue. His one-man show in New York that spring includes that painting

and a number of others representing her, with less explicit titles. "Max was so insane about Leonora that he really could not hide it," says Peggy.

The end: in the summer of 1942, five years after their fateful meeting in London, Leonora leaves New York for Mexico. She and Max will both live to old age, but they will never see each other again.¹

TT WOULD MAKE A WONDERFUL MOVIE, I told myself half ironically (but only half) as I drove to Leonora Carrington's apartment in Oak Park, Illinois, on a dark afternoon in late December 1990. I had visited her twice before there, aware each time of the incongruity: what was this extraordinary woman artist doing in that dreary Chicago suburb, whose only claim to art was that it had once been home to Frank Lloyd Wright? Leonora had moved there from New York a few years earlier, to be near her son Pablo Weisz-Carrington, a physician in charge of the pathology laboratory at the local Veterans' hospital. Her other son, Gabriel, was a professor of literature in Mexico City, where she had lived for many years and where she still returned for lengthy visits. (Her husband, the photographer Csiki Weisz whom she married in 1946, still lived in their house; although no longer living together, they remained on friendly terms.) On my two earlier visits, we had talked about Gnosticism and motherhood, cooking and the Cabbala, Jungian psychology, Tibetan Buddhism, humor (she values it highly), collage (she hates that word to describe her work—I had used it in connection with her novel The Hearing Trumpet, a "verbal collage"), writing and painting ("when I write, it's for others; when I paint, it's for myself"-but she has lots of unpublished writings, diaries, notes, and until recently even a number of stories written in St. Martin before the war), grandchildren (she has several, enjoys being a grandmother), chance ("there's no such thing as chance"), women's independence ("I earn my own way. No one keeps me"), feminism (she is a feminist, though not a dogmatist), Chicago, New York, Mexico. We talked about people she had known: André Breton, the great Surrealist poet and leader of the group ("a bit too formal with women, he kissed their hand in greeting"), Remedios Varo, her good friend and fellow painter in Mexico (I showed her a

new biography of Varo by Janet Kaplan: "I don't want anyone to write my biography," she said firmly), and several other friends, old and new. The only person we studiedly did not talk about was Max Ernst.

Before I met her, I had heard from a few people that Leonora could be "difficult." I was all the more charmed by her warm reception on both my visits: she fed me, asked me questions about my family, my work, offered me her own opinions on a surprisingly wide range of subjects ranging from politics to photography. I was especially impressed by her interest in current controversies, current work: she had read Salman Rushdie's Satanic Verses before I did, as soon as the fuss began; and when I sent her two books by Angela Carter (whom she hadn't read-I was convinced she would find affinities between them), she replied quickly to say she was enjoying them and thanked me for the introduction. I had long admired Leonora's writing, and had taught it and written about it before I met her. Many Surrealist artists (Ernst among them) wrote as well as painted, but few had as considerable a body of work in both domains as she did. In short, I felt I had a good rapport with Leonora. That is what emboldened me, before my third visit to her, to call and ask whether I could bring along a tape recorder and do a formal interview. "I would like to talk to you about your early work," I told her on the telephone, "and also about your relations to the Surrealists." "All right," she said.

As soon as I stepped into her dark living room, I realized that it was not totally all right. Leonora was not as relaxed as she had been on my earlier visits. She was getting ready to leave for an extended stay in Mexico and the small apartment was cluttered with boxes. She told me she hadn't painted in a while, which bothered her. She felt isolated and lonely. "Who can blame you for feeling isolated in Oak Park, Illinois?" I remarked not very diplomatically. "But what about the Chicago Surrealists, don't they come around?" (Chicago is the last American outpost of Surrealism, with an "official" Surrealist group led by Franklin Rosemont, who met Breton as a young man). Leonora shrugged her shoulders: "I'm interested in the present, not the past."

With a slightly sinking feeling, I turn on the tape recorder and pull out of my bag the small envelope in which I have brought two photographic reproductions: one is the portrait of Max Ernst painted by Leonora in 1940, the other her famous self-portrait of 1937, also known as *The Inn of the Dawn Horse*. It shows Leonora dressed in a riding outfit, tight white jodhpurs, green jacket, high-heeled black

booties, sitting on the edge of a ladylike Victorian armchair in the middle of a large, otherwise unfurnished room; the feet of the chair are high-heeled women's shoes like her own: the armrest too echoes her own left arm and hand. Her unruly black hair, like a horse's mane. falls around her shoulders as she looks straight out at the viewer with a scowling air. Standing in front of her is a black striped hyena with a highly expressive face and piercing blue eyes, its head also turned toward the viewer. Behind her, a white rocking-horse is suspended in mid-air; outside the window framed by gold Victorian curtains like a stage set, a white horse, its forelegs extended like those of the rocking horse, runs free in a clearing surrounded by a copse of trees. "I wonder if you could comment on this painting?" I ask her, purposely vague. "No. Put it away, please. I know it quite well, I don't need to see it." But" "It's a good painting. Period." "Well, but what about your representing yourself in that particular pose?" "Well, that's what I did." She will say no more: nothing about her love of horses, dating to early childhood; nothing about the white rocking horse bought at a second-hand shop in Paris shortly after she moved there with Ernst (there is a photograph of him sitting, long-legged, on that horse); nothing about the recurrent, highly overdetermined motif of horses in nearly all of her paintings of that period, or about the horses that appear in some of her best-known stories of that time. Nor is she willing to say anything about the figure of the hyena, another heraldic animal featured in what may be her best-known story, "The Debutante," in which a young society girl befriends a hyena at the zoo and gets the animal to take her place at a debutante ball. This story of adolescent rebellion and violence (the hyena eats the girl's maid and uses her face as a mask) first appeared in 1939 in La Dame ovale (The Oval Lady), a collection of stories illustrated by Ernst, and has often been anthologized since then, most notably by Breton in his Anthologie de l'humour noir (Anthology of Black Humor, 1939), in whose first edition that was the only work by a woman.

About all this, Leonora refuses to speak. Daunted but not yet defeated, I try again. "And your portrait of Max?" "I have nothing to say about it." It too shows a white horse, but this time immobile, frozen; and if one looks carefully, one notices that what first appeared to be a lantern carried by the merman dressed in his gorgeous red cloak, is actually a glass container in which a small white horse is imprisoned in a greenish liquid. If the white horse is her emblem, could this be a negative commentary on her relationship with Ernst? I don't dare to ask the question, and she remains silent. I say: "What

Leonora Carrington, The Inn of the Dawn Horse (Self-Portrait), 1937

about those bird-like feet?" "They're striped socks," she replies. "Yes, but they look like bird feet." "That's true, there was something very bird-like about Max, although I didn't realize it at the time." This from a woman who in 1942 had written "The Bird Superior, Max Ernst," about a man whose alter ego, appearing repeatedly throughout his paintings, collages, collage novels, and autobiographical writings, was Loplop, the Superior of the Birds, sometimes also called (as in the collage novel of 1930, *La Femme 100 têtes, The Hundred-Headed*/*Headless Woman*), "Loplop l'hirondelle," Loplop the swallow. In her painting of around 1937 (the same period as *The Inn of the Dawn Horse*) titled *Woman and Bird*, Carrington represents a horse-woman with black mane, looking down at a small black bird in whose plumage one sees the white figure of a headless woman.

In fact, no single figure is more closely associated with Ernst than that of the bird Loplop. In a well-known passage of his autobiographical notes, "Some Data on the Youth of M.E., as told by himself," he traces this association to an event in his adolescence, when the death of a beloved pet bird coincided with the birth of his sister: "The *perturbation* of the youth was so enormous that he fainted. . . . A dangerous confusion between birds and humans became encrusted in

Leonora Carrington, Woman and Bird, ca. 1937

his mind and asserted itself in his drawings and paintings. This obsession haunted him until . . . 1927, and even later Max identified himself voluntarily with Loplop, the Superior of the Birds. This phantom remained inseparable from another one called Perturbation ma soeur, la femme cent têtes."² Occasionally, the Ernst bird appears as a flying man dangerous to young girls, as in the famous 1923 painting Two Children Threatened by a Nightingale, where the nightingale is a black-clad man on a rooftop, about to carry off a young girl in his arms, while below a girl lies on the ground in a swoon and another one flees in fright. This painting was reproduced in Herbert Read's book Surrealism, which Leonora Carrington's mother gave her as a present in 1936, when she was an art student in London. She told the story to Paul de Angelis: "In the book I saw Deux enfants menacés par un rossignol, and it totally shocked me. This, I thought, I know what this is. I understand it."3 Looking recently at a 1947 work by Leonora that I had not seen before, Crookhey Hall (exhibited in the Serpentine Gallery in London in 1991-2), I was struck by the running figure of a young girl, whose stance and flying hair are similar to those of the girl in Ernst's painting.4

When Leonora told me, straightfaced, that she had never thought of Max as a bird, I acknowledged my defeat. There was nothing to do

but put away the photographs and turn off the tape recorder. (Later, she agreed to have it turned on again, but only to talk about generalities.) It was around then, as I recall, that she exclaimed, in a tone of enormous frustration: "Those were three years of my life! *Why* doesn't anyone ask me about anything else?"⁵

I have often thought about that failed interview—so much so that, curiously, I have come to consider it not a failure at all. For if it failed to yield the information I sought (one reason, I soon realized, was simply that Leonora had spoken at length about the subject with other interviewers: with Marina Warner in 1987, and, only a few months before I saw her, with Paul de Angelis), it gave me something more valuable: a way to think about the frustration itself—both hers and mine—as a vital piece of information. Leonora helped me in that regard, for she remarked to me later during my visit: "I don't know why I'm so hung up about not wanting to deal with those years. I just realized talking to you that I have not gotten reconciled—that is why I don't want to talk about my past." "Reconciled with what?" I asked. She didn't answer.

Frustration, lack of reconciliation: the urge to interpret psychoanalytically is great. Analysts would no doubt speak of ambivalence, an unresolved opposition between simultaneous feelings of love and hate directed toward the same object. I will resist the psychoanalytic temptation in this instance, for I think it would yield only a truism: what, if not ambivalence, would characterize the feelings of a very young woman toward a much older man who appeared in her life at once as mentor, lover (both faithful and faithless), idealized father, and artistic brother in arms? Yet the notion of ambivalence, if used in a broad sense rather than in a narrowly psychoanalytic one, proves useful. Think of it as the simultaneous presence of equally strong positive and negative effects in a single emotional and artistic relationship: suddenly, not only does the Ernst-Carrington relationship become illuminated, but the question becomes formulable in more general terms. What are the positive and negative effects, for both parties, of any relationship between a young artist just starting out and an older, more established figure, possibly a "genius," who acts as both mentor and lover? Do gender and sexual politics play a role, making a significant difference whether the younger person is a woman or a man, of the same sex or the "opposite" sex? What role does the historical and cultural context play: for example, the radical displacements and upheavals caused by the Second World War in

Europe, or, on a different level, the assumptions about sex roles prevalent not only in a particular society or social class at a given time, but even within a particular subgroup like the French Surrealists between the wars? Finally, and perhaps most importantly, do these biographically slanted questions allow for a new, compelling understanding of the works produced during the relationship, by both the younger and the older artist?

In the case of Carrington and Ernst, it seems clear that the immediate positive effects of their meeting were tremendous for both artists, if for somewhat different reasons. On the strictly practical, material level, the change was no doubt more radical for her: after years of struggling against her family's middle-class disparagement of art ("I was born into a hundred percent philistine family," she told me) as well as against the "huge putdowns" she received as an art student in London ("Forget it, you're no good, and anyway there are no good women artists"), meeting Ernst had an inestimable importance. Here was a major artist whose work she understood and admired, who took her own work seriously and introduced her to others who did the same. Literally, he brought her into a new life—a new city, a new language (they spoke French together, as he knew no English at the time), a world where art was respected and women artists were not automatically dismissed.

Recent feminist criticism has rightly called attention to the subtle (and not so subtle) constraints placed on women even within the revolutionary, anti-bourgeois ideology of Surrealism: for example, by means of glorified but ultimately stifling roles like that of femme-enfant ("child-woman") or "inspired madwoman" such as Breton's heroine in his best-known work, Nadja (1928). Carrington herself recently spoke of the role assigned to women as "slightly crazy muse."6 Despite all this, there is no doubt that Surrealism also provided many women artists, including Leonora Carrington, with their first recognition, their first opportunity to exhibit their work. A few months after moving to Paris, she participated in the major International Surrealist Exhibition of January-February 1938, which then went on in a modified version to Amsterdam (where she exhibited The Horses of Lord Candlestick). That same year, when she turned 21, she published La Maison de la peur (The House of Fear), with a preface and collage illustrations by Ernst.

It is true that this early recognition and inclusion in the Surrealist circle also had negative effects, and I will get to that. But considering the well documented difficulty that many women artists—especially

of Carrington's generation, but even today—have in taking themselves seriously as artists, I think it is important to acknowledge the positive consequences of recognition by an established, generally male "authority" before dwelling on its disadvantages.

Remaining still on the practical level, we can see a "new life" offered to Max Ernst as well, by his encounter with Leonora. Although when he met her he was lacking neither in recognition by his peers nor in women's adulation (the autobiography of his son by his first marriage, Jimmy Ernst, offers instructive glimpses into Ernst's love life, as do the memoirs of Peggy Guggenheim, who supported him during his first years in New York and to whom he was married for a short time), Ernst was clearly reenergized and rejuvenated by his union with a young woman in whom he recognized a sister soul. By 1937, his marriage to Marie-Berthe Aurenche, a young Frenchwoman from a bourgeois Catholic family whom he had married ten years earlier, was foundering, possibly because she had become extremely devout. Ernst, himself the son of devout Catholics, took pleasure throughout his adult life in mocking the Church and everything connected with his own extensive Catholic education. He had been excommunicated by the bishop of Cologne for his blasphemous painting of 1926, The Blessed Virgin Chastising the Infant Jesus before Three Witnesses, which shows a sexy Madonna spanking a little boy whose halo has fallen on the ground (the fallen halo was what most outraged the prelate).7 Ernst continued the provocation in his collage novel of 1930, Rêve d'une petite fille qui voulut entrer au Carmel (Dream of a Little Girl Who Wanted to Become a Carmelite), whose heroine, the curvaceous Marceline-Marie, is a most unlikely nun. Even his self-naming as "the Bird Superior" was a parody of convent terminology. Like Ernst, Carrington came from a devout Catholic family whose religious and social convictions she found pleasure in lampooning; unlike Marie-Berthe Ernst, she never did return to the fold.

In 1934 Ernst published a short text in the Surrealist-dominated journal *Minotaure*, which can be read both as a fable of disillusionment with his increasingly Catholic wife, and as a premonitory evocation of a different woman. "Les Mystères de la forêt" ("The Mysteries of the Forest") contrasts two kinds of forests, fully exploiting the fact that the gender of forest in French is feminine. First, there is the forest who, having been "a friend of dissipation" in her youth, suddenly "lets herself be touched by virtue" and becomes "geometric, conscientious, industrious, grammatical . . . boring." This virtuous

forest consults the nightingale (a stand-in for Ernst, as we have seen), who is not happy with her change of mood and advises her to go and see how forests are in Oceania. She will not go, "being too proud." But the text continues: "Do forests exist over there? They are, it seems, wild and impenetrable, black and redhaired, extravagant . . . negligent, ferocious, fervent and lovable . . . From one island to the other, above the volcanoes, they play cards with mixed-up decks. Naked, they dress themselves only in their majesty and mystery."⁸

As it happens, the forest—represented as a place of mystery and verdant nature, sometimes grotesque but always luxuriant—was a recurrent motif in Ernst's paintings, especially during the 1930's. Art historians have noted the link between these works and German Romantic painting, especially the subjective dreamscapes of Caspar David Friedrich, whose work Ernst knew well. His painting *La joie de vivre* (1936) represents a forest landscape filled with fantastic animals and rampant foliage; surely not by chance, it is in a similar setting that he placed his 1940 portrait of Leonora, *Leonora in the Morning Light*. It seems clear that the young woman with the thick black hair whom he met in London in 1937 corresponded to a deeply embedded fantasy of "wild womanhood," already evoked in his "mystery of the forest" story three years earlier.

With that observation, we have moved from the level of practical considerations to what might be thought of as the Surrealist equivalent of the mystical communion of souls. The Surrealists set great store by what they called "objective chance," which often took the form of a fateful encounter that had somehow been prepared by premonitory fantasies or visions. Breton, in his book L'Amour fou (Mad Love, 1938), described his encounter with Jacqueline Lamba, who would become his second wife, as an event "foreseen" by a poem he had written eleven years earlier. In the same way, Ernst appears to have considered Carrington as the embodiment of some of his most powerful fantasies, reflected in work done years before he met her. Reciprocally, she seems to have found in his earlier work (as in Two Children Threatened by a Nightingale) meanings that were immediately clear to her, a visual language that corresponded to her own imagination and desires.

The single most powerful image joining them during those years was that of the wild horse. In 1927, Ernst had painted a series of pictures all with the same title (he often explored a single theme or obsession in multiple versions): *The Bride of the Wind*. Each picture represented two or more horses joined in ecstatic coupling, or in one

Max Ernst, The Bride of the Wind, 1927

case in a wild ride against a yellow sky. Uwe Schneede has pointed out that "la mariée du vent" is a literal translation of the German Windsbraut, a slightly archaic word meaning tempest or stormwind.9 The great modernist painter Oskar Kokoschka had first exploited the metaphorical possibilities of the word in his 1914 painting of that title, showing himself and his lover Alma Mahler lying side by side enveloped in a whirlwind. Ernst obviously knew that painting and seized on its erotic content. Quite probably, however, he was also familiar with the many Germanic legends about a figure known as the "wild hunter," who drives before him the "wood-wives" and other inhabitants of the forest. One encyclopedia of Germanic mythology specifically mentions "the North German belief in the Wind's Bride, driven before the Hunter," citing Jacob Grimm's Teutonic Mythology as a source.¹⁰ Ernst, like Grimm and the Romantics, was deeply interested in folklore; the legends of the "wild hunter" may provide one explanation for his association of unbridled (I use the word advisedly) sexuality with horses.

The horse as a symbol of sexuality functions equally well as male or female: the wild horse can symbolize male potency and sexual drive but also the female who is ridden by the male, carrying him on a

whirlwind journey. In Ernst's 1927 "bride of the wind" paintings, the title does not seem to differentiate between stallion and mare but refers rather to their coupling, their joint ride. However, whether for linguistic (*braut*/"bride" can only be feminine) or other reasons, the term eventually came to refer, for Ernst, specifically to a female: in the 1940 drawings he did in the Les Milles detention camp which bear the title *Bride of the Wind*, the figure is that of a hybrid "horse-woman" standing on two curvy legs, seen from the back, with a horse's head and a long flowing mane that could also be a woman's hair. This figure was later included as one of several female horse figures, some of them shown mating with the Loplop-bird, in Ernst's visual poem "First memorable conversation with the Chimera," which appeared in the first issue of the journal VVV in New York in June 1942.

The next issue of the journal carried Leonora Carrington's story "The Seventh Horse," written in 1941. Before discussing that New York story, however, I want to return to Europe. For we have not yet finished with Ernst's variations on the "bride of the wind," and we must also look again at some of Carrington's works done between 1937 and 1941.

In the early 1930's, Ernst did a series of self-reflexive paintings and collages titled *Loplop presents* . . ., in which the Bird Superior seems to offer the viewer a framed picture. One of these, *Loplop Presents a Young Girl* (it exists in three versions with small variations, 1931-6), is a mixed media work that was shown in his 1937 solo exhibition in London; featured prominently in it is a long black mane that could be either a horse's or a woman's hair. Once again, the Surrealists would see in this coincidence an example of premonitory vision; one of the "bride of the wind" pictures had also been exhibited in London the previous year, in the big International Surrealist Exhibition of 1936. As if in recognition of the "objective chance" that had brought together and materialized these two series of fantasy images in a single encounter, Ernst entitled his 1938 preface to Carrington's *The House of Fear* "Loplop Presents the Bride of the Wind." Here are the last three paragraphs of his preface:

"Who is the Bride of the Wind? Can she read? Can she write French without mistakes? What wood does she burn to keep warm?

She warms herself with her intense life, her mystery, her poetry. She has read nothing, but drunk everything. She can't read. And yet the nightingale saw her, sitting on the stone of spring, reading. And though she was reading to herself, the animals and horses listened to her in admiration.

Leonora Carrington, The Horses of Lord Candlestick, 1938

For she was reading *The House of Fear*, this true story you are now going to read, this story written in a beautiful language, truthful and pure."

Well. On the one hand, there is enormous admiration and praise here for the work, as well as a deep personal infatuation with the mythologized figure of its author. On the other hand, there is a patronizing putdown, suggesting that the author is more an inspired medium who knows not what she does than a self-conscious artist. True, the Surrealists set great store by "automatic writing" and other quasi-inspired states; nevertheless, it is doubtful that any male Surrealist would have been happy to see himself portrayed as a creature who has "read nothing" and indeed "can't read." A London journalist commenting on this text recently remarked, with a tartness that seems only slightly exaggerated, "he envisaged her... as a kind of holy idiot."¹¹

On the one hand, on the other hand: we are back to the question of positive *versus* negative effects. Looking at the work, both painting and writing, produced by Carrington between 1937 and 1941 with that question in mind, one sees an astonishingly even division between positive and negative, as if she were playing out in her imaginary representations the ambivalent effects of her relationship with Ernst. On the positive side, the figure of the wild horse, and the identification between horse and young woman, serves as a gesture of liberation, of power, or of rebellion against social and sexual constraints: thus the white horse running free in the self-portrait, the group of horses resting in *The Horses of Lord Candlestick* (two of them, the brown and the white, seem to be exchanging sexual messages) and

the strikingly phallic horse-woman of *Woman and Bird* can all be seen as variations on the theme of sexual and creative power. A number of critics have pointed out that the power is linked to a certain androgyny, as in the pose and garb of the artist in the self-portrait. In *Woman and Bird* it is the horse-woman who is phallic, and much bigger than the (presumably) male bird with whom she is joined. As for the published stories of this period, in *The House of Fear* the horse is a friend to the reclusive narrator-heroine; in "The Oval Lady," the rocking horse—who in the end starts to neigh as if "suffering extreme torture"—is an alter ego for the rebellious daughter, with the implication that no amount of punishment will succeed in taming her.

We might call these representations Carrington's own version of the "bride of the wind." In fact, she did not need Ernst to put her in touch with horses and their possible symbolic significance, for as she has stated in various interviews, she was "thoroughly obsessed with horses" long before she met him. She and her mother both had their own horses and rode frequently. At one time, as a little girl, she even wanted to transform herself into a horse: "It would give me another kind of energy to become a horse."12 Nevertheless, the meeting with Ernst and his particular obsession with wild horses could well have reinforced her own positive identification, and contributed to her preoccupation with that motif throughout the time they were together. There exists at least one painting from 1940 on which they actually collaborated, entitled Encounter. Carrington did the left side, featuring a horse-woman similar to the figure in Woman and Bird; she also painted the volcanic landscape in the background, which evokes (whether she was familiar with Ernst's text or not) the volcanoes he associated with the "wild and naked" forests of Oceania in "Les Mystères de la forêt."

Alongside these powerful positive images of the horse and the horse-woman in Carrington's work, however, there existed a far less happy version; it is significant, I think, that this negative version, although written around 1937–8, remained unpublished until very recently. I refer to the long story, actually a novella, "Little Francis," which was first published in an abridged French translation (unlike other stories of that period, Carrington wrote it in English) in 1986, then in its original version in 1988. The story is a transposition of the painful triangle formed by Ernst, Carrington, and Marie-Berthe Ernst during the first months after the breakup of the marriage. Carrington appears as a young English boy visiting his uncle in Paris; Ernst appears as Uncle Ubriaco, the playful and unconventional, irresistibly

attractive "drunken uncle," while Marie-Berthe figures as Amelia, Ubriaco's spoiled and possessive daughter. Carrington wrote this sad tale during the time when she found herself alone in St. Martin, abandoned by Ernst and uncertain of the future. In the story, after weeks of happiness spent with Francis in the south of France, Ubriaco returns to Paris with Amelia. Francis, in his grief, grows a horse's head and becomes a freak attraction in the local café. In one dreamlike sequence, he visits a fantastic castle and witnesses his own execution (before he grew the horse's head). Eventually, he is lured to Paris by Amelia just as Ubriaco has gone to rejoin him; Amelia attacks his horse's head with a hammer and keeps beating him until he dies, then has his body shipped back to England. Ubriaco, griefstricken, follows, and in a last gesture of co-conspiracy and defiance, paints Francis's plain white coffin with black and yellow stripes.

In her perceptive analysis of this story, Marina Warner notes that Carrington's choice of a male alter ego is in this instance not a sign of androgynous power, but rather of youthful vulnerability: "By changing herself into a youth, she uncovered a deeper truth about her relation to Max Ernst, revealing in the devotion and passivity of the boy Francis the tutelage in which Ernst and other masters held their femmes-enfants, their brides of the wind; similarly, by transforming Ernst's wife into his daughter, Leonora unveiled that relation of dependence and authority as well."¹³ It is indeed true that in the story the emphasis is on Francis's vulnerability, his adoration of Uncle Ubriaco, and his relation of pupil to teacher ("[Uncle Ubriaco] found Francis very ignorant indeed ...," p. 117). Significantly, however, the critique of Ernst that Warner finds implicit in the story never rises to full consciousness; on the contrary, Ubriaco remains Francis's ally and fellow rebel defying bourgeois convention even beyond death. The negative characters are Francis's English family and Amelia.

What I am suggesting is that although it is possible to read a critique of Ernst, and indeed of the whole relation of women to Surrealism, into this story, at the time of its writing that critique was not consciously available to Carrington. Her conscious energies were focused, rather, on her liberation from middle-class propriety and attainment of an identity as an artist, a project in which Ernst and the Surrealists could only appear as allies. But—and this is the really interesting twist—it is also obvious that a certain unease with the *femme-enfant* role, and a certain ironic view of her male allies, including Ernst, was present, even if not always acknowledged, both in "Little Francis" and in several other stories that remained unpublished until

very recently. In "Little Francis" the mood is tragic rather than ironic (although there is a biting sendup of an "artistic" party at the castle Francis visits as a horse); but the unease I refer to is evident in the significance accorded the horse's head. It transforms Francis into a hybrid figure, like one of Ernst's collages. But rather than becoming a strong sexual outlaw or a figure of potency like Ernst's hybrids or like the horse-woman of *Woman and Bird*, the horseheaded boy is simply a freak, the object of other people's curiosity. Note that the Francis of before, the one with the human head, is guillotined while the horseheaded Francis watches; the horse's head thus functions as an alienation from self, a "loss of one's head" that is a kind of death rather than a positive metamorphosis.

Still, one could argue that Francis loses his head only after Ubriaco leaves him, not because of Ubriaco's presence. Another story written between 1937 and 1940, however, leaves no doubt as to the target of the author's ironic critique. This one, entitled "Pigeon, Fly," was written in French and first published in French in 1986 before appearing in The Seventh Horse and Other Tales. There are no horses in this tale, but there is a man who takes himself for a bird; and he is chillingly portrayed. The story is stunning, difficult to summarize briefly despite its own brevity. The narrator, a woman artist, is summoned by a certain Monsieur Airlines-Drues (he looks like a sheep and is surrounded by other men with high-pitched voices like sheep), who asks her to paint the portrait of his "adored" dead wife before she is buried. The artist accepts the commission, only to notice, to her astonishment, that the portrait she has painted is of her own face. Monsieur Airlines-Drues offers her a room in his house where she can finish the portrait; it is his wife's studio, where the narrator finds a profusion of costumes and the diary of the dead woman. In it, the young wife describes her husband Célestin, who comes to her dressed in a feather robe and wears "blue stockings with red stripes." Later, he tells her: "You will always be a child, Agathe. Look at me. I am terribly young, aren't I?"14 Living in his house, she has the feeling of becoming transparent: "Every day, ... I lose myself a little more. ... I try to paint my portrait so as to have it near me still ... But ... I can't. I elude myself" (p. 27). The diary comes to an abrupt end after she describes a game of "Pigeon, fly" in which Célestin terrifies her by actually flying up in the air. After reading this, the narrator turns to Agathe's portrait, but the canvas is empty. "I didn't dare look for my face in the mirror. I knew what I would see" (p. 29).

Here, as clear as in a polished glass, is the nightmare image of

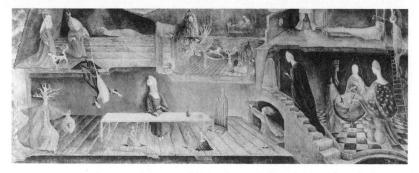

Leonora Carrington, The House Opposite, ca. 1945

what it was like to be a *femme-enfant* among the Surrealists: robbed of one's face, one among a series of replaceable women, each "adored" in turn, then buried by a band of bleating sheep who want never to grow old.

In Oak Park, Illinois, in 1990, Leonora said to me during our taped conversation: "There is always a dependency involved in a love relationship. I think if you are dependent, it can be extremely painful." And a bit later: "I think that a lot of women (people, but I say women because it is nearly always women on the dependent side of the bargain) were certainly cramped, dwarfed sometimes, by that dependency. I mean not only the physical dependency of being supported, but emotional dependency and opinion dependency . . ." When, the question arises, did she come to this understanding? I have tried to suggest that she already possessed it, albeit in an unacknowledged form, even during the most euphoric period of her relationship with Ernst; but at that time, as so often happens in life, the emotional attachment and other undeniably positive effects of their life together kept this understanding in the background. Only after being separated from Ernst, against her will, by the brutal forces of history, and only after undergoing a harrowing experience of mental breakdown from which she emerged perhaps as a different person, did she realize what she must do.

Peggy Guggenheim, who is not necessarily the most reliable witness as far as Ernst is concerned, seems to me entirely believable when she reports that, in Lisbon in 1941, Leonora refused to return to Max despite his pleading: "She felt that her life with Max was over because she could no longer be his slave, and that was the only way she could live with him."¹⁵ Although this decision did not immediately manifest itself in her work (the writing and painting she did in New York does not represent a radical break with the earlier work), a few years later her painting looked quite different: a much lighter palette

than before, more of a miniaturist attention to detail, and an entirely new set of images inspired by her interest in Celtic, Mayan, Egyptian, and Tibetan mythology. It is only after 1945 that she attained her mature style as a painter, as evidenced for example in one of the earliest paintings she did in Mexico, *The House Opposite*. To attribute this maturation entirely to her separation from Ernst would be too simple, for there were many other changes in her life as well, including the sheer passage of time and the growth of experience. Still, it is not unlikely that coming into her full identity as an artist and abandoning the *femme-enfant* role were closely related. In 1946, she became a mother—yet another way of abandoning the role of child.

This does not mean, of course, that Carrington's separation from Ernst was easy, or free from pain for either of them. The stories she wrote in New York and published there ("Waiting," "White Rabbits," "The Bird Superior, Max Ernst," "The Seventh Horse") testify to the contrary as far as she is concerned. As for Ernst, the testimony of his son is eloquent: "I don't recall ever again seeing such a strange mixture of desolation and euphoria in my father's face [as] when he returned from his first meeting with Leonora in New York. ... Each day that he saw her, and it was often, ended the same way. I hoped never to experience such pain myself . . . "16 The series of paintings Ernst did between June 1940 and the spring of 1942, most of them exhibited in his one-man show at the Valentin Gallery that year, include some of the greatest in his oeuvre: The Robing of the Bride, The Anti-Pope, Europe After the Rain. I call them the "Leonora pictures," for each one contains, quite clearly, a fantasy portrait of Leonora Carrington. In the center of the ruined landscape of Europe After the Rain, the last picture to be completed in this series, we see a tall, slim, dark-haired woman turning her back on a bird-headed man. It was his version of their mutual farewell, not only to each other but to Europe as well. (Ernst eventually moved back to France, but not until the mid-1950's; Leonora has remained on this continent, save for a few rare visits.)

That could be an ending, but I promised earlier to return to "The Seventh Horse," published in the second issue of VVV; it can be read as Carrington's version of the farewell. The story features three main characters: Hevalino, a "strange-looking creature" with a long mane, actually a young woman accompanied by the lord of the manor's six horses; Philip, "the friend of the horses" and lord of the manor; and Mildred, his very proper wife, who disapproves of Hevalino and whom Philip despises. After a dispute at the dinner

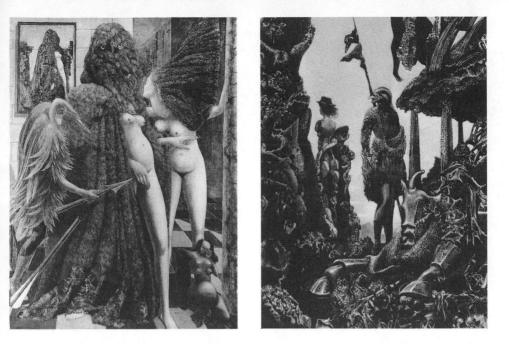

Max Ernst, The Robing of the Bride, 1940; Europe After the Rain (detail), 1940–42

table, during which Mildred claims to be pregnant and Philip insists she cannot be, since he hasn't slept with her in five years, he leaves and calls his horses: "He counted seven horses as they galloped by. He caught the seventh by the mane, and leapt onto her back. The mare galloped as if her heart would burst. And all the time Philip was in a great ecstasy of love; he felt he had grown onto the back of this beautiful black mare, and that they were one creature." The story ends cruelly: at dawn, Mildred is found dead, apparently "trampled to death" despite the gentleness of Philip's six horses. In the empty seventh stall, there is no black mare, only a "small misshapen foal" whose presence "nobody could explain" (p. 71).

"The Seventh Horse," with its suggestion of an extremely powerful but aborted love, is the last of Carrington's works in which the figure of the horse-woman appears. By the time it was published, in 1943, she had left New York for Mexico and Ernst had met the American artist Dorothea Tanning, whom he married in 1946 (his fourth marriage) and with whom he spent the rest of his long life. He died, covered with honors, on April 1, 1976, the day before his 85th birthday.

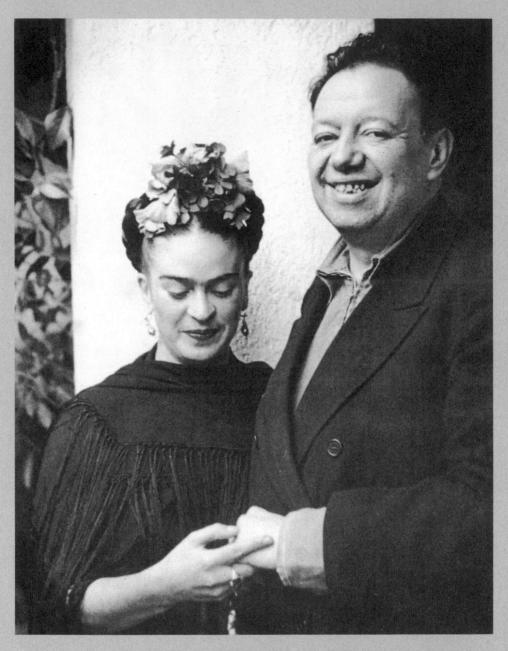

Frida Kahlo and Diego Rivera, ca. 1940

велиту то ніѕ велят Frida Kahlo & Diego Rivera

HAYDEN HERRERA

When the Mexican painters Frida Kahlo and Diego Rivera married in 1929 the bride's parents said "it was like the marriage between an elephant and a dove."1 With his enormous girth and his slow lumbering walk; Rivera at 42 certainly was elephantine. Beside him Kahlo at 22 did look small and delicate. But her voluptuous lips and her dark piercing eyes beneath joined eyebrows hardly suggested dove-like innocence. Indeed, the photographer Edward Weston who met Kahlo during her engagement said she reminded him of an eagle, and when her father took note of Rivera's interest in Frida, he warned: "She is a devil." Nor did Rivera's hugeness and her fragility mean that he was the stronger of the two. Like an elephant, Rivera could trample over people, but Kahlo, with her drive to invent herself and to persevere against all odds, was in many ways the stronger character. Perhaps to make him smaller and to express her affection, Kahlo called him by nicknames such as "frogtoad." Both of them have become myths. Rivera was world famous in his lifetime; largely thanks to feminism and multiculturalism Kahlo has recently become a cult figure. They encouraged such legendary status; Kahlo by playing the role of heroic sufferer and by the flair with which she played beauty to Rivera's beast, Rivera by his mania for publicity and his talent as a fabulator. He loved to talk while he painted, entertaining groups of admirers with tall tales like the time he fought in the Russian Revolution alongside of Lenin, or the time he ate female flesh wrapped in a tortilla-"It's like the tenderest young pig," he said.2

Although she needed complete privacy when working, Kahlo could be gregarious as well, and she too was capable of telling different stories about the same event on different occasions. She said of her first meeting with Rivera, for example (and this story is probably true), that they met at the photographer Tina Modotti's house: "Once at a party, given by Tina, Diego shot a phonograph, and I began to be very interested in him in spite of the fear I had of

him."3 Another time she said they had met when in 1928 she took her first painting to show to Rivera who was then at work on his Ministry of Education murals in Mexico City. After demanding that he come down from his scaffold, she asked him whether it was worth her while to go on painting. Rivera, whose own version of the story agrees with this version of Kahlo's, told her she definitely had talent. In his autobiography he described the young Frida as a spunky girl whose paintings "revealed an unusual energy of expression, precise delineation of character, and true severity."4 Both Kahlo and Rivera recalled that their first informal encounter occured in the early 1920's when she was a student at Mexico City's National Preparatory School. the place where the Mexican mural renaissance was born and where Rivera, recently returned from a long sojourn in Europe, painted his first mural. Kahlo not only made Rivera the target of her mischief, she also liked to watch him paint. School friends recall her infatuation with the frog-like Rivera who came to work wearing a Stetson hat and a cartridge belt. To their horror, she told them that her ambition in life was to have his child. Her fascination with the muralist was cut short when in September 1925 the bus she was riding home from school was hit by a trolley. She almost died from her injuries. While convalescing at home she began to paint. From this time on, the need to confront, communicate, and exorcise pain became a motivating force in her art.

Kahlo's and Rivera's work could not be more different. Working for the post-revolutionary government which hired artists to create murals that would edify the people and give them a pride in their Mexican heritage, he painted monumental murals embracing broad historical and political subjects on vast public walls. By contrast, the majority of Kahlo's paintings are small, extraordinarily personal selfportraits. Although her focus was narrow, she probed deep, and her self-portraits capture universal feelings so vividly that they pull out all our empathy and reveal us to ourselves. Rivera's work, on the other hand, takes in the panorama of Mexico past and present. Its great scope does not make it shallow, but its force and meaning are cumulative. The viewer must look first at one part and then at another to gather a picture of Rivera's intent, whereas Kahlo's impact is immediate, direct, and as centered as an icon.

For many viewers, Rivera's broader, more objective subject matter has, over time, lost much of its relevance. Yet the poetry and human concern that underlie his political message and his formal brilliance remain fresh. Kahlo's message is so clear that most people faced with one of her self-portraits feel that she speaks directly to

them. The spouses' creative motivation and processes were different as well. Rivera was the complete professional. He started painting young and had years of academic training both in Mexico and in Europe. He was convinced that making art was his destiny; he put in Herculean hours and it was obvious to everybody that painting was the center of his life. The center of Kahlo's life was Rivera. She taught herself to paint because, she said, she was "bored as hell in bed," and that the accident prevented her from pursuing her studies toward a medical career. She painted when she felt like it, sometimes working hard, other times hardly at all.

Their approaches to work follow male and female stereotypes that prevailed in Mexico (and elsewhere) at that time. Rivera liked to think of himself as both a disciplined worker (a painter, he said, is a worker among workers) and a demiurge; Kahlo preferred the role of the charming amateur who produced little paintings that were both folkloric and eccentric and that fulfilled private needs. Rivera's ambition was as monumental as his art. Kahlo hid her ambition behind a playful facade. Being married to a famous artist not only gave her access to the art world, it also provided a protective buffer that allowed her, for many years, to avoid the risks and bruises of building a career. Both husband and wife believed their need to paint was a spontaneous urge with a biological basis. Rivera said that for him painting was as natural as a tree putting out flowers and fruit. Kahlo, somewhat disingenuously, said, "The only think I know is that I paint because I need to, and I paint always whatever passes through my head, without any other consideration."5 She described her drive to paint as a form of compensation: "Painting completed my life. I lost three children. . . . Painting substituted for all of this. I believe that work is the best thing."6 Rivera's purpose was to move the world toward a Marxist state. He said, for example, that he wished his mural cycle at the Ministry of Education (1923-8) "to reproduce the pure basic images of my land. I wanted my painting to reflect the social life of Mexico as I saw it, and through my vision of the truth to show the masses the outline of the future."7

Kahlo's and Rivera's reverence for each other's art was a powerful bond. He encouraged (even cajoled) her to keep on painting in spite of the misery of the numerous surgical operations that never healed the damage the accident caused to her back and her right leg. Rivera loved her shockingly self-revealing subject matter, her courage to paint, for example, her own birth or herself in 1932 having the one of the several miscarriages that made her realize that she

would never fulfill her wish to bear Rivera's child. When she was depressed after this miscarriage, it was he who suggested that she paint the important moments of her life on small sheets of tin like the Mexican retablo or ex-voto painters who depict people being saved from accidents or other disasters by a holy intercessor. He also pushed her to show and sell her work. Rivera's support of her art was absolutely essential to Kahlo's continuing artistic endeavor. In a 1943 essay on his wife's relationship to Mexican art, he wrote: "In the panorama of Mexican painting of the last twenty years, the work of Frida Kahlo shines like a diamond in the midst of many inferior jewels; clear and hard, with precisely defined facets. . . . Frida's art is individual-collective. Her realism is so monumental that everything has "n" dimensions. Consequently, she paints at the same time the exterior and interior of herself and the world."8 Rivera often told friends that Kahlo was a better painter than he was-no doubt his praise was lavish because her painting and the scale of her ambition was so distinct from, and so much smaller than, his own.

In turn, Kahlo thought Rivera was the greatest painter in the world; she called him the "architect of life."⁹ Next to his, her own art seemed insignificant; perhaps in part because she did not want to compete with Rivera, she frequently spoke of her work in diminishing terms, as if it were an amusing pastime. She acted surprised when people took an interest in it, and purchases astonished her. "For that price they could buy something better," she would say, or "it must be because he's in love with me."¹⁰ Sometimes she would turn her serious engagement with painting into a joke, for example when she told the writer of a *Detroit News* article entitled "Wife of the Master Mural Painter Gleefully Dabbles in Works of Art," that Rivera "does pretty well for a little boy, but it is I who am the big artist."¹¹

When it came to his art, or himself, Kahlo passionately defended her husband against all detractors. She was the critic he respected the most, and even if he grumbled at her occasional negative comments, he was apt to make the changes she suggested. For all the extreme contrast between her painting and his, there are many similarities, especially in subject matter. Since he was the older and more experienced artist, the exchanges of influence usually ran from him to Kahlo. Both of them expressed in their work a powerful allegiance to Mexico. Rivera painted the saga of Mexican history, for example in his National Palace murals (1929-35 and 1945) from a Marxist point of view and with an abundance of well-researched detail. By contrast, in works like *My Nurse and I* (1937), in which she imbibes her

nourishment from the breast of an Indian wet nurse wearing a Teotihuacán mask, Kahlo made clear her Mexican origins. When she became involved with Rivera Kahlo's art changed dramatically. In her self-portraits she now presented herself wearing Mexican jewelry, hairstyles and costumes, all of which met with Rivera's approval, for, like many artists in post-revolutionary Mexico, he wanted to reaffirm Mexico's indigenous culture. As he put it, "The classic Mexican dress has been created by people for people. The Mexican women who do not wear it do not belong to the people, but are mentally and emotionally dependent on a foreign class to which they wish to belong, i.e., the great American and French bureaucracy."12 Kahlo also followed her husband's example in painting Indian women and children, as opposed to her earlier portraits of her white middle-class friends. In paintings like The Bus (1929), where she juxtaposes a blueeved gringo holding a moneybag (a motif taken from Rivera's 1928 Night of the Rich panel in his Ministry of Education mural) with a Madonna-like, barefoot Indian woman holding a baby wrapped in her shawl, she reveals that she shared Rivera's leftist political sympathies.

In fact, Kahlo had joined the Communist Youth organization before she married Rivera, but her association with him intensified her political engagement. Until he was expelled in 1929, Rivera was a prominent (but anarchic and controversial) member of the Mexican Communist Party, and even after his expulsion he continued to play a political role in Mexico. Although few of Kahlo's paintings addressed political subjects until a year or so before her death in 1954, her intertwined Mexicanism and leftism prompted her paintings' use of popular and prehispanic art sources as well as her choice to decorate her home and herself with popular and pre-Columbian art objects. Rivera, too, admired and learned from Mexican popular and pre-Columbian art, and the couple's Mexicanism was shared by a whole generation of artists and intellectuals who revalued the native Mexican culture that had been despised under the dictatorship of Porfirio Díaz (toppled by the Mexican Revolution of 1910-20). Rivera had a large collection of prehispanic sculpture, and together with Kahlo he gathered hundreds of ex-votos which he admired so much that he called his first mural "nothing but a big retablo."

But his approach to Mexican popular and pre-Columbian art was more intellectual and more esthetic than his wife's. Although he, like Kahlo and with equal sophistication, sometimes adopted a mockprimitive or popular style inspired by ex-votos, nineteenth-century folk portraiture and still lifes, and by Mexican religious imagery, he

did not integrate this primitivism with his painting's emotional content with the same urgency and authenticity as she did. Most often he used popular and pre-Columbian artifacts as props in the unfolding drama of history painted in a realistic manner. Kahlo, on the other hand, frequently borrowed her format, her style, and even her voice from popular art. She did this in part to endow her art with a naive charm. Her paintings' quaintness, for example, their folkloric frames and their use of popular art devices like inscribed ribbon scrolls, is, like her choice to wear Mexican costumes, a kind of pose, a way of throwing up a screen of *alegría* (joy) and pretending to be playful and light when in fact she was talking about serious issues like pain, love, and death. Her popular art style also demonstrated her alliance with *la raza* (the people), and, most important, it distanced the impact of her horrific subject matter.

Kahlo and Rivera both learned a great deal from the Mexican printmaker José Guadalupe Posada (1851-1913), whom Rivera claimed as his first teacher. Although Rivera's sense of dramatic narrative had much more to do with Giotto's murals than with Posada's broadsides, his work does contain something of Posada's humor and his talent for presenting historical and topical events in a dramatic, easily read format. Likewise Kahlo had a Posadaesque black humor that expressed itself in paintings like A Few Small Nips (1935). a painted broadside modeled on Posada's etchings of news events like violent crimes. This murder scene illustrates a newspaper story about a man who, having killed his girlfriend, said to the judge, "I only gave her a few small nips." Kahlo said she needed to paint it because she herself felt "murdered by life."13 It was one of only two paintings that she produced in the year after she discovered that Rivera was having a love affair with her favorite sister. For her Self-Portrait with Cropped Hair (1940) Kahlo used Posada's song illustration format and placed the words of a popular song above an image of herself wearing men's clothes, surrounded by the hair she cut off in anger when Rivera divorced her in 1939. (The couple remarried a year later.) Rivera used the song illustration format for more political purposes on the third floor of the Education Ministry where the words of a revolutionary ballad are written beneath scenes such as Insurrection, in which Kahlo and Modotti hand out arms to revolutionaries.

Similar sources in modern European art inspired Kahlo and Rivera as well. Both were affected by Surrealism, and both were influenced by Gauguin and Douanier Rousseau's primitivism. These sources they combined with the naive style and fantastical imagery

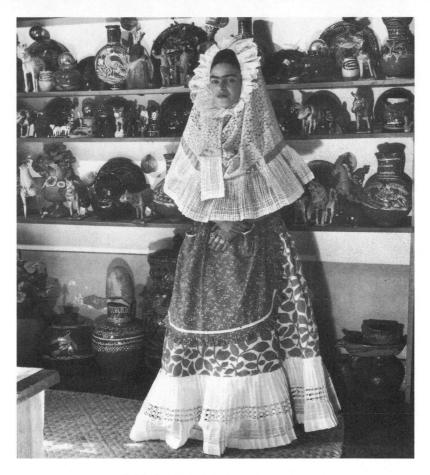

Frida Kahlo in Mexican dress, 1942

they admired in Mexican popular art. The irony is that although Kahlo's and Rivera's folkloric mode was intended to make their art "of the people" and not a commodity for the rich, it actually appealed to sophisticated taste, and their work sold well to foreign buyers.

On the whole Kahlo eschewed direct political content and painted for a small audience composed mainly of friends. But she did give her work a political inflection in paintings like *My Dress Hangs There* (1933), in which she countered Rivera's contemporaneous mural *Man at the Crossroads*, painted above the main elevator bank at Rockefeller Center, New York, with her own political manifesto. Here she collaged newspaper photographs of breadlines and protests and linked Trinity Church, whose mullions are shaped like a dollar sign, with Federal Hall, whose steps are made of a collaged graph that

says "Weekly sales in millions." But the painting's value as propaganda is diminished by her spoof of American values seen in the setting of a golf trophy and a toilet on pedestals. *My Dress Hangs There* is also too personal to carry much political clout. Appalled by the lavish cocktail parties given by the rich while the poor stood in breadlines, Kahlo showed her disdain for Capitalist society by painting her Tehuana dress hanging above Manhattan without herself in it. She wanted to go home to Mexico. Rivera's *Man at the Crossroads* opposed an idealized view of Russian Communism with a negative view of Capitalist New York where police brutally suppress a protest while rich people drink champagne. But Rivera put an urban worker who looks like a pilot at the controls of history; he wanted to stay in an industrialized country where he thought Marxism would triumph.

In the last two years of her life, 1953–4, when her health was deteriorating quickly, Communism became a kind of religion to Kahlo. Part of her vehemence must have come from her desire to help Rivera gain readmittance to the Communist Party. Kahlo's diary, written in her final decade, is full of professions of Marxist faith, and several of her last paintings show her struggle to find a way to make her art serve the revolution. The problem was that her paintings remained too self-referential to function as political rhetoric, whereas Rivera's murals could give post-revolutionary Mexico a leftist view of the possibilities for social progress.

Kahlo's and Rivera's approaches to other subjects almost always differ along the same lines. Again following cultural stereotypes about differences between men and women, she was more personal and saw the world in relation to herself, specifically in relation to her body. He took in the world with his erudite and deeply curious mind, transforming what he saw according to his elaborate political mindset. Kahlo expressed her feelings in terms of things done to her body. Her flesh is punctured with nails, thorns, and arrows, or it is torn open to extract her bleeding heart. She is always immobile, and her face is a mask of heroic impassivity. When Rivera depicts himself in murals and self-portraits, it is his own visual capacity, his huge, allpowerful eyes that dominate. Kahlo recognized his stress on seeing and knowing by painting her husband with an extra eye, the eye of superior vision, in his forehead. The only other characters to be blessed with this "eye of supervisibility" are Moses, Buddha, and the sun. Rivera's eyes swept over reality and collected a multiplicity of details to build his vast word view. As Kahlo put it: "His bulging, dark, highly intelligent and large eyes are held in place with

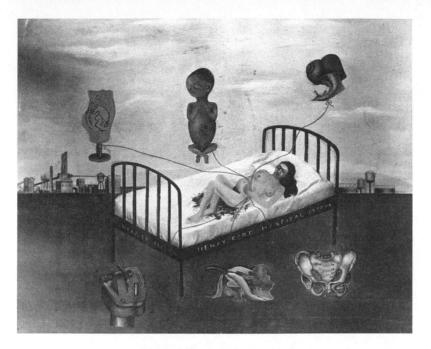

Frida Kahlo, Henry Ford Hospital, 1932

difficulty—almost coming out of their orbits—by eyelids that are swolen and protruberant, like those of a frog. They are very much more separate from each other than other eyes. They enable his vision to embrace a much wider visual field, as if they were constructed especially for a painter of spaces and multitudes. Between those eyes, so distant one from the other, one divines the invisible eye of Oriental wisdom."

One subject that both Kahlo and Rivera painted with a Mexican lack of squeamishness was birth. When, partly to allieviate her misery after her miscarriage, Kahlo set out to depict the important events in her life in 1932, she painted first her miscarriage, showing herself in *Henry Ford Hospital* lying naked and hemorrhaging in a hospital bed with the "little Dieguito" she had failed to bring to term floating in the sky along with other symbols of miscarriage. Then, some months later, in *My Birth* she painted, as she put it, "how I imagined I was born," which shows her mother naked from the waist down with an apparently dead child emerging from between her spread legs.¹⁴ To paint such an image in the 1930's took extraordinary courage and originality: there is no precedent for such a frank image of birth in the history of Western art. The mother, who, like the baby, is dead,

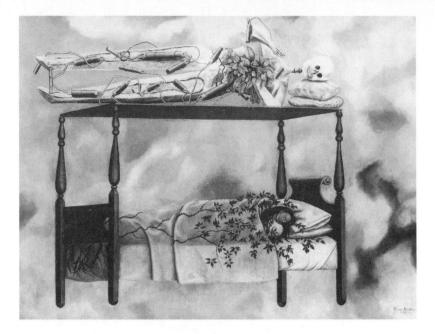

Frida Kahlo, The Dream, 1940

represents both Kahlo having the miscarriage and Kahlo's mother giving birth. As Kahlo explained, her mother's head is covered because while Kahlo was at work on this painting her mother died. On the wall above the bed is an image of the Virgin of Sorrows, not an auspicious overseer for the entrance into life. Kahlo called this votive painting a "memory image."¹⁵ It is the kind of icon that her devoutly Catholic mother would have hung on her wall, and it is possible that the icon-like quality of Kahlo's self-portraits stems from votive paintings remembered from childhood.

My Birth is tiny and painted in a primitivist style on a small sheetmetal panel like those used to make *retablos*. Like ex-votos, too, *My Birth* has a scroll along its bottom edge. In ex-votos, these scrolls are filled with information about the disaster and words of thanks to the Virgin, Jesus, or a saint for salvation. Kahlo did not fill in her scroll. The Virgin is present, but in this scene of double death she brings about no miracles.

Rivera's approach to birth is understandably less autobiographical. In his allegory of the agrarian revolution at the National Agricultural School at Chapingo (1926–7) he included a nude woman crouched in the womb of the earth to show the germination of social change. In his Detroit Institute of Arts mural sequence on the theme

of Detroit industry (1932), he decided to paint a fetus inside a womb buried in the earth to symbolize Detroit's rich natural resources after Kahlo's miscarriage. Both of these womb images ostensibly have more to do with his historical perspective than with his love or concern for any particular woman or child. Yet, because they are connected with a woman close to him, they do have a particular poignancy.

Later at his Hospital de la Raza mural (1952–4) illustrating the history of medicine, Rivera painted birth in prehispanic and modern times in terms that are almost as shockingly literal as Kahlo's in *My Birth*, except that her image is harder to take because she showed birth as bloody, seen from the doctor's vantage point, and involving a specific woman's personal plight rather than a generic female standing for the creative forces of nature and history. Finally, in his Lerma waterworks murals (1951), Rivera used the womb image to symbolize the source of water in a fantastical vision of the importance of water to evolution.

Both Kahlo and Rivera shared their country's preoccupation with death; among other subjects that they treated from divergent points of view are skeletons and the idea of death. But, like everything else she painted, Kahlo saw mortality as something that affected her personally. She painted herself dead in *What the Water Gave Me* (1938), and when she portrayed a dead person as in *A Few Small Nips*, *The Deceased Dimas* (1937), and *Suicide of Dorothy Hale* (1939), she projected her own agonies onto another person's demise. By contrast, when Rivera painted a worker's or a revolutionary's death in his murals at the Education Ministry and at Chapingo, he saw death as a step in social change.

In 1937, when she painted herself as a child sitting near a skeleton and in 1938 when she portrayed herself as a little girl wearing a skull mask, Kahlo expressed her sense of life's fragility, a sense that must have begun with her witnessing death as a child growing up in the revolutionary decade and that must have been exacerbated by her brushes with death at about 7, when she had polio, and again at 18 when she was nearly killed in the bus accident. Thereafter, as one friend put it, "she lived dying."¹⁶ She had something like thirty-five operations. "I hold the record for operations," she announced.¹⁷ The skeleton that lies on her bed's canopy in her sleeping self-portrait called *The Dream* (1940) was modeled on one of Kahlo's many papier mâché Judas figures (made to be exploded on the Saturday before Easter). This skeleton actually did recline on her four-poster and

Rivera called it her lover. Another skeleton, this time a clay one, puts his arm around her in *The Wounded Table* from the same year. The skeleton replaces Rivera as Kahlo's companion, for both images have to do with her suicidal feelings during the year Rivera divorced her before remarrying her on his birthday, December 8, 1940. Three years later in *Thinking of Death* she felt moribund again because of poor health and because she discovered that her second marriage with Rivera had all the problems of the first. As his doctor observed, Rivera was unfit for fidelity. Kahlo confronts the skull placed in a medallion on her forehead with all her habitual forbearance.

Rivera painted himself accompanied by skeletons as well, but his approach was more festive and folkloric: his skeletons come from an appreciation of Mexican popular culture. In *The Day of the Dead in the City*, a section of his Ministry of Education mural cycle, he and his second wife Lupe Marin appear beneath a dancing skeleton. In his Hotel del Prado mural entitled *Dream of a Sunday Afternoon at the Alameda Park* (1947–8), he holds hands with an ostentatiously dressed female Calavera (skeleton) taken from the skeleton prints that ridicule human foibles by Posada, who is the man with the bowler hat to the skeleton's left.

Both husband and wife painted the life/death cycle, and both were aware of the importance of this dichotomy in pre-Columbian thought. In his Detroit murals Rivera symbolized the opposition with a succinct juxtaposition of a skull and a living head, rather like the pre-Columbian heads that are half skull and half living flesh. In her portrait of *Luther Burbank* (1931—a subject Kahlo no doubt took on because Rivera had just put the Californian horticulturalist into his mural allegory of California at the San Francisco Stock Exchange Luncheon Club), Kahlo painted the cycle of life in a more fanciful way, showing the inventor of hybrid fruits as part man, part tree and with his roots fed by his own skeleton.

Hybrids of plant and human life appear frequently in both Kahlo's and Rivera's art. The couple saw all aspects of the universe as interconnected and governed (as in pre-Columbian philosophy) by a series of dualities—life/death, night/day, sun/moon, male/female. Apart from her portrait of Burbank, Kahlo's hybrids refer to her own body—its sexuality, its inability to bear children, and its physical suffering. Her self-portrait *Roots* (1943), for example, is a childless woman's dream that her torso opens up to give birth to a vine that pours its life blood into the parched Mexican earth. Her *Flower of Life* (1944), probably a love note to Rivera, is a lily composed of male and

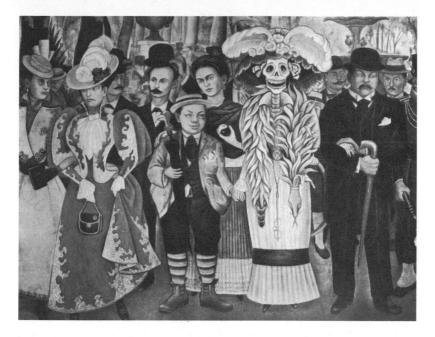

Diego Rivera, detail from his mural Dream of a Sunday Afternoon in the Central Alameda, 1947–8, Hotel del Prado, Mexico City: Rivera, Kahlo, skeleton, and José Guadalupe Posada

female sexual organs, and in *Sun and Life* (1945), plants enfold genitalia and a crying fetus, while the sun, with Riveraesque features plus a third eye, weeps in sympathy with Kahlo's sorrows.

Although some of Rivera's hybrids are no less sexual, they carry a more objective message. His tree-woman at Chapingo (actually a portrait of his current mistress Tina Modotti) forms part of the revolutionary saga he couched in agricultural terms. His 1945 canvas *After the War* shows new life sprouting from a nearly dead anthropomorphic tree. (Similarly, Kahlo placed fresh sprouts on aged tree trunks in her 1945 *Moses.*) Rivera's wonderfully bizarre tree/ person in his Hospital de la Raza mural sports multiple and multicolored breasts and a penis that is sufficiently substantial to support a swing upon which sits an Aztec stone sculpture of birth.

Both Kahlo and Rivera included depictions of prehispanic art in their paintings. Rivera was interested in archeological exactitude and in showing Mexico before Cortés as a highly civilized culture. In works like *Four Inhabitants of Mexico* (1938), Kahlo offered her own whimsical vision of Mexican history, but her real subject was her feeling of separation and loneliness that underlies many of her selfportraits. In a desolate, de Chiricoesque city square she placed four

Mexican artifacts that she and Rivera owned. The plaza is empty, she said, "because too much revolution has left Mexico empty."¹⁸ The inhabitants that populate Mexico are fragile objects, not living beings, and they belong to a culture that is passing, not to the modern era. The *Four Inhabitants of Mexico* includes a pre-Columbian clay figure of a pregnant woman. No doubt the Nayarit fertility image, like the skeleton, represents a possibility in the child Frida's future.

When Rivera depicted or alluded to pre-Columbian sculpture, as in the goddess figure in the section devoted to Mexico's geographic regions on the Education Ministry's stairway, or in his Detroit mural where the stamping press at the Ford Motor Company is made to resemble the goddess Coatlicue, his purpose was always sociological or historical.

A central subject that both Kahlo and Rivera addressed was each other. When she painted him she depicted him as her husband and the man she loved. With the exceptions of one bust-length portrait and a 1931 lithograph showing his nude young wife putting on her stockings, Rivera always depicted Kahlo as a political or a symbolic figure. Early on in their relationship, each recorded their attachment to the other. In his 1928 Insurrection Rivera painted Kahlo as an eager political activist dressed in a red work shirt emblazoned with a redder star. In her Frida and Diego Rivera (1931), Kahlo produced a wedding portrait a year and a half after she married. Rivera holds his palette and brushes while she holds his hand. She always put his art and its demands before her own-as one friend noted, otherwise life with Rivera would have been impossible. Her head is cocked toward him; she pictures herself as his devoted wife, but there is a feisty gleam in her eye, as if she knows she is playing a role, and the real Frida is the devil her father described. In her self-portraits Kahlo always painted herself as both the model scrutinized by her own gaze and as the painter doing the scrutinizing. Part of her self-portraits' ferocious strength comes from her unwillingness to be the passive model, her need to give life and iconic permanence to the seer, to the woman inventing herself by creating her own image.

In her marriage portrait, the danger signs are already there: Rivera stands solidly on his two feet—on a separate and firmer ground than Kahlo who seems to float like a doll. And he turns away from her. Years later she was to say: "Being the wife of Diego is the most marvelous thing in the world.... I let him play matrimony with other women. Diego is not anybody's husband and never will be, but he is a great comrade."¹⁹ Kahlo was not the stereotypical long-

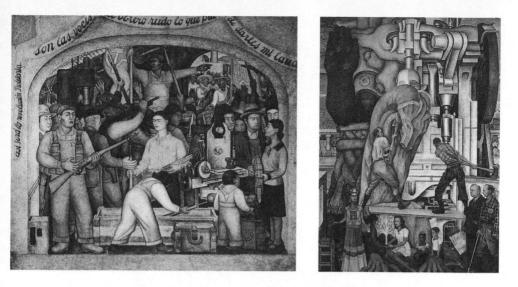

Diego Rivera, Insurrection, 1928, mural panel from Education Ministry, Mexico City: Kahlo distributing arms; Pan-American Unity (detail), 1940, San Francisco: Kahlo, Rivera, and Paulette Goddard

suffering, passive Mexican woman. Early in her marriage she began to have affairs of her own. Those with women Rivera could tolerate, but her attachment to other men infuriated him, even prompting him to pursue one interloper with a pistol. "I don't want to share my toothbrush with anybody," he said.²⁰

In his 1940 Pan-American Unity mural produced in public at San Francisco's Golden Gate International Exposition, Rivera commemorated his reunion with Kahlo after a year of being divorced by painting her in the Tehuana costume that she had shed in her Self-Portrait with Cropped Hair, a painting that expresses her rage and sorrow during divorce. As a mark of his respect for her as an artist, Rivera depicts her holding a palette. But she stands stiff as a statue on a pedestal. She is, he said, the "Mexican artist with [a] sophisticated European background who has turned to native plastic tradition for inspiration; she personifies the cultural union of the Americas for the South." Rivera turned his back on this personification. Just behind Kahlo in his mural he sits holding hands around the tree of love and life with the film star Paulette Goddard who may have been one of the causes of his divorce. Asked why, the always incorrigible Rivera said "it means closer Pan-Americanism."²¹

Kahlo agreed to remarry Rivera on the grounds that they would refrain from sexual intercourse and that each would pay half of the

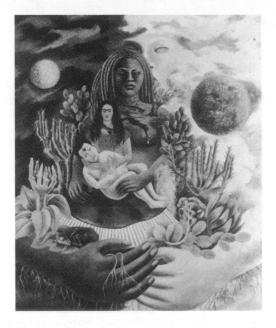

Frida Kahlo, The Love Embrace of the Universe, the Earth (México), Diego, Me and Señor Xolotl, 1949

household expenses. She accepted the fact that their marriage would not be monogamous and that she would have to live a rather independent life. Though she said she did not think it hurt the banks of a river to let the water run, her self-portraits bear witness to her suffering over Rivera's continuing infidelities. In *Self-Portrait as a Tehuana* she puts a miniature portrait of Rivera in her forehead to reveal her thoughts. Whereas in other paintings she put a third eye with which to look out at the world in the middle of Rivera's forehead, in her own brow she placed his image as if he was all that she could see. Trapped as in a spider's web, Rivera is the object of her obsessive love.

In the painted chronicle of her marriage, *The Love Embrace of the Universe, the Earth (México), Diego, Me and Señor Xolotl* (1949) reveals that there was, in the end, some resolution. The best way to keep Rivera, she found, was to play a maternal role. In her diary she wrote, "At every moment he is my child, my child born every moment, diary, from myself."²² *The Love Embrace* shows Kahlo holding a naked baby Rivera in her lap, and the couple's union is sustained by a series of evermore dematerialized love embraces. That this solution did not eradicate pain is indicated by her tears and by the bloody gash in Kahlo's chest.

During the quarter century that they were married, the light grip that Kahlo had on Rivera in her 1931 wedding portrait grew into a deeper, more complex interdependence, a relationship that was kept alive by filled and unfulfilled demands and needs. They appear to have needed each other in order to maintain their separateness; mutual dependence allowed for the autonomy that was necessary for their art. In her diary Kahlo wrote of the multifarious ways in which she was bound to Rivera and yet felt his distance:

Diego. beginning Diego. constructor Diego. my baby Diego. my boyfriend Diego. painter Diego. my lover Diego. "my husband" Diego. my friend Diego. my friend Diego. me Diego. me Diego, universe Diversity in unity Why do I call him My Diego? He never was nor ever will be mine. He belongs to himself.

There was no question in either of their minds, or in the minds of their close friends, that they were the most important people in each other's lives. Friends recall that when Kahlo died on July 13, 1954, Rivera was like a "soul cut in two," and that "he became an old man in a few hours, pale and ugly."²³ In his autobiography Rivera wrote that the day Kahlo died "was the most tragic day of my life. I had lost my beloved Frida, forever. . . . Too late now, I realized that the most wonderful part of my life had been my love for Frida." The spectacle of their love lives on in their art and in the memories of friends like art historian Luís Cardoza y Aragón who said, "Diego and Frida were part of the spiritual landscape of Mexico, like Popocatepetl and Iztaccihuatl in the valley of Anahuac."²⁴ Whether they are described as an elephant and a dove or as Mexico's most famous volcanos, Kahlo and Rivera are legendary creatures whose art colors and is colored by their myths.

Yves Tanguy and Kay Sage, Connecticut, 1954

SEPARATE STUDIOS Kay Sage & Yves Tanguy

JUDITH D. SUTHER

KAY SAGE and Yves Tanguy would have greeted the following pages with a great show of irritation. Both painters tirelessly resisted inquiry, whether directed at their work or their lives. Sage's style of resistance was tight-lipped and aloof, much like her public persona-indeed, akin to the tight lines and severe control of her mature paintings. A brief exchange of letters in 1955 between her and Hermon More, then Director of the Whitney Museum of American Art, reveals her typical defiance. More had written to acknowledge the museum's purchase of Sage's painting No Passing (1954), and had asked her for a statement of her "philosophy of art." She replied: "Have never made any statements except to say that were I able to give any explanations, I would probably not paint. Have no other comment to make."1 Tanguy's style of resistance was no more expansive than Sage's, despite the occasional unelaborated remark. He told James Johnson Sweeney in 1946, for example, that his move to the United States may have translated into "greater space-more 'room'" (in his paintings).² Tanguy's customary response to critical inquiry took one of two forms. The first was to stonewall. He routinely refused to comment on his work, on the grounds that to do so would lock him into whatever he might say, and thus shackle his imagination. The second was to throw questioners off the trail with false leads, such as the Irish grandmother he invented to reinforce his Celtic credentials.³

Although most artists develop strategies for deflecting analysis, Sage and Tanguy's resistance seems almost pathological. Not surprisingly, both also remained profoundly ambivalent toward the narratives, critical and biographical, constructed for them by others. Sage would certainly not have cooperated with efforts to "place" her in the spectrum of modernist painting or in the collective narrative of women artists' life experiences. She regarded herself as a loner, did not identify with women, and, despite four years of academic training in art, kept the entry "studied with no one" on her résumé. More

outgoing than Sage, and more of a joiner—he "converted" to Surrealism in 1925—Tanguy would none the less have made himself an equally elusive subject. Blatantly anti-intellectual, he ridiculed Patrick Waldberg, his friend and future biographer, for "succumbing to university cretinism" when Waldberg registered for a graduate degree program at the Sorbonne.

In their resistance to being "sorted out," Sage and Tanguy may have maintained the very sense of freedom essential to creativity. The story of their lives as artists and of critical response to their work, however, traces a less autonomous pattern, one shaped by issues of gender. As might be expected, the impact of outright gender bias fell more heavily on Sage. She was dogged by the "wife of" tag that functioned—can still function—as a disenfranchising diminutive when applied to a woman who, along with her husband, "also paints," "also writes," "also" does whatever he does. Even when left unstated, the implication is that she does it less well. Like other women of her generation, Sage was trivialized in this way not only by the community of artists she considered to be her natural peers, but by reviewers who, on esthetic counts, regularly praised her work. Not until the 1970's, with the upsurge of critical interest in art by women-a focus in which a certain distortion is also inherent-did Sage's painting begin to be viewed on its own merits.

Tanguy, of course, was not susceptible to the same brand of sexism. In fact, he turned it to his advantage by declining to endorse Sage's work and accepting her unqualified admiration of his. What he did not escape was a different kind of role-bound tyranny. His lot in the sad history of gender roles was to be relegated to a low rung in the hierarchy of Great Men. He had no gift for the "rational" discourse prized by the European critical establishment, and no love of theory. He was not a catalyst whose vision or technique altered the subsequent course of artistic expression (as Picasso was and, to widespread consternation, Warhol may be). By these absurd standards, Tanguy's work has more often been seen as repetitive than innovative. Yet it was himself he was repeating in his fantastic renderings, especially in the drawings and gouaches, the so-called minor genres in which he excelled and which account for over two thirds of his surviving work.

The beginning of Sage and Tanguy's life as artists together gives scarcely more than a hint of the mixed professional fortunes in store for them. When they met in Paris shortly before the Second World War, both were ripe for change. Sage had recently arrived from Italy,

where she had spent much of her childhood (she was born in 1898), undergone the conservative academic instruction in drawing and painting available in Roman academies in the 1920's, and left an unsatisfying marriage to a member of the minor Italian nobility. An inheritance from her father, Henry Manning Sage of Albany, New York, had assured her financial independence. Tanguy, of Breton heritage but born (1900) and reared in Paris, had lived in the city all his life except for childhood summers in Brittany and two years in the merchant marine shortly after the First World War. With no formal training in art, he had been drawing and painting since his teens. For about five years in the mid-1920's he had been largely supported by his friend Marcel Duhamel, an editor and translator at Gallimard publishers, and later had held short-term jobs such as streetcar conductor and newspaper vendor. Like Sage, he had exhausted the promise of an early marriage. When the two met, probably around the time of the annual Salon des Surindépendants exhibition in the fall of 1938, they were both seeking a way to establish themselves as artists and stabilize their personal lives.

What each sought, the other seemed to provide. For Sage, who would make the point in her autobiography that she "liked men very very much," Tanguy was the ideal male artist to ally herself with. According to her sister-in-law, he was "very Breton, very male, very attractive"; perhaps equally important, he was already secure in the Surrealist affiliation to which she herself aspired. As an artist marked by the upheaval of modernism, Tanguy was at least twelve years ahead of Sage. It was this head start, as much as any actual reputation outside his own circle, that lent him the distinction he enjoyed in her estimation. He had shown some drawings at the ephemeral Salon de l'Araignée in 1925 and had had his first solo show of oils in 1927 at André Breton's Galerie Surréaliste. By the time he met Sage, he had long been an insider in Breton's group. Without selling reliably or otherwise supporting himself with his painting, he had continued to exhibit with the Surrealists and had had solo shows with Julien Levy in New York (1936) and Peggy Guggenheim in London (1938). To Sage, if not to the art world at large, Tanguy at 38 was already an artist of stature. The power emanating from this image probably increased his attractiveness to her, for she had come to Paris in search of artistic as well as personal fulfillment.

Sage's appeal to Tanguy, however genuine, appears to have been enhanced by his knack for finding caretakers and also by timing weary of the hand-to-mouth existence he still led in his late 30's, he

needed money. The speed with which their alliance took place leaves little doubt that she offered him financial stability, along with fierce loyalty and admiration. Although she always maintained a public facade of "correctness" acquired from her upper-middle-class background, and he preferred tall tales to accurate accounts of his circumstances, their status as a couple quickly became known; her rooftop apartment on the quai d'Orléans became his headquarters soon after the two met. A social acquaintance who knew both of them in Paris before the war remembers that they showed up together at parties and that Sage "was simply infatuated with Tanguy ... who was always laughing and laughing." Another acquaintance remembers that "these Surrealists, Tanguy, Matta, and everyone included, were penniless. Most exciting, admirably excitable but all of them BROKE, and Kay Sage had the advantage of having some money and a natural generosity. . . . For the Surrealists, she was a matter of convenience." It seems likely that the danger of war and the uncertainty of everyone's future in France also played a part in Tanguy's choice of a companion.

Initially through her liaison with Tanguy and then, rapidly, in her painting, Sage laid claim to the Surrealist identity. In the euphoria of her new life in Paris, she seems to have been oblivious to the absence of fully enfranchised women artists within the Surrealist intimacy. As Whitney Chadwick and Susan Rubin Suleiman, among others, have amply shown, Surrealism may have exalted Woman, but in doing so, effectively denied the experience of real women, particularly those who saw themselves as artists.⁴ By the late 1930's the young and alluring femme-enfant, the idealized version of the male Surrealists' muse, had achieved icon status; compounded of Gradiva-Nadja-Melusine, she made no provision for the heterosexual female artistor for the homosexual male artist, for that matter. Leonora Carrington, a perfect embodiment of the femme-enfant when she came to Paris with Max Ernst in 1937, eventually recognized the effect of being gazed at and reified. "I was never a Surrealist," she told Chadwick, "I was with Max." Sage, however, who was not a 20-yearold woman-child when she encountered the Surrealists, apparently did not register their attitudes then or afterward. In the immediate prewar years and for the rest of her life, she was "with Yves." For her that seems to have signified being "with the Surrealists" in spirit.

In the brief time of her association with the group in Paris, an association always linked with Tanguy, Sage immediately became a figure of controversy between him and Breton. According to

Waldberg, "From the beginning [Breton] detested Kay Sage and never missed an opportunity to denigrate her to Yves." There appear to have been several reasons for Breton's dislike of her. She was an American with money and thus automatically subject to his scorn. She was a middle-aged woman who took her painting seriously, worked hard at it, and certainly did not fit the male Surrealist construct of the passive, inspiring muse. Sage's most serious infraction of Surrealist protocol, however, was surely her appropriation of Tanguy. No doubt she viewed her personal life as beyond Breton's jurisdiction, but such a view underestimated his sense of himself as Surrealist paterfamilias and parliamentarian. Tanguy's status as one of the original "children" of Breton's "family" can only have exacerbated relations in this strange triangle. Matthew Josephson remembers that in the 1920's, Tanguy began calling Breton "Papa," a slightly mocking endearment well suited to the older man's self-image and the vounger one's eternal child persona.5

In the summer of 1939, with a German invasion of France seemingly inevitable. Sage and Tanguy decided to take refuge in America. On Tanguy's part especially, this was a watershed decision. Other members of the old Surrealist group in France, of course, also chose exile in the face of deteriorating political stability in Europe; few, however, anticipated expatriation beyond the war years. Tanguy, on the other hand, was leaving France to take up permanent residence in a country he regarded with ambivalence. To French artists of his persuasion in the 1930's, America was not the promised land. It was a crass, materialistic technocracy whose chief characteristic was the absence of cafés. Worse, Americans could not speak French or, if they did, they mispronounced it. They had money-this much was evident from the art-buying habits of dealers and curators who traveled across the Atlantic to furnish their galleries and museums-but they were not up to the French in taste and artistic sensitivity. (An energetic challenger of these stereotyped views was Duhamel, who had discovered American novels before they were the vogue in France, and even affected Scott Fitzgerald-style American dress.) For Tanguy to cut himself loose from the moorings of Paris and Brittany, the only places he knew and loved, for the alien planet of New York—as it appeared to his circle in 1939—was a calculated gamble. In a reversal of traditional gender roles, he faced the uprooting which the impecunious partner often accepts in exchange for the material security of marriage.

In October 1939 Sage sailed for New York. Tanguy remained in

France, awaiting a dispensation from military service. Before her departure, Sage made arrangements through the French Ministry of Education and the American Embassy to sponsor Tanguy's entry into the United States. According to a proposal which she presented to the Ministry and the Embassy, he would be the first artist in a series of French modernists to be brought to New York. "His work is popular there," she advised the Ambassador.⁶ (In fact, Tanguy's only American show, with Levy in 1936, had resulted in "sad accounts and almost no sales," according to Levy.) Pierre Matisse, the son of Henri Matisse and an old school friend of Tanguy's, who had established a gallery in New York in 1926, would be his dealer and hang his second American show. Sage guaranteed Tanguy's support to the U.S. Immigration Service, and he followed her to New York in November 1939.

If Tanguy suffered the pain of displacement in his emigration from France, Sage suffered the pain of rejection by the group whose artistic values she felt were her own. That the Surrealist clan in prewar Paris had not welcomed her is clear from several sources. Nor did her exclusion from the circle break down among the exiled contingent in New York during the war years. Breton's antagonism toward her was especially virulent, but it was not an attitude unique to him. As Waldberg notes, with some restraint, "Kay Sage was not very well liked by the Surrealists." Judging from her always marginal artistic standing in the movement, as well as from her limited friendships with Breton's inner circle, Waldberg's observation is a careful understatement. Enrico Donati, a less diplomatic witness, says flatly, "Everyone hated her. No one liked her. We were the friends of Tanguy and she just got in the way." Despite a carefully cultivated appearance of indifference to such ostracism, Sage was not indifferent at all. The iconography of her painting from the 1940's onward, the anger and defiance expressed in her French-language poetry, and her behavior in later years all suggest that her exclusion from the Surrealist intimacy inflicted deep wounds that never healed.

In 1939, however, nothing could deter her from pursuing the new life as a Surrealist which she intended to live. Before leaving Europe, she had arranged for civil and religious annulments of her marriage to Ranieri di San Faustino. As soon as Tanguy could obtain a divorce from his wife Jeannette, for whom a financial settlement was made with Sage's money, the couple were married in Reno in 1940. Back in New York, their apartment in the Village became a gathering place for a growing number of exiled artists from France. Sage's hospitality

to members of the Surrealist group and her contributions to their travel and living expenses are a matter of record. In addition to sponsoring Tanguy, she paid passage for Matta and his wife; frequently provided meals for the Nicolas Calases; found and furnished an apartment for the Bretons, paid the first term of the lease, and secured additional support for them from Peggy Guggenheim, including transatlantic passage and a monthly allowance; arranged an exhibit for Jean Hélion at the Georgette Passedoit Gallery and guaranteed the expenses. After she and Tanguy settled in Woodbury, Connecticut, in November 1941, they remained in touch with the Surrealists in New York, often inviting them for weekends in the country. In fact, one of Breton's most hilariously obsessive statements originated on a visit there: "Truly surrealist flora has been enriched," he explained in a 1941 interview published in View, "with a new species, shown me by Kay and Yves Tanguy: a staghorn fern suspended in its superb turtleshell." Breton's Surrealist taxonomy was elicited by a question from Charles-Henri Ford, the editor of View: "What do you think of the countryside around New York?"7

Neither Sage's personal generosity nor the expertise she would develop as a painter in the 1940's and 50's substantially altered her position as persona non grata in the artistic group whose endorsement she most coveted. Jacqueline Breton-who married Sage's cousin David Hare in 1946—would grudgingly admit that Sage was a good painter, but only of "her kind of Surrealism." According to her and others inside and outside the Surrealist circle, Sage's work was never regarded as authentically Surrealist by the arbiters of such authenticity. The title of Princess, which had devolved to her from her first marriage, also did not endear her to these self-styled revolutionaries. Tanguy, on the other hand, enjoyed the affectionate regard of his Surrealist friends, not only for the strange originality of his drawings and paintings but also for the playfulness of his personality. In contrast to characterizations of Sage as aloof and sometimes imperious, Tanguy is most often remembered as exuberant and charming. The epithet of "amateur" was never leveled at him despite the loose, even self-indulgent proliferation of nonsense forms in his drawings and the toylike gadgetry in his paintings. Sage, howeveras a consort, not a "real" Surrealist-seems to have felt obliged to counter the epithet with a stunningly controlled painting technique.

Upon their arrival in the United States, both Sage and Tanguy began to exhibit regularly, with stubborn separateness. Tanguy's first show, as the first in the series of French modernists envisaged by Sage,

was held at the Matisse Gallery in December 1939. (Hélion's was the second and last, in March and April 1940.) Sage had her first American show in June 1940, also with Matisse. In a determined effort to establish her own artistic identity, she changed dealers, exhibiting with Levy in 1944 and 1947, and then with Catherine Viviano in 1950, 1952, 1956, 1958, 1960, and 1961. In connection with the 1950 Viviano show, Sage told a reporter for *Time* magazine who asked her the inevitable question about how she managed to paint independently of Tanguy: "We both dislike terribly the idea of being a team of painters" and "We refuse to exhibit together."⁸

Tanguy seems to have been as little inclined to appear on the same walls with Sage as she was with him, if for different reasons. Friends and associates willing to voice an opinion say that he did not encourage her in her work and was jealous of it. According to a neighbor in Woodbury, Sage once quoted Tanguy as having said to her, "I made it on my own. Let's see you do it." To keep the domestic peace-eternally the woman's job-"Kay's painting was kept rather in the background," Miriam Gabo recalls from her and her husband Naum's frequent visits to the Sage-Tanguy household in Woodbury. Although Tanguy exhibited with other male Surrealists throughout the war years and in the decade afterward, and had solo American shows of his oils in 1940, 1942, 1943, 1945, 1946, 1948, and 1950, he did not lend Sage whatever coattails he may have had. They also exhibited separately in 1953 in Paris, on the occasion of their only return to the city where they had met. Aside from group shows to which each contributed one or two works, the couple exhibited together only once, after she was buttressed by almost fifteen years of critical endorsement and his American reputation was secure as a survivor among the original Surrealists. Their joint show was held in 1954 at the Wadsworth Atheneum in Hartford and drew strong praise for both artists.

The paths by which Sage and Tanguy reached the milestone of the Atheneum show were long and, after 1938, artistically parallel but not intertwined. Both went through a period of apprenticeship to the craft of painting; both evolved a personal visual idiom in dialogue with the work of more experienced artists. Both developed a highly individualistic style. In the blinkered optic of pre-women's movement art criticism, Sage's breaking away from her artistic antecedents, which occurred in her mid-40's, was rarely recognized. The undervaluing of Tanguy's achievement was not fully evident until after his premature death in 1955. Although he had been automati-

cally marginalized by the dominance of Abstract Expressionism in American artistic culture, his death dealt a further blow to his status as a painter. When he died, assessment of his place among the Surrealists passed from the Surrealists themselves, who had embraced him as a fraternity brother, into the public domain, where drawing was not a sanctioned activity for Great Men. Only recently, with the decline of the larger-than-life paradigm of the male painter, has renewed interest in non-oil media shifted attention to the metamorphic world Tanguy created with pen and ink.

Sage's late start as a serious artist is, of course, a common feature of women's career patterns. She had shown signs of an artistic vocation from an early age and for a time in her 20's had worked hard at learning the basics of drawing and painting, but her potential remained untapped until the move to Paris in 1937. Having finally focused her ambitions, she was quick to identify with what she called the "modern artistic trends" prevalent in the French capital. The six abstract "Compositions" which she showed at the Surindépendants exhibition in 1938 demonstrate her rapid turning away from the conventional landscapes and figure drawings she had done as an art student in Rome. Her contact with modernist painting in Paris would galvanize her talent, leading her to Surrealism through a period of experimentation under the influence of de Chirico's early "metaphysical" canvases. Some borrowings from Dalí's use of the distant plain/ far horizon perspective also appear likely in her work from the late 1930's.

By 1940, the date of her first full-scale solo show, the beginnings of a personal imagery of walls, draped figures (later, drapery fragments), and architectural elements are already evident. The other traits of her mature iconography-scaffolding and latticework-first appear in the 1944 exhibition. The building blocks of her most complex work, executed from about 1946 onward, are thus in place by the end of the Second World War. In addition to the emergence of a personal iconographic vocabulary, the rigorous technical standards she set for herself can also be dated to this time. Sage was a slow, meticulous painter. She used a tight line, defined the hard edges of her geometric designs with exacting care, and built up a seamless paint surface. The haunting, dreamlike atmosphere of her paintings arises in large part from a flawless rendering of objects one cannot quite name and scenes one cannot quite place, that seem suspended in midair. The cool, gray-green palette, sparing use of color accents, and intense lighting which Sage perfected during the last decade she

Yves Tanguy, The Sun In Its Casket, 1937; untitled, 1949

painted in oil, from 1948 to 1958, are also evident in her canvases from the mid-1940's. None of these characteristics refer to the work of artists preceding her. Her development occurred independently and efficiently, once her delayed artistic career was under way.

Tanguy's evolution from novice to accomplished painter was equally self-directed. Like Sage, he passed through a period of experimentation that owes much to de Chirico and, somewhat later, to Dalí. Like her, he emerged from these intervals with an unmistakably personal pictorial style. By about 1935, the marine settings, deep spatial vistas, biomorphic figures, and recurrent forms evocative of bones or of once-submerged rocks, all of which he would endlessly rework in later years, are familiar motifs in his paintings. Also characteristic of his style by the mid-30's, and further refined in his works executed in the United States, are a glossy, jewel-like finish-often set off with bright, saturated color-and an almost precious intricacy of minutely drawn forms. The Celtic moodiness that dominates Tanguy's late American work would be expressed in gradually subdued colors and a more dramatic use of a low horizon line. With the sharpened memory that often accompanies exile-Tanguy became an American citizen in 1948—the stranded menhirs and dolmens of the 1950's paintings begin to evoke his Breton origins more literally than the canvases painted while he still lived in France.

It is the drawings and gouaches, however, that now seem the real touchstones of Tanguy's inventiveness. More numerous than the paintings, they are also freer and funnier. He began them before he took up oils, and continued doing them throughout his career. The traditional value accorded oil painting in preference to works on paper seems lame in the face of the ludic riot of Tanguy's pen. What he drew does not appear to have come from anywhere other than his startling imagination. The drawings, which he often executed in green ink, reveal a penchant for bricolage-puttering, tinkering, taking things apart and reassembling them in new combinations. The gouaches, usually less intricate than the drawings and more expansive in their treatment of space, are equally recognizable as Tanguy creations. No one has found a genealogy for these works, nor is anyone likely to. Their central place in Tanguy's oeuvre is reflected in Pierre Matisse's practise of featuring them in shows separate from the oils, a practise he continued after Tanguy's death, when the works on paper could not have been considered preparatory to oil paintings.

In several ways, Sage and Tanguy's artistic itineraries form a commentary on gender arrangements at mid-century. Despite the distinctiveness of both artists' work, and the lack of overlap in their evolution as painters, they have been portrayed as disciple and master. According to this assumed relation of inferiority-superiority, Sage's paintings have been seen as lesser versions of Tanguy's. The favorable critical press that greeted each of her shows would invariably assert her indebtedness to his work. Specific borrowings or influences were rarely identified; verifiable ones, never. Typical of the virtually Pavlovian pairing of her work with his is a comment on her 1950 show. "The artist, wife of Tanguy, is to be congratulated for not having been absorbed esthetically by her husband's dynamic brush,' writes a reviewer. "While Miss Sage also explores a fantastic dream world, not unsimilar to her husband's, she has managed to retain he own identity."¹⁰ Well, yes. So why invoke the comparison, if it doe not stand up? Yet as late as 1977, the curator of an exhibition o American Surrealist painting would refer to Sage's work a "important variations on Tanguy."11 The odds for survival of thi peculiar notion have been overwhelming, given the male bias that has prevailed until very recently among critics, curators, dealers. collectors, casual viewers, and among artists as well-women and men.

Sage herself reinforced the prevailing bias by regarding Tanguy as a superior being, in a class of his own. "He's perhaps the only true

surrealist," she explained to a reviewer of the Atheneum show, "almost like a medium."¹² To one of Tanguy's friends in France she wrote that a painting of his in the show, *Multiplication of the Arcs* (1954), was "the most beautiful picture that could be painted". In another comment in connection with the Sage-Tanguy exhibition in 1954, she exlained that when the two painted in their separate studios in the converted barn behind their house in Woodbury, they never knew what picture the other was working on. "Although," she added, as if she considered the logic of her statement unassailable, "I take more interest in his than he does in mine—naturally."¹³ To a degree unusual even for the 1950's, Sage assimilated the culture's endorsement of the male as creator and leader versus the female as emulator and follower. To a degree unusual for any artist at any time, she never recognized, or at the very least never acknowledged, the damaging self-denial inherent in this hierarchy.

An interesting corollary of the master-disciple syndrome is the persistent critical harking back to de Chirico's influence on Sage long after any actual traces had given way to her own iconography and painting style. Without pictorial evidence-without any documentary evidence at all-critics continued to allude to Sage's work as derivative of the Italian's. No matter that keen interest in de Chirico had been common to virtually all the Surrealists working in the 1920's and 30's, an interest that led to outright borrowings; they themselves acknowledged the debt in the prominence accorded his metaphysical paintings in the International Surrealist Exhibition in Paris in January and February 1938. No matter that Tanguy's career in oils was launched under the direct inspiration of de Chirico, around 1925. Over the years, Tanguy himself would elevate his early encounter with the decisive de Chirico canvas The Child's Brain (1914) to the level of myth. Despite this well-established artistic patrimony, Tanguy's relation to the Italian precursor of Surrealism was never construed as derivative nor his debt a mortgage of his own creativity. The same consideration was not given to Sage. Years after she had moved beyond a fascination with the Mediterranean villa settings, oversized eggs, phantom statues, and dramatic shadowing of the early de Chirico, reviewers would continue to see her work as "like" his, when it demonstrably was not.

With Sage and Tanguy, as with their contemporaries, assumptions based on gender operated as strongly in the private sphere as in the public. Not only was critical response to her work colored by the disciple-master model, and his by the Great Man fallacy; their lives as

Kay Sage, I Saw Three Cities, 1944; The Passage, 1956

Kay and Yves Tanguy were also shaped by culturally assigned roles. She used her maiden name professionally and her husband's name in private life. She accepted the assignment of accommodation and selfdenial to such an extent that her identification with Tanguy contributed both to her abandonment of painting and to her suicide. For him, the dominant culture's social and artistic roles carried less damaging expectations. Yet Tanguy's very life may have been shortened by the excesses of alcoholism and physical violence that were tolerated, indeed regarded as natural, in male artists of his generation.

The documents that afford a glimpse into the interpersonal dynamics between Sage and Tanguy are almost all of her making. To skew the perspective further, almost all of them date to the years between January 1955, when Tanguy suddenly died of a cerebral hemorrhage, and January 1963, when Sage shot herself. During those years, sorrow and despondence plagued her, and her health declined steadily. The most debilitating condition, physically and psychologically, was cataracts in both eyes. Despite three bouts with surgery, the restoration of her sight was not sufficient to allow her to paint by the exacting standards which for her had become a point of honor. As her health deteriorated and her social isolation increased—she stayed on alone in the house in rural Connecticut which she and Tanguy had

renovated and filled with Surrealist artifacts—she withdrew into the past and dedicated herself to serving his memory.

The image of Tanguy that emerges from Sage's writing and from her advocacy of his reputation is an image of heroic proportions. Her gallant defense of him is at odds not only with his actual work, which was narrowly channeled, but also with his demeanor, which Pierre Matisse described as "sometimes a little wild."14 In a balanced and sympathetic portrait of the man and the artist, Walberg admits that on the frequent occasions when Tanguy had had too much to drink, his unbridled behavior could be frightening. He would butt his head against street lamps and, as also attested by other witnesses, grab the nearest man by the ears and crack skulls with him. Testimony is ample on Tanguy's habit of drinking to excess at social gatherings and then shouting abuse at Sage, who remained cool and unresponsive, at least in company. Matisse, perhaps the most loyal of Tanguy's friends and also a mainstay for Sage after Tanguy's death, has said, picking his words carefully: "He could be rude and treat her badly ... really insult her, talk to her in a way that would be difficult to take, in front of friends mostly. She would never reply or anything like that; she would be above it." For reasons one can only surmise, Tanguy was exempt from Sage's criteria for "correct" behavior. Imperfections, even when they took the form of public affronts to her considerable pride, had no place in her picture of the fallen hero. As she wrote to a critic who had expressed condolences upon Tanguy's death: "He was the purest artist I have ever known and the greatest man."¹⁵ She made this statement in the depth of shock and grief, when the bereaved typically express exalted sentiments out of proportion to the deceased's qualities. Yet her sentiments about Tanguy appear not to have changed over the remaining eight years of her life.

In the months after his death, Sage launched into two memorial projects. The first was a Tanguy retrospective at the Museum of Modern Art in New York—an exhibition which she was determined to see travel to Paris—and the second an inventory of his work. The New York show, which opened in September 1955, featured three decades of the artist's paintings and drawings, assembled by Sage, Matisse, and the exhibition curator, James Thrall Soby. Progress on the exhibition was encouraging, she wrote to Duhamel in the spring, but her "dream plan" was to ensure that the show would hang in triumph in Paris, at the Musée d'Art Moderne. While preparations proceeded for the U.S. opening, she carried on months of correspondence with contacts in France, made transatlantic phone calls, and

even appealed to the French Ambassador to the United Nations. But the show closed in New York at the end of October without an invitation to Paris. Sage never accepted, perhaps never understood, the falling of the old Surrealists' stock in postwar France. She would die believing that the refusal of the Tanguy retrospective by French museum officials was shabby treatment of an artist of genius who deserved a prodigal's welcome home. (No major Tanguy show would be mounted in France until 1982, when "Yves Tanguy, rétrospective 1925–1955" hung at the Centre National d'Art Contemporain Georges Pompidou.)

The inventory of Tanguy's work, a longer-range project than the retrospective, occupied Sage for the next four years. She tirelessly tracked down drawings and paintings, wrote to persons who had known Tanguy as a young man and who might have information on his early work, and hired a research assistant to edit the material she was collecting. She finally gave up the attempt to locate all the drawings, but did succeed in producing the most complete record of the oils that would be compiled until Waldberg's biography and catalog appeared in 1977. "I would have liked this summary of Yves Tanguy's work to be perfect and complete," she wrote in the foreword to her book. "I have done my best, but have not been able to do the impossible." In that disarming statement Sage reveals something of the intensity of her devotion to Tanguy. Less evident is the agony of her own struggle against despair: in April 1959, her work on the book completed and provision made in her will for financing its publication, she attempted to kill herself by taking an overdose of sleeping pills. Although the attempt was not successful, it did signal the private hell Sage would live in until her suicide by gunshot wound in the chest in January 1963. Her death came two months before Yves Tanguy, Un Recueil de ses oeuvres | A Summary of His Work finally appeared in New York under the imprint of the Pierre Matisse Gallery. Not the least irony of Sage's story is the fact that she never saw this book in which she invested the last hope of her life.

Sage's other writing from the period after Tanguy's death traces the gradual erosion of her sense of self and, inevitably, of her will to live. She wrote a 150-page autobiography called *China Eggs* (1955), which does not include the years of her life with Tanguy—years which his absence seems to have made too painful for her to face. She made irregular entries in a journal, often alluding to the life-saving tension between herself and Tanguy, and the reason for living which he had provided for her. She kept up an active correspondence with

some of Tanguy's Surrealist friends in France, with frequent references to him and to what he "always said" or "used to do." She wrote three one-act plays in French, in which she projects her own voice through a series of male characters who allow her to vent her anger and grief. The language she uses is the raucous and vulgar idiom that she and Tanguy had spoken together and that contrasts astonishingly with the proper persona she maintained in her public discourse, especially in English.

The fullest record of the linguistically uninhibited Kay Sage, the woman who depended on Tanguy as a sparring partner, is in her verse in French. Typically composed as dialogues, and always in an everyday, conversational idiom, two volumes of the poems appeared in France-with Duhamel's help in finding publishers and Sage's financial subsidies-as Demain, Monsieur Silber (Seghers, 1957) and Faut dire c'qui est (Debresse, 1959). A third volume, Mordicus (Pierre Benoît, 1962), was a joint project between Sage and Jean Dubuffet, who contributed woodcut illustrations. Several dozen additional poems remain unpublished. The profane, "tough-guy" vernacular which Sage adopts in her verse is the same language that had shocked and displeased Breton when he first heard her speaking it in Paris with Tanguy. She would later remember Breton's having admonished her: "I really don't like to hear women talk like that." She apparently did not heed the admonition then; she certainly did not heed it later. In the years after Tanguy's death, she would continue to "talk like that" in the extended conversation of the poems. They were another facet of her homage to the memory of Tanguy-a tribute to the oral memory of him, to the rollicking cadences of his speech.

Although the story of Sage and Tanguy together ends in 1955, the epilogue of Sage alone compels a new look at them as two very good artists and very commanding personalities. It is well established that the achievement of each was substantial, and marked in the public sphere by awards, purchase prizes, favorable reviews, representation by respected galleries, and acquisition of their work by museums with excellent modernist credentials. It is also well established that Tanguy's reputation rose higher and held more steadily than Sage's, once they had settled into the relative seclusion of their house and studios in Connecticut. This is the facet of their record that invites new questions.

Was Tanguy more talented than Sage, as has been assumed, or are there no grounds for comparison because her talent went so long undeveloped and may never have been fully deployed? Why did it go

so long undeveloped? Was his creative imagination more fertile than hers, or was hers so impinged upon that its visual expression came out as walls, barriers, and other figures of constriction? Was he the more significant artist of the two because he painted more pictures and drew more drawings than she did, and for a longer time, or would the question be more usefully recast to ask why this was so? Why is the very issue of comparison so persistent?

The central fact which all the questions, new and old, have to be measured against is the absolute hegemony of the male artist in the years when Sage and Tanguy lived and worked together, and the years she survived him. By prevailing norms, Tanguy expected more validation, and he received it. Sage expected less; her expectations were also met. When she gave up the burden of herself in favor of the memory of Tanguy, she earned respect from many who knew them both. "I don't want to hear any more talk about disloyal widows," Duhamel wrote admiringly of her in his memoirs, published in 1972.¹⁶ Only as a Surrealist widow was Sage accorded this distant and ironic respect from Tanguy's old crowd. By the time the strange endorsement came, in the late 1950's, her eyesight had begun to fail, she was geographically and emotionally isolated from the artists whose company she had so longed to join, and she had less than a decade left to live.

Much, of course, has changed since Sage and Tanguy's time and even since Duhamel's unwitting statement. Most women have not interpreted the culture's messages as extremely or irreversibly as Sage did, and most men have recognized the potential damage to themselves in the formulas for masculinity that circumscribed Tanguy. Yet the basic elements of Sage and Tanguy's story are neither idiosyncratic nor obsolete. They are still dangerously familiar.

Anaïs Nin and Henry Miller, both at Louveciennes, ca. 1933

the literate passion of Anaïs Nin & Henry Miller

NOËL RILEY FITCH

C HE was a delicate European flower and he a gravel-throated OBrooklyn-bred vagabond when they met one December day in 1931 in a small village outside Paris. As he approached her home in Louveciennes, she noticed his lean body, balding head and piercing eves: he looked like a Buddhist monk with a full sensuous mouth, she thought. He first noted her large round eyes and shy manner. It was to be a casual lunch, but he was penniless and hungry. He came with the man who was putting him up in his apartment, Richard Osborn, who worked in the same bank as her husband, Hugh Guiler. Osborn had been telling the two writers that they should meet. He had been giving Anaïs Nin Guiler legal advice on her manuscript, D. H. Lawrence: An Unprofessional Study, which he showed Henry Miller; to Nin he had given Miller's review of L'Âge d'or, Luis Buñuel's Surrealist film. Each had expressed interest in the work of the other: she thought Miller's piece was "primitive, savage"; he was more than a little interested in a woman who would write about Lawrence, with courage and delicacy. They did, indeed, like each other and slipped into lively dialogue. He ate heartily, grateful for the free meal, hoping this would lead to more invitations. She confided to her diary, which she had been keeping since her eleventh year, that she found his "toughness" fascinating and "new."1 She sensed that she had something to learn from his primitiveness; he, in turn, intuited that he might be instructed by her refinement.

They met frequently in the days and weeks afterward to talk about books, philosophy, and history, for he was as hungry for new ideas as he was for a free meal, and she too was an autodidact. She lent him copies of Proust; he spun great tales of Brooklyn. But the subject he seemed most obsessed about and in which he most engaged the interest of Nin was his wife, June Mansfield, who was then in Paris for a visit. It was June, whose dark blond earthiness embodied Nin's concept of female beauty, with whom Nin fell in love ("You are that woman I want to be. I see in you that part of me which is you"). Only

after June left France did Nin and Miller fall in love. It happened after they had written many letters (he tried teaching English in Dijon in January) and had long discussions about June (he read portions about her to Nin from a manuscript called *Tropic of Cancer*). She read to him portions of her diary that analyzed June. Soon, they moved from an intellectual relationship to a physical one.

Now, with fuller access to their life-writing, one can see the extent of their remarkable mutual enrichment, their pollination, of each other's intellectual and artistic capacities. They shared what Nin called the two lives that writers live: the living/tasting and the writing/reaction. They shared ideas, quotations, and books, their essays and journals. They read and critized each other's work. They both noted the "equality" of their relationship, though eleven years separated their ages. "I imagined many books born out of our intimacy," she says in "Djuna" (1939). They even talked of collaboration (he for the money, she for the publicity), but their styles were too different; instead she contributed condensation to his work. and he encouraged realism in hers. He made her see the streets and life around her. She piqued his interest in Lawrence (Lawrence had freed her mind, Miller freed her body), and he helped her promote her books through his reviews. She introduced him to the work of many European artists, and he helped her shake off her Cuban Catholic schoolgirl prudery-what she called the "chill curse of Christianity." In short, they were, in the words of Philip Jason, "soulmates, fleshmates, unique contributors to one another's very different paths as writers."2

Their passion began soon after March 4, 1932 when from a café table in Chez les Viking on rue Vavin in Montparnasse Miller wrote Nin, who had just left the café: "I love you.... I am in a fever." After the next café meeting, he wrote: "you have started my sap flowing" and "You have fired me and now I can never again be what I was before, just your friend."¹³ She soon agreed to go with him to his hotel room. The walk they took across the boulevard du Montparnasse and up rue Delambre was a walk that would last a decade and permanently spice literary history.

"Anaïs, when I think of how you press against me, how eagerly you open your legs and how wet you are, God, it drives me mad to think what you would be like when everything falls away," he wrote March 11. And fall away it did—all her Catholic girlhood inhibitions, her sense of middle-class sexual decorum, her vows of marital fidelity. She had begun cautiously experimenting outside her marriage before

she met Miller. She would devote the remainder of her life to tapping and expressing those sexual and artistic energies released in her trysts with Miller. He had found someone who would give him a vision of himself and a woman who could meet him book for book and bed for bed (word and womb). They also became literary partners: he edited her fiction, dedicated his *Black Spring* (1936) to her, and wrote glowing essays about her unpublished diary. She wrote a preface to and paid for the printing of *Tropic of Cancer* (first published in 1934). She gave him financial support for more than a decade, including rent on the Villa Seurat apartment where they, Lawrence Durrell, Alfred Perlès, Michael Fraenkel, and others made a literary center during the 1930's.

Was it a case of opposites attracting? To the casual observer they could not have been more dissimilar in temperament and style. Even their mutual friends thought they were worlds apart. Miller was almost 40, robust, and at home in the street and the brothel. Nin would soon be 29, feminine, mysterious, seductive; she cultivated beauty and harmony. She designed her clothes, her diary and her home to an ordered life, while he immersed himself in the chaos, filth and decay around him (he embraced the subject of dirt—personally he was fastidious). He hated "beauty," poetry, the precious precisely those qualities of artifice to which she was devoted. As she expressed it, "He wants to touch bottom. I want to preserve my illusions."

They certainly came from different worlds. Born in 1903 in France, she was the daughter of a Danish-French singer (born and reared in Cuba) and a Cuban composer. She had lived in Belgium, Germany, and Spain before her father deserted the family and her mother moved Anaïs and her two younger brothers to New York, where from age 11 to 20, her life was centered largely in the musical Cuban community. By contrast, Miller was a working-class New York boy, born of a German tailor and a classic *hausfrau* in Brooklyn in 1891. He had done menial jobs, managed a Western Union office, and learned to live hand-to-mouth. He was divorced from his first wife, who reared their daughter alone.

Even their voices and pens spoke differently. She expressed herself in what Fred Perlès, who shared an apartment with Miller, called a kind of international "supra-lingual language," atonally as if "only part of her vocal cords were involved."⁴ When she first began writing fiction (she called it the "smoke" from her diary), he called it (she told Durrell) "neurotic fulgurations." "Henry is the real writer. I

just breathe," she added.⁵ In conversation, Miller expressed himself in realistic "gutter language" (Nin called it) and rhythmic incantation. While she chose her words carefully and uttered them in a small-girl whisper, his voice sounded as though it was stuck on 33¹/₃ speed and paused to hum between sentences. In a letter to her, he described his own voice, when he heard it for the first time in 1941, as having a "gutteral quality—like a big bear humming to himself."

Their writing styles echoed these differences. She reached for the beautiful and distilled it on the page; he wrote like rolling thunder, exploding as she imploded. His style was ejaculatory. Nin told him that she had an "enameled style" and he a "masculine one." He flowed, gushed, and spilled, she added, while she sought "the core and . . . struggle[d] to coordinate, to tie up loose ends." The content and focus of their work also emanated from these different springs. She probed her feelings, dreams, and unconscious-proceeding, as Jung expressed it, from the dream outward. He catalogued the physical world and sexuality, the "blood and flesh," as she called it in her preface to his Tropic of Cancer: a "brutal exposure of the substantial body" for a world "paralyzed with introspection and constipated by delicate mental meals." Miller himself announced that this novel was "libel, slander . . . a prolonged insult, a gob or spit in the face of Art, a kick in the pants to God, Man, Destiny, Time, Love, Beauty. . . ." That the novel is also full of dreams is a credit to her encouragement of his use of dreams.

Although not readily apparent, their affinities were deep. She recognized this immediately in December 1931: "I've met Henry Miller.... He is like me." She recognized the female aspect of Miller, and he her toughness, even ruthlessness. She sensed his spirituality, and he her materialism. They were hungry, curious, and enjoyed play.

They read and discussed Goethe, Dostoevsky, and D. H. Lawrence, but they were also in the American Romantic tradition (she Emersonian, he Whitmanesque). Both knew their Ralph Waldo Emerson. She discovered his essays in April 1921 and mentions his ideas occasionally during the years before her marriage. Miller is preoccupied with Emerson in his *Tropic of Cancer*, using the following quotation as an epigraph to the novel—an 1841 passage from Emerson's *Journal* that seems to herald both Nin and Miller:

These novels will give way, by and by, to diaries or autobiographies captivating books, if only man knew how to choose among what he calls his experiences that which is really his experience, and how to record truth truly.⁶

Both answered the call of Whitman's "myself!" They believed in the primacy of the self, the colossal ego; followed the cult of the artist, the writer as hero, and the writer and the work are one; they exalted spontaneity, chaos, ecstasy—they wished to be like Lawrence's "kindled bonfires on the edge of space"—and attacked tradition and the worship of the rational. These were their Romantic American tenets. They followed the American narration of self-discovery initiated by Thoreau and sustained in Wolfe, Bellow, and Mailer.

Both were self-taught artists hungry for accomplishment and recognition. Many years of rejection only sharpened the edge of their hunger. Also, both feared starvation—he feared physical starvation, she the loss of love, for her father had abused and abandoned the family before she was 11. Also out of that fear (and Nin's insecurity) came a capacity for cruelty.

In their own manner, each was writing a "letter" to the world she in her diary, at over forty volumes when they met, he in his voluminous letters to friends, letters that were used for his selfreferential anecdotal fiction. His letters were public—he told her on 30 July 1932 that he wrote them as "a link between me and the world [because] I can make people read letters"; she began her diary as selfcreation and self-therapy. Each of their life's work, in fact, can be read as one large narrative. Each was catching the flow of life, desperately devoted to writing daily, and aware of the necessity of the writer's colossal if not hurtful ego (she envied his ability to put his art above everything). And each was playing a role, says Jay Martin: he the hobo artist of Montparnasse and she the prim banker's wife.⁷

On the personal level—for this was as much a passionate as a literary union—they were connected by parental betrayal and enough Puritan or Catholic repression and sexual frustration to provoke their sexual rebellion and obsession. "Henry was the last Victorian," says his friend Bob Snyder, who made documentary films on both Miller and Nin. And there was a "tremendous vein of Spanish prudery in her," Lawrence Durrell observed to me. Hence the obsession: "I want my dress torn and stained!" says Lillian in *Ladders to Fire* (1946). "I want to undress you, vulgarize you a bit," he tells her. They wrote enough erotica to keep publishers busy for years.

They each wanted to be Don Juan. She often talked of herself as a "Donna Juana," Renata Druks told me. After her first encounter with Miller, Nin began collecting lovers with near abandon—father figures as well as homosexual young men. She found Miller's mythic animality, what she called his "fearless, ugly, cathartic strength,"

appealing; but she saw beneath the blunt realistic tough guy to the wounded romantic rebel. He saw the intensity and imagination beneath her delicate manners and bowed head, and told her later that she was the first woman with whom he could be sincere. He told his friend Emil Schnellock, on October 14, 1932, that it was a love between equals: "Can't you picture what it means to me to love a woman who is my equal in every way, who nourishes me and sustains me? If we ever tie up there will be a comet let loose in the world."

The depth of their love and the important role that they played in each other's lives and literary accomplishments is not vet fully known because Nin remained married to Hugh Guiler (the Millers divorced in 1933) until her death, determined not to embarrass publicly or divorce him. She insisted that all mention of her private life with Miller be kept secret. This silence kept her out of the literary history of an important period and deprived his public image of a softer, more thoughtful side. The literary critic Mary Dearborn believes that the silence also had a deleterious effect on Miller by limiting his subject matter to June, when during the richest period of his writing he could not mine his most important experience. Though many of his letters to her (minus the intimacy) were published in 1965, it was not until 1987, after the deaths of Nin and Miller (and two years after the death of Hugh Guiler), that many of their love letters (Miller claimed they had written nine hundred during their first year alone) were published, thus first documenting their love affair.

What began early in 1932 as a lusty itch and self interest—she needed love and fatherly acceptance, he could use her money and connections—bloomed into a personal and literary partnership. They spent hours together in cafés, at the Guiler home in Louveciennes (a half-hour by train from Paris), and in the Clichy apartment of Perlès and Miller. She called her diary and Louveciennes her "laboratory of the soul" and the Clichy apartment the "black-lace laboratory." When they were not making love they were reading their work, going to movies, and discussing film and literary styles, philosophy, and music. She was analyzing and recording every experience in her diary; he was writing about his Paris experience (except for that of her) in *Tropic of Cancer*, though he would transpose some incidents to fiction set in New York. Everything went into their art.

Although he could not mention her name, his lovely portraits of the town of Louveciennes, which offers a view of Paris, reveal his happiness there: "Coming in from Louveciennes . . . Below me the valley of the Seine. The whole of Paris thrown up in relief, like a

geodetic survey. . . . there she stands, the fair city of Paris, soft, gemlike, a holy citadel whose mysterious paths thread beneath the clustering sea of roofs to break upon the open plain."⁸

June hovered over the first ten months of their union. Both of them were writing about her. And they spent hours analyzing her to the point at which June ceased to be herself and became a creation of their own reflections; she became their muse. Miller had long been disturbed by his wife's irrational behavior and drug addition. Nin was captured by June's seductive powers and her capacity for fabrication and illusion. She would help Miller finally exorcise June; he would help Nin focus on herself as artist, while nurturing the woman.

For nearly a decade even the lives they had apart from each other-Miller's friendship with Brassaï, his travels with Perlès, his street prowlings: Nin's society life with Hugh, the companionship and astrology she shared with her cousin Eduardo Sanchez, and her analysis with Dr. René Allendy-everything, influenced or was influenced by their relationship. Allendy was analyzing her dreams, Sanchez was reading her star charts. Soon she was analyzing Miller's dreams and Sanchez was doing Miller's astrological chart. Sexually liberated by Miller and encouraged by Allendy not to take love so seriously, she was open, even compulsive, about sexual experience, making love to Miller, Sanchez, Allendy, and her husband, occasionally on the same day. The edited "unexpurgated" diary of the events of this first year with Henry was published as Henry and June in 1986, the year after Guiler's death, and Incest: From a Journal of Love (1992) covers the "unexpurgated" second and third years of their relationship.

The passion was intense for several years. They set up a love nest at 26 rue des Marronniers in the winter of 1933–4 when Dr. Otto Rank, Nin's second psychoanalyst, insisted she lived near him in the 16th arrondissement. During this time Nin became pregnant and aborted the fetus (a girl) in August 1934. The experience was partly expressed in her short story "Birth" (1938), a title suggesting that the author-narrator was born with the death of her fetus, and in "Winter of Artifice" (1939): "And with the little girl died the need of a father." In early manuscripts of the two stories, it is very clear that her decision was influenced by Miller's lack of enthusiasm and his irresponsibility (he had already abandoned one daughter).

About the time of the publication of *Tropic of Cancer* on September 1, 1934, Nin rented an apartment for Miller at 18 Villa Seurat, where they could have more privacy—she told Hugh it was to

be her studio for writing. Miller now had a home base that attracted more and more friends, most of whom she did not like. This factor (she was used to compliant lovers), plus Miller's desperation and jealousy of Rank and an unhappy five months with Nin in New York, where she worked for Rank and Miller attempted to secure a pirated U.S. edition of Cancer, caused them to drift somewhat apart. Though no longer fully in the center of each other's world, they remained lovers and the early readers of each other's work. Miller was nonjudgmental when her father had come back into her life and sexually seduced her in 1933. Strengthened by analysis with Rank, she eventually exorcised the tyranny of her father's earlier abandonment and her need for his approval. She withdrew from her father, who returned to Cuba. Miller knew about the incest-he had told her about his whores, after all. Though jealous, Miller was supportive and understanding of Nin. Yet, as an abandoning father himself, he also sympathized with Joaquin Nin. He took complete interest in her psychoanalysis with Rank, whose book Art and the Artist they admired. Psychoanalysis met several needs for them, including their exploration of themselves as artists and as source material for their art.

During the decade of their love affair neither was "faithful" to the other, but their physical and artistic union was primary. Their literary output was never greater. They wrote voluminous letters to each other (often immediately after parting) and her diary grew exponentially. He wrote Tropic of Cancer, Tropic of Capricorn, and Black Spring and undertook an enormous study of Lawrence. She read and responded to everything he wrote. She began her first two "fictional" works under Miller's careful editing. The first was a poetic, Surrealist novel, The House of Incest, which she called her "season in hell." The second would appear as the first section ("Djuna") of the 1939 Paris edition of The Winter of Artifice and then be dropped in later printings because it was too close to the truth. Both these works began as one story-of her relationship with Henry and June, specifically her duality with June, whom she called her "Mona," then named Alraune, then Johanne, and, in The House of Incest, Sabina. The third Nin work that Miller heavily edited (the manuscript is full of his corrections) was the story of her father, called "The Double" (1934), then "Lilith," and finally "Winter of Artifice," published as the second section in the book by the same name. Miller wrote a screen treatment of The House of Incest, which he called Scenario and she called a parody.

Her encounter with June, already built up to the point of

mythology, began a long process in which Anaïs tried to resolve an internal struggle: between the selfish artist father and the nurturing mother in her. She longed to be both, yet she believed them to be, as her parents had been, irreconcilable. When she met the assertive and selfish June, who created her lies with impunity, she recognized in the earthy woman not only the beautiful woman she had always longed to be (that is, the mistress her father had always pursued), but also the destructive artist that she wanted to be as well—the woman who lived impulsively on the edge. She created "June" in that image, or archetype, and used her in her fiction. Miller did the same. June never forgave either of them.

Nin's literary treatment of Henry and June Miller is a study in the complexities of Nin's diary and fiction-two genres whose boundaries Nin blurs to the the point of confusion. Her literary treatment of their friendship in her first published Diary (1966) and fiction shows her as exercising judgment and control and observation. Yet when the first unexpurgated diary (Henry and June) appeared twenty years later she appears to be, even when interpreting one person to the other, clearly swept away by the emotional conflicts. Perlès later said that she had not been in control, but naive and unsure, and distressed and distracted by Miller's obsession with June; she was not tough enough for Henry. He thought she needed Miller more than he needed her. This is a very different portrait from the one she first published. Whatever events and relationships transpired at a given moment, they were first filtered through the neuroses of Nin, whose admitted desire was to create something beautiful in her diary; then, as the years went by and she retyped and changed the events as first recorded, the portravals of Miller and others also changed and evolved. Miller's fiction, though only occasionally read biographically, also distorted and enhanced his personal experience.

Despite these changes to their "life-stories," the personal influence these two writers had on each other is historically established in their letters. He told her (26 July 1932) that he had "never before loved a woman with this unselfishness"; she responded (28 July) that she had "outgrown the idea of perpetual solitariness." She gave him a vision of himself that kept him together: "Write on. I love you, I believe you [are] the greatest writer on earth today." She was, he implied, the "missing hub" for which he had long sought. "Between Henry and me there is the diabolical compact of two writers who understand each other's human literary life, and conflicts."

Nin was first able to assist Miller, for she was financially able to

allow him to spend time writing. Though by no means wealthy, the Guilers were comfortable. From her personal allowance and from her budget for the gardener and dressmaker, she began by giving him envelopes with 100-franc notes inside and finally paid rent on each of his abodes. She also paid for the publication of *Tropic of Cancer*, with money she borrowed from Rank. She had carried the manuscript to publishers in London, but it was finally published by Jack Kahane of Obelisk Press in Paris. Critics are divided on who wrote the introduction but she signed it, and in his dying letter to Lawrence Durrell on May 8, 1980 Miller declared she "did the whole job" on his preface. Durrell told me that "she was a very brave woman to walk around Montparnasse with Henry's manuscript looking for a publisher." It is not surprising that in one of his periodic "wills" he left all to Nin, though all he had beside his talent was \$3,300 in debts.

On the professional level, their influence on each other's work was "about fifty-fifty," she told Kenneth Dick years later. Because she came from a different world, she could introduce Miller to many European artists and works. He began reading Freud and Jung and, with a new interest in the subconscious, kept a record of his dreams, which he put in *Black Spring* (dedicated to her). She introduced him to her world of music (her father, mother, and brother were musicians) and bought him a record player, which filled his nights with music. She introduced him to the magazine *transition* and the writings of Eugène Jolas. "You gave me reality and I gave you introspection," she told him November 26, 1933, "but we have to keep ourselves balanced *against* each other."

Nin helped him to exorcise his destructive relationship with June and, according to the author Jay Martin, to believe again in an ideal conception of woman. Recent attempts to cast Miller as a gross misogynist (Kate Millett accused him of being a "compendium of America's sexual neuroses"⁹) are in part contradicted by his unselfish love of Nin and his enthusiastic encouragement of her work. Later, when he found his great love Eve (his fourth wife), he told Durrell that she compared to Anaïs in her harmony, ease, and graciousness.

"She was his confessor and his companion, his collaborator and his guardian angel," she wrote in *Ladders to Fire*. He agreed with this interpretation of their relationship: "You have been the teacher—not Rank, nor even Nietzsche, nor Spengler. . . . In you . . . was the guide who conducted me through the labyrinth of self to unravel the riddle of myself, to come to the mysterious."¹⁰ She was mentor, mistress, and patron. Occasionally she was caught in more traditional roles, as

when she spent days helping him organize his notes and read his manuscripts. She preferred her roles as mistress and literary partner. "I'm hoping you'll find time to read all I've sent you. I'm waiting to know whether it's good or bad," he wrote on September 1, 1933.¹¹ She urged him to trim and condense his writing, which had gotten unwieldy in his manuscript on D. H. Lawrence, to minimalize his stupid philosophizing, and stop collecting quotations. In short, she told him to write his own ideas in his own words.

No one has stated her influence on his life better than Miller himself, first in a passage he wrote in her diary on New Year's Day 1933, and second in a letter of January 29, 1944:

Louveciennes becomes fixed historically in the biographical record of my life, for from Louveciennes dates the most important epoch of my life. She was to me, and still is, the greatest person I have known—and one who can truly be called a "devoted soul." *I owe her everything*.

Finally, she gave Miller and, to a larger degree, history the best portrait of this Brooklyn novelist that has ever been drawn. She captures in her *Diary* his walk, his talk, his Rabelasian joy and exaggeration, and his writing style.

And what did Miller do for Nin as woman and artist? Falling in love with Miller was a maturing step in her sexuality because for the first time she accepted what she called "her opposite," a lover who was different from herself. For years, she would later acknowledge, she had sought twinship ("incest") with those like herself—her cousin Eduardo, her father, June, even her husband. Unlike this romantic and adolescent incest, her union with Miller challenged all her being and filled her early work. If she was lunar and he solar, he brought in the sunshine, the open road, the streets of Paris. He "breathed new life into her nostrils until she began to glow with an incandescent glow," says Perlès, "Henry fertilized every artistic ovum in her. . . . Whenever I think of Henry and Anaïs, the image of Castor and Pollux comes to my mind—the twin stars which, seen from afar, resemble a single star, with a monocle in its eye."¹²

Most importantly, he took her seriously as a fellow artist. He became her mirror, reflecting artistic success. He was her teacher and mentor, as she was his. He was her best editor, as the manuscripts of her early fiction (at Northwestern University) illustrate. He encouraged her to write fiction, and his comments were pointed and blunt, despite the fact that she did not ordinarily take criticism well. Sometimes she crumbled under his editing of her work. His letters

reveal how firmly and patiently he argued to convince her that his criticism was not betrayal or rejection. She would return to the manuscript and rewrite. He renewed her faith, checked her integrity, honed her style as well as her fighting spirit, and urged her to ignore the criticism of others. "Henry and I—alone—against the world," she wrote March 28, 1934; though she hesitated to marry him, she felt that their artistic life was wedded. A comment she made in 1955 suggests why she continued to listen to his criticism:

Henry's writing did not arrest my own. We incited each other . . . It is true that I set out to encourage, to publish, to make Henry known as a writer, and that I lagged behind, and that the recognition of his superiority as a writer enabled me to accept his advice, his help and encouragement.¹³

In locking horns on their different writing philosophies and their differences as man and woman, they articulated their critical theory. Nin rehearsed her views in her diary, where she records their lengthy literary discussions, particularly during the late 1930s when Lawrence Durrell frequently came to Paris, and they forged a theory of the lifeserving power of confessional writing. They were intellectual companions.

He also taught her about other sides of life—prostitutes, brothels, oral-genital sex, the poor of Paris ("I walked through the street which Henry taught me to love," she records in her diary). He introduced her to Lawrence Durrell and the literary world of Montparnasse and loosened her confining social life, which had been largely restricted to the Cuban-French concert world and her husband's world of banking. Any reader of her unexpurgated diary can trace the change in her language, from the nineteenth-century language of Romantic idealism to the gradual introduction of his explicit sexual words. Miller counseled her to go with the flow of life, and she tried, for she admired his freedom, amorality, and destructiveness.

Miller set an example of uncompromising devotion to writing. She wanted this life of the artist, but feared that it denied her feminine self. She feared choice, openness, destruction of the past—all necessary to art, but acts she feared would lose her the love of others. "I never destroy, I do not criticize, attack, punish, hurt others," she wrote in a classic example of self-deception.¹⁴ Because her artist father, the composer, had deserted the family, she equated the selfish artist role with the masculine principle and the nurturing role with the

feminine and believed them mutually exclusive. Both Miller and Rank would only begin to help her get over this guilt about being creative. The feminist critic Ellen Peck Killoh says that as a result she posits the new model of the woman artist as "preserver" and tried to "make herself into the Ideal Woman Artist." As a result, "she is out of touch with her demons" and her writings, adds Killoh, reveal "evidence of strain, of self-consciousness, of trying too hard."¹⁵

"Please read, Henry, read . . . I need your faith to go on," she wrote him on October 4, 1933. "Keep on believing in yourself," he had written on August 3, 1933, "and trust in Providence. I can see the world knocking at your door." "Write on," he added five days later. "I love you, I believe you [are] the greatest writer on earth today." For thirty-five years before its publication he believed in her diary: "I am thinking of the reader to come in the year 2,000 AD. and later, when the original manuscript, with the correct names, is brought to light." He not only assured her of her world appeal, he tried to convince the world. First, in a nine-page letter of August 2, 1933 to William Aspenwall Bradley, the literary agent, when he pleaded for the publication of her uncut diary. Then in letters of praise about her to many, including "Letter to Anaïs Nin Regarding One of Her Books," published in one of his books in 1944, in which he says her English "plays on raw nerves with effects of delirium and ecstasy." Finally, he wrote what Durrell thought was the best essay on Nin, "the best description of her and her spirituality": "Un Être Étoilique" ("A Starry Being"). His most frequently quoted passage from this essay is his prediction of greatness.

Anaïs Nin has begun the fiftieth volume of her diary, the record of a twenty-year struggle towards self-realization. . . . a monumental confession which when given to the world will take its place beside the revelations of St. Augustine, Petronius, Abélard, Rousseau, Proust, and others.

After rereading the essay a decade later on 21 April 1944, when she lived in New York and he in California, Miller wrote her that it was the "best bit of writing I ever did"; it had brought tears to his eyes. Do not give up on its publication, he warned: "I urge you with all my heart to concentrate on the Diary." (When the first volume appeared in 1966, it disappointed him because it was severely edited.) For all she did for him, he paid her back "the only way he knew," said Durrell, "by writing 'Un Etre Étoilique." "He did try, when he could, to repay some of her financial investment in him. Once on Valentine's

Anaïs Nin as the author and as some of her characters in "This Hunger," 1945

Day 1943, when he was given money, he sent a check with which she bought paper to print her short stories *Under a Glass Bell* on a hand press in Greenwich Village. When a benefactor began sending Miller checks the following year, he split the money with her, urging her to use it to publish her diary. His greatest financial repayment was to give her the rights to all his letters to her.

He had acknowledged her generosity on April 30, 1939, when he was leaving Europe ahead of the Germans, by sending another "will" to a lawyer friend in the United States:

I will be sorry to leave France.... But I must add in the interest of truth that I owe nearly everything to one person: Anaïs Nin. I want you to remember if you survive me, what I have said and written about her

diary. I haven't the slightest doubt that 100 years from now this stupendous document will be the greatest single item in the literary history of our time.... [T]he thing to remember is that it was A woman, Anaïs Nin, by whom I was rescued and pressured and encouraged and inspired.¹⁶

Each of these two writers, who finally drifted apart after the Second World War when she settled in New York and he in California, gave literary history the best description and insight both personally and artistically—of the other. They had come close to marriage several times—once when planning to run away to Spain together, in 1939 in the south of France when he was fleeing the war for Greece, and again during his first year back in the United States when he was traveling and she writing erotica for a dollar a page to pay for his trip across America that resulted in *Air-Conditioned Nightmare* (1945). He wrote of these plans to his best friends, and their letters suggest that she too discussed marriage. But she would not or could not leave Hugh, her husband and economic support since 1923, and she knew that Miller would not make a good (or compliant) husband. She wanted his full attention, but beginning with the Villa Seurat years he was always surrounded by his friends.

Literary letters and mutual support continued in the 1940's, between Greenwich Village and Los Angeles (and then Big Sur), for they both expected that when his literary reputation was established, he would help her. She saw him again in 1947 after coming west with Rupert Pole, the young man who would be her second "husband" (she never divorced Hugh). Miller and Nin met very briefly in Big Sur, both showing off youthful companions half their age: he his wife Lepska, and she a homosexual young man and former lover (not Pole). But misunderstanding estranged them and regrets lingered. As she said to one of their friends,

He was like a spouting whale, a tornado, sweeping wide swathes through everything . . . He was avaricious in his appetites for everything. Me, I was the mist-maker—"Un Être Étoilique."¹⁷

Miller had two more children and married several times. Nin, who had no children, continued bicoastal "marriages" for nearly thirty years (Hugh remained in Greenwich Village). Eventually they began seeing each other occasionally again in Los Angeles in the 1960's and early 70's.

Their last meeting occurred in Cedars Hospital, where he was visiting for tests or treatments for his arteriosclerosis and she was

dying of cancer. She preceded him in death, on January 14, 1977, by more than three years. Five years after he died, on June 7, 1980, Hugh Guiler passed away, and the love letters between Nin and Miller, as well as the expurgated portions of her diary, could finally be published (in 1987 and 1986, respectively). According to her editor, Gunther Stuhlmann, Miller had kept "an honorable discreet silence" about her secrets.

He had indeed found fame if not notoriety, largely through the censorship of his *Tropics* books, which provoked worldwide publicity and antics such as posing for a photograph in *Playboy* playing pingpong with a nude woman as if he were the grandfather of the sexually liberated. She was chiefly known as the woman who wrote the preface to Miller's *Tropic of Cancer*. Fame in her own right came only when she was 63 years old and the first volume of the diary appeared. She was taken up by the women's movement and the liberated youth of the 1960's at the very time that she was first diagnosed with cancer. But she lived for a decade as the mother-goddess of many women, addressing thousands of eager students in universities around the country. Kate Millett called her the "mother to us all, as well as goddess and elder sister. . . . She gives us the first real portrait of the artist [as] a woman that we have ever had."¹⁸

Their works have come to represent Paris of the 1930's, when each did her and his best work. Their influence was little felt in New York in the 1940's, when they were out of step with the prevailing political concerns, rejected by harsh reviews, and driven to selfpublish or submit work to ephemeral publishers. But their literary emphases fit right into the California of the 1950's and 60's. The Beats, hippies, and Aquarian-agers sought them. Miller collected his share of oddballs, Nin attracted her share of dreamers and the wounded. To this day, their romantic rebellion appeals to a growing number of admirers.

Both Miller and Nin suffered by being type-cast—he for his *Tropics* alone, she for the erotica published at her death and the periodic publication of expurgated portions of her *Diary*. They are both over-rated by devotees and under-rated by high-brow academics. Even the serious new biographies of Henry Miller have failed to assess the extent of their assistance to and influence on each other. Reassessment of their place in American literature is only just beginning. Whether critical judgment ebbs or wanes, the story of their passionate literary union will always capture the imagination.

Anaïs Nin with the manuscript volumes of her complete diary, stored in a bank vault, 1966

Dashiell Hammett and Lillian Hellman, Hardscrabble Farm, Pleasantville, NY, late 1940's

NON-NEGOTIABLE BONDS Lillian Hellman & Dashiell Hammett

IO

BERNARD BENSTOCK

TUST AS the victors write the history, the survivors write the J biography, and there is little doubt that Lillian Hellman was a survivor. Her three books of autobiography offer various kinds of insights into her thirty-year relationship with Dashiell Hammett, both revealing and concealing. Theirs was a Hollywood romance, with all of the glitz and glamor, heights of passion, and depths of despair for which Hollywood love affairs are famous. It only fell short of scandal because they were writers rather than movie stars. And even more dramatic was the turbulence of their affair when set against one of the ugliest chapters of American history, the hounding of leftist intellectuals that seriously affected Hellman's life and ruined Hammett's. Introverted and alcoholic, fiercely proud and scrupulously honest, and suffering from a severe writing block, Hammett became almost totally dependent on Hellman, while she, extroverted and demanding, personally brave but often devious, enjoyed a success as one of America's major playwrights at a time when her lover was left staring at blank pages in his typewriter.

From the moment they met in a Hollywood restaurant in 1930, they became passionately involved with each other, and through the years found that they had as much difficulty living together as they had breaking apart. They moved in and out of various residences in Hollywood and New York, and later country and resort houses in the northeast, some of them his, some hers, and some theirs. Their continued devotion to one another was often marred by their numerous sexual infidelities, and their writing careers were as much a mutual pleasure as they were another source of constant irritation and dispute, but their political commitments may well have provided one of the firmest anchors of the relationship. Hammett was certainly the more committed of the two, dedicatedly self-educated in Marxist political ideology, whereas Hellman's politics were quite probably more a matter of compassion and concern—and a vital part of her commitment to him. He was 36 when they met and the most famous

writer of crime fiction in America, and she was 25 and attempting to get a foothold in the entertainment industry as a film scriptwriter. When Hammett died in 1961, Hellman buried him and eulogized him, and then set to work to write the story of her life, almost completely abandoning her career as a dramatist to devote full time to autobiography. She had lost the only person on whose critical advice and assistance on the writing of her plays she thoroughly relied.

Hammett had no illusions about Hellman's capacity for survival, or her strong sense of self. When she casually mentioned the prospect of someday writing a biography of him, Hammett was caustic in his comment that "it would turn out to be the history of Lillian Hellman with an occasional reference to a friend called Hammett."¹ Whereas at least two of her twelve plays, *The Little Foxes* and *Another Part of the Forest*, were somewhat autobiographic in telling the story of the Southern business family who were her ancestors, none of them told her personal story nor that of her lover. Within the short span of seven years Hellman then published three very different kinds of autobiography, *An Unfinished Woman* (1969), *Pentimento* (1973), and *Scoundrel Time* (1976), with much more than just occasional references to a friend called Hammett, but not necessarily with complete frankness about either herself or him.

Dominating her thoughts as she wrote was the incident she records in *An Unfinished Woman*, dating from the first year of their intense relationship. Hammett was then the author of numerous short stories and four very successful detective novels, and was in the process of writing what would be his last one, *The Thin Man* (1934), in which he depicted the almost ideal marriage of Nick and Nora Charles that seemed to mirror his love affair with Lillian Hellman. "So it was a happy day when I was given half the manuscript to read and was told that I was Nora. It was nice to be Nora, married to Nick Charles, maybe one of the few marriages in modern literature where the man and the woman like each other and have a fine time together."²

That idyllic rapture, however, was quickly undermined: "I was soon put back in place—Hammett said I was also the silly girl in the book and the villainess. I don't know now if he was joking, but in those days it worried me: I was very anxious that he think well of me."³ Hammett had few illusions about anyone, and he did not allow his judgments of others to alter his constant refusal to interfere in other people's lives, even of those he loved. As Hellman's three attempts to retell the story cannot disguise, there were certainly at least three faces of Lillian apparent throughout her life, and only one

of them was that of the adoring and irrepressible Nora Charles. Hammett's later cynicism, at a time in his life when he was slogging away in Hollywood on yet another *Thin Man* spin-off, puts the Nickand-Nora relationship in a very different perspective: "how Nick loved Nora and Nora loved Nick . . . no one ever invented a more insufferably smug pair of characters."⁴

For thirty years together Lillian and Dash were everything to each other but a married couple. They were both already married when they met, although their marriages were well on the way to being dissolved and both were having affairs. Hellman soon divorced her author-husband, Arthur Kober, yet remained a devoted friend (and lover) for decades thereafter. Hammett eventually divorced his wife, but visited her and their two daughters occasionally. (In their altered state the ex-marriages remained as constant as the new alliance.) They never married, yet neither ever married anyone else, although in the mid-1940's Hellman seemed on the verge of marrying a career diplomat. This other intense and prolonged relationship, however, for some odd reason merits very little attention in Hellman's autobiographic writings.

Within four years of their first meeting Hammett published *The Thin Man* and Hellman had her first play, *The Children's Hour* (1934), produced on Broadway. She was immediately acclaimed a success, but two years later her second play failed, despite Hammett's efforts as a play doctor. Overcoming disappointment and anxiety over the failure, Hellman succeeded in regaining her prominence, and the successes were fairly consistent thereafter. The arc of her ascent coincided exactly with the arc of his descent, and for the next three decades he was painstakingly helpful to her with her literary work while totally unable to help himself with his own.

The 1930's were of course troublesome years. The economic depression and the rise of Nazi power in Germany strongly politicized both Hellman and Hammett: he joined the American Communist Party, and she probably did as well. Although he was in his late 40's (and had already served in the United States Army during the First World War), Hammett again volunteered and was finally accepted, serving in the Pacific, unaware that the F.B.I were searching for him and were somehow unable to track him to the Aleutian Islands. When the Second World War was over they both came under scrutiny of Congressional investigators for un-American activities; Hammett refused to cooperate and served a prison sentence, but Hellman managed to avoid imprisonment. Their sexual intimacy had already

Dashiell Hammett, photographed by Lillian Hellman, and on his way to jail, 1951

been destroyed, primarily because of Hammett's heavy drinking, but they continued to retain and often revitalize their friendship, even to the extent that she became his sole means of support and care during the poverty and illness of his final years.

Many of their friends, and later more objective biographers, have taken turns portraying Hammett and Hellman individually, strongly favoring the handsome, tormented, principled, aloof but compassionate Dashiell, and often unfavorable toward the gregarious, demanding, difficult, and manipulative Lillian. The friends in particular supported the notion of a fairly positive coupling, consistently presenting the image of two people unusually suited to and almost fated for one another. What emerges from the composite portraits is a misleading picture of the strong, silent man bolstering up a weak woman who is draining him of his energy for her own needs. (Few of these commentators seem to be aware that not only were their literary interests central to their otherwise disturbed relationship, but that their mutual political commitment was at least as potent.) Hellman admits that in the opening days of their affair Dash had lots of money when she was almost penniless, and that he spent freely on her, as well as on all of his friends. The most dominant refrain in her memoirs is of his role as inspiration for her work and a determined taskmaster who insisted on numerous rewrites and goaded her relentlessly into working even harder. Meanwhile, all that he could manage to turn out were Hollywood film scripts, until even that field of creativity dried up.

A closer examination of their lives reveals a far more complex alignment, in which Hellman remains solidly consistent in her work and her way of life, while Hammett, for all his cold logic, weaves brilliantly erratic patterns with his life. Their relationship underwent numerous changes as they led separate but interconnected existences, with long periods of co-habitation interspersed with near-estrangement, sexually absorbed with each other but eventually merely companionate once he decreed it to be so. She was a confirmed worldtraveler, he stubbornly unwilling to leave the continental United States. He once reported (to her ex-husband) his refusal to attend a conference in Paris by saying, "Madame has a firm belief that one should go almost anywhere for almost any purpose if it's free, and of course she's been trying to get me to go to France for years."5 What sustained their disjointed relationship was a mutual respect for each other's privacy and their diligence in never making unilateral decisions that obligated the other. Theirs was a co-existence determined by their insistence on their distinct individualities, with agreed-upon dependencies and a delicate balance of shared concerns. Their mutual values were first set by their affluent lifestyle, their network of intellectual friends, and their literary work, but would become solidified in the late 1930's by their strong political convictions.

Despite the seeming similarities in their adult lives, Hellman and Hammett came from diverse backgrounds which shaped their particular outlooks. His was of old American stock only a generation away from their farm roots, his father a clerk in Baltimore whose finances were often uncertain; hers of German-Jewish ancestors who were successful merchants in Alabama and Louisiana. Although basically a pampered child, Lillian was also a sensitive child aware of conflicts and animosities in the extended family in which she lived, and consequently a "difficult" child by her own admission. Because of the split between the two sides of her family, she spent her childhood in New York for half of each year and in New Orleans for the other half, and as an adult related that disjunction in terms of her control of her own life: "the stubborn, relentless, driving desire to be alone as it came into conflict with the desire not to be alone when I wanted not to be. I already guessed that other people wouldn't allow that, although, as an only child, I pretended for the rest of my life that they would and must allow it to me."6 Dash was probably the one person in her life who did.

By the time he had met her, Hammett had served in the Army,

raised a family, worked as a Pinkerton detective and in advertising, and had written for pulp magazines. Several events in his unsettled life had left their permanent scars: witnessing Pinkertons murdering a union organizer contributed to his committed leftwing politics, and the tuberculosis that he contracted in the Army resulted in a brush with death that may have determined the way in which his career as a writer disintegrated. Nunnally Johnson, a fellow scriptwriter, observed that "from the day I met Hammett, in the late twenties, his behavior could be accounted for only by an assumption that he had no expectation of being alive much beyond Thursday."7 By the early thirties Hammett assumed that his finances were secure for the rest of his life, even if he was psychologically living on "borrowed time," and experienced difficulties in completing his last two books, The Glass Key (1931) and The Thin Man, admitting that they were being "held back thus far by laziness, drunkenness, and illness." He never expected that in the 1950's the F.B.I. and I.R.S. would render him permanently unemployable, and as Nunnally Johnson commented, "by the time he came to realize that he would in all likelihood be here not only next Thursday but for many Thursdays to come it was too late to sit down at the typewriter again with much confidence."8

By the end of the thirties Hammett and Hellman quite openly signed petitions, attended meetings, and contributed money to many leftwing organizations, sometimes together, at other times separately. It is hardly surprising that in the early days of the Cold War they were caught in the dragnet of anti-Communist hysteria and individually brought before investigative committees. Hammett categorically refused to cooperate, although he could easily have cleared himself of the particular charge and had no access to the information the committee wanted, but took pride in going to prison for his beliefs. Some time later Hellman had her hearing, and with incredible skill and subtlety in her testimony evaded prosecution and went free. Despite the self-congratulatory tone of her version of these events in Scoundrel Time, she was certainly adroit in her evasive technique, without compromising herself or anyone else, whereas Hammett preferred not to use his logical skills but accept the inevitable with characteristic fatalism. (He did, however, caution her not to follow his lead but to be evasive, convinced that she would not survive prisonas he so easily had, making friends with the other inmates.) Only with the third autobiographic volume, when she considered the political atmosphere no longer as oppressive, did Hellman acknowledge that she was "fairly sure that Hammett joined the Communist Party in

1937 or 1938," adding: "I do not know because I never asked, and if I had asked would not have been answered, and my not asking, knowing there would be no answer, was typical of our relationship."⁹

The period of the red scare marked one point of permanent change in their lives-and their life "together"-but there had been others along the way. In spite of the dynamic sexual attraction between them during the first years, Hammett's infidelities were frequent, and were extremely distressing for her. On one occasion she flew from New York to Los Angeles to break up an intrigue with a "secretary" who answered Hammett's phone at three a.m. His infidelities were far more casual than hers, since she only chose men she loved and admired, including ex-lovers periodically recycled. (His penchant was for racially exotic prostitutes and the results were numerous painful bouts with venereal disease.) One of Lillian's few women friends observed her inner turmoil, noting that "she controlled it and didn't talk about it, but it was very upsetting to her because she was jealous of him and he was never jealous of her."10 In Pentimento Hellman recalls that in 1939, when Hammett was particularly valuable to her in the writing of The Little Foxes (what she acknowledges as her "dependency" on him), she was considering getting married-to someone she never identifies. "I don't know if I was paying him back for his casual ladies of our early years," she muses; "it takes a jealous nature a long time to understand that there can be casual ladies—but certainly I was serious or semi-serious about another man and Hammett knew it."11 Hammett, however, is reported by her to have said that she wouldn't marry without his "permission," and the matter is left at that.

The sex life shared by Hellman and Hammett came to an end on a summer night in 1942, when for the first time she seriously objected to his drunken advances and turned him down. According to Hellman, in her interview with Hammett's biographer, he was stunned by her refusal and determined never to have sex with her again, much to her astonishment. Soon after that he was finally accepted into the Army and sent to the Aleutian Islands, while Hellman went on an even more dangerous assignment to wartorn Russia. It was to be their longest separation, and a time in which she was amorously involved with a foreign-service officer she met in Moscow. It was also the year in which she was writing *The Searching Wind*, and for the first time didn't have Hammett there to help, to "spur, quiet, goad, pacify and tease you," as he put it, "according to what's needed at the moment."¹² Her letters to him were agonized, but he wrote back that she was merely

experiencing "the normal bellyaching of La Hellman at work."¹³ He advised her as much as he could by mail, confessed that she was "breaking my heart with your letters about the play,"¹⁴ but was convinced that she had full control now of her own talent.

At the core of Hellman's recollections of her life-and her life with Hammett-is the country estate that she bought in 1939, Hardscrabble Farm, returning it to its function as a working farm. The exciting social whirl they had in Hollywood and New York, in which they were outdoing each other in heavy drinking and were tempted by the proximity of other lovers, was now replaced for long periods of time with rural tranquility. Hammett had taught her to hunt and fish, and she raised livestock and vegetables. There were many visitors, but there were also days of solitude and time for writing, with Hammett frequently there, although he retained his New York apartment. Hellman insisted that "Hammett, who disliked cities even more than I did, came to spend most of his time there, and maybe the best of our life together were the years on the farm."¹⁵ As a memoirist Hellman moves back and forth across the years recaptured, often noting the moments in which the idyllic rural scenes were instrumental in creating the amalgam that brought them closer together. She harks back to 1934, when newly flush with money from The Thin Man, they found themselves "in a primitive fishing camp in the Keys where we stayed during the spring and summer, fishing everyday, reading every night. It was a fine year: we found out that we got along best without people, in the country."¹⁶ Glossed over in this account were the drunken days in Miami just prior to the sanctuary in the Florida Keys, when Hammett was arrested for smashing a department store window.

The years at Hardscrabble Farm span the middle years of the Hellman-Hammett relationship, and her remembrances of them are rhapsodic, although they were also the years that span all of the Second World War and the beginnings of the Cold War. It was here that she wrote five of her twelve plays, as well as several film scripts, while he concentrated on reading voraciously in a variety of totally unrelated subjects, hunting and fishing and tinkering, retreating more and more into himself, but never failing to show up in New York every week to teach his classes at the Marxist Jefferson School. Both of them at the time had good reason to worry about excessive drinking, Hellman turning to psychoanalysis for help and Hammett finding himself brought to the brink of death. In 1948 he made his decision never to drink again, and with the same decisive tenacity

with which he decreed an end to their love-making, he stopped drinking for the remaining thirteen years of his life. And Hellman was as astounded at his will power in this instance as she had been in the previous one, as in many another instance in which he asserted himself with an iron will. (Years before, she had watched him lock himself away to finish writing *The Thin Man*, refusing to come out until it was done.) For her at least the twelve years at Hardscrabble Farm were a watershed, bought with the money earned from *The Little Foxes* and sold in 1951 to pay attorney fees for her defense before the House Un-American Activities Committee. Hellman's biographer, however, notes that the sale took place the year previous to the one she claims, but the hostility of her anti-Communist neighbors may well have accounted for the urgency to sell.¹⁷

Early in that same year, prior to the political crackdown and the consequent loss of Hardscrabble Farm, a rather fleeting moment of stasis seemed to exist in their lives: "I was at a good age," Hellman recalls; "I lived on a farm that was, finally, running fine and I knew I had found the right place to live for the rest of my life. Hammett and I were both making a lot of money, and not caring about where it went was fun. We had been together almost twenty years, some of them bad, a few of them shabby, but now we had both stopped drinking and the early excited years together had settled into a passionate affection so unexpected to both of us that we were as shy and careful with each other as courting children. Without words, we knew that we had survived for the best of all reasons, the pleasure of each other."¹⁸

On the other side of that great divide, a year or so later, life became difficult for both of them. Hammett had served his prison sentence and was hounded for the rest of his life by claims for back taxes, and Hellman was banned from writing for the movies and had lost her farm, but survived her hearing and continued having her plays produced on Broadway, deciding also to direct them herself in order to earn more of the profits. Hammett was a pathetic figure in his decline, attempting to retain his proud independence but totally dependent on Hellman for financial support. "I have learned that proud men who ask for nothing may be fine characters," she writes, "but they are difficult to live with or to understand. In any case, as the years went on he became a hermit, and the ugly country cottage grew uglier with books piled on every chair and no place to sit, the desk a foot high with unanswered mail."¹⁹

It is simplistic to assume that once Hammett was dead, of lung

cancer, Hellman stopped writing plays because she had lost her mentor. (Her one post-Hammett effort was an "adaptation," and that hardly a successful accomplishment.) In those last twenty-three years until her own death in 1984, however, Lillian Hellman had become a legendary person, lionized and feared, and much in demand as a public figure and a lecturer. These were the years in which she undertook to write and rewrite the legend, repeatedly searching for the truth and just as often seeking ways to subvert it to a truth she preferred. She had run roughshod over many people with whom she had come into professional contact and had made enemies, not the least of whom were those who differed with her politically, so that there was no shortage of negative reviewers to accuse her of lying.

Hammett's early verdict that her egotism would dominate proved to be basically correct, and the portraits of him that recur in her memoirs are often fleeting and ambivalent. But they serve the primary function of providing added validity to her portraits of herself, his devotion to her proof of her own personal worth. She underplays the importance of the other men in her life in order to stress his, yet keeps even Hammett at arm's length so as not to diminish her own stature. Her major concern throughout is to build up an image of Hammett as the determining factor in her becoming a dramatist, and his genius as a guiding hand in the writing of the plays. Hellman focuses so powerfully on Hammett as her mentor that one begins to suspect that perhaps she protests too much.

Hammett's own creative career, on the other hand, hardly figures in her history since she enters the stage when he is almost totally unproductive. Many factors contributed to Hammett's inability to write anything of significance after 1933. Like other writers of crime fiction he was contemptuous of that commercialized genre, and had only taken it up because of his need to provide support for his family should he die prematurely. When these contingencies faded away, and incredible success resulted in the accumulation of unimagined wealth, the need to write detective fiction also faded, even though he had written superlative crime novels. But unlike most such writers he turned away from producing a succession of books featuring a serial detective, attempting instead to create a different variation in each of the five novels. (The early short stories he rejected as worthless and refused to allow any of them to be republished; only after his death did Hellman bring them back into print.)

Each of the five novels is unique: Red Harvest (1929) a Westernized action novel with political impact; The Dain Curse (1929)

a Gothic horror of abnormal psychology; *The Maltese Falcon* (1930) a dark, cynical mystery focusing on a private detective with an ambiguous code of honor; *The Glass Key* an exposé of city politics with an even more ambiguous "detective" at its center; and *The Thin Man* an urbane, sophisticated comedy featuring a casually aloof retired private eye. In *The Thin Man* Nick Charles is as reluctant to solve the murders as his creator was to continue writing murder mysteries, and the book is obviously a "farewell to all that." "I stopped writing because I found I was repeating myself," said Hammett, casually adding that "It is the beginning of the end when you discover that you have style."²⁰

Throughout the many unproductive years Hammett never stopped thinking of himself as a writer, and hoped to find a better medium for his literary talent. "If I stick to the stuff that I want to write—the stuff I enjoy writing—I can make a go of it," he stubbornly insisted, "but when I try to grind out a yarn because I think there is a market for it, I flop."²¹ Already an accomplished novelist, he saw the possibility of a dramatic adaptation of *The Maltese Falcon*, but considered himself incapable of doing it, requiring instead "the help of somebody who was interested in writing for the theatre."²² Yet, as he was effortlessly mastering the art of writing film scripts, he was at the same time involved with a young woman who was interested in writing for the theatre.

The crime incident that was to be the source of The Children's Hour was suggested to Hellman by Hammett, and he quickly discovered in himself a talent for assisting in the writing of the play. Their intense personal involvement and the sponsorship of her creative process fulfilled a dual purpose for Hammett that eliminated the need for him to risk embarking on a new writing career. Hellman's second play, Days to Come (1936), had the political background of union activity deriving from his experiences in the Pinkertons, and again his participation in her creativity was substantial. But the play proved to be a failure despite Hammett's efforts, a failure with which neither one of them was ever reconciled. ("It was six years after we had first met," Hellman reminisces, "six full, happy, unhappy years during which I had, with help from Hammett, written The Children's Hour, which was a success, and Days to Come, which was not.")23 The third play, The Little Foxes, was Hellman's finest, based this time on her own background material.

Hammett's continued efforts as a writer in his own rights resulted mostly in blank sheets of paper in the typewriter—despite the

various typewriters he insisted on buying. Whether Hellman needed his continued assistance or not, he continued to assist, and she was all the more grateful for it. When she started to write *Watch on the Rhine* (1941), a powerfully anti-Nazi play that Hammett might be expected to be concerned with, considering his strong political consciousness, he was actually less involved than ever before. This was the period of the Russo-German Pact, when American Communists were not nearly as enthusiastically anti-Nazi as before, so it is particularly interesting that Hellman claims that "*Watch on the Rhine* is the only play I have ever written that came out in one piece."²⁴ There is no mention of Hammett involved in the writing, nor any apparent reason for his play-doctoring services.

Yet, when Hollywood bought the rights to the play, the political climate had changed again, and the Soviets were America's allies in the war against Hitler—and Hammett was hired to write the screenplay for *Watch on the Rhine*. His enthusiasm, however, appears to have carried him away, and his writing was heavily pedantic and preachy, hardly the refined style of the author of *The Thin Man*, but understandably the work of someone as committed to the topic of antifascism as Dashiell Hammett. Hellman found herself revising his film script in a reversal of the roles of mentor and disciple, although the later loss of his mentorship when she was alone writing *The Searching Wind* (1944) attests to the intricacy of their symbiotic relationship.

Hellman eventually chafed at the manner in which Hammett provided these services. As she recalls the writing of each of her plays, nostalgia pervades the early ones: "he was very happy about *The Children's Hour*, proud that all his trouble with me had paid off."²⁵ But about the writing of *The Little Foxes* she is somewhat less comfortable: "I was on the eighth version of the play before Hammett gave a nod of approval," adding: "Even then I knew that the toughness of his criticism, the coldness of his praise, gave him a certain pleasure. But even then I, who am not a good-tempered woman, admired his refusal with me, or with anybody else, to decorate or apologize or placate. It came from the most carefully guarded honesty I have ever known, as if one lie would muck up his whole world."²⁶

Such moments of painful honesty occasionally penetrate the numerous lies that have been exposed in her self-portraits, as if Hammett's "carefully guarded honesty" had eventually forced the issue for her. She frequently refers to Hammett's contributions to her

successes, more and more uncomfortable with his attitude. By the time she was at work on *The Autumn Garden* (1951), "Dash's pleasure" at her accomplishment is offset by her displeasure with him: "I can hear myself laugh at the fierce, angry manner in which he spoke his praise, as if he hated the words, was embarrassed by them. He was forever after defensive—he had never been about my work or his—if anybody had any reservations about the play."²⁷ Hellman pinpoints the basic differences in their temperaments as they affected their working relationship: "I grew bored," she admits, "as I often did, with the slow precision which was a part of Dash's doing anything."²⁸

The bonds that were forged with *The Children's Hour*, and strengthened with *The Little Foxes* (where Hellman attained the greater advantage), became unravelled with *The Autumn Garden*. The incident that she describes is a bitter one: "It was not the usual criticism," she reports, "it was sharp and angry, snarling. He spoke as if I had betrayed him. I was so shocked, so pained that I would not now remember the scene if it weren't for a diary that I've kept for each play." Hammett was fiercely demanding, apparently feeling that she had somehow betrayed him. When she obstinately refused to rewrite a scene he disliked, Hammett "said O.K., he'd do it, and he did, working all through the night."²⁹ That they were both unrelentingly self-willed and determined to create a superior piece of work proved to be a better amalgam for the play than for their personal relationship.

Soon after this incident Hammett served his six-month jail sentence, and thereafter financial dependency, reclusiveness, and serious illness severely lessened his role in that relationship, although an important change not easily noticeable took place in his own creativity. For years Dashiell Hammett had casually offered a plethora of titles to anyone who asked what he was writing at the moment, so it is understandable that no one took his references to *Tulip* seriously, considering it rather unlikely as a Hammett title. But he really was writing, rather than just staring at blank paper, slowly and painfully, and *Tulip* was intended as a piece of fictional autobiography—of an aging man who had recently been imprisoned for his political beliefs. Hellman published the existing fragment after Hammett's death in a volume of the old short stories that he refused to have reprinted.

Physical attraction, a penchant for high living, and a joint dedication to Hellman's writing were the bonds that kept them together for a lifetime, but each of these was negotiable and subject to the changes in their lives. What proved to be non-negotiable were

their political commitments: these remained firm despite the turbulent forces of change. Hammett's Marxism was carefully thought out and firmly fixed, and had far less to do with variations in the political climate than a systematic belief anchored in a theoretical base that remained constant. Hellman's was emotional and passionate, and derived its tenacity from her refusal ever to betray her friend. She understood his uncompromising determination to accept imprisonment rather than cooperate in any way with his inquisitors, and he was as understanding of her adherence to *realpolitik* and her maneuvers to outwit her inquisitors.

In many ways Lillian Hellman was the more vulnerable, attacked not only from the Right but also from the virulently anti-Communist Left, and without the ideological weapons necessary for her defense, only her sentimental attachment to the Soviet Union and her loyalty to Dashiell Hammett. Her assessment of the twin threads of the personal and political appears in oblique form in *Pentimento*: "we . . . never made a plan, and yet we had moved a number of times from West Coast to East Coast, bought and sold three houses, been wellheeled and broke, parted, come together, and never had plans or even words for the future. In my case, I think, the mixture of commitment with no-commitment came from Bohemia as it bumped into Calvin; in Hammett's it came from never believing in any kind of permanence and a mind that rejected absolutes."³⁰

As the survivor Lillian Hellman wrote and rewrote the biography, and more than six years after Hammett's death she subjects the relationship to still another scrutiny:

I lie on the bed telling myself that nothing had ever gone right, doubting even Hammett and myself, remembering how hard the early years sometimes were for us when he didn't care what he did or spoiled, and I didn't think I wanted to stay long with anybody, asking myself why, after the first failure, I had been so frightened of marriage, who the hell did I think I was alone in a world where women don't have much safety.³¹

Hammett would never have challenged her contention that he was responsible for much of what went wrong between them, that his self-destructiveness spilled over into their life together, and in *Tulip* he tentatively examines a self far removed from the dashing image of a Hammett as depicted in the character of Nick Charles. Had he lived to read *An Unfinished Woman*, perhaps in search of some hint of "a friend called Hammett," he might have been fascinated by a portrait that appears early in the book, where Hellman comments, "He wished to

Lillian Hellman, 1975

win me to his side, and he did. He was a handsome man, witty, hightempered, proud, and—although I guessed very young I was not to be certain until much later—with a number of other women in his life."³² But the proud, handsome womanizer in this instance was Max Hellman, Lillian's father, rather than Dashiell Hammett who would eventually replace him in her affection.

Jasper Johns in front of a *Target* in his studio, photographed by Robert Rauschenberg, ca. 1955

Robert Rauschenberg, self-portrait, Fulton Street studio, New York, 1953

THE ART OF CODE

II

Jasper Johns & Robert Rauschenberg

JONATHAN KATZ

A LMOST from the very beginning of their relationship, Jasper Johns and Robert Rauschenberg were linked together, usually by people who had little or no idea of what they really meant to each other. Early critics tagged them both with the same facile labels neo-Dada, assemblage, junk art—and viewed and reviewed them as a pair. They showed together, were discussed together, even discovered together by their dealer. Still later, they would be declared Pop, or more subtly, proto-Pop, and credited with the development of the first American style that led away from Abstract Expressionism. Artistic movements generally involve more than two artists: theirs was confined to them alone.

All the more remarkable then that the work of Jasper Johns and Robert Rauschenberg is so completely distinct; one could simply never mistake one artist's hand for the other's. It seems that the fact that Johns and Rauschenberg were involved together determined to some extent how they were understood. And yet, paradoxically, while their partnership was widely acknowledged, few comprehended what it really meant, and fewer still knew that it transcended simple friendship. Johns and Rauschenberg are in the curious position of being understood as a pair, but not a couple. Yet they were a couple, and the rather obvious silences, ellipses, and omissions that permeate the usual accounts of their history make no sense unless arrayed against an insistent and damaging homophobia that has led both artists actually to deny the substance of what they had together.

Although the artists remain circumspect on this point, there is reliable evidence that for over six years Jasper Johns and Robert Rauschenberg were lovers.¹ For both artists, it was probably the most serious and intense relationship of their lives, a relationship which was to have a profound effect on the work of each of them at a critical moment in their development. When they finally split up in 1961, the after-effects were so powerful that both artists left New York for their native South, changed their pictorial styles radically, and neither saw

nor spoke to one another for a decade or more. Given the intensity of this relationship, it comes as something of a shock to realize that Johns has never spoken of it, and Rauschenberg has addressed it but a few times, and then only cursorily. His most open and direct acknowledgement of his life with Johns occurs in the following interview:

RR: I'm not frightened of the affection that Jasper and I had, both personally and as working artists. I don't see any sin or conflict in those days when each of us was the most important person in the other's life. Interviewer: Can you tell me why you parted ways?

RR: Embarrassment about being well known.

I: Embarrassment about being famous?

RR: Socially. What had been tender and sensitive became gossip. It was sort of new to the art world that the two most well-known, up and coming studs were affectionately involved.²

While to a greater or lesser degree both artists have resisted further elaborations on this relationship, their art offers a number of interesting clues. That there is some kind of pictorial dialogue at work in their artmaking is undeniable. Not only do they share a number of motifs—from light bulbs to the use of newsprint—some images directly mine gay cultural references and a few actually seem to invoke aspects of their relationship. The chief connection between them, however, is neither stylistic nor thematic, but concerns their joint opposition to Abstract Expressionism, the dominant artistic practice of the day. It was in response to Abstract Expressionism's dominance that Rauschenberg and Johns cultivated their most lasting contributions to American art. And it is because of this joint opposition, and the work it generated, that they have been branded a two-person movement.

Most critics agree that Johns and Rauschenberg's finest work grew out of the period between 1954 and 1961, a time of intense emotional involvement during which they searched together for an alternative to Abstract Expressionist picturemaking. Rauschenberg once remarked of this moment, "We gave each other permission."³ The statement demands to be taken seriously both in terms of constraints on artistic innovation and constraints on homosexual desire, for in the lives of these men, as we shall see, the two were correlated.

The dealer Leo Castelli often repeats the tale of his discovery in 1957 of the connection between his two most famous artists to great dramatic effect. He recounts that he went to Rauschenberg's apartment to select paintings for a show he was planning—

Rauschenberg's first with Castelli—when Rauschenberg mentioned Johns's name. While the rest of the story varies with the telling, the constant is that Castelli then connected Johns's name with a curious green painting he had seen in an earlier show. He asked to meet the artist, who just happened to live in an apartment below. Rauschenberg was happy to oblige and Castelli soon entered a room full of paintings, years of work never before exhibited, all those flags, targets and other images which would soon turn their maker into the most successful living American artist. Castelli immediately offered Johns a show; the Rauschenberg exhibition was, at least temporarily, forgotten.

Rauschenberg's and Johns's careers are thus linked from the beginning. And right from the start a dynamic is set up in their relationship, one in which Rauschenberg, the senior and more experienced figure, acts as agent and enabler of his younger lover's more dynamic career. Johns has remarked that he considers Rauschenberg to be the most fecund and important artist of the twentieth century after Picasso.⁴ Although there is no reason to doubt his sincerity, career imbalance has often been implicated in discussions of what went wrong between the two. Thus there is an interesting specificity to this male/male relationship, one possibly lacking or minimized in heterosexual partnerships in which imbalance has historically been factored into the formula from the beginning. With no social roles to fall into, no models to pattern their expectations on, Johns and Rauschenberg were forced to negotiate every aspect of their lives together.

It was the winter of 1953 when Rauschenberg first met Jasper Johns, although both had moved to New York in 1949. Rauschenberg, who was born in 1925 and grew up in Port Arthur, Texas, arrived after two years' draft in the navy and four more years trying out various art schools from Kansas City to Paris to North Carolina. Johns, born in 1930, moved to New York from his native South Carolina in order to attend commercial art school, but his stay was interrupted by the draft and he spent two years in the army, returning to the city in 1952. He got a job at the Marboro bookstore, unsure of whether he was working toward becoming a poet or a painter. Visiting at Black Mountain College, North Carolina, he was introduced to Rauschenberg by a mutual friend, the artist and art writer Suzi Gablik, who had known Rauschenberg at school. They met again later at an artist's party and struck up a friendship. Rauschenberg and Johns began to see more of one another.

Rauschenberg convinced Johns to quit his job at the bookstore and join him in doing window designs for department stores. They worked together under the name Matson-Jones, and they were quite successful. In 1955, Rauschenberg moved from his Fulton Street studio into John's building on Pearl Street and then they moved together again to a space on Front St.

When Rauschenberg first met Johns, he had already shown a few times at prestigious avant-garde galleries connected to Abstract Expressionism, and had participated in an invitational show with some of its leading figures. He was known in Abstract Expressionist circles, a friend of important painters like Franz Kline and a regular with them at the Cedar Bar. The Cedar, then the epicenter of the New York avant-garde, was a place where painters and poets met to drink, argue, comfort and console one another. For most of its habitués, the Cedar's other patrons constituted the only appreciative audience they ever had. The world at large had yet to hear of Abstract Expressionism in 1953, and the fame that it would gain as America's first international artistic movement was still at least a decade off.

A young, ambitious artist new to the New York art world, Rauschenberg gravitated naturally to the Cedar, a dirty neighborhood bar that had been adopted by the painters and their hangers-on in part because of its seediness. Definitionally bohemian, it was so bad it was good. When fame finally arrived and the owners responded to the new influx of artists' cash by promising new interior decor, the artists threatened a boycott. They wanted to avoid at all costs the impression of an artists' bar, with its connotations of an effete elite preoccupied with questions of beauty. Unwilling to countenance that, the Abstract Expressionists created a facsimile of the Wild West that never was within the confines of the Cedar, a macho art world complete with drunken brawls, fights over women, vain boasting, and, of course, artist talk. It was a heady mix.

If machismo, as we are increasingly finding, is connected to fear, then the Abstract Expressionists feared for their maleness. America has a history of suspicion with regard to its artists and their manliness, and perhaps never more so than in the early 1950's when the rest of America was rolling up its shirtsleeves and getting down to work to defeat Communism.

With Abstract Expressionism, American art became a struggle to voice identity, an attempt to forge a tenuous connection between the individual subjective consciousness and the outside world. That the consciousness in question was always straight, white, and male does

The Fulton Street studio, 1954, photographed by Robert Rauschenberg, with his Yoicks (detail) at left

not seem to have interfered with its claims to universality. Abstract Expressionist art claimed to stand in for speech, attempting to articulate self-presence before the void. No wonder its artists used martial metaphors to describe the act of painting, words like engagement, struggle, victory and defeat. Theirs were totemic battles with the elemental forces of silence. And their painting, achieved through remarkable self-sacrifice (Pollock, Gorky, and Rothko all committed suicide), sought to give form to the evanescent realm of the unconscious. Thomas Hess, the great promoter and friend of the Abstract Expressionists, once wrote that the New York School marked, "a shift from aesthetics to ethics: the picture was no longer supposed to be Beautiful but True—an accurate representation or equivalence of the artist's interior sensation or experience."⁵

For Rauschenberg, the lively scene at the Cedar probably both attracted and repelled him. While he passionately admired the work of some of the Abstract Expressionists—particularly Franz Kline and Barnett Newman—and valued his friendships with them, the intense male bonding of this almost exclusively masculine art world, coupled with its generalized anxiety over the very act of artmaking, created an atmosphere in which the merest suggestion of homosexuality was vigorously opposed. How could the young Rauschenberg paint among such men?

Moreover, never before in American history was homosexuality under such scrutiny and so vigorously suppressed. Leaders of the anti-Communist right such as Joe McCarthy explicitly aligned homosexuality with Communism, declaring both to be moral failures capable of seducing and enervating the body politic. "Sex perverts" were declared a security risk, and both the President and Congress authorized the FBI to bring its formidable powers of investigation to bear to ferret them out. During the Red Scare, more homosexuals than Communists lost jobs in the Federal government, and homosexuality and its evils became an unprecedented topic of public discourse.⁶ How in this homophobic decade could Rauschenberg paint true pictures in the Abstract Expressionist sense, pictures revealing his interior state? Men in the closet were necessarily enjoined from painting as a drama of self-revelation. And even if he could paint such revealing pictures, how could he ever believe that images generated by a gay man could have universal intelligibility? Rauschenberg remarked: "But I found a lot of the artists at the Cedar Bar were difficult for me to talk to. It almost seems that there were many more of them sharing some common idea than there was of me."7 Indeed.

When Rauschenberg first entered the Cedar sometime in 1950, he probably did not think of himself as a gay man. He was actively involved with Susan Weil, a fellow artist whom he had met the year before when both were students in Paris. After returning to the US, they enrolled together at Black Mountain College, the experimental arts institution located in the mountains of North Carolina. At the conclusion of the term, Rauschenberg and Weil settled in New York City and in June of 1950 they were married. But the relationship was not to last: less than a year later Rauschenberg became involved with the artist Cy Twombly. In July of 1951, shortly after Weil gave birth to their son Christopher, Rauschenberg re-enrolled at Black Mountain in the company of Twombly and without his wife. Rauschenberg and Weil divorced the next year and Rauschenberg and Twombly began a series of trips together that led them from Key West to Cuba to Europe. After an extended trip to North Africa, Rauschenberg returned to New York and moved into a studio on Fulton Street which he occasionally shared with Twombly.

The work Rauschenberg produced during this period with Twombly, but before he met Johns, shares a number of telling characteristics. In the context of Jackson Pollock's rage, de Kooning's slashes, and Kline's ponderous pronouncements, the young Rauschenberg's art struck a curiously insistent quiet note. He became

famous for a series of all-white canvases consisting of flat white paint on a flat white surface: no incident, no brushstrokes, no detail. These paintings are the absolute inverse of Abstract Expressionism in mood, surface, color, and expression. They are a kind of pure anti-Abstract Expressionism. About the size of Abstract Expressionist canvases, they are so without autographic or gestural content of any kind that Rauschenberg decreed they were to be painted by others, using a roller. There is an overwhelming feeling of silence in these paintings, a sense that there is nothing to say, or better, that there is nothing to say that can be said. To quote the artist Allan Kaprow, "in the context of Abstract Expressionist noise and gesture, they suddenly brought one face to face with a numbing, devastating silence ... now much, if not everything having to do with art, life, and insight, was thrown back at him as his responsibility, not the pictures'."⁸

The spectator had never been a concern for the previous generation. In seeking to represent the self, Abstract Expressionism registered only the individual artist, not society, not culture. It was as if individuals were in no way influenced by a larger social sphere, as if to be an individual meant to transcend one's position in society. The Abstract Expressionists paraded themselves as painters without a country, stripped of the exigencies of culture—those particularities of time, place and audience that make manipulated pigment meaningful. They thought of themselves as totally autonomous individuals, as anti-cultural, cultural workers.

Many gay men knew differently. Branded unnatural by the dominant culture, hounded and persecuted, the limits on their individuality were enforced by law. Gay men were therefore keenly aware of the limitations of romantic individualism. If the dominant culture offered the myth of self-determinism, a myth central to Abstract Expressionism's founding ideology, gay men like Rauschenberg never had the luxury of believing in expression as an individual struggle of the will. As Rauschenberg said recently, "There was a whole language [of Abstract Expressionism] that I could never make function for myself-words like 'tortured', 'struggle' and 'pain' ... I could never see these qualities in paint."9 Rauschenberg could never see those qualities in paint precisely because they stood out in such high relief in life, in comparison with which paint was revealed as just, well, paint. Rauschenberg's art would soon come to reflect the insights born of marginality, refusing a painted world in favor of opening up the canvas to the detritus of culture.¹⁰

An early art-school friend, Knox Martin, remembers that one of

Rauschenberg's first works, executed while he was still a student, consisted of putting butcher paper on the floor of the Art Students League in order to capture the imprints of foot traffic. It may have been his first work to mine what we might call non-subjective painting, painting that quite deliberately has nothing of the self in it. If we look at the media explored by Rauschenberg even at this early date, it includes not only footprints, but blueprints and photography—all forms of artmaking that defy the Abstract Expressionist conventions of art as a self-revelatory process.

Perhaps Rauschenberg's most famous statement of opposition to Abstract Expressionist pictorial practice is his *Erased de Kooning* (1953). For this composition, Rauschenberg requested a drawing to erase that he would then exhibit as his own work. De Kooning reportedly picked a complex, well-worked drawing to make the task as difficult as possible. None the less, Rauschenberg succeeded in erasing it and the critics went wild. But it is very much to the point that this bold statement of generational succession and critique should be couched, not in the form of a manifesto or some similar positive statement of identity, but rather in the form of an erasure, an absence. Again, as in the *White Paintings*, it is as if Rauschenberg's assertion of self could only be presented as the negation of macho Abstract Expressionist identity, not as an alternative co-equal form.

It is this which would change after the meeting with Jasper Johns. Two gay men working and living together, Rauschenberg and Johns developed between themselves some semblance of the kind of community that the Abstract Expressionists took for granted. Together, they formed a new pictorial language, new symbol systems, new subjects—and a new subjectivity in painting. After meeting Johns, Rauschenberg turned away from painting as an Abstract Expressionist drama of selfhood and started bringing culture history, politics, Judy Garland and Abraham Lincoln—back into art. In turn, Johns, after meeting Rauschenberg, finally became a painter.

Whether these developments are more properly credited to the influence of one man or the other, or whether they were instead a product of their conjunction is difficult to determine. But the importance of community as perhaps the defining issue in the development of gay subjectivity is clear. Given the insistent social pressure that isolates and pathologizes gay and lesbian people, community and commonality are the chief ingredients in the development of a specifically gay identity. Recent scholarship in lesbian and gay studies has made clear, for example, the importance of

the Second World War in the development of lesbian and gay communities in the United States precisely because it forced together individuals from diverse places and backgrounds, including lesbian and gay people, each thinking they were the only ones like themselves. As they came to discover one another, they began to articulate their difference and develop communities of mutual support which continued, even grew, after the war. Coupledom operated in a similar fashion for Johns and Rauschenberg in the context of Abstract Expressionism, creating in each of their lives a possibility for dialogue, understanding, and support such as they had never experienced. As Rauschenberg put it, "Jasper and I used to start each day by having to move out from Abstract Expressionism."¹¹

Although Johns and Rauschenberg looked primarily to one another for community, by the mid-50's a newly assertive gay and lesbian minority was beginning to make its presence felt. Not only were new lesbian and gay civil rights organizations like the Mattachine Society holding regular meetings in New York, but figures like Frank O'Hara and Allen Ginsburg were writing about their gayness in explicit terms. Johns and Rauschenberg knew and were friendly with some figures in this gay avant-garde, but it was primarily a literary world and never their main social focus. The art world was still overwhelmingly heterosexual, and while Rauschenberg and Johns were always invited out together as a couple, neither they nor their hosts were ever explicit as to the relationship between them. As a couple, they were able to reap the benefits of a shared subjectivity without having to identify or affiliate with a larger gay and lesbian community.

By 1954, Twombly had been drafted into the army, and Johns had become the major focus of Rauschenberg's attention. At this time, Rauschenberg even stopped going to the Cedar Bar and socializing with the Abstract Expressionist painters he had known for years. He has remarked about Johns:

He and I were each other's first serious critics. Actually, he was the first painter I ever shared ideas with, or had discussions with about painting. No, not the first, Cy Twombly was the first. But Cy and I were not critical. I did my work and he did his. Cy's direction was always so personal that you could only discuss it after the fact. But Jasper and I literally traded ideas. He would say, "I've got a terrific idea for you," and then I'd have to find one for him. Ours were two very different sensibilities, and being so close to each other's work kept any incident of similarity from occurring.¹²

Rauschenberg's life and art changed significantly after he became involved with Johns. Indeed, one can almost divide his career in two at the moment of their meeting. This is not to say that one was a leader, the other a follower, but rather that they reinforced each other's inclinations, gave each other permission to strike out in new directions, supported risk taking, and provided an understanding context for discussion and debate.

Among the first works Rauschenberg completed after meeting Johns were a series of square paintings made out of diverse materials such as tissue paper, dirt, and gold. Johns reportedly helped on the series, the point of which was to explore a cultural hierarchy of values that considers dirt and paper humble materials but gold precious and rare. Rauschenberg predicted that the gold works would be valued and the others ignored. He has proven prescient: only one dirt and one clay painting survive, none in tissue paper, but ten in gold leaf.¹³ With this series, Rauschenberg initiated a new focus on the social and its role in the making of meaning, the determining of value, and the conveying of significance. The artist's ability to communicate is no longer understood as a transcendent individual gift as it was under Abstract Expressionism, but as the product of a shared cultural heritage. In these simple collages, the Abstract Expressionist alchemy transmuting feelings into paint was ruptured and replaced by a new concentration on the role of the audience in creating meaning in a work of art.

Another early sign of change in focus is a curious painting titled *Yoicks* (1954). It was unlike anything Rauschenberg had produced before. A huge canvas covered with alternating strips of cloth and paint in bright yellows and reds, it is different from the relatively somber palette of previous works. The combination of the title, derived from a comic strip pasted on the surface, and the lively palette gives *Yoicks* a celebratory tone. It marked a new direction in Rauschenberg's conception of the canvas. No longer understood as a place to register sentiment and sensibility, an emotive field in the manner of Abstract Expressionism, the canvas now became a material fact, an actual thing upon which to place other actual things, from strips of cloth to newspaper comics. The alternating horizontal stripes of *Yoicks* seem to derive from the rectilinearity of the canvas itself, as if the painting were not so much an imposition of mind on materials, as a product dictated by the materials themselves.

Rauschenberg next turned to an assemblage of painted images and sculptured objects. He would soon dub this type of additive

composition a Combine, signaling a new genre somewhere between painting and sculpture. He would make combines for the next seven years—throughout the entire period he and Johns were together ceasing about a year after their breakup. He once told a collector who was buying his first combine, called *Untitled (with Stain Glass Window)*, that it was painted at a time of passion for a friend, presumably Johns.¹⁴ The paint-splashed floor boards attached to the bottom of this work are an ironic literalization of the Abstract Expressionist splatter, a concrete reminder of the common joke that some of the best painting is left on the floor.

Within a few short months of meeting Johns then, Rauschenberg had embarked on three new, highly significant changes of direction in his art: exploring the role of the social in the determination of meaning; employing the canvas not as field but as literal support; and finding in the development of the combine a medium to make concrete these two new considerations. These changes in direction and focus remain the chief preoccupations of Rauschenberg's art to the present day. Taken together, these new themes constitute a kind of refusal of the then ubiquitous Abstract Expressionist pictorial practices. Perhaps the dedication of this first combine to Johns was a sign of his determining role in its development.

For Johns, the meeting with Rauschenberg may have been even more significant. The simple fact of the matter is that Johns was not an artist until after they met. The association with Rauschenberg did more than give him the courage to give up his day job and become an artist, it showed him what that decision really meant. Rauschenberg taught Johns discipline, exchanged ideas, showed him alternatives to Abstract Expressionism, and nurtured his career. Johns has remarked of their meeting, "He was kind of an *enfant terrible* at the time, and I thought of him as an accomplished professional. He'd already had a number of shows, knew everybody, had been to Black Mountain College working with all those avant-garde people."¹⁵

Little record remains of Johns's work during the early months of the relationship because he tried to destroy it all. But enough pieces survive to indicate what some of it must have been like. Judging from these few works, they seem very much in the spirit of Rauschenberg's combines. Johns covered a toy piano with collage, mounted a similarly collaged panel above a plaster cast of a head, covered a Jewish Star with encaustic and collage. Perhaps he destroyed these works because, in their use of found materials and collage, they seemed too close in spirit to the work of his mentor.¹⁶

Johns's breakthrough came in a painting called Flag (1955). A single image of an immediately recognizable American icon, Flag at first seems to have nothing in common with Rauschenberg's work of this period. In that sense, it succeeded in opening an avenue of exploration that had not been claimed by his lover. But beneath their surface differences, both Johns's flags and Rauschenberg's combines share a similar dynamic. Both take fragments of culture as the stuff of art, making the relationship between viewer and object the subject of inquiry. Flag poses fundamental ontological questions. Is it a flag or a painting of a flag? Whatever the answer, it has nothing to do with the artist's sense of self. Once again, the artists' gayness has led them away from a celebration of the individual and toward the bedrock of culture where all meaning is made.

Johns's career developed swiftly after his first exhibition at the Leo Castelli Gallery. The Museum of Modern Art bought three paintings from that first show and one appeared on the cover of *Art News*. Johns's stark, single-image canvases struck the art world as completely new. In contrast, Rauschenberg's drips and complex pictorial arrangements still had something of the Abstract Expressionist about them. He would enjoy no similar degree of success until his victory in the Venice Biennale of 1964.

There is no doubt, however, that Johns and Rauschenberg were extremely close both professionally and personally during this time. Johns has said: "our world was very limited. I think we were very dependent on one another. There was that business of triggering energies. Other people fed into that but it was basically a two-way operation."17 That two-way operation is evident in many of the paintings from this period. In a large combine called Untitled (1955), Rauschenberg explicitly addressed his relationship with Johns and its place in his emotional life. He collaged onto the surface of the piece drawings by Twombly, a photo of his young son, clippings about his family from a hometown newspaper (some going back many years), a naive oil painting by a relative, a drawing of an American flag (the year Johns painted his first one), a photo of Johns that Rauschenberg once termed "gorgeous," as well as letters from Johns, judiciously torn up. The combine thus stands as a meditation on family and love, merging seemingly incommensurable fragments of past (family) and present (sexual) love into the integrated whole that was unvailable to the artist any other way.

Another combine of the same year called *Short Circuit* is literally a combination of the work of three artist friends within an armature

Robert Rauschenberg, Bantam, 1954

provided by Rauschenberg. In this piece, submitted for an annual retrospective at the Stable Gallery, Rauschenberg protests the exclusion of these friends from the show by smuggling them in through his painting. The combine includes a Johns flag under one door, a painting by Weil under another, and a third image by his friend Ray Johnson. In addition, there is a program from an early John Cage concert and an autograph by Judy Garland. While the participation by friends and lovers is logical given the circumstances, the Garland autograph is a most curious addition, signalling the development of yet another new phase in Rauschenberg's art, a phase again tied to his relationship with Johns.

Judy Garland was and is the high priestess of gay culture, the queen diva of all time. Her inclusion in this and other combines of the period (like *Bantam* of 1954) directly alludes for the first time in Rauschenberg's work to his identification as a gay man. These works were part of a new series of combines that began to figure gay cultural tropes in increasingly explicit ways, from the evocation of the Ganymede myth in *Canyon* (1959), to the phrase "YOUR ASS" that dominates one side of *Photograph* (1959), to the tracing of a nude man, complete with genitals, in *Wager* (1957–9). However, these images constitute a "coming out" legible only to those who are "in." The gay

references tend to be so subtle and obscure that only now are scholars beginning to recognize them. Indeed, whether Rauschenberg intended these references to gay culture to be understood as a statement of identity by any audience, straight or gay, is a matter of conjecture. He never identified himself publicly as a gay man, and the possibility exists that these references were intended only as private jokes to an audience perhaps no larger than his lover.

What references there are to gay culture tend to be complex and indirect. For example, Bantam includes a team portrait of the New York Yankees spattered with Abstract Expressionist paint which is then juxtaposed with delicate fabric swatches, a nineteenth-century nude odalisque staring at herself in a mirror, and another autographed photo of Judy Garland. While the presence of Garland alone was curious enough, the reference was coupled with a peculiar title. According to Webster's Dictionary, "bantam" means "a small but aggressive or pugnacious person; 2. any of several breeds of small fowl in which the male is often a good fighter; 3. a boxer or wrestler weighing between 113 and 118 pounds." In short, bantam refers to an over-wrought, overacted masculinity-a kind of nervous overcompensation for a perceived lack. Here the gestural paint splashed over the Yankees photo, coupled with a curious title, seems to deliver a highly coded, campy indictment of Abstract Expressionism and its self-conscious and exaggerated masculinity. Such a reading is reinforced by the odalisque looking at herself in a mirror, and the star photograph of Judy Garland.

Where Rauschenberg's allusions to his sexuality are more explicit, they require a fairly sophisticated literary background. In one drawing for a series of images illustrating Dante's *Inferno* (1959–60) he pays particular attention to the canto describing the fate of sodomites. According to Dante, sodomites are sentenced to run forever barefoot over hot sand. And at the top of his drawing, Rauschenberg has outlined his foot in red. The more explicit references to gay culture and his identification with it seem to be the product of a deepening relationship with Johns, for they increase in number and specificity as the relationship develops. Although no similar pattern can be discerned over the span of his earlier relationship with Twombly, by 1959 references to gay culture can be found in a large percentage of Rauschenberg's work.

Johns's art has never been as explicit. Beginning in 1956 with the painting *Canvas*, he began to make the question of his identity the central focus of his art, always posing it in the form of a query or a

Jasper Johns, Target with Plaster Casts, 1955; Painting with Two Balls, 1960

problem, never celebrating it as the Abstract Expressionists would have done. *Canvas* consists of two stretched canvases facing in on one another so that the image is primarily the back of one canvas covered with paint. The painting is structured as if it were a self-portrait, but where the face would be there is instead a refusal, a turning away.

After completing this picture, Johns continued to explore the theme of closeted identity. He paints over a drawn shade in the painting *Shade* (1959), covers a book with paint in *Book* (1957), obscures a newspaper in *Newspaper* (1957). He paints drawers that can't be opened in *Drawer* (1957). These objects function only when opened and yet Johns offers them painted shut. In each case, the surface is obscured with layer upon layer of rich encaustic. Even the target and flag imagery is painted in thick encaustic over fragments of newspapers so that the print can be discerned but rarely read.

Another groundbreaking work, *Target with Plaster Casts* (1955), consists of a series of little boxes with doors containing plaster-cast fragments of a man's body. These fragments are placed above a target painted in encaustic. Here, the targeted body is literally closeted. As Johns has written in one of his early sketchbook notes, "An object that tells of the loss, destruction, disappearance of objects. Does not speak of itself. Tells of others."¹⁸ It's a phrase that applies equally well to Johns's art and to Johns himself.

Exchanging ideas and motifs was an important part of the relationship between Johns and Rauschenberg despite their different approaches. Johns tells us something of this interchange: "You get a lot by doing. It's very important for a young artist to see how things are done. The kind of exchange we had was stronger than talking. If you do something then I do something then you do something, it means more than what you say. It's nice to have verbal ideas about painting but better to express them through the medium itself."¹⁹ For example, both Johns and Rauschenberg often used flashlights and light bulbs. Rauschenberg tended to incorporate the actual objects into his combines while Johns often drew them or made them out of sculptmetal. It appears that Johns followed Rauschenberg's lead in most of these object-oriented exchanges, and he continued with them even after the relationship itself ended.²⁰

Over the course of their relationship, Johns's painting became less solemn and meditative, occasionally even picking up the camp humor of Rauschenberg's work. *False Start* (1959) consists of a gestural Abstract Expressionist color field labeled with unmatched color names; the word orange, for example, stenciled in white letters over a red field. The painting operates as a kind of Abstract Expressionist drag—Johns putting on the Abstract Expressionist style and at the same time showing how ill it fits him, how complicated and mediated is this presumed automatic translation of gesture into subjectivity. The color names act as a barrier to our reading of these strokes of color as pure expression, and the falsity of the labels reinforces the falsity of the gestures. In *False Start*, Johns chronicles the misfiring of emotional authenticity, painting an Abstract Expressionist picture that is manifestly untrue.

In the series of paintings of flags and numbers that preceded this image, Johns painted Abstract Expressionism's "hot" gestures in the medium of encaustic—a suspension of pigment in melted beeswax that requires slow application and precise temperatures. Creating frozen "spontaneous" gestures in painstaking encaustic was thus another means of offering the signs of immediacy and emotional authenticity that were Abstract Expressionism's hallmark, without any possibility of their sincerity. Johns's *Thermometer* (1959) made this problem of authentic, unmediated gesture explicit. Placing a thermometer on top of a field of "hot" Abstract Expressionist brushstrokes, he took its temperature. Not only does Abstract Expressionism's "heat" require a cultural gauge, the thermometer reads room temperature.

Nowhere is Johns more explicit in his campy critique of Abstract Expressionism than in *Painting with Two Balls* (1960). Inserting two small wooden balls into a horizontal opening in an Abstract Expressionist gestural field nicely summarizes Johns's take on the source of Abstract Expressionism's classically masculine pictorial ambition. *Painting with Two Balls* can profitably be compared with Rauschenberg's *Bed* (1955), a combine that features an Abstract Expressionist gestural painting on what could be (it isn't, after all, a mattress) a real bed, complete with quilt and pillow. *Bed* also located the origin of Abstract Expressionist ambition within its sexual politics. Early reviews of *Bed* claimed that the piece resembled nothing so much as the sight of a rape, or maybe even a murder. In joining sex and violence in his painting, Rauschenberg both imitates the Abstract Expressionists he knew so well and reconfigures their linking of esthetics and sexual politics.

In the middle of 1959, Rauschenberg left New York for Florida to work on his Dante drawings. It would prove to be the beginning of the end of his relationship with Johns. While they were often close in their thinking, they were almost polar opposites in terms of personality. Where Johns has always been shy, Rauschenberg is outgoing, so much so that some of the older painters even thought of him as something of a clown. Johns works slowly and deliberately-a cool, serious intellectual who obsessively repeats themes and whose references tend toward the literary. Although exceedingly well-read and articulate, he rarely discusses his work, and his reticent and selfprotective interview style has generated its own adjective, Johnsian. Rauschenberg on the other hand is famously garrulous, and his working method is spontaneous and intuitive. References in his work tend toward the pop cultural and are rarely literary. Indeed, Rauschenberg suffers from dyslexia which makes reading difficult. Johns remembers that he used to read his favorite poetry aloud to Rauschenberg who, while willing to listen, had neither the patience nor interest to make it the object of serious study.

Rauschenberg has remarked that his "sensual excessiveness" alienated Johns.²¹ It is a remark that functions on a number of levels, both stylistic and biographical. After the final breakup in 1961, which was by all accounts quite painful, the artists severed relations for a long time. The camp humor of the Abstract Expressionist parodies evaporated in favor of a return to a highly coded and idiosyncratic imagery. Neither artist would employ explicit homoerotic themes for some time. Johns moved south and began a series of paintings that, in

his usual coded way, addressed his feeling about the relationship. One of these pictures, called *Liar* (1959), consists simply of the word "liar" stenciled on a canvas. Other images are more complex, such as *In Memory of My Feelings*—*Frank O'Hara* (1961), which, tellingly, takes its name from a well-known poem by O'Hara that speaks of gay love and the disintegrated and reintegrated self. Rauschenberg, in turn, worked on a combine called *Slow* or *South Carolina Fall* (1961) dating from the year of the breakup. It features a South Carolina licence plate set above a piece of crumpled, discarded metal, the whole composition looking like nothing so much as discarded debris. Johns, of course, was born in South Carolina and had returned there.

After the breakup, Johns began to make increasingly larger, multi-panel paintings to which he attached different objects, abandoning the single-image works that initially garnered him such attention in favor of pictures that approach the appearance of combines. In turn, Rauschenberg began to give up attaching objects to his surfaces in favor of experimenting in the two-dimensional realm of the silkscreen. Perhaps the separation allowed them to experiment more explicitly in one another's styles.

In 1955, Johns had painted a cheerful bright blue painting called Tango. It featured the word "TANGO" stenciled on a brushed encaustic ground with a small key sticking out of the lower right-hand corner. The key belongs to a music box and could be turned to play a tune. The whole composition was very much in the spirit of Rauschenberg in its use of objects, its synesthesia, its humor, its address to the spectator and the concomitant innuendo, as in "it takes two to tango." It's so uncharacteristic of Johns's work that it could very well have been painted as a tribute to Rauschenberg. After they split up, Johns pictured relationships in a very different way in a series of paintings inspired by the life and work of the gay poet Hart Crane. In these paintings, he seems to concentrate on Crane's suicide by drowning at the age of 33 in the Gulf of Mexico as he returned, despondent, from his honeymoon. The paintings feature a stark hand and arm rising from the depths and reaching, unsuccessfully, for the sky. Johns, himself in his early 30's, used his own arm to make the image. Negative though they may be, the Crane pictures remain the only even vaguely gay images Johns painted after the breakup. Rauschenberg, too, ceased to use explicitly gay imagery after they parted. It is as if, without one another, Johns and Rauschenberg have lost the ability to represent themselves.

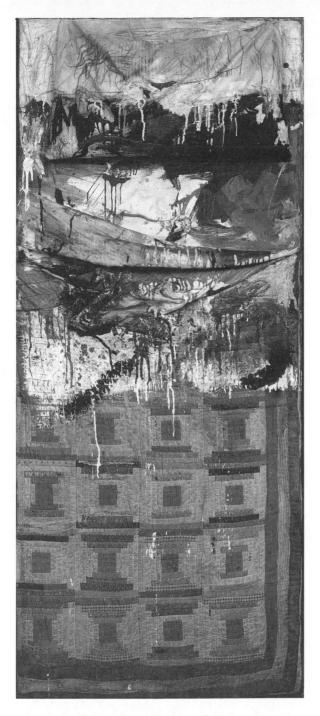

Robert Rauschenberg, Bed, 1955

207

Simone and André Schwarz-Bart, 1960's

SIGNIFICANTLY OTHER Simone & André Schwarz-Bart

RONNIE SCHARFMAN

THE MULTICULTURAL, multiracial marriage and literary project of Simone and André Schwarz-Bart are surely unique in the contemporary literary world. For not only are these two writers committed to giving voice to human loss and suffering, to bearing witness to the past of their respective peoples—his Jewish, hers African-Caribbean—they are also deeply involved in supporting one another's literary efforts to memorialize genocide and slavery through writing that simultaneously celebrates human dignity.

One cannot imagine two stories, two personalities, and eventually, two styles of writing more different, in superficial ways at least, than those of the Schwarz-Barts. He is a white, Jewish, European male, survivor of the Shoah (Holocaust), and she, a black woman from Guadeloupe, descendant of African slaves in the colonial diaspora. And yet their common endeavor, as fragile and fraught with risks as it is, also makes so much sense when one examines them closely, that one cannot help but be moved by the ways in which they, as a couple and as writers, testify to the strength of the human spirit and love's capacity to build bridges. They constitute a model for our times, when the rhetoric of hatred and bigotry is once again surfacing with impunity.

Both authors have been pained by the contradictory public reaction to their works—widely acclaimed and award-winning on the one hand, violently criticized on the other. And both have sought with scrupulousness and discretion to create works that serve as a repository for collective memory, testifying to the authenticity of a people's history through the imaginative transfiguration of fiction.

André Schwarz-Bart was born Abraham Szwarcbart in Metz, in eastern France, in 1928. His parents were Yiddish-speaking immigrants from Poland, who had come to France in 1924, and settled in Metz's Jewish quarter. Although his father was a learned Jew, in France he made his modest living selling stockings in the market, with the help of his older children. André was destined to remain among the working class for many years, since the war interrupted his

education. He was 11 years old when the Second World War erupted in 1939, 12 when his family was evacuated to the interior of France, and 14 when he became head of what remained of his family, three younger brothers. The Nazis had arrested and deported his parents, his older brother, his little sister, his great aunt. He would never see his parents again. His world famous novel, *Le Dernier des justes (The Last of the Just)*, which won France's prestigious Prix Goncourt in 1959, ends with its hero, Ernie Lévy, being gassed in Auschwitz. But it begins in 1185, with the massacre of the Jews of York, England. It is not, as Schwarz-Bart himself has emphasized many times, a novel of the Shoah. When we know about the tragedy that befell his family and his turbulent adolescent years, we understand how he could not, because of what he calls his terror and his sense of the sacred, write his family's story and how, paradoxically, he could not write any other.

His life during the war years consisted of odd farm jobs to keep his little brothers alive until 1943, when the French police moved them all to Paris. There, the young André made contact with the Resistance, which helped him move his brothers and his little sister, miraculously saved from deportation, to the Free Zone in 1944. He was arrested in Limoges by the militia for his Resistance activities, but managed to escape. After the Liberation of France, he organized with Jewish companies to continue the fight, but they were not being sent to the Front. So he enlisted in the regular French army and fought with them until the end of the war on the Atlantic coast. In 1945, back in Paris and living in a Jewish Foyer (Home), he joined the thousands who went daily to the Hotel Lutétia to meet those returning from the camps. His parents never returned. It is difficult to sound the depths of André's reality at this point. He was only 17 and had lost half his family. He had not been to school since age 11 and even then French had been only his second language. His early adolescence, coinciding with the war, was devastating. But it formed a young man of great courage. His post-war trajectory is astonishing, for in those years, working as a mechanic in a factory, as a miner, a foundry laborer, he taught himself enough French to pass the difficult Baccalauréat exams, enroll in university at the Sorbonne, and begin to write. An avid reader of mystery novels, he had also discovered literature. He began a working-class novel, some imaginative renderings of his parents' lives in a Poland he never knew and which was now annihilated, and some short lyrical pieces. He already seems to have felt a visceral need to write about the Shoah, but is scrupulous in not wanting to betray the memory of its victims.

These years, the mid-1950's, are the ones during which André attempted to give form to what would become, in its fourth version, his masterpiece. They are years during which he turned inward, learning about the history of Eastern European Jewry in all its richness, researching for his novel the spirit of the world Hitler exterminated. In his daily life, Schwarz-Bart was also culturally active in Jewish organizations, earning some extra money as a counselor, then as a teacher, in Jewish orphanages and schools. Here, too, he is filled with stories of the unbelievable horror, as well as the growing determination to bear witness to it.

Yet at the same time André turned outward as well. In his generosity of spirit, he recognized and befriended another persecuted, marginalized, nomadic community in Paris: the French West Indians. In 1946, when the Caribbean islands of Martinique and Guadeloupe were granted departmental status by the French government, giving them equal rights as French citizens, another population displacement occurred. These grandchildren of slaves, from islands where slavery had been abolished, but not forgotten, since 1848, had moved back across the Atlantic, this time to Paris. They sought to further their education, get better jobs, sometimes even "become French." Among these was young Simone Brumant, from Guadeloupe, born in 1938, continuing her studies in Paris. She and André were married in 1961.

In one of his few public statements, André Schwarz-Bart discusses his attraction and feelings of kinship for the West Indian community. In this interview-which he granted Le Figaro Littéraire in January 1967 on the eve of the publication of the novel that he and his wife co-authored, Un Plat de porc aux bananes vertes (A Dish of Pork with Green Bananas)-André speaks of two different, equally compelling emotions. He loved these people, he says, not out of some abstract sense of solidarity with "our brothers of color," but because of a "very lively sympathy that I felt, almost immediately, for their ways of being, for their gaiety, for their gentleness, their wisdom, their art of living, for this kind of verbal lyricism such that, in the mouth of a West Indian, of a true West Indian, all becomes poetry, beginning with himself. In all, as often happens, I loved, I admired, the Antilleans for the qualities that I do not possess."1 The "other" here is acknowledged by Schwarz-Bart, in his difference, not as a threat, but as an ideal.

However, his attraction went beyond that of wanting to participate in the other's joy. What drew Schwarz-Bart to the

Antilleans was the common bond he felt with their slave past. In the same interview, we read his account of the last Passover Seder he spent with his parents in 1941, reciting the story of the exodus of the Israelites from their slavery under Pharaoh in Egypt. It was already that child, he tells us, who was seized by a fraternal and definitive love for the West Indians.

To bear witness to oppression, to transform suffering into art, to triumph over loss by giving it form as well as to triumph over the forces that would eradicate it to oblivion, and to demonstrate that suffering has a dignified dimension without glorifying it—these were André's artistic goals. And when they wrote their first book together, Simone discovered that they were hers as well.

If André spent excruciating years on the different versions of LeDernier des justes, finding the right tone, mastering his language, expanding the historical fresco of the Lévy family to encompass all of Europe since medieval times, delving assiduously into Jewish theology and mysticism, writing and rewriting drafts obsessively so as never to demean his subject (European Jewry exterminated by Hitler), we can begin to imagine how scrupulously he might approach his next novel (Un plat de porc . . .), about a poor, aging, lonely Martinican woman, waiting for death in an old people's home in Paris. He probably would never have even dared to speak for such a radically different community from his own had it not been for three factors in his life.

The first occurred in 1955, in the form of a conversation with an old West Indian friend who revealed to André that she had been hurt by racist remarks directed toward her by some of his supposedly progressive white friends. He was devastated to realize how subtle racism can be, and motivated to prove to her, in a book, that things could change, be changed. The second factor was, strangely, the critical reception in 1959 to Le Dernier des justes. For despite its immediate international acclaim, there were harsh criticisms as well. What came to be known as "The Schwarz-Bart Affair" consisted of accusations of all kinds-from plagiarism (unfounded), to deforming history (insensitive to the powerful mythical dimensions of the novel), to a betrayal of Jewish persecution by what seemed like a Christian theology of redemption (missing the point of Schwarz-Bart's brave decision to portray non-heroic characters). André was confused, pained, and angered by the ways in which his text had been misconstrued. And although he had not even begun to treat the haunting issue of the Shoah that obsessed him, he began more and

more in his mind to formulate a Caribbean novel which would deal with the memory of slavery. The Prix Goncourt allowed him to travel to Guadeloupe in 1960, where he met his fiancée's family, then to Martinique and French Guyana. He described the trip as a real awakening to the everyday reality of the ineradicable scars of slavery, as well as to the lack of genealogical memory beyond the era of the Middle Passage, the forced transatlantic slave crossing. History was rupture. He discovered that historical dimension without which, as for the Jews, the most insignificant daily gestures are incomprehensible.

Before undertaking this research trip for his second novel, Schwarz-Bart went to the Parisian publishing house Présence Africaine to meet the founders of the literary movement known as *négritude*. He was seeking their benediction for his new project in the form of an ethical pact. He would submit his new manuscript to them for their approval (he made an appointment for "eight or ten years" from then), letting them judge its validity before giving it to his own publishers. His reason was a moral one: believing that a writer is responsible for the living reality he portrays, he asked himself if, as a white man, he had the right to speak for people of color without their agreement.

This strange, ambitious, and perhaps impossible project would never have come to fruition were it not for the third factor, fortuitous and, as fate would have it, felicitous for both the Schwarz-Barts and the literary world.

Perhaps to escape the ambiguous celebrity, the Schwarz-Barts moved to Senegal in the early 1960's, where their first son was born. The initial years in Africa were so overwhelming in the intensity of their experience that André wrote nothing for months. Then the project grew, went through multiple versions during long, painstaking years, and finally became the narrative of one old Caribbean woman trying to reconnect with her painful past, and recount her life from the lonely exile of an old-age home where everybody was deteriorating around her in a concentration camp like atmosphere. By this time, after 1963, the Schwarz-Barts were living with Simone's family in Guadeloupe, and had had their second son. André had discovered the history of a woman named Solitude, leader of a slave insurrection in Guadeloupe at the end of the eighteenth century, and armed with this what he called "mythico-historical" scaffolding, left for Europe to cloister himself away in order to finish. Instead, he reached an agonizing impasse. Recognizing, despite his expressed

belief in the universal possibility of human communication, that there is also an "unfathomable core" to each people, to each cultural entity, he had to admit that his manuscript respected the letter of the Caribbean world, but lacked what he called its "perfume." He was thrown up against his own limitations, realizing that he could not become this perfume himself. At this point he made the despairing decision to renounce it completely.

Enter Simone Schwarz-Bart. André had asked her from Paris to refresh his memory about a rural scene they had witnessed together in Guadeloupe where two young boys were arguing, insulting each other in Creole. What she wrote back is described by André at length as the birth of a writer. His admiration and emotion are palpable here, and, as the moment also constitutes the beginning of their collaboration, I will let the writer speak for himself:

One day, and why not say, one beautiful day, I received a text where I had a hard time recognizing the brief account I had asked of my wife. Not only had she found a translucent, silken equivalent for each one of the turns of phrase and expressions of the Creole language, but also, without knowing it, her imagination had interpreted, transformed, added all those little details by which one recognizes a true writer. I was overwhelmed. I held in my hands the very substance I was vainly seeking, and which had been forbidden to me. All that I had loved in West Indians for ten years, all the colors and all the perfumes were to be found there in this text whose modesty was all the more moving as it claimed only to revive my memory.

Lest the reader misconstrue his account as being in any way patronizing or exploitative, let me briefly add that André immediately wrote back an admiring letter, encouraging Simone to continue writing, and asking her, as well, to collaborate fully on his novel, since he could not just incorporate the piece he had received from her in all good faith.

Is it naive to think that some writers are made and others born? André's depictions of his endless agonizing over multiple drafts and rewrites, as well as the years of research he put into each of his three novels, combined with what we know about his coming to schooling late and with some difficulty, and what he lived through as a youth, all point to André Schwarz-Bart's struggle to make himself a writer. By contrast, Simone's first "literary" text is illuminated by its grace and apparent spontaneous generation. Although some serendipity surrounds this moment in the couple's story, we might also look to cultural difference and acknowledge it as a partial explanation of their

very different writing styles, rather than fall prev to clichés and generalizations. Because of the magnitude of the catastrophe he first sought to record, and because of his own feelings of ignorance and limitation, André became an avid autodidact, recapitulating, perhaps unconsciously, an identification with the ancient origins of his community-the People of the Book. Although it was not only the Holy Book he steeped himself in, André's approach to writing always included years of careful reading and note-taking and interpreting and questioning and transforming, all reminiscent of Jewish Talmudic scholarship. Simone, on the other hand, came from the culture of the conte, the oral tale. All of her characters are storytellers as well as stories told. She grew up in a world where stories were always alive, swirling around her head, and, therefore, inside her head as well. In an interview she gave to two Antillean scholars in 1979, Simone discusses the technique of orality, and her identification with it. She traces it to the African griot and his role as memory of the collective genealogy. "The tale is, in large part, our capital. I was nourished on tales. It is our bible. Our whole behavior in life, our ways of reacting, in fact, issue from the tale. . . . I don't have a technique, but I know. I'm familiar. I've heard. I've been nourished. I know how it has to be told.... And I think, like the Africans, that when an old person dies, a whole library disappears."² This self-assurance derives from a sure sense of place, both geographical and familial, that Simone was not only born with but also nourished on.

Who then is this confident writer who went on, after her first collaboration with André, to write two highly successful novels, a play, and the six-volume Hommage à la femme noire? In the Hommage Simone Schwarz-Bart credits her mother, Alice Didier Brumant. whom she extols at the end of the six volumes recording the lives of black women, with having given her "the highest idea of the courage of the black woman and of her dignity." This good mothering, so essential for a young girl's sense of self-esteem, would be incarnated in her first solo novel in the character of the grandmother, Reine Sans Nom. Simone's mother was a schoolteacher. That meant Simone was from a modest milieu, what she calls the very petite bourgeoisie, but was not a rural peasant. The advantages of growing up in such a milieu were that she did not really have to abide by class distinctions. She claims the social strata were not rigidly defined in her childhood, and, more importantly, people of different classes mixed more than among the urban bourgeoisie. Moreover, because her mother belonged to what she designates as that "heroic generation of teachers

who fashioned the features of the Antillean face," and because she was orphaned and unprotected, she was sent to the most God-forsaken posts with single-room schoolhouses containing 100 to 130 students. Simone therefore moved a great deal, and was most frequently in rural communities. Her mother had to share her students with their seasonal chores in the fields, but Simone came to learn about "back country folk" that way, and to feel part of their life and customs. The ease with which she writes of their daily struggles as well as her use of Creole come directly from her rootedness in that culture.

If she lauds her mother's fighting against impossible odds as being the inspiration behind the magnificent volumes of black women throughout the ages, it is another woman, a kind of adopted mother, a rural healer named Stéphanie Priccin, who served as the model for the protagonist, Télumée, in Simone's award-winning novel Pluie et vent sur Télumée Miracle (The Bridge of Beyond, 1972). Simone knew this woman as a child, became intimately linked to her in womanhood, admired her savoir-faire and savoir-vivre, her sense that she was a unique individual whose life had meaning and dignity. She represented a whole generation of women to whom Simone Schwarz-Bart ascribes her sense of what the Martinican poet Edouard Glissant calls antillanité, her sense of who she is. After this woman died, Simone found herself writing short pieces about her, and André encouraged her to expand them into a novel. It was based on her life as an example of a kind of permanence of the Caribbean being, and certain values, particularly feminine ones. Simone had never thought of herself as a writer. But her experience of using Creole to express the interior world, the world of feeling, to translate into French a whole Antillean universe, had already given flesh and bones to the earlier character of Mariotte in the Plat de porc written with her husband. Suddenly, with this friend's death, Simone felt the same sense of historical urgency that had always plagued her husband—the need, as she put it, "not to let another piece of our history escape" yet again, the need to bear witness, to restitute memory.

Télumée was published in Paris in the same year that André's La Mulatresse Solitude (A Woman Called Solitude) came out, 1972. Télumée was Simone's first solo novel; La Mulatresse, though projected as the second in an eventual cycle of seven about Antillean history, was André's last. He has again fallen silent. In a telephone conversation in 1991 Simone said that he was in a convent in Europe, trying to write, perhaps the narrative of the Shoah that has always haunted him. Since Télumée, Simone has gone on to write a second novel, Ti-Jean l'horizon

(1979), a play, Ton Beau Capitaine (Your Handsome Captain, 1987), and the homage volumes already discussed. It is as if André had passed the flame to Simone, and she carries it high and bright, creating a very different Caribbean universe in Télumée from the one her husband had in La Mulatresse. Like André, Simone had great success with her first novel. Published in Paris, as most postcolonial Francophone literature still is, it was awarded the "Grand Prix des Lectrices" of the women's magazine Elle. Although not of the status of the Goncourt, this was still an important literary prize in Paris, particularly for a Guadeloupean woman, and the novel continues to be a commercial success, as was Le Dernier des justes. Its translation into English has made it a particularly beloved novel amongst readers of African-American literature.

And yet, also echoing her husband's experience, Simone Schwarz-Bart was criticized by the Caribbean intellectual elite who did not find it political enough—it was not *engagé* in the sense that it is not an overt call to arms against the alienating powers of colonialism. Simone's response was lucid and solid: the very act of writing that novel was political because a black woman wrote it, because it deals with a matriarchal lineage of women who triumph in dignity over loss of all kinds and, especially for her, because simple people recognized themselves in it, could identify with the characters. In a lovely anecdote in the Toumson interview she recounts how women selling in the market in Guadeloupe would ask her to write the name of her book in the palm of their hands so they could ask for it at the bookstore, since they had heard passages on the radio. She was delighted with such an enthusiastic local response.

It is another unusual aspect of this writing couple that, because each is different from the dominant culture's norm, each is "significantly other," each had to inflect the French language in a unique way to render an un-French world. If André sent his mother tongue, Yiddish, underground so to speak, in order for his Frenchlanguage novel to function as a form of resistance against oblivion (how many were left, after the genocide, who could read Yiddish?), Simone, in contrast, has brought her mother tongue, Creole, to the surface of the French language, in order that both her colonized, often bilingual compatriots might read themselves there, and the French might have access to the Creole world she represents. The novel is not a picturesque curiosity punctuated by exoticism or local color. It is, rather, an authentic human experience expressed from the inside of Creole reality. The narrative is interspersed with proverbs, epigrams,

snippets of folk wisdom, more often than not referring to a common feminine experience ("However heavy a woman's breasts may be, she is always strong enough to carry them"). Allegorical tales or parables, whose heroes are the flora and fauna of Africa in their local Caribbean incarnations, are used to illuminate the great mysteries of life, from the biological to the historical. In particular, young Télumée comes to understand her link to her slave ancestors by listening to tales her grandmother, Reine Sans Nom, and her sorceress friend, Ma Cia, exchange.

Simone Schwarz-Bart makes use of humor and the marvelous (here some find her related to the Magical Realists of Latin America, such as García Marquez) as fundamental aspects of the inventiveness of Creole. Her way of writing consists of transcribing and translating passages from Creole into French. She claims, modestly, in the Toumson interview, not to analyze what she does, not being a critic or scholar, only to go on working.

French is, for both of them, the language they have chosen to write in, yet neither is completely at home there. This is a metaphysical issue rather than a linguistic one, since both are geniuses with French, each in his or her own style. But it is as if André were irrevocably exiled there, his mother tongue having been murdered, whereas Simone seems like a willing visitor, comfortable, yet rooted elsewhere. Her native Creole may be denigrated in the metropole, but it has never been wrested from her. She is so secure in this that in *Télumée* she did not intersperse any sequence actually written in Creole. She commented on this aspect of her choice in the Toumson interview: "A language is first of all communication. . . . I have the impression of putting into this sort of French that I write in my Creole way the spirit of our language."³

On the other hand, La Mulatresse Solitude, the second novel written by André Schwarz-Bart alone, which takes place briefly in Africa and then in Guadeloupe around the time of the French Revolution and its aftermath, despite its Caribbean subject matter, does not in any way read like a Creole novel. The restraint, the exquisite lyricism, the irony, the historical representation of suffering, bear the unmistakable mark of the author of Le Dernier des justes. It is a magnificently imagined reconstruction first of the uprooting of the slaves, then of the experience of the Middle Passage, and finally of the life of the strange, rejected, autistic little girl with two differently colored eyes and two souls (she is the product of her mother's rape by a white sailor on board ship). Solitude, the obscure run-away slave

girl, went on to lead an important revolt against the French that, although eventually suicidal for the *marrons* (escaped slaves), is an episode of resistance to colonial oppression of proud memory in Caribbean history.

What is particularly fascinating about André's beautifully wrought and convincing rendering of the event is his linking it, in the epilogue of the novel, with the Jewish insurrection against the Nazis during the Warsaw Ghetto uprising of 1943. The linking shows the will to memorialize and to relate, both as telling and as connecting. These themes and problems, as we have seen, have always been characteristic of André's literary endeavor. The connection between the Jewish experience of genocide at the hands of the Nazis in the Shoah, and the Black experience of slavery and the Middle Passage at the hands of the colonizing Europeans, was present in André's mind already in the early 1950's, as the *Figaro* interview demonstrated. It was expressed, at least implicity, in the Schwarz-Barts' collaboration on *Un Plat de porc*, which bears the double dedication to Aimé Césaire, the great Martinican poet of *négritude*, and Elie Wiesel, the great French-language chronicler of the Shoah.

In La Mulatresse André makes the link explicit at the end of his text, so that it can be understood retrospectively as an allegory for the Shoah and resistance to it, without the first reading of the powerful Antillean subject matter having been adulterated in any way. This admirable project, so diligently executed, is highly problematic as well. Although no community has a monopoly on suffering, neither can such suffering be universalized. André Schwarz-Bart does not see the experiences of Jews and African-Caribbeans as interchangeable but, rather, attempts through metaphor to connect our understanding of the two greatest human disasters to occur in the West in modern times. The enterprise is noble, but perhaps impossible. The planned seven-volume cycle, tracing the history of the Blacks in the West Indies from 1750 to 1953, was never brought to fruition.

Is it a coincidence that Simone Schwarz-Bart's most recent work (1988) is her six-volume *Hommage à la femme noire?* In no way a substitute for her husband's former project, Simone's none the less echoes it, but in her own inimitable way. It is thoroughly researched from a historical point of view, beginning with "Lucy" in Africa, "the grandmother of us all." Its goal, says Simone in her Preface, is clear: "For the first time in any language, a work evokes the history of the black woman in her continuity, from the origins of time to our own days, thereby putting an end to a millennary silence."⁴ But far from

Simone Schwarz-Bart, Ubu Repertory Theater, New York, 1988

being a dry historical compendium of facts, the results are glorious. The volumes are in a large, glossy format, magnificently illustrated with art from the past and gorgeous color photographs of contemporary women. They are, in short, a celebration, and a popular success. In the French West Indies, families have subscribed to each enormous volume, sometimes on credit, wanting the entire collection. Mingled with excerpts from Black writers from Africa and the Diaspora, the homage is a literary treat, yet accessible to all. And it is clearly, on Simone's part, an act of love.

Nobody can or should attempt to measure the extent to which two people share love. Yet anybody who has seen the Schwarz-Barts together would be hard put to deny its existence, and perhaps this is how and where an essay on significant others should conclude. It is not only that the Schwarz-Barts constitute a mini United Nations

unto themselves that makes them so special. Nor that they are so supportive of each other's writing and yet so autonomous that he can create in solitude in Lausanne, while she runs her antique shop in Pointe-à-Pitre (another way of respecting the past). It is also because the affective bond between them is clearly deep and strong. His dedication at the beginning of *La Mulatresse Solitude* reads simply "For you, without whom this book would not be, nor my life."

Several years ago they were in New York together to attend the opening of Simone's play Ton Beau Capitaine at the Ubu Repertory Theatre. The play is about a lonely Haitian worker who has come to Guadeloupe to work and "corresponds" with his wife back home in Haiti by cassette tapes. In the course of the story he overcomes the hurt she causes him when she becomes pregnant by another man, and he triumphantly learns to love the baby to be and to forgive his wife. After the premiere, I was present during her discussion with the audience. Simone was alone on stage under the lights. André was sitting toward the rear of the theater, in obscurity. An angry young man in the audience rose to ask why, since she was married to someone who "wasn't exactly black," she hadn't written a play about race and sexual relations (perhaps he was looking for Spike Lee's movie Jungle Fever?). It was, once again, a criticism being levelled at her work for being insufficiently political. Simone answered calmly and simply. She was radiant in fact. "I wanted to write a story about love. It seems to me that in the Antilles, with all the problems, one doesn't speak enough about love.... As for my husband, when I look at him [and here their eyes met across the theater] I just see someone I love. For me, he isn't any color at all."

Jackson Pollock and Lee Krasner, Springs, ca. 1950

FICTIONS

Krasner's Presence, Pollock's Absence

ANNE M. WAGNER

When the painter Lee Krasner died in 1984 at the age of 76, she had been a widow for almost three decades. Her eleven-year marriage to Jackson Pollock-the only marriage either was to contract—ended at Pollock's death on August 11, 1956. He was 44. The union was childless, and his will named her his executor and heir. These events were the necessary precondition to Krasner's entry into that special company of contemporary artists' widows ("Action Widows," the novelist and critic B. H. Friedman called them¹), which in 1965 Harold Rosenberg, the champion of Abstract Expressionism, classified as a major art world force. "It is hard to think of anyone in the Establishment who exceeds the widow in the number of powers concentrated in the hands of a single person," Rosenberg jealously declared, and Mrs. Jackson Pollock was his case in point: she "is often credited with having almost single handedly forced up prices for contemporary American abstract painting after the death of her husband."2 Such critical treatment rankled with Krasner (and incidentally, with Friedman, who having cited Rosenberg's verdict, made it a point to insist that in her "slow and regular" release of the paintings-they were sold even more slowly than friends had advised-she acted out of "love" rather than "power politics," let alone any particular business acumen).³ Krasner's own grievance took a different form: being a widow was too much like being a wife. "I was put together with the wives, and when Rosenberg wrote his article many years ago, that the widow has become the most powerful influence, I don't know, powerful something in the art world [sic] : . . He never acknowledged me as a painter, but as a widow, I was acknowledged. And, in fact, whenever he mentioned me at all following Pollock's death, he would always say Lee Krasner, the widow of Jackson Pollock, as if I needed that handle."4

When it comes to criticism, Krasner seems always, if not literally to have "needed that handle," certainly to have been unable to escape identification with Pollock. The present essay is evidently no

exception. Writing about Krasner has inevitably meant investigating the impact of her marriage on her work and identity. The results vary, of course, yet Edward Albee's recent declaration when surveying her career, "There is no marriage blip there," seems to me as much a case of special pleading as the earlier critical assessments, while Pollock lived, that his wife was utterly dependent as a painter on his art.⁵

This view was given something like canonical form in a review of a 1949 group show at the Sidney Janis Gallery in New York, "Artists: Man and Wife," to which the pair contributed. Read *Art News* on their painterly relations: "There is a tendency among some of these wives to 'tidy up' their husbands' styles. Lee Krasner (Mrs. Jackson Pollock) takes her husband's paints and enamels and changes his unrestrained, sweeping lines into neat little squares and triangles."⁶

Conversely, writing about Pollock since his death has inevitably meant, if not looking for the marriage blip, then encountering his painting according to the legal terms and physical conditions Krasner was able to establish for its consumption, curating, and interpretation. Seeing Pollock's life or art as definitively intertwined with Krasner's, by contrast, is a rare and recent occurrence. When he died, for example, neither Time nor Newsweek nor Life even saw fit to mention his marital status in their obituary notices. Krasner's sagacious management of her legacy suggests not that Rosenberg's analysis of the power-window "got it right"-the envy cum resentment of his terms are enough to open suspicions on that score. Rather, it points to the necessity of determining the extent to which understandings of artistic identity, performance and reputation are bound up in-even result from-specifiable social circumstances, their aftermath and residue. The demise of the Pollock/Krasner partnership meant, that is to say, that Pollock could not curate himself; he was unavailable to undertake the task that Krasner legally assumed on his behalf. The point is not that he necessarily would have done so, had he lived; on the contrary, the assumptions of most writing about the two tend to urge the reader toward the opposite conclusion. Time and again Krasner emerges, Svengali-like, as the power behind the throne, the calculating and ambitious dealer/ manager of an alternately inept and recalcitrant spouse. This Pollock, we are meant to understand, was both unable to confront the realities of daily life and resistant to the commodification of his person and his art. But this is also the Pollock who did not survive, if he ever existed.

In this essay I wish to take up the implications of Pollock's death and Krasner's bereavement particularly for their reputations as a

couple of painters. I want to try to spell out how Krasner's presence and Pollock's absence have helped to shape the terms in which their artistic identities have been and might be interpreted. My central contention, moreover, is that it is only their art which can any longer be understood. The terms of their relationship as man and woman, husband and wife, by contrast, are now more or less beyond recovery as anything other than discursive effects, inventions fashioned in the course of the urgent, ongoing mythologizing of both partners. The loss of any viable view of their relationship, in other words, is the result of the various efforts, Krasner's included, to fill the void opened by Pollock's demise.

In 1967 Lee Krasner was interviewed by the writers Francine du Plessix and Cleve Gray and her responses published in the May/June issue of Art in America under the title "Who was Jackson Pollock?" Only a month before Arts had run its own Pollock piece, in the form of reflections on the stature of the artist by the sculptor Don Judd, then aged 39 and at something like the height of his creative powers and influence. The two articles could not be more different in their authors, but their purposes are oddly similar in their address to the issue of his reputation. Krasner was taking this opportunity-one of many she mobilized—to have her say on Pollock: he was an alcoholic, yes, but one who never painted drunk; an alcoholic, yes, but one whose problems rested with his mother; an alcoholic, yes, but one whose violence never extended beyond abuse of words and inanimate objects. And he could bake a mean apple pie.7 These reflections, we understand from their tenor, are meant to do more than "set the record straight;" they are meant to counteract the particular excesses of the myth of "Jack the Dripper," the "bearded shock trooper of modern painting," a myth of whose existence Krasner was entirely aware and by which, as she told her interviewers, she was profoundly "bored." Judd's purpose was likewise to address Pollock's status: he wanted to go on record with one central claim: "I think Pollock's a greater artist than anyone working at the time or since." But for a great artist, Pollock was, according to Judd, remarkably ill-served by his epigones: "Not much has been written on Pollock's work and most of that is mediocre or bad. . . . Quotations and biographical information should be considered more carefully than they usually are. Dumb interviewers often get dumb answers."8

Seen from our jaded vantage point in 1993, Krasner's and Judd's

avowed impatience with the excesses and simplifications of the Pollock myth may seem a trifle oversensitive, or prescient, or both. Note, though, that they were not alone in their efforts to resist sensationalism. Within a few months of Pollock's death Clement Greenberg, the critic who in the 1940's had done most to interpret Pollock's paintings, published a two-page piece on the artist in the Evergreen Review. It was an obituary, pure and simple-the facts, ma'am, just the facts. And when Greenberg learned that one or two of his facts were fictitious-they were contested in personal letters from Peggy Guggenheim, the painter's dealer, and Charles, his brotherhe immediately wrote the editors to correct them: "Not that I wish to magnify the importance of every detail of Jackson Pollock's life, but I would not like to see errors of fact, however unessential, become current because of their appearance in a note like mine, which was designed to give nothing but facts."9 Such scrupulousness on Greenberg's part still haunted him in 1961, when for the benefit of the readers of the New York Times Magazine he attempted to explain why prices for Pollocks had soared. What was being consumed at astronomical cost was not painting but a mythology which metastasized, as Pollock himself internalized it and assumed the provided identity of artiste maudit, into real suffering-suffering, however, which the public found entirely glamorous and consumable. "As one who was a friend of Pollock," Greenberg wrote, "I can only deplore this. Glamour is cast over a lot of wretchedness that in principle had little to do with art. And somehow the false glamour interferes with a recognition of the great and sophisticated qualities of his art itself."10

Matters have improved little in the thirty years or so since then; on the contrary, it might be argued that they have gone sharply downhill. Judd's wariness of dumb questions, Greenberg's insistence on facts not false glamour—these are mostly things of the past, where the public Pollock is concerned. Consider the character of two of the most recent Pollock biographies, Jeffrey Potter's To a Violent Grave: An Oral Biography of Jackson Pollock (1985) and Jackson Pollock: An American Saga (1989) by Steven Naifeh and Gregory White Smith. The first of these, as a self-declared "oral biography," wears its use of interviews on its sleeve: in its 280 pages the testimony of scores of different named informants is cited; a handful of unnamed sources appears as well, sometimes under aliases—"First Neighbor (mechanic)," "Second Neighbor (bulldozer operator)"—which give their speeches a quasi-theatrical air. But the number of "witnesses" Potter consulted pales next to the thousands of hours of testimony that, we

learn from the proud calculations of the authors, went into the manufacture of the Naifeh/Smith opus: upward of 800 different informants were consulted; their collected recollections run in transcription to more than 18,000 pages which together total some 10,000,000 words. Apparently the reader is meant to marvel at these statistics—but it may make more sense to conserve your amazement, the better to wonder that thirty years after Pollock's death so many people still had something interesting to say about him. Perhaps their memories had become more "interesting" over the years.

Given the extraordinary weight and confidence placed by these authors in the "spoken word," it would be foolish not to consider the ends to which these hours and volumes of speech are put. The purpose of the exercise, of course, is to conjure up a Pollock whose fictional status will be obscured by the apparent authenticity of the materials used to confect him. What needs emphasizing is the various ways that fiction was dependent on Krasner-on both the woman herself and the character she was assigned to play in the Pollock drama. First things first: for these authors there was the necessary initial task of negotiating a relationship to her in her guise as the official repository of Pollock's memory. Hence their shared choice of an oral technique. As a result of such a method, Krasner can become simply one of many witnesses, if a valued one; her word need not be taken as law. (Though from a legal point of view it seems to me no accident that both of these books appeared only after Krasner's death-her absence was in this instance the decisive factor.) And both to invoke such an authentic source and to circumvent her is the point. Potter's biography, for example, though dedicated to Krasner, was not a work with which she collaborated, although according to the author (like Pollock and Krasner a resident of East Hampton) it had been begun in 1971 when she was still alive and well. She was to have been Potter's last interviewee, "mainly for fact checking." Her death meant that this plan never came off.11

To Naifeh and Smith, Krasner gave seven interviews, though in failing health, and provided "many insights." However illuminating those might have been (the authors fail to signal those remarks they found especially useful), they could never withstand the sheer weight of materials with which they are supplemented and supplanted. And they certainly could not resist the pull of interpretation to which the various events of both Pollock's and Krasner's lives have been submitted. Take for example Naifeh and Smith's opinion of Krasner's decision in 1932 to "withdraw from the field" (the phrase is

Krasner's) and enroll in a teacher training course at City College: "it was more like a rout than a withdrawal. She not only left art, she retreated all the way back to the most traditional and secure aspiration a young Jewish woman could have: teaching. . . . Lee later tried to explain the sudden reversal as a financial necessity. . . . But no excuse could conceal the truth. Even Lee must have realized that at a critical moment in her career, her will had failed; that for all her style and rhetoric, her fire didn't burn hot enough."¹² Where to begin? With the sanctimoniousness of this opinion, or its sexism, or its doctrine of rampant individualism and free will, or with its duplicitous notion of "the truth"? Or perhaps with that snide "even," which singlehandedly, effortlessly turns Krasner into the most self-deluded of mortals, the last to recognize her motivations and her failures.

It is, of course, not the use of interviews alone which poses a problem for students of Pollock and Krasner, it is the way they are used. Which testimony does an author take to be most convincing? What criteria are established to evaluate the motivations-to say nothing of the truthfulness-of the informant, once testimony has been collected? When we read, for example, that the sculptor Harry Jackson (Mr. Grace Hartigan) thought that Lee had "asked for it" (physical abuse from Pollock),¹³ or that "Lee had a goddam hold on him, terrific hold-right by the ving-vang, like a goddam kosher icicle,"14 what confidence should we place in him as a source for knowledge about Pollock's attitude to Krasner's painting? "He encouraged her, but he was disdainful. He had that 'little woman' attitude toward her. He took me up to look at her paintings and said something like 'That's Lee's little painting.' He wasted almost no time with her and considered almost everything he did in that area as sort of encouraging the little lady."15 "Little lady"-even if we were to give good ole Harry the benefit of the doubt and assume that, as a Wyomingite, he is just speaking some local (sexist, anti-Semitic) dialect, such a concession would not be enough to boost confidence in his dispassion as an art critic, let alone trust in his skills as an analyst of personal motivation. Except, perhaps, for Naifeh and Smith, who side with Harry to opine that Pollock's encouragement of Krasner was "superficial" and his discouragement "strong, if subtle."16

Did these writers on Pollock and Krasner believe everything they were told about the pair, or just some things? Did they never wonder, as their sources spoke, "Why is s/he telling me this?" or ask "What kind of person would say such a thing?" (Perhaps the sheer volume of interviews conducted put time for such reflections at a premium.)

How much did their own tastes for the sordid and sensational guide their questions, as well as the ways they cut and pasted and tucked the reams of testimony they accumulated? What about their tastes for commercial success? Ernst Kris and Otto Kurz demonstrated long ago that artists' biographies traditionally were recounted, from antiquity through the Renaissance, so as to ensure that the lineaments of identity-the key events of a career, the means by which talent is recognized and celebrity won-conformed in broad outline to recognizable patterns which supplied their readers with certain expected satisfactions.¹⁷ The Pollock biographies likewise offer contemporary readers their own set of narrative pleasures, the same pleasures Greenberg labelled "false glamour" and tried, however ineffectually, to fend off. Stories of artistes maudits attract because they are anti-romances, first cousins and antitheses of the Harlequin genre. Their interest and marketability rest on their inversion of the romance formula: "plucky, independent woman wooed and won by dashing hero" becomes "creative, flawed hero/genius, his masculinity threatened by women-modernity-failure, tragically succumbs." It is essential to the experience of this second kind of story, like that of the romance, that the outcome is known in advance: victim and hero (henpecked and abusive), Pollock must and will go to his "violent grave" in due course, but meantime the oral format, with its reliance on opinion and pseudo-controversy, breathes life into the old clichés and lends texture and a certain suspense to the telling. The result is biography for the fin de siècle, quasi docu-drama, a genre whose immediacy, like that of its cinematic or television counterpart, is supplied by the contingent claims of the so-called evewitness (actually post facto) account. The sampling of critical opinion which introduces the 1989 paperback version of Potter's work only confirms this conclusion. From Newsweek's critic we learn that "Pollock is like a character out of a Sam Shepard play." The Guardian declares "It cannot be a long time now before there is a major Hollywood production." And the reviewer for Dan's Papers writes that the book "reads as if it were a thriller."

Yet if Pollock's life is to be conceived of as "scripted," its lineaments should be understood as conforming to rather different unities and conventions from the patterns recurrently invoked by the media as the stuff of thrills and entertainment. Pollock's life reads like a movie/novel/play because it has been written that way; the tools which would be most useful to explain it any differently are not in these, or perhaps in any, biographers' hands. Like their various

informants, they are too profoundly engaged in fashioning a Pollock-and, it should be emphasized, a Krasner to go with himwhich will satisfy their requirements for narrative and character. That they went into print only after Krasner's death seems to bear out the conclusion that her presence served as at least a partial brake against these particular kinds of fictionalizations. The brake removed, the biographers went to town. Tempting though it might be simply to dismiss the results as too tendentious to be taken very seriously, such an impulse would be mistaken. This is not just because Naifeh and Smith won a Pulitzer prize for their effort, though that fact should be noted. Remember that such works, and the institutional honors they receive, help to legitimize the myth of artistic identity that fuels them. The paradigm of an assertive and unstable Pollock-a character who is, need I say it, relentlessly made to conform to the familiar role of a freewheeling, handsome, inarticulate, white, Protestant, Westernborn male genius, "born under Saturn," as the old phrase goes-is cemented when it is coupled with its complementary fiction, Krasner. She is urban, Eastern, Jewish, the daughter of immigrants, homely, capable, good with money, a wily bargainer and strategist, intellectually competent but lacking "inner fire"—in short, she is everything that Pollock is not, the antithesis which confirms the thesis concerning modern male identity sited in his person. The point is not to claim that Krasner was someone other than a non-practicing Jew born in Brooklyn, or Pollock a lapsed Protestant from Cody, Wyoming-not, in other words, to dispute the relevance of particular biographical circumstances-but rather to recognize how and when any one account hardens those circumstances into stereotype. This occurs in the case of Pollock and Krasner when the elements of biography are used to suspend confidence in the authenticity and depth of their relationship, or in the interest of Krasner's purposes as a painter, or both. The result, of course, is yet another offering laid at the feet of that familiar cultural deity, the independent and superior male artist.

* *

Nowadays it seems that the tools and methods of feminist criticism are most useful in contesting the kinds of fictions that have given Krasner and Pollock public selves. If this is the case, as I think it is, the issue then becomes finding the materials which could contribute to another account. We might, for example, look again at evidence which has already served another purpose. Take Greenberg's obituary in the

Evergreen Review. Now is the time to note that it contained a few other errors of fact that neither Krasner nor any one else bothered to clear up: the dates the two painters met and married. Greenberg put both too early, the former in 1940 rather than in 1942, and the latter in 1944 instead of 1945. Minor errors, of course, except when accuracy is the stated goal. I suspect the main reason Greenberg's slips went unnoticed, at least by Krasner, is offered by the terms in which he described the artists' relationship: "She first met Pollock on this occasion [an exhibition at the McMillen Gallery to which they both contributed], and they were married in 1944, but even before their marriage her eye and judgment had become important to his art, and continued to remain so."18 This was an opinion Greenberg has not since reneged on, even though his friendship with Krasner came to an embittered end in 1959. It provides a certain identity for Krasner within her marriage-that of Pollock's closest critic-an identity which apparently had for Greenberg something like the status of fact. It certainly functioned as such in the obituary, where facts were at issue. And it has been reinforced by Krasner's memory of the kinds of questions Pollock used to ask her about his painting: "Should I cut it here? Should this be the bottom?" or most famously, "Is this a painting?"19

Now add to this a brief sequence from the notorious film of Pollock at work made by Hans Namuth and Paul Falkenberg in 1950. It is a sequence which seems to have remained more or less invisibleif not literally, then functionally so-since the film was released (it was first shown at the Museum of Modern Art [MoMA], New York, and then made available for rental to colleges and universities). Sandwiched between the film's two main parts, those canonical frames in which Pollock is seen painting first on canvas and then on glass, is footage which Namuth has described as follows: "In the next sequence, a long painting, 'Summertime,' is pulled slowly beneath the camera. The canvas appears to be floating past the viewer. Next, Pollock is seen tacking the same painting onto the walls of the Betty Parsons Gallery. There are other paintings in the Gallery, and a visitor (actually his wife)."20 Namuth does not go on to add that the visitor, seen mostly from behind, enters the gallery to stand lost in thought before the works on view. I take this sequence to function within the film as an explicitly affirmative answer to the implicit question "Is this a painting?"-a question which others asked of Pollock's art even more frequently and suspiciously than he did. Yet while the film betrays the need to make Pollock's products socially and contextually

recognizable *as art*, it does not also "need" to posit a woman, "(actually his wife)," as the figure of the ideal viewer, the arbiter of the status of Pollock's painting as art. That its makers chose to do so suggests, it seems to me, that Krasner was profoundly "in character" in the role.

It was a character, moreover, she herself worked hard to keep hold of as the interviewers trooped through with their microphones and eager repetitive questions. What this meant, though, was not acting after the fact as taste- or phrasemaker about the pictures. Rather it seems to have meant maintaining a certain scrupulousness concerning what she felt she could and would say about his art; she seems to have been consistently unwilling to pretend to know the answers to questions whose answers she didn't know. We might even say that she made a show of having forgotten just those morsels of information her questioners seemed to prize most. For example: Krasner's notable taciturnity when questioned by Barbara Rose cannot be laid at the door of reserve or hostility toward the interviewer, as it might have been in other circumstances. (The painter proved herself willing to cooperate with Rose several times over the years: it was Rose, for example, who made the major film of Krasner and who organized her 1983 MoMA retrospective.)

BR: The first "drip" paintings were made in 1947. Do you think moving into the barn had anything to do with greater physical freedom?

LK: It would be very convenient to think along those lines, but I don't believe that was it. Pollock had a lot more space on 8th St. He wasn't confined to one tiny little room. I think the increase in size has more to do with the fundamental aspects of why he did what he did. He certainly needed the physical space to work as he did, but I think he would have found the physical space whenever he was ready to paint with large gestures.

BR: Do you remember how and why Pollock started the drip paintings?...

LK: I can't remember, that is the point. I am always rather astonished when I read of a given date. I actually cannot remember when I first saw them.

BR: Do you have any idea why he had the drive to enlarge the gesture onto a physical scale?

LK: Why he did this I don't know.

. . .

BR: I have always believed that the installation of Monet's *Water Lilies* in the Museum of Modern Art had a big effect on Pollock . . .

LK: I don't recall him looking at them, but that doesn't mean that he

didn't. We didn't go to shows together necessarily. He would go when he wanted to, and I would go when I wanted to. Occasionally we went together, but not that much.²¹

Krasner's stonewalling responses here and elsewhere are characteristic of a witness who did not often claim to know why Pollock had done something; moreover she could only sometimes say how. She seems resolutely skeptical of the art historical interest in influences, mechanics and motivation, and unwilling to play the historian's role herself—but she is never skeptical about the paintings themselves: "[Interviewer]: What was it in Pollock's work that made you respond so profoundly? LK: It was a force, a living force . . . Once more I was hit that hard with what I saw."²² This is what it is like when Krasner does remember. Each gap in her memory, by contrast, seems to function to hold open a place in which more "fundamental aspects" of meaning, in her terms, could be left understood and unstated. This was the proper reaction to interesting art, from her point of view; in fact neither Krasner nor Pollock seems to have considered responding to painting a particularly verbal experience.

Being a viewer of painting is not identical to being its critic or its keeper. As Pollock's viewer, Krasner said yes, no or maybe-literally not much more than that-and then sooner or later returned to her studio to try to weigh what those verdicts might mean for her own art. She did so, however, not having surrendered her status as Pollock's viewer, and that identity perforce cohabited with the painter, woman, and wife she also was. The first tangible result of their commingling was the group of pictures she produced from about 1946 to 1949 and called "Little Images" (the selfsame pictures whose title Harry lackson took as a slur). Their achievement is the way they view and review Pollock, profiting from and differing with his example in ways which are strategic and intentional. In Krasner's hands Pollock's techniques of the moment-including versions of his signature "pours"-are chastened, made anti-rhetorical, almost erased by devices imposed like a baffle before the pictures' surfaces. I am thinking of the black network of Abstract # 2 (1946-8) or the flickering overlay of brushstrokes of white paint laid into the surface of Night Light (1949), which in different ways silence and repress the energy implicit in the pour. Once in place, as in these two works, such devices function like prohibitions, with the result that the work simply will not coalesce into imagery, least of all the imagery of action. Its measure stays even; its marks, though separable, are

equivalents of each other; they seem, if not exactly anxious *not* to mean, then at least reluctant to do so in the ways that Pollock had made his own.

What the "Little Images" patently do not do, in other words, is aim to find a visual equivalent to Krasner's verbal response to Pollock's art: "it was a force, a living force ... I was hit that hard with what I saw." Even if we concede that those phrases may have been used retrospectively to describe a first encounter, naming not Pollock's drip paintings but the very first work by him that Krasner knew (Birth, ca. 1938-41, his contribution to the fateful McMillen Gallery show, which she kept until her death), Krasner's own ongoing production makes it clear that the impact of her husband's painting did not lessen for many years, if ever. Viewing a hard-hitting art did not mean producing one; it meant painting pictures that offer their own special description-their fiction-of Pollock's achievement. The point for Krasner, we might say, was to retrieve from his work-and in the case of the "Little Images" her inspiration was particularly his poured paintings of 1947-9, works like Full Fathom Five—a set of principles whose logic she would maintain but whose overall rhetoric she could then negate. Krasner agrees with Pollock at this moment that painting should be resolutely severed from its familiar functions and allegiances. References to bodies and objects in the real world are to be banished; traces of the artist's hand are there for the viewing but will not add up to "paint handling" in the old sense. But while these principles are worked by Pollock to erode, complicate and restructure notions of artistic unity and presence in a dramatically high-risk way, Krasner's procedures deliberately take a rhetoric of risk out of the equation. She invented such techniques because, I believe, Pollock's operations are too easily read as self-risk, as the Pollock myth exists to demonstrate. Krasner's technique, by contrast, resolutely keeps the self out of it, and does so, moreover, at the moment in her career when that "self" was most easily thought of as Mrs. Jackson Pollock.

I want to argue that "keeping the self out of it" was for Krasner a protective device. I think she adopted it as part of an effort to avoid her art being read as that of a woman, that is to say, according to male standards. She knew the backhandedness of compliments like the one Hans Hofmann paid her when she worked with him in the early 1940's: "This is so good you wouldn't know it was painted by a woman."²³ The calculations of her painterly technique were one strategy adopted toward that goal. Her name itself—the deter-

Lee Krasner, Night Light, 1949

Jackson Pollock, Full Fathom Five, 1947

Lee Krasner, Abstract #2, 1946-8

minedly androgynous "Lee" was a contraction for Lenore, sometimes spelled Leonore—was another. And her chosen signature throughout the 1940's, the elliptical "L.K.," had the same talismanic neutering effect. Yet one of her favorite stories from her early life with Pollock centers exactly on how elusive anonymity could be. The story has Pollock botching the arrangements for Peggy Guggenheim's visit to their shared studio; as a result she was leaving when they arrived. She stormed out muttering, "L.K., who is this L.K.? I didn't come to see L.K.'s work." When she told the story herself, Krasner would add the punchline "She damn well knew at that point who L.K. was and that was really like a hard thrust."²⁴

Even late in her life, when her critical fortunes had improved considerably, Krasner still believed that women and men should judge and be judged by equivalent principles. In 1980, in response to receiving an award from the Women's Caucus for Art for "Outstanding Achievement in the Visual Arts," she said, "I am really very pleased—honored . . . However I await the day when such an award could be a joint acknowledgment from men and women."²⁵ I do not think this remark should be read simply as sour grapes. It is the residue of a time when such joint acknowledgments were rarely if ever awarded. The particular strategic otherness to Pollock which the "Little Images" invent was invisible to all but a very few viewers, chief among them Alfonso A. Ossorio, who owned some of the best and gave one of them to MoMA. But for professional critics of the day, she was only painting like the tidy little lady she could not in their eyes fail to be.

Krasner's revision of the rhetoric of Pollock's painting provides something like a paradigm of the ways gender has shaped twentiethcentury painting. In her effort not to be Pollock, while profiting from her view of his art, she seems to point directly to those aspects of his work which were impossible for her, as a painter, woman and wife, to emulate. She avoided exactly those effects which would be easiest to identify as the probable catalysts for her reaction of violence and force. She could not reproduce in her own art, it seems, what meant most to her about Pollock's—at least until after he died. Krasner's direction after 1956 offers the clearest possible corroboration of her earlier refusal. Painting after painting from the ten years following Pollock's disappearance—from her own *Birth*, say, of 1956, through *The Gate* (1959–60), *Polar Stampede* (1960), and *Primeval Resurgence* (1961), and then on through the works of the mid-1960's—puts into operation a roiling, circular energy which seems to wheel across the

Lee Krasner, Polar Stampede, 1960

canvas. When I first saw those last three pictures in 1989, I wrote in my notebook that they were "more Pollock than Pollock" and then immediately, nervously retreated from that verdict, unwilling to return Krasner once again to the old comparison. Yet on one level the analogy can stand. Krasner seems here to be reacting to the lifting of an old prohibition, and doing so with a vengeance, in order to work out of Pollock more thoroughly than did any other painter of the day. What is most like Pollock is the sheer control of the language of uncontrol, the achievement of the effect of unbridled energy, and the turning of those technical innovations into a painting. Not poured so much as thrown (Krasner worked on the wall, not the floor), these images are neither tidy nor neat, and they are anything but pretty. Very often painted in umber or an excremental brown, shot with explosive streaks and gashes and splatters of white, sometimes mixing in a jarring magenta, they have a peculiar kind of voluble nihilism more or less the opposite of the taciturn intransigence of the "Little Images."

Once upon a time I was prepared to claim that of these two painterly modes the "Little Images" were decidedly superior, and to underline the irony (if not actually to savor it) of the fact that the "better" works were the products of the peculiarly cramped social and psychic circumstances in which they were produced. (As has often been noted, Krasner painted in a converted bedroom upstairs at The Springs, while Pollock had the barn. Yet given her answers to Rose, I reckon she might have been prepared to deny that the size of her studio was decisive for her pictures.) As Krasner reworked her

painterly identity in Pollock's absence, I thought, she operated as if now licensed to embrace and expand, rather than negate his legacy. And by taking up Pollock's inheritance, she could transform what was once "personal" about his art into the elements of a pictorial practice or language in which she shared. The result was a set of pictures that, because they emerged from these purposes, might be said to come too close for comfort to their sources, or to fail to leave them far enough behind. Now as I write these words, however, I am no longer sure of my own verdict. Whose comfort? How close is too close, anyway, and according to whom? In whose interests are such judgments? It seems likely that these paintings are still not particularly easy to understand. But their response to Pollock is incontrovertible. and its tenor is tense, declarative and complicated. Such a view seems justified not simply by the works themselves but also by a peculiar action on Krasner's part. In 1974 she discovered a painting, folded and in ruinous condition, in an outbuilding on her property, a work which to most eyes closely resembles her paintings of the early 1960's. Not according to Krasner, however. She took it for an "unresolved" Pollock of about 1950-53; so as not entirely to contradict her, the canvas was catalogued among Pollock's works as a "Problem for Study."26 It is difficult to take this occurrence at face value as a simple loss of memory; nor is it probable that, given the painting's condition, she meant to sell it as a Pollock. The most likely explanation-though it remains a hypothesis-is that, consciously or not, Krasner was supplying her own pictures with a precedent in Pollock's practice. If her work could be claimed to come even more directly from Pollock. she might thus be able to avoid the "personal" readings which had dogged her art.

One thing which seems certain, however, is that if Krasner gained an uneasy painterly confidence after the death of her husband, if she thought his absence would now necessarily mean that her own presence as a painter was incontrovertible, she was soon disabused of that illusion. There was no extracting her painterly self from its social context. The widow's duties in managing the legacy were exacting, to put it mildly. Ruth Kligman, with whom Pollock had been involved at the time of his death, sued the estate for damages for injuries sustained when she was thrown free of the death car. Peggy Guggenheim sued in 1961, claiming that she had not received an adequate share of his production (the case was dismissed in Spring 1965). In 1962 Krasner was stricken by an aneurysm which those around her did not hesitate to attribute to these circumstances. It is

tempting to think that this string of events (termed by a friend in the aftermath of her stroke, "the feuds, the jealousies, the petty politics and grasping"²⁷) contributed to her paintings of these years some of their notably vehement and nihilistic cast.

But there were other circumstances which were equally, if more subtly, discouraging-circumstances which played their part in informing Krasner just what (just how little) her continued presence on the scene might be said to mean. In 1962, for example, B. H. Friedman, a New York real estate executive before he became an author (he championed both Pollock and Krasner, wrote the early biography Jackson Pollock: Energy Made Visible, and owned examples of their work), published his first novel, Circles. He gave Krasner a copy. It was not exactly a roman à clef, though set in New York and East Hampton. There is no pseudo-Pollock or Krasner among the dramatis personae, even if the artist in the book, Stanley (Spike) Ross, who drinks a lot and "paints" by riddling canvases with bullets sprayed by a machine-gun, is inconceivable without Pollock and his myth. Yet the more immediate point for Krasner was presumably the representation of female artists in the book. There was only one, a painter known simply, condescendingly, by the nickname Virginia Wolfe. Her sole function in the story is to be wounded by Spike's machine-gun (note symbolism) as he jettisons it in Long Island Sound, having decided to go back to painting real pictures, using ordinary oil on canvas. Exit the bleeding Virginia, to be carted off to hospital.

So much for female creativity. Now add to this brief synopsis one more scenario, this time of a 1968 short story, "Small Change," published by May Natalie Tabak in the *Kenyon Review*.²⁸ It follows the flowering of a fantasy which consumes Cecily Lake, wife of the painter Cob Lake, until it becomes a full-fledged neurosis. She vividly and repeatedly imagines he is dead and sometimes cannot tell her fantasy from reality. Thus prematurely obsessed, she is becoming yes—an Action Widow (Tabak's husband was Harold Rosenberg). The story closes as Cecily worries that there won't be room for Cob in the cemetery at The Springs. "Who had said that the plots were all sold out? Perhaps she could get Jackson's widow to let Cob share his. It was too large for one man anyhow." *Finis*.

These are not examples of great fiction, needless to say, but that does not mean that they should be dismissed out of hand. Their interest for students of Krasner and Pollock is that they emerged from the immediate context in which the two artists lived out their lives and

careers. Both authors, moreover, surely were able consciously to analyze and deplore the distortions and excesses of the Pollock myth, as well as its impact on Krasner. Yet those abilities and sympathies, we must conclude, are evidently to be put into abeyance when it comes to fictionalizing a painter's life and times. Friedman's novel takes for granted the relative positions of Spike Ross and Virginia Wolfe as anti-hero and victim; it cannot imagine any other order of things. And although Tabak, in aiming at social satire, is necessarily dependent on picking a plausible and recognizable target (her *Art News* review of Friedman's novel condemns its lack of social resemblance), she seems to have swallowed the notion of the Action Widow hook, line and sinker.

If these are the attitudes and beliefs of Krasner's immediate circle, was there much hope of Krasner gaining the kind of acknowledgment-let alone the separate identity-to which she aspired? That she actively aimed at so doing is endlessly documented by her personal papers, with her efforts to create a persona for herself taking a variety of forms: she deflected the interviewers onto the subject of her own painting whenever that tactic seemed necessary or possible; after Pollock's death she drew up several lists of the events in her life, as if she now needed to summon and codify her own past, and in 1967 asked Francis V. O'Connor, the historian of the WPA and eventual cataloguer of Pollock's art, to rediscover those facts about her life which had apparently grown hazy in her mind (he obliged with official transcripts of her artistic education and the record of her place on the Federal payroll from 1934 to 1943). She had Pollock's studio renovated for her own use and commissioned photographs to show herself ensconced and working there. (It was clear that the old photographs of her with Pollock, taken by Namuth and the like, would no longer do the trick.) And so on.

I take all these moves as meant to fly in the face of the Action Widow persona, to counter it by establishing another independent painter's self; I have tried to show that they were only—could only ever have been—partly successful. Explaining their lack of success means demonstrating the near seamless overlap among the various identities Krasner—and Pollock—were asked to assume. There was no prizing them apart—no social space in which "artist" was separable from "woman," "wife" or "widow," or, for that matter, from "man" (though of course among these various categories, those of "husband" or "widower" are not at issue). But perhaps the best way to represent the inseparability of these various identities is to

Contact sheet detail by Wilfred Zogbaum, showing Lee Krasner and Jackson Pollock at Springs, ca. 1950

have recourse to two sets of photographs: some contact sheets by Wilfred Zogbaum showing Krasner and Pollock working in the garden at home in Springs (the year seems to be about 1950) and a second photographic campaign undertaken in the 1960's by the East Hampton photographer John Reed. His subject was Krasner alone. What is striking about both sets of images is the vivid sense of role playing, of performing for the camera, each projects. In the double portraits, a variety of postures is assumed, using dog and wateringcan and shovel as props; holding flowers, the happy couple is silhouetted against the sky. Years later, a carefully dressd Krasner arranges and rearranges herself in an armchair, each time fixing the camera with a commanding gaze. Here is the letter with which Reed accompanied the resulting proofs: "Dear Lee, These being the kind of pictures they are-character studies? neo-realist sociology? Vogue athomes—I should appreciate credit lines when they are used."29 A brief enough missive. None the less it is long enough to make the point that no one of these phrases achieves a proper description of the portrait: on the contrary, it is the play of possible descriptions which is important here. We might think that the task of achieving realism or

psychological penetration or high style in portraiture would call for quite different kinds of imagery, yet this was apparently not the case. Instead Reed could pin all three genres to a single photo, could see them there. Isn't it because the precise genre of his photos seemed undecidable that he wanted credit as their author?

I suspect that these three terms were put into circulation around the photos precisely because Krasner is here occupying something like three identities at once: she is simultaneously legible, at least according to Reed, as an individual, as the representative of a social category, and as a media fiction—all the while remaining "herself." My sense is that a similar play of identities and genres circulates within Zogbaum's photographic efforts, as both painters enact social selves before the camera, making public the privacy of marriage. Yet that moment of theater, of course, is dependent on painterly reputation and, in 1950, on Pollock's reputation above all.

It might be comforting to conclude by pulling a rabbit out of a hat, so to speak, and claiming that for Krasner, the practice of painting offered the means to escape just this circuitry of social identities through which shuttled her public self. Or perhaps some kind of feminist magic might be worked in order to bring off a similar claim concerning her ability to elude the roles and constraints of personal circumstance. After all, both art and feminism have often been thought of as different kinds of social and personal salve, healing agents with real power to assuage. Either thesis, however, would go squarely against the grain of my argument-to say nothing of Krasner's own experiences. Let me state that argument once again: I have claimed that the painter's identity-above all, when she is a woman and because she is a woman-cannot be prised apart from the other roles she is customarily asked to play. And though for Krasner those various roles coexisted uneasily, even paradoxically, they could not be eluded. They took a toll measurable in the terms in which her life has been represented and her art received; neither the genuine interest of her painting nor the feminist recuperations of her career (including the present essay) can or will change that history. Nevertheless it should be granted that Krasner herself seems to have operated with certain powerful illusions about her practice as an artist. She seems to have thought of painting in particular as offering a space separable from social identity. I think she trusted, not so much that painting was an entirely private endeavor, as many of her contemporaries would have alleged, but rather that it was an activity in which a gendered notion of the self (or even selves) might be held at

Lee Krasner, 1960's, photographed by John Reed

bay, above all by means of a tactical deployment of the techniques and vocabulary of the modernist idiom in its most advanced—that is, Pollockian—form. Therein lies the paradox of her career: her painterly ambitions demanded she face up to Pollock, while social circumstance made the encounter, if not impossible, then at least highly unsatisfactory from Krasner's own point of view. Yet it must also be conceded, if only to underline the paradox still further, that this most cherished fiction—her confidence in painting, not just as a practice she could control, but as a special category in which sex differences did not apply—was exactly what enabled her to keep on painting. We all need our fictions; they have their uses. Abbreviation: AAA Archives of American Art, Smithsonian Institution, Washington, D.C.

Introduction

Notes

1. In Western culture, individuality and uniqueness are central to evaluations of art, as well as life. Psychoanalysts, literary critics, and cultural historians have all analyzed the importance of the notion of individuality, and the particular role of the artist as the embodiment of free will, however illusory in Western societies; with regard to the artist, see for example Carol Duncan, "Virility and Domination in Early Twentieth-Century Vanguard Painting," repr. in Norma Broude and Mary D. Garrard, Feminism and Art History: Questioning the Litany (New York: Harper and Row, 1982), pp. 293-313. The work of psychoanalytic and feminist theorist Nancy Chodorow explores the ways that gender is constructed around identifications with separateness (masculinity) and connectedness (femininity); see her The Reproduction of Mothering: Psychoanalysis and the Sociology of Gender (Berkeley: University of California Press, 1978), and Feminism and Psychoanalytic Theory (New Haven and Lon-don: Yale University Press, 1990). French philosopher Luce Irigaray has argued that the values that speak cultural another language, a language of nearness, plurality, and diversity, are simply erased by the cultural hegemony of phallocentrism; see her Speculum of the Other Woman, trans. Gillian Gill (Ithaca: Cornell University Press, 1985), and This Sex Which is Not One, trans. Catherine Porter with Carolyn Burke (Ithaca: Cornell University Press, 1985).

2. Ruth Perry and Martine Watson Brownley, eds., Mothering the Mind: Twelve Studies of Writers and Their Silent Partners (New York and London: Holmes and Meier, 1984).

3. Shari Benstock, "Afterword to Neice Boyce and Hutchins Hapgood," Intimate Warriors: Portraits of a Modern Marriage, 1899-1944 (New York: The Feminist Press, 1991).

4. Simone de Beauvoir endorsed this conclusion in her own autobiographical statements, as well as in The Second Sex, her groundbreaking study of woman's lot under patriarchy. Unlike Sartre, she stated over and over again, she was not a philosopher; she had not "erected" a system: see The Second Sex, trans. H. N. Parshley (New York: Bantam Books, 1952); Margaret A. Si-mons, "Two Interviews with Simone de Beauvoir," in Nancy Fraser and Sandra Lee Bartky, eds., Revaluing French Feminism: Critical Essays on Difference, Agency, and Culture (Bloom-Indiana University ington: Press, 1992).

5. Nancy Huston, Journal de la création (Paris: Seuil, 1990); see also Susan Stanford Friedman's "Creativity and the Childbirth Metaphor: Gender Difference in Literary Discourse," in Robyn R. Warhol and Diane Price Herndl, Feminisms: An Anthology of Literary Theory and Criticism (New Brunswick: Rutgers University Press, 1991), pp. 371-96.

6. Quoted in Anne M. Wagner, "Lee Krasner as L.K.," in *Representations*, 25 (Winter 1989), p. 42.

1 Claudel and Rodin

Notes

1. Frederic V. Grunfeld, Rodin: A Biography (New York: Henry Holt, 1987), p. 95.

Holt, 1987), p. 95. 2. Perseus Triumphant literally took the place of what was probably at the time the single most revered sculpture of Classical antiquity, the Apollo Belvedere. After Napoleon took the figure so acclaimed by Winckelmann and others to the Louvre as part of his war spoils, the *Perseus*, already underway, was chosen to take over *Apollo's* crucial role in the Vatican collection.

3. Grunfeld, p. 86.

4. Ibid., p. 130.

5. Ibid., p. 159.

6. Ovid, The Metamorphoses, ed. Horace Gregory (New York:

Viking, 1958), pp. 116–17. 7. Reine-Marie Paris, *Camille Claudel* (Paris: Gallimard, 1984), p. 44.

8. Ibid., p. 212.

9. Ibid., p. 211.

10. Grunfeld, p. 82.

11. Anne Wagner, "Rodin's Reputation," in Lynn Hunt, ed., *Eroticism and the Body Politic* (Baltimore: Johns Hopkins University Press, 1991), pp. 191-242.

12. Ibid., p. 191.

13. Ibid., p. 198.

14. Quoted in Elizabeth Chase Gusbahler, Rodin's Later Drawings (Boston: Beacon, 1963), p. 31.

15. Wagner, p. 227.

16. Ibid., p. 229; see also pp. 233 and 235.

17. Ibid., p. 235; see also pp. 229-34.

18. Paris, p. 22.

19. Claudine Mitchell, "Intellectuality and Sexuality: Camille Claudel, The Fin de Siècle Sculptress," *Art History*, vol. 12, no. 4 (December 1989), p. 437. **20.** Ibid., p. 436.

21. Quoted in Gusbahler, p. 20. 22. From G.-J. Geller, Sarah Bernhardt (Paris: Gallimard, 1931), p. 110; quoted in Elaine Aston, Sarah Bernhardt: A French Actress on the English Stage (Oxford, RI: Berg, 1989), p. 13. 23. Grunfeld, p. 197.

24. Paris, p. 21.

25. Ibid., p. 22.

26. For the most complete catalog to date of Claudel's sculpture, see *Camille Claudel* (exh. cat.), Musée Rodin, Paris, 1991. 27. Paris, p. 101.

Selected Bibliography

BUTLER, Ruth, ed., Rodin in Perspective. Englewood Cliffs, NJ: Prentice-Hall, 1980.

- CAMILLE CLAUDEL (exh. cat.). Musée Rodin, Paris, 1991.
- GRUNFELD, Frederic V., Rodin: A Biography. New York: Henry Holt, 1987.
- MITCHELL, Claudine, "Intellectuality and Sexuality: Camille Claudel, The Fin de Siècle Sculptress," Art History, vol. 12, no. 4 (December 1989).
- PARIS, Reine-Marie, Camille Claudel. Paris: Gallimard, 1984.
- RIVIÈRE, Anne, L'Interdite: Camille Claudel 1864-1943. Paris: Tierce, 1983.
- WAGNER, Anne M., "Rodin's Reputation," in Lynn Hunt, ed., Eroticism and the Body Politic. Baltimore: Johns Hopkins University Press, 1991.

2 Sonia and Robert

Delaunay

Notes

1. Quoted in Sherry Buckberrough, Sonia Delaunay: A Retrospective (exh. cat.), Albright-Knox Art Gallery, Buffalo, 1980, p. 20; the present essay is heavily indebted to Sherry Buckberrough's important essay on the artist. See also Robert Delaunay Sonia Delaunay (exh. cat.), Musée d'Art Moderne de la Ville de Paris, 1987.

- 2. Buckberrough, p. 40.
- 3. Ibid.
- 4. Sonia Delaunay, interviewed in Cindy Nemser, Art Talk: Conversations with Twelve Women Artists (New York: Scribner's, 1975), p. 37.
- 5. Buckberrough, p. 22.
- 6. Ibid., p. 102.
- 7. Ibid., p. 26.

8. Quoted in Arthur A. Cohen, Sonia Delaunay (New York: Abrams, 1975), p. 41.

- 9. Ibid.
- 10. Buckberrough, p. 40.
- 11. Quoted in Michel Hoog, Robert Delaunay (Paris: Flammarion, 1976), p. 53.
- 12. Cohen, p. 23.

13. Buckberrough, p. 30.

14. Jay Bochner, Blaise Cendrars: Discovery and Re-Creation (University of Toronto Press, 1978). 15. Daniel Abadie, "Sonia Delaunay, à la lettre," in Art et Publicité 1890-1990 (exh. cat.), Centre Georges Pompidou, Paris, 1990, pp. 344-57. 16. Robert Delaunay Sonia Delaunay, p. 20.

17. Buckberrough, p. 38. 18. René Crevel, "A Visit to Sonia Delaunay," repr. in The New Art of Color: The Writings of Robert and Sonia Delaunay (New York: Viking, 1978), pp. 185-9. 19. Clair Goll, "Simultaneous Clothing" (1924), repr. in The New Art of Color, pp. 183-5. 20. Buckberrough, p. 69. 21. Ibid.

22. Ibid., p. 82.

23. Nous irons jusqu'au soleil (Paris: Laffont, 1978), p. 206 (my translation).

Selected Bibliography

- BUCKBERROUGH, Sherry A., Sonia Delaunay: A Retrospective (exh. cat.), Albright-Knox Art Gallery, Buffalo, 1980. COHEN, Arthur A., Sonia Delau-nay. New York: Abrams, 1975.
- Robert and Sonia Delaunay (exh. cat.), Musée d'Art Moderne de la Ville de Paris, 1987.
- Hoog, Michel, Robert Delaunay. Paris: Flammarion, 1976.
- MADSEN, Axel, Sonia Delaunay: Artist of the Lost Generation. New York: McGraw-Hill, 1989.

3 Clara and André

Malraux

Notes

1. Susan Rubin Suleiman, "A Double Margin: Reflections on Women Writers and the Avantgarde in France," in The Politics of Tradition: Placing Women in French Literature," Yale French Studies, 75 (1988), p. 150. 2. Shari Benstock, Women of the

Left Bank (Austin: University of Texas Press, 1986), p. 452.

3. Jean Paulhan, La Vie est pleine choses redoutables (Paris: de Seghers, 1989), p. 88.

4. I would like to thank Susan Rubin Suleiman for steering me away from "repeating the gesture," and Edward Baron Turk, comme toujours, for his judicious editorial comments.

Selected Bibliography

- BENSTOCK, Shari, Women of the Left Bank. Austin: University of Texas Press, 1986.
- DE COURTIVRON, Isabelle, Clara Malraux: Une feme dans le siècle. Paris: Olivier, 1992.
- DRIEU LA ROCHELLE, Pierre, "Malraux, l'Homme Nouveau," La Nouvelle Revue Française, 207 (December 1930).
- GOESSL, Alfred, and Cham-pagne, Roland, "Clara Mal-raux's Le Bruit de nos pas: Biography and the Question of Women in the 'Case of Malraux,'" Biography, vol. 7, no. 3 (Winter 1986)
- LACOUTURE, Jean, André Malraux: Une vie dans le siècle. Paris: Seuil, 1973.
- MADSEN, Axel, Malraux. New York: Morrow, 1976.
- MALRAUX, André, Les Conquérants. Paris: Grasset, 1928.
- , La Voie royale. Paris: Grasset, 1930.
- La Condition humaine. Paris: Gallimard, 1933.
- -, L'Espoir. Paris: Gallimard, 1937.
- Antimémoires. Gallimard, 1967.
- MALRAUX, Clara, Le Bruit de nos pas. Paris: Grasset, 1963-79.
- Par de plus longs chemins. Paris: Stock, 1953.
- NIXON, Cornelia, "The Cult of Virility in Modernist Literature," talk given at the Cam-Bunting Institute, bridge, MA, November 5, 1986.
- PAYNE, Robert, A Portrait of André Malraux. New York: Prentice-Hall, 1970.
- SARDE, Michèle, Regard sur les
- françaises. Paris: Stock, 1983. SULEIMAN, Susan Rubin, "Malraux's Women: A Re-vision," in E. Flynn and P. Schweickart, eds., Gender and Reading: Essays on Readers, Texts and Contexts. Baltimore: John Hopkins University Press, 1986.
- "A Double Margin: Reflections on Women Writers and the Avant-garde in France, in The Politics of Tradition: Placing Women in French Literature, Yale French Studies, 75 (1988).

4 Bell and Grant

Notes

I. The Letters of Virginia Woolf, Nigel Nicolson and Joanne Trautmann, eds. (London: Hogarth Press, 1975-80), vol. 3, p. 164. Further quotations from the Letters and The Diary of Virginia Woolf (5 vols), ed. Anne Olivier Bell (London: Hogarth Press, 1977-84), are listed here, in order, in abbreviated form: L.v3, p. 271; D.v3, p. 298; D.v3, p. 220; D.v1, p. 120; L.v3, p. 44; L.v2, p. 400; L.v1, p. 43; L.v2, p. 149; L.v2, pp. 498-9; D.v2, p. 193; L.v4, p. 391, n. 1; L.v2, p. 331; D.v2, p. 73; L.v1, p. 408. 2. Their "round robin" letter is quoted in full in The Letters of Wyndham Lewis, ed. W. K. Rose (London: Methuen, 1963) pp. 47-50. S. P. Rosenbaum reprints useful articles on the "Ideal Home Rumpus"; on Omega see Judith Collins, The Omega Workshops (London: Secker and Warburg, 1984). Omega sold pottery, rugs, painted furniture, fabrics, and clothes; it was intended to introduce Post-Impressionism and a "spirit of fun" into modern interiors, and subsidize artists without a living from their work.

3. John Rothenstein, Modern English Painters, vol. 2 (London: Eyre and Spottiswoode, 1956, rev. Macdonald and Jane's, 1976), p. 45; Vanessa Bell to Angelica Garnett, August 23, [1951]; quoted by Frances Spalding, Vanessa Bell (London: Weidenfeld and Nicolson, 1983), p. 349.

4. Charles Harrison, "Critical Theories and the Practice of Art," British Art in the Twentieth Century (exh. cat.), Royal Academy of Arts, London, 1986, pp. 54-5. In English Art and Modernism 1900-1939 (London: Allen Lane, 1981), Harrison concludes that none of the Bloomsbury artists were very competent painters. He offers a fairly judicious assessment of Grant in half a page and concludes merely that "similar virtues and similar failings are discernible in the work of Vanessa Bell" (pp. 51, 69).

5. Bell and Grant quoted in

Woolf, D.VI, p. 120; Vanessa Bell to Roger Fry, September 11, 1912, quoted in Richard Shone, *Bloansbury Portraits* (Oxford: Phaidon, 1976), p. 80.

6. See Angelica Garnett, Deceived with Kindness (London: Chatto and Windus/Hogarth Press, 1984), p. 165; also Mary Ann Caws, Bloomsbury Women (London and New York: Routledge, 1990), pp. 91-2.

7. Bell to Fry, March 2, 1922, quoted in Shone, p. 81; Woolf, D.v4, p. 322, June 15, 1935, reporting a conversation with Clive Bell: "He said Segonzac thinks Nessa the best painter in England, much better than Duncan. I will not be jealous, but isn't it odd—thinking of gifts in her? I mean when she has everything else." Fry to Bell, May 12, 1921, in *Letters of Roger Fry*, ed. Denys Sutton (London: Chatto and Windus, 1972), vol. 2, p. 507.

8. Clive Bell quoted by Walter Michel in Rosenbaum, p. 355; ibid., p. 65.

9. Clive Holland, "Lady Art Students' Life in Paris," *Studio*, 30 (1903), pp. 225-31.

10. Grant quoted by Paul Roche, With Duncan Grant in Southern Turkey (Honeyglen: Renfrew, 1982), pp. 74-5: "I executed a drawing perfectly in the manner of Tonks. Sure enough, he took the bait. When he came round to me he held up my drawing as an example of what a good drawing should be. I felt rather mean, and also disillusioned." (In 1900 Grant took lessons with Louise Jopling, who became a prominent artist in the women's suffrage campaign; in 1909 the Artists' Suffrage League published Grant's poster Handicapped. Vanessa Bell, "Notes on Bloomsbury" (1951), repr. in Rosenbaum, p. 75. Henry Tonks quoted in Diane Gillespie, The Sisters' Arts: The Writing and Painting of Virginia Woolf and Vanessa Bell (Syracuse, NY: University of Syracuse Press, 1988), o. 201. See also Hilary Taylor, "'If a young painter be not fierce and arrogant, God . . . help him': Some Women Art Students at the Slade, 1895-1899," Art

History, vol. 9, no. 2 (June 1986), pp. 232-44.

11. Raymond Williams, "The Bloomsbury Fraction," Problems in Materialism and Culture (London: Verso, 1980).

12. "Mr Bennett and Mrs Brown," in *Collected Essays by Virginia Woolf*, ed. L. Woolf, (London: Chatto and Windus, 1975), vol. 1, p. 320.

13. Memoir VI quoted in Spalding, p. 92.

ing, p. 92. 14. Quoted in Michèle Barrett, ed., Virginia Woolf: Women and Writing (London: Women's Press, 1979), p. 13. In the same article Woolf refers to the difficulty of "telling the truth about my own experiences as a body" (p. 12). Bell's "experiences as a body" included probable sexual interference by her half-brother as a child, marriage, pregnancy, miscarriage, a passionate extramarital affair, three births (including a child by the lover she shared with another man), menopause, breast cancer and a mastectomy. But except for maternity, which is a subject in her work and which she urged her sister to write about, her paintings are not about the feminine as a body so much as about the woman who speaks.

15. Quentin Bell, Virginia Woolf: A Biography (London: Hogarth Press, 1972), vol. 1, p. 124. This anecdote needs reading against Woolf's description of Hyde Park Gate: "Mounds of plush, Watts' portraits, busts shrined in crimson velvet . naturally dark and thickly shaded . . . by showers of Virginia Creeper-and the agitations suppressed behind the black folding doors of the drawing room." See Moments of Being, ed. Jeanne Schulkind (rev. softback edn., London: Grafton, 1989), p. 179.

16. Vanessa Bell, "Notes on Bloomsbury" (1951) in Rosenbaum, p. 79; Leonard Woolf, Beginning Again: An Autobiography of the Years 1911–1918 (London: Hogarth Press, 1964), pp. 34-5, quoted by Williams, p. 153; Duncan Grant, from reminiscences of Virginia Woolf published in Horizon, 3 (June 1941), repr. in Rosenbaum, p. 67, a reference to the Cambridge society, the Apostles, to which several in the Bloomsbury circle had belonged.

17. Sickert, quoted in Wendy Baron, Ethel Sands and her Circle (London: Peter Owen, 1977) p. 81.

18. See Simon Watney, "The Connoisseur as Gourmet," Formations of Pleasure (London: Routledge and Kegan Paul, 1983) for a discussion of Fry, Bell and "significant form." Fry is quoted on Cézanne (1917), p. 75. In To the Lighthouse (London: Penguin, 1964) see particularly

pp. 62, 23, 57, 181. 19. Quentin Bell, Bloomsbury (London: Futura, 1968, softback edn., 1974) p. 84.

20. Quoted by Paul Levy, "The Colours of Carrington," The Times Literary Supplement, February 17, 1978, p. 200.

21. Vanessa Bell to Roger Fry, July 2, [1915], quoted in Spalding, p. 144; Spalding p. 139.

22. Angelica Garnett, pp.

128-9. 23. Virginia Woolf, Moments of Being, p. 121; the unrevised text of the speech given to the Lon-don/National Society for Women's Service (1931), which became "Professions for Women," published in The Pargiters (London: Hogarth Press, 1978) pxxxix; and on Mr Tansley, p. 120.

24. Angelica Garnett, quoted in Simon Watney, The Art of Duncan Grant (London: John Murray, 1990) p. 36.

25. Watney, passim, and Christo-pher Reed, Re-Imagining Domesticity: The Bloomsbury Artists and the Victorian Avant-Garde, PhD thesis, Yale University, 1990. Woolf, Bell, and to some extent Grant himself, seem to have distanced themselves from what they perceived as the more misogynist homosexuality of the Strachey circle (what Woolf called the "bugger crew"). Strachey was nevertheless a close and influential friend. Woolf wrote that the "society of buggers has many advantages - if vou are a woman. It is simple, it is honest, it makes one feel . . . at one's ease." Moments of Being, p. 211.

26. Ouentin Bell, Virginia Woolf, vol. 1, p. 62. 27. Angelica Garnett, p. 94.

Selected Bibliography

- Caws, Mary Ann, Women of Bloomsbury: Virginia, Vanessa and Carrington. London and New York: Routledge, 1990.
- Deceived GARNETT, Angelica, with Kindness: A Bloomsbury Childhood. London: Chatto & Windus/Hogarth Press, 1984.
- GILLESPIE, Diane Filby, The Sisters' Arts: The Writing and Painting of Virginia Woolf and Vanessa Bell. Syracuse, NY: University of Syracuse Press, 1988.
- ROSENBAUM, S. P., ed., The Bloomsbury Group. Toronto: University of Toronto Press, 1975

SHONE, Richard, Bloomsbury Portraits. Oxford: Phaidon, 1976.

- SPALDING, Frances, Vanessa Bell. London: Weidenfeld and Nicolson, 1983.
- WATNEY, Simon, The Art of Duncan Grant. London: John Murray, 1990.
- WOOLF, Virginia, The Letters of Virginia Woolf, eds. Nigel Nicolson and Joanne Trautmann, 6 vols. London: Hogarth Press, 1975-80. , The Diary of Virginia Woolf,
- ed. Anne Olivier Bell, 5 vols. Press, London: Hogarth 1977-84.
- The Charleston Papers (including letters between Vanessa Bell, Duncan Grant, and Roger Fry), Tate Gallery Archives, London.

5 Woolf and

Sackville-West

Notes

I. Virginia Woolf, The Diary of Virginia Woolf, ed. Anne Oliver Bell (New York: Harcourt Brace Jovanovich, 1978), vol. 2, pp. 225-8.

2. Leonard Woolf, Downhill All the Way (New York: Harcourt Brace Jovanovich, 1967), pp. 111-12.

3. Vita Sackville-West quoted in Nigel Nicolson, Portrait of a Marriage (New York: Atheneum, 1987), p. 201. 4. Sackville-West, The Letters of

Vita Sackville-West to Virginia Woolf, eds. Louise DeSalvo and Mitchell A. Leaska (New York: Morrow, 1985), p. 65.

5. Woolf, Diary, vol. 2, p. 235.

6. Ibid., p. 313. 7. Sackville-West, p. 111.

8. Woolf quoted in Victoria Glendinning, Vita (New York: Knopf, 1983), p. 163.

9. L. Woolf, p. 112. 10. Woolf, The Letters of Virginia Woolf, eds. Nigel Nicolson and Joanne Trautman (New York: Harcourt Brace Jovanovich, 1977), vol. 3, p. 247.

11. Sackville-West, pp. 118-19. 12. Ibid., p. 68.

13. Woolf, Diary, vol. 2, pp. 306-7.

14. Ibid., vol. 4, p. 287.

15. Sackville-West in Nigel Nicolson, ed., Vita and Harold (New York: Putnam's, 1992), p. 392.

Selected Bibliography

- BELL, Quentin, Virginia Woolf: A Biography, 2 vols. New York: Harcourt Brace Jovanovich, 1972.
- Соок, Blanche Wiesen, "Women Alone Stir My Imagination': Lesbianism and the Cultural Tradition," Signs, vol. 4, no. 4 (Summer 1979), pp. 718-39.
- Virginia Louise, DESALVO, Woolf: The Impact of Childhood Sexual Abuse on Her Life and Work. New York: Ballantine Books, 1989; London: Women's Press, 1991.
- GLENDINNING, Victoria, Vita: A Biography of Vita Sackville-West. New York: Knopf, 1983.
- JULLIAN, Philippe, and Phillips, John, The Other Woman: A Life of Violet Trefusis. Boston: Houghton Mifflin, 1976.
- LEES-MILNE, James, Harold Nicolson: A Biography, 2 vols. London: Chatto and Windus, 1980-81.
- NICOLSON, Harold, Diaries and Letters, 3 vols., ed. Nigel Nicolson. New York: Atheneum, 1966–8.
- NICOLSON, Nigel, ed., Vita and Harold: The Letters of Vita Sackville-West and Harold Nicolson. New York: Putnam's, 1992.

---, Portrait of a Marriage. New York: Atheneum, 1987. SACKVILLE-WEST, Vita, The

- SACKVILLE-WEST, Vita, The Letters of Vita Sackville-West to Virginia Woolf, eds. Louise DeSalvo and Mitchell A. Leaska. New York: Morrow, 1985.
- STEVENS, Michael, Vita Sackville-West: A Critical Biography. New York: Scribner's, 1974.
- TRAUTMANN, Joanne, The Jessamy Brides: The Friendship of Virginia Woolf and V. Sackville-West. University Park, PA: Pennsylvania State University Press, 1973.
- WOOLF, Leonard, Downhill All the Way: An Autobiography of the Years 1919 to 1939. New York: Harcourt Brace Jovanovich, 1967.
- WOOLF, Virginia, The Diary of Virginia Woolf, vols. 2-5, ed. Anne Olivier Bell. New York: Harcourt Brace Jovanovich, 1978-84.
- -, The Letters of Virginia Woolf, vols. 3-6, eds. Nigel Nicolson and Joanne Trautmann. New York: Harcourt Brace Jovanovich, 1977-80.

6 Carrington and Ernst

Notes

1. The facts mentioned in this "movie script" were culled from various published sources, most of which are mentioned in the notes that follow. In addition, I wish to thank Leonora Carrington, Whitney Chadwick, and Andrea Schlieker for their generosity in providing me with information and materials for this essay. The interpretations and the argument are, of course, my sole responsibility.

 Max Ernst, Beyond Painting and Other Writings by the Artist and his Friends (New York: Wittenborn, Schultz, 1948), pp. 28–9.
 Paul de Angelis, "Interview with Leonora Carrington," in Leonora Carrington: The Mexican Years, 1943–1983 (exh. cat.), The Mexican Museum, San Francis-Co, 1991, p. 34.

4. See Leonora Carrington: Paintings, Drawings and Sculptures 1940–1990 (exh. cat.), Serpentine Gallery, London, 1991, pl. no. 14 (p. 65). Ernst's Two Children ..., and many of his other works mentioned here, have been reproduced in Werner Spies, ed., Max Ernst: A Retrospective (exh. cat.), Tate Gallery, London, 1991; the essay there by Sarah Wilson, "Max Ernst and England," provides many details about the Ernst-Carrington relationship. See also Whitney Chadwick, Women Artists and the Surrealist Movement (London: Thames and Hudson; Boston: Little, Brown, 1985).

5. This quotation is from a conversation, Oak Park, IL, December 27, 1990; other personal quotations in this essay are from that interview, or from earlier meetings in November 1988 and April 1989. Carrington, in her interview with Paul de Angelis, Oak Park, June 1990, stated about these same three years: "It was a kind of paradise time of my life..."

6. De Angelis, p. 42.

7. I have discussed this painting in detail in Subversive Intent: Gender, Politics, and the Avant-Garde (Cambridge, MA, and London: Harvard University Press, 1990), ch. 7, which also deals with Carrington's novel The Hearing Trumbet.

The Hearing Trumpet. 8. Ernst, "Les Mystères de la forêt," in *Ecritures* (Paris: Gallimard, 1970), p. 223. My translation.

9. Uwe Schneede, *The Essential Max Ernst*, trans. R. W. Last (London: Thames and Hudson, 1972), p. 95.

(1972), p. 95.
10. The Mythology of All Races, vol. 2: Eddic, ed. Canon John Arnott MacCulloch (Boston: Marshall Jones, 1930), p. 207.
11. Andrew Graham-Dixon, "The Rocking-horse Winner" (review of the Carrington retrospective exhibition at the Sertiospective exhibition at the sentine Gallery), The Independent, December 17, 1991.

12. Interview with Marina Warner, July 4, 1987; parts of this interview are reported in Marina Warner's introduction to The House of Fear, Notes from Down Below (New York: Dutton, 1988; London: Virago, 1989). My thanks to her for sharing the complete version with me.

13. M. Warner, "Introduction,"

The House of Fear, Notes from Down Below, p. 10. Page refs. to "Little Francis," given in parentheses, are to this edn.

14. "Pigeon, Fly," in *The Seventh* Horse and Other Tales (New York: Dutton; London: Virago, 1988), p. 28. Other page refs. to this story and to "The Seventh Horse" are given in parentheses in the text.

15. Peggy Guggenheim, Out of This Century: Confessions of an Art Addict (New York: Universe, 1979) p. 239. For a perceptive scholarly discussion of the Ernst-Carrington relation-ship, see Renée Riese Hubert, "Leonora Carrington and Max Ernst: Artistic Partnership and Feminist Liberation," New Literary History, vol. 22, no. 3 (Summer 1991), pp. 715-45. 16. Jimmy Ernst, A Not-So-Still Life: A Child of Europe's Pre-World War II Art World and His Remarkable Homecoming to America (New York: St. Martin's, 1984), pp. 213-14.

Selected Bibliography

- CARRINGTON, Leonora, The House of Fear, Notes from Down Below. New York: Dutton, 1988; London: Virago, 1989. —, The Seventh Horse and Other
- Tales. New York: Dutton; London: Virago, 1988.
- Leonora Carrington: Paintings, Drawings and Sculptures 1940-1990 (exh. cat.), Serpentine Gallery, London, 1991.
- CHADWICK, Whitney, Women Artists and the Surrealist Movement. London: Thames and Hudson; Boston: Little, Brown, 1985.
- DE ANGELIS, Paul, "Interview with Leonora Carrington," in Leonora Carrington: The Mexican Years, 1943-1981 (exh. cat.), The Mexican Museum, San Francisco, 1991.
- ERNST, Jimmy, A Not-So-Still Life: A Child of Europe's Pre-World War II Art World and His Remarkable Homecoming to America. New York: St. Martin's, 1984.

ERNST, Max, Beyond Painting and Other Writings by the Artist and bis Friends. New York: Wittenborn, Schultz, 1948.

-, "Les Mystères de la forêt,"

in Ecritures. Paris: Gallimard, 1970.

- HUBERT, Renée Riese, "Leonora Carrington and Max Ernst: Artistic Partnership and Fe-minist Liberation," New Literary History, vol. 22, no. 3 (Summer 1991).
- SCHNEEDE, Uwe, The Essential Max Ernst, trans. R. W. Last. London: Thames and Hudson, 1972.
- SPIES, Werner, ed., Max Ernst: A Retrospective (exh. cat.), Tate Gallery, London, 1991.
- and Metken, Sigrid and Günter, Max Ernst: Oeuvre-Katalog, 5 vols. Catalog raisonné. Houston, TX: Menil Foundation; Cologne: Du-
- Mont Schauberg, 1975-87. SULEIMAN, Susan Rubin, Subversive Intent: Gender, Politics, and the Avant-Garde. Cam-bridge, MA, and London: Harvard University Press, 1990.

7 Kahlo and Rivera

Notes

1. Bambi, "Frida Es una Mitád," Excelsior (Mexico City), June 13, 1954, p. 6. 2. Lucienne Bloch, interview

with me, November 1978.

3. Bambi, p. 6.

4. Diego Rivera, My Art, My Life (New York: Citadel, 1960), pp. 169-72.

5. Bertram D. Wolfe, "Rise of Another Rivera," Vogue, November 1, 1938, p. 64.

6. Raquel Tibol, Frida Kablo: Crónica, Téstimonios y Aproximaciones (Mexico City: 1977), p. 50. 7. Desmond Rochfort, The Murals of Diego Rivera (exh. cat.), Hayward Gallery, London, 1987, p. 24.

8. Diego Rivera, "Frida Kahlo v el Arte Mexicano," Bolitín del Seminario de Cultura Mexicana (Mexico City), 2 (October 1943), р. 101.

9. Paul Boatine, interviewed by the author, Detroit, January 1978.

10. Private interview with a friend of Kahlo's who wishes to remain anonymous, and Lucienne Bloch, private interview. 11. Florence, Davies, "Wife of the Master Mural Painter Gleefully Dabbles in Works of Art," Detroit News, February 2, 1933, p. 16.

12. Time, "Fashion Notes."

May 3, 1948, pp. 33-4. 13. Parker Lesley, interview with Frida Kahlo, May 1939. I am indebted to Parker Lesley for giving me copies of his interview notes.

14. Ibid.

15. Ibid.

16. Andrés Henestrosa, "Frida," Novedades (Mexico City), Supplement, "México en la Cultura," July 17, 1955, p. 5.

17. Rafael Lozano, dispatch to Time, November 9, 1950.

18. Lesley, notes. 10. Ibid.

20. Carmen Phillips, interview with me, Pippersville, PA, November 1979.

21. Newspaper clipping in the archive of the California School of Fine Arts, San Francisco.

22. Kahlo's diary is in the Frida Kahlo Museum in Mexico City. This and the other quotation from her diary are my translation.

23. Rosa Castro, interview with me, November 1977, and Ella Paresce, letter to Bertram D. Wolfe (July 23, 1954), Hoover Institution, Stanford University

24. Luís Cardoza y Aragón, "Frida Kahlo," Novedades (Mexico City), Supplement, "México en la Cultura," January 23, 1955, p. 3.

Selected Bibliography

- Exposición nacional de homenaje a Diego Rivera (exh. cat.), Palacio de Bellas Artes, Mexico City, 1977. Essays by Frida Kahlo, Berta Taracena, Rita Eder, Raquel Tibol, Antonio Rodríguez, and Fernando Gamboa.
- HERRERA, Hayden, Frida: A Biography of Frida Kahlo. New York: Harper and Row, 1983; London: Bloomsbury, 1989.
- Frida Kablo and Tina Modotti (exh. cat.), Whitechapel Art Gallery, London, 1982. Essay by Laura Mulvey and Peter Wollen.
- PRIGNITZ-PODA, Helga, and Grimberg, Salomón and Kettenmann, Frida Kahlo: Die

Gesamtwerk. Frankfurt: 1988. Diego Rivera: A Retrospective (exh. cat.), Detroit Institute of Arts, 1986.

WOLFE, Bertram D., Diego Rivera: His Life and Times. New York and London: Knopf, 1939.

8 Sage and Tanguy

Notes

I. Letter from Hermon More to Kay Sage, February 24, 1955; letter from Sage to More, February 26, 1955, AAA, microfilm #2887. Further refs. to Sage materials in the AAA are taken from the following microfilm reels: #685, #2886; #2887; reel 2886 contains material from Mildred Devereux Sage, Eleanor Howland Bunce, Margaret Barr, Julien Levy, Patrick Waldberg, Enrico Donati, Jacqueline Breton, Miriam Gabo, Jehan Mayoux, and Pierre Matisse. Unless otherwise indicated, interviews cited were conducted between 1972 and 1977 by Stephen R. Miller. I am grateful to him for making the interviews available.

2. Quoted in Marcel Jean, Autobiographie du surréalisme (Paris: Seuil, 1978), p. 434. 3. Patrick Waldberg, Yves Tan-

guy (Brussels: André de Rache, 1977), p. 14. Further refs. to Waldberg can be found on pp. 181 and 228.

4. Whitney Chadwick, Women Artists and the Surrealist Movement (London: Thames and Hudson; Boston: Little Brown, 1985). Susan Rubin Suleiman, Subversive Intent: Gender, Politics, and the Avant-Garde (Cambridge, MA, and London: Harvard University Press, 1990). The other ref. to Chadwick is on p. 56.

5. Matthew Josephson, Life Among the Surrealists (New 5. Matthew York: Holt Rinehart and Winston, 1962), p. 226.

6. Drafts of letters in Sage's handwriting, courtesy of Pierre Matisse.

7. Charles-Henri Ford, "Interview with André Breton," View, 7-8 (October-November 1941). Special Surrealist Issue.

8. "Serene Surrealist," Time, March 13, 1950.

9. Alexandra Darrow in conversation with me, October 1986. 10. "Kay Sage's Ordered Sur-realism," Pictures on Exhibit (March 1950).

II. Surrealism and American Art, 1931-1947 (exh. cat.), Rutgers University Art Gallery, New Brunswick, NJ, 1977, p. 24. Introduction by Jeffrey Wechsler.

12. "Seance in Connecticut,"

Time, August 30, 1954. 13. Julien Levy, "Tanguy, Con-necticut, Sage," Art News, 53 (September 1954), p. 27.

14. Pierre Matisse in conversation with me, October 1984. The other ref. is also to this conversation.

15. Letter from Kay Sage to Emily Genauer, February 2, 1955. Emily Genauer Papers, AAA.

16. Marcel Duhamel, Raconte pas ta vie (Paris: Mercure de France, 1972), p. 578.

Selected Bibliography

Anon, "Kay Sage's Ordered Surrealism," Pictures on Exbibit (March 1950).

"Seance in Connecticut,"

- Time, August 30, 1954. , "Serene Surrealist," Time, March 13, 1950.
- CHADWICK, Whitney, Women Artists and the Surrealist Movement. London: Thames and Hudson, Boston: Little, Brown, 1985.
- DUHAMEL, Marcel, Raconte pas ta vie. Paris: Mercure de France, 1972.
- FORD, Charles-Henri, "Interview with André Breton," View, 7-8 (October-November 1941). Special Surrealist Issue.

Emily Genauer Papers, AAA.

JEAN, Marcel, Autobiographie du surréalisme. Paris: Seuil, 1978.

- JOSEPHSON, Matthew, Life Among the Surrealists. New York: Holt Rinehart and Winston, 1962.
- LEVY, Julien, "Tanguy, Connecticut, Sage," Art News, 53 (September 1954).

Kay Sage Papers, AAA.

SULEIMAN, Susan Rubin, Subversive Intent: Gender, Politics, and the Avant-Garde. Cambridge, MA, and London: Harvard University Press, 1990.

- Surrealism and American Art, 1931-1941 (exh. cat.), Rutgers University Art Gallery, New Brunswick, NJ, 1977. Intro-
- duction by Jeffrey Wechsler. WALDBERG, Patrick, Yves Tanguy. Brussels: André de Rache, 1977.

9 Nin and Miller

Notes

I wish to thank the more than 200 friends of Anaïs Nin and Henry Miller who talked to me in the years 1990-93. Those persons who directly contri-buted to the material in this chapter include the following, with the dates of my interviews with them: Daisy Aldan (July 11, 1991), George Belmont (July 11, 1991), Renata Druks (April 12 and May 20, 1991), Lawrence Durrell (June 14, 1990), Mary Ryan Gordon (June 19 and July 6 and 15, 1992), Gershon Legman (June 12 and 13, 1990), Rupert Pole (August 15, 1992), and Robert Snyder (September 5, 1990). I also wish to thank Mary Dearborn, Ronald Gottesman and Nancy Scholar for reading all or portions of my MS.

1. Anaïs Nin, The Diary of Anaïs Nin, vol. 1, 1931–4 (San Diego: Harcourt Brace Jovanovich, 1966), p. 11. All refs. to the published diary, unless otherwise indicated, are to this vol., which is well indexed.

2. Philip Jason, "Dropping the Other Veil," Anaïs: an International Journal, 6 (1988), p. 32. 3. Miller to Nin, [March 4, 1932] and [March 6, 1932]. A Literate Passion: Letters of AN and HM, 1932-1953 (San Diego: Harcourt Brace Jovanovich, 1987), pp. 16, 18, 19. Hereafter, unless otherwise indicated, all letters are in this vol.

Alfred Perlès, My Friend Henry Miller: An Intimate Biograpby (New York: John Day, 1956), pp. 48, 56.

5. Nin to Lawrence Durrell, [n.d.], Lawrence Durrell Papers, Morris Library, Southern Illinois University.

6. R. W. Emerson, Journals of

RWE, eds. Edward Waldo Emerson and Waldo Emerson Forbes (Boston: 1889-1914), vol. 5, p. 516.

7. Jay Martin, Always Merry and Bright: The Life of Henry Miller (Santa Barbara: Capra, 1978), p. 241.

8. Miller, Black Spring (New York: Grove, 1963), pp. 166-7. 9. Kate Millett, Sexual Politics (Garden City, NY: Doubleday, 1970), p. 413.

10. Ca. March 1, 1933, The World of Lawrence manuscripts, 9, University of California, Los Angeles, quoted by Martin, p. 267.

11. Miller, Letters to Anaïs Nin, ed. Gunther Stuhlmann (New York: Paragon House, 1965), p. IIS.

12. Perlès, pp. 50 and 47.

13. Nin, Diary, vol. 6, pp. 21-2.

14. Nin, Diary, vol. 2, p. 218.

15. Ellen Peck Killoh, "The Woman Writer and the Element of Destruction," College English,

34 (October 1972), pp. 31-2. 16. This letter to Huntington Cairns from the Villa Seurat was read to me during an interview with George Belmont in Paris, July 1991.

17. Kenneth Dick, Henry Miller: Colossus of One (The Nether-lands, 1967), p. 113. 18. Kate Millett, "Anaïs—A

Mother to Us All: The Birth of the Artist as a Woman," Anaïs: An International Journal, 9 (1991), pp. 4 and 7.

Selected Bibliography

- DEARBORN, Mary, The Happiest Man Alive: A Biography of Henry Miller. New York: Simon and Schuster, 1991.
- DURRELL, Lawrence, and Miller, Henry, The Durrell-Miller Letters 1935-80, ed. Ian S. MacNiven. New York: New Directions, 1988.
- MARTIN, Jay, Always Merry and Bright: The Life of Henry Miller. Santa Barbara: Capra, 1978.
- MILLER, Henry, Black Spring. New York: Grove, 1963. —, "Un Être Étoilique," The
- Criterion, 17 (October 1937), repr. A Casebook of Anaïs Nin, ed. Robert Zaller. New York: NAL, 1974.

"Joey," in Book of Friends: A Trilogy. Santa Barbara: Capra, 1987.

"Letter to William Bradley" [not sent] in Sunday After the War. Norfolk, CT: New Directions, 1944.

- , "Letter to Anaïs Nin Regarding One of Her Books, in Sunday After the War. Nor-folk, CT: New Directions, 1944.
- Letters to Anaïs Nin, ed. Gunther Stuhlmann. New York: Paragon House, 1965.
- , Letters to Emil, ed. George Wickes. New York: New Directions, 1989.
- Henry Miller Collection, Department of Special Collections, University of California, Los Angeles.
- , Quiet Days in Clichy. New York: Grove, 1978.
- , Tropic of Cancer, preface by Anaïs Nin. New York: Grove, 1961. NIN, Anaïs, "Alraune," MS
- (Northwestern University), winter of Artifice (Paris: Obelisk, 1939), repr. "Hans and Johanna," Anais: An International Journal, 7 (1989),
- pp. 3-22. , "Birth," in Under A Glass Bell And Other Stories. Chicago: Swallow, 1948 (originally pub. in *Twice a Year*, Fall/ Winter 1938).
- , The Diary of Anaïs Nin, vols. 1 (1931-4), 2 (1934-9), and 6 (1955-66). New York: Harcourt Brace, 1966, 1967, 1976.
- , Henry and June: From the Unexpurgated Diary of Anaïs Nin. San Diego: Harcourt Brace Jovanovich, 1986.
- , Incest: From a Journal of Love; The Unexpurgated Diary, 1932– 1934. San Diego: Harcourt Brace Jovanovich, 1992.
- "A House and a Garden: The Rise and Fall of 2 bis Rue Monbuisson," Anaïs: An International Journal, 7 (1989), pp. 32-46.
- House of Incest. Athens, OH: Swallow and Ohio University Press, 1979.
- Ladders to Fire. Chicago: Swallow, 1959.
- Anaïs Nin Papers, Department of Special Collections, Uni-

versity of California, Los Angeles.

- , Seduction of the Minotaur. Athens, OH: Swallow and Ohio University Press, 1961. , Winter of Artifice: Three Novelettes. Chicago: Swallow, 1945. [First published with
- "Djuna". Paris: Obelisk, 1939.] NIN, Anaïs, and MILLER, Henry, A Literate Passion:
- Letters of Anaïs Nin and Henry Miller, 1932-1953, ed. and introduced by Gunther Stuhlmann. San Diego: Harcourt Brace Jovanovich, 1987.
- PERLES, Alfred, My Friend Henry Miller: An Intimate Biography. York: John New Day. 1956.
- SCHOLAR, Nancy, Anaïs Nin. Boston: Twayne, 1984.
- SPENCER, Sharon, Collage of Dreams: The Writing of Anaïs Nin. Chicago: Swallow, 1977.

10 Hellman and Hammett

Notes

- 1. Lillian Hellman, An Unfinished Woman, in Three (Boston: Little, Brown, 1979), p. 276.
- 2. Unfinished, p. 290. 3. Ibid.
- 4. Quoted in Richard Moody, Lillian Hellman: Playwright (New York: Pegasus, 1972), p. 77 5. Carl Rollyson, Lillian Hellman: Her Legend and Her Legacy (New York: St. Martin's, 1988), p. 309.
- 6. Unfinished, p. 22.
- 7. Nunnally Johnson, quoted in Diane Johnson, Dashiell Hammett: A Life (New York: Random House, 1983), p. 124.
- 8. Quoted in Johnson, p. 316. 9. Hellman, *Scoundrel Time*, in Three, p. 609.
- 10. Quoted in Rollyson, p. 214. 11. Hellman, Pentimento, in
- Three, p. 472.
- 12. Quoted in Johnson, p. 195.
- 13. Ibid., p. 176.
- 14. Ibid., p. 195.
- 15. Unfinished, p. 133.
- 16. Ibid., p. 292.
- 17. Rollyson, p. 317. 18. Pentimento, p. 501.
- 19. Unfinished, p. 297. 20. Richard Layman, Shadow Man: The Life of Dashiell Ham-mett (New York: Harcourt

- Brace Jovanovich, 1981), pp. 234-5
- 21. Quoted in Johnson, p. 53.
- 22. Ibid., p. 77.
- 23. Unfinished, p. 279.
- 24. Pentimento, p. 495.
- 25. Ibid., p. 462. 26. Ibid., pp. 474-5.
- 27. Ibid., p. 502.
- 28. Ibid., p. 573.
- 29. Unfinished, p. 288.
- 30. Pentimento, p. 510.
- 31. Unfinished, p. 211.
- 32. Ibid., p. 18.

Selected Bibliography

- HELLMAN, Lillian, Three (An Unfinished Woman, Pentimento, and Scoundrel Time). Boston: Little, Brown, 1979.
- JOHNSON, Diane, Dashiell Hammett: A Life. New York:
- Random House, 1983. LAYMAN, Richard, Shadow Man: The Life of Dashiell Hammett. New York: Harcourt Brace Jovanovich, 1981.
- MOODY, Richard, Lillian Hellman: Playwright. New York: Pegasus, 1972.
- ROLLYSON, Carl, Lillian Hellman: Her Legend and Her Legacy. New York: St. Martin's, 1988.

11 Johns and Rauschenberg

Notes

1. Since Calvin Tomkins' initial discreetly between-the-lines account of the relationship in his Off the Wall: Robert Rauschenberg and the Art World of Our Time (New York: Penguin, 1980), other scholars have slowly begun to explore this territory, although, in keeping with the artists' wishes, never before from a primarily biographical point of view. See C. Harrison and F. Orton, "Jasper Johns: 'Meaning What You See," Art History, 7 (March 1984), pp. 77-101. Kenneth Silver's groundbreaking paper at the Annual Meeting of the College Art Association in 1986 was the first explicitly to connect the two artists to gay culture, and Roni Feinstein's unpublished New York University dissertation, "Random Order: The First Fifteen Years of Robert Rauschenberg's Art, 1949-1964," is the

most detailed account yet of the relationship as reflected through the work.

2. Paul Taylor, "Robert Rauschenberg: 'I can't even afford my works anymore," *Interview*, vol. 20, no. 12 (December 1990), pp. 146-8.

3. Tomkins p. 213.

4. Leo Steinberg, Other Criteria: Confrontations with Twentieth Century Art (Oxford and New York: Oxford University Press, 1972), p. 90.

5. Quoted in Mary Lynn Kotz, Rauschenberg Art And Life (New York: Abrams, 1990), p. 90.

6. See John D'Émilio, Sexual Politics, Sexual Communities: The Making of a Homosexual Minority in the United States, 1940–1970 (Chicago: University of Chicago Press, 1983), pp. 40–53.

7. Tomkins, unpublished notes quoted in Feinstein, "Random Order," p. 152.

8. Allan Kaprow, Art News, 65 (March 1966), p. 63.

9. Kotz, p. 90.

to. For a theoretical account of the formation of gay subjectivity, see Jonathan Dollimore, Sexual Dissidence (Oxford: Clarendon Press, 1991). For an historical account, see Jeffrey Weeks, Against Nature (London: Rivers Oram, 1991).

11. Kotz, p. 90.

12. Tomkins, p. 118.

13. Walter Hopps, Robert Rauschenberg: The Early 1950's (Houston, TX: Houston Fine Art, 1991), p. 161.

14. Feinstein, p. 185.

15. G. Glueck, "Once Established, Ideas Can Be Discarded," New York Times, October 16, 1977, p. 31.

16. Feinstein speculates on this point, p. 243.

17. Tomkins, unpublished notes, quoted in Feinstein, p. 249.

18. Johns, [undated sketchbook note], publ. in *Jasper Johns* (exh. cat.), ed. Alan R. Solomon, Jewish Museum, New York, 1964. 19. Glueck, p. 31.

20. For example, Rauschenberg created a combine featuring metal paint cans in 1954. Johns picked up the theme of paint cans 6 years later in a bronze sculpture of a coffee can with brushes sticking out of it. He then began to feature the can again in the 70's, painting it, drawing it, and printing it so often that it came to be identified with Johns alone and its original resonance with Rauschenberg was lost.

21. Tomkins, p. 119.

Selected Bibliography

- CRICHTON, Michael, Jasper Johns. New York: Abrams, 1977.
- ^{19/7/} FEINSTEIN, Roni, "Random Order: The First Fifteen Years of Robert Rauschenberg's Art, 1949–1964". Ph.D. dissertation, New York University, 1990.
- FRANCIS, Richard, Jasper Johns. New York: Abbeville, 1984.
- HARRISON, Charles, and Orton, 1984. HARRISON, Charles, and Orton, Fred, "Jasper Johns: 'Meaning What You See,''' Art History, 7 (March 1984), pp. 77–101.
- HOPPS, Walter, Robert Rauschenberg: The Early 1950's. Houston, TX: Houston Fine Art Press, 1991.
- Korz, Mary Lynn, Rauschenberg/ Art and Life. New York: Abrams, 1990.
- Robert Rauschenberg (exh. cat.), National Collection of Fine Arts, Washington, D.C., 1976. Essays by Walter Hopps and Lawrence Alloway.
- TOMKINS, Calvin, Off the Wall: Robert Rauschenberg and the Art World of Our Time. New York: Penguin, 1980.

12 Schwarz-Barts

Notes

r. "André Schwarz-Bart s'explique sur huit ans de silence: 'Pourquoi j'ai écrit *La Mulatresse Solitude*," *Le Figaro Littéraire*, January 27, 1967 (my translation). This and subsequent quotations from A. Schwarz-Bart are from this interview, unless otherwise noted.

2. Héliane and Roger Toumson, "Interview avec Simone Schwarz-Bart. Sur les pas de Fanotte," *Textes, études et documents*, 2 (Paris: Caribéennes, 1979), pp. 20, 15. Subsequent quotations are from pp. 14, 18, 21-2.

3. Ibid., pp. 18 and 19.

4. Hommage à la femme noire (Belgium: Consulaires, 1988), Avant-Propos [n.p.].

Selected Bibliography

- BRODZKI, Bella, "Nomadism and The Textualization of Memory in André Schwarz-Bart's La Mulatresse Solitude," Yale French Studies, 82 and 83 (Winter 1993).
- KAUFMANN, Francine, Pour Relire "Le Dernier des justes." Paris: Méridiens Klincksieck, 1987.
- SCHARFMAN, Ronnie, "Mirroring and Mothering in Simone Schwarz-Bart's Pluie et vent sur Télumée Miracle and Jean Rhys' Wide Sargasso Sea," Yale French Studies, 62 (1981).
- -, "Exiled From the Shoah: André and Simone Schwarz-Bart's Un Plat de porc aux bananes vertes," in Mary Jean Green et al, eds., Beyond The Hexagon: Francophone Women Writers. Ithaca: Cornell University Press, 1993.
- SCHWARZ-BART, André, Le Dernier des justes. Paris: Scuil, 1959.
- -, *La Mulatresse Solitude*. Paris: Seuil, 1972. -, and Schwarz-Bart, Simone,
- -, and Schwarz-Bart, Simone, Un Plat de porc aux bananes vertes. Paris: Seuil, 1967.
- SCHWARZ-BART, Simone, Pluie et vent sur Télumée Miracle. Paris: Seuil, 1972.
- -, Ti-Jean l'Horizon. Paris: Seuil, 1979.
- -, Ton Beau Capitaine, trans. Your Handsome Capitain by Jessica Harris and Catherine Temerson. New York: Ubu Repettory Theater, 1987.
- —, *Hommage à la femme noire.* Belgium: Consulaires, 1988.
- TOUMSON, Héliane and Roger, "Interview avec Simone Schwarz-Bart. Sur les pas de Fanotte," *Textes, études et documents*, 2. Paris: Caribéennes, 1979.
- TOUREH, Fanta, L'Imaginaire dans l'oeuvre de Simone Schwarz-Bart: approche d'une mythologie antillaise. Paris: L'Harmattan, 1987.

13 Krasner and Pollock

Notes

1. B. H. Friedman, Jackson Pollock: Energy Made Visible (New York: McGraw-Hill, 1972), p. 245.

2. Harold Rosenberg, "The Art Establishment," *Esquire*, 62 (January 1965). A copy of this article is among the Lee Krasner Papers, AAA, microfilm reel #3777.

3. Friedman, p. 246.

4. Lee Krasner, undated interview with B. Cavaliere, transcript, AAA, #3774/289; published as Barbara Cavaliere, "An Interview with Lee Krasner," *Flash Art*, 94-5 (January/February 1980), pp. 14ff. The published interview differs markedly from the transcript, however, and the citation above is not included there.

5. Edward Albee et al., Lee Krasner (New York: Robert Miller Gallery, 1992), [n.p.]; for a discussion of critical responses to Krasner's work before Pollock's death, see my "Lee Krasner as L.K.," Representations, 25 (Winter 1989), pp. 42-57. 6. G. T. M. [Gretchen T. Mun-

6. G. T. M. [Gretchen T. Munson], "Man and Wife," Art News (October 1949), p. 45, cited in Wagner, pp. 44-5.

7. Francine du Plessix and Cleve Gray, "Who was Jackson Pollock?" Art in America, 55 (May/ June, 1967), pp. 48ff. Ellen Landau, in her monograph Jackson Pollock (New York: Abrams, 1989), p. 270, gives a list of 18 interviews with Krasner, including her own; transcripts of most of these are at the AAA; to them should be added those published interviews, of which there are some 10, for which transcripts are not at the AAA or which are unmentioned by Landau.

8. Don Judd, "Jackson Pollock," Arts Magazine (April 1967), p. 32.

9. Clement Greenberg, [Letter to the Editors], Evergreen Review,

vol. 2, no. 5 (Summer 1958), p. 160; for his obituary of Pollock, see *Evergreen Review*, vol. 1, no. 3 (1957), pp. 95-6.

(1957), pp. 95-6. 10. Clement Greenberg, "The Jackson Pollock Market Soars," New York Times Magazine, April 16, 1961, p. 136.

11. Jeffrey Potter, To A Violent Grave: An Oral Biography of Jackson Pollock (New York: Putnam's, 1985; softback edn. Wainscott, NY: Pushcart, 1987), p. 248.

12. Steven Naifeh and Gregory White Smith, Jackson Pollock: An American Saga (New York: Clarkson Potter, 1989), p. 379. 13. Naifeh and Smith, p. 695.

14. Potter, p. 142.

15. Naifeh and Smith, p. 571.

 Ibid., p. 880.
 Ernst Kris and Otto Kurz, Legend, Myth, and Magic in the Image of the Artist: A Historical Experiment (New Haven and London: Yale University Press, 1979), first pub. in Ger. in 1934.
 Greenberg, 1957, p. 95.
 B. H. Friedman, "An Inter-

19. B. H. Friedman, "An Interview with Lee Krasner Pollock," in Barbara Rose, ed., *Pollock Painting* (New York: Agrinde, ca. 1980), [n.p.].

20. Hans Namuth, "Photographing Pollock—A Memoir," in Rose, [n.p.].

21. Rose, [n.p.].

22. Cindy Nemser, Art Talk: Conversations with Twelve Women Artists (New York: Scribner's, 1971), p. 86.

23. Ibid., p. 85.

24. Ibid., p. 88.

25. Krasner's vision of a "joint acknowledgement" of the merits of her art by men and women was not contingent on a rejection, at this point in her career, of contemporary feminism. The rest of her speech reads: "The belated recognition I have already received is largely due to consciousness raising by the feminist movement which I consider the major revolution of our time." Transcript, Lee Krasner Papers, #3771/246, AAA.

26. Francis V. O'Connor and Eugene V. Thaw, Jackson Pollock: A Catalogue Raisonné of Paintings, Drawings, and Other Works (New Haven and London: Yale University Press, 1978), vol. 4, p. 166, no. S/n. 27. Sanford Friedman to David Hare, January 22, 1963, Lee Krasner Papers, #3771/734, AAA.

28. May Natalie Tabak, "Small Change," *Kenyon Review*, XXX, vol. 122, no. 5 (1968), pp. 627–51.

29. Undated letter from John Reed, Lee Krasner Papers, #3777/416, AAA.

Selected Bibliography

- CLARK, T. J., "Jackson Pollock's Abstraction," in Serge Guilbaut, ed., Reconstructing Modernism: Art in New York, Paris, and Montreal 1947-1964. Cambridge, MA, and London: MIT Press, 1990.
- don: MIT Press, 1990. Lee Krasner: A Retrospective (exh. cat.), Museum of Modern Art, New York, 1983. Essay by Barbara Rose.
- LANDAU, Ellen G., "Lee Krasner's Early Career," Arts (October 1981) and (November 1981).
- NEMSER, Cindy, Art Talk: Conversations with Twelve Women Artists (New York: Scribner's, 1975).
- O'CONNOR, Francis V., and Thaw, Eugene V., Jackson Pollock: A Catalogue Raisonné of Paintings, Drawings, and Other Works, 4 vols. New Haven and London: Yale University Press, 1978.
- RADWAY, Janice A., Reading the Romance: Women, Patriarchy, and Popular Literature. Chapel Hill, NC, and London: University of North Carolina Press, 1984.
- Rose, Barbara, ed., Pollock Painting. New York: Agrinde, ca. 1980.
- WAGNER, Anne M., "Lee Krasner as L.K.," Representations, 25 (Winter 1989).

Notes on the Contributors

BERNARD BENSTOCK is professor of English at the University of Miami. He has co-edited three volumes of *The Dictionary of Literary Biography* on mystery fiction and has written and edited thirteen books on James Joyce. His biography of Lillian Hellman and Dashiell Hammett, *Love*, *Hate*, and *Pity*, will be published in 1993.

WHITNEY CHADWICK is an art historian and professor of art at San Francisco State University. Her books include Myth in Surrealist Painting (1980), Women Artists and the Surrealist Movement (1985), and Women, Art, and Society (1990).

ISABELLE DE COURTIVRON is professor of French studies at the Massachusetts Institute of Technology. She is the coeditor of New French Feminisms (1981) and the author of Clara Malraux: une femme dans le siècle (1992).

LOUISE DESALVO is professor of English at Hunter College, New York. She is the editor of *The Letters of Vita* Sackville-West to Virginia Woolf (1985) and the author of Virginia Woolf: The Impact of Childbood Sexual Abuse on Her Life and Work (1989).

NOËL RILEY FITCH teaches at the University of Southern California. She is the author of *Sylvia Beach and the Lost Generation* (1983). Her biography of Anaïs Nin, *Anaïs*, is scheduled for publication in 1993.

HAYDEN HERRERA is an art historian and critic. She is the author of *Frida*: *A Biography of Frida Kahlo* (1983) and *Frida Kahlo: The Paintings* (1991).

ANNE HIGONNET teaches the history of art at Wellesley College. She is the author of *Berthe Morisot*: A Biography (1990) and *Berthe Morisot*'s Images of Women (1992), as well as the essays on women and visual culture in Volumes IV (19th century) and V (20th century) of The History of Women (1991–2). JONATHAN KATZ teaches in the department of lesbian and gay studies at City College of San Francisco. He is the author of the forthcoming *Andy Warhol* and is currently working on a book about the homosexualization of the avant-garde during the 1950's. A long-time activist, he is a founder of Queer Nation, San Francisco.

RONNIE SCHARFMAN is associate professor of French language and culture at the State University of New York, Purchase. Her book "Engagement" and the Language of the Subject in the Poetry of Aimé Césaire (1987) received the Gilbert Chinard literary prize. She has co-edited a special double issue of Yale French Studies entitled Post-Colonial Conditions: Exiles, Migrations, and Nomadism (1993).

SUSAN RUBIN SULEIMAN, co-editor of The Reader in the Text: Essays on Audience and Interpretation (1980), author of Authoritarian Fictions (1983, rev. edn. 1992), Subversive Intent: Gender, Politics, and the Avant Garde (1990) and editor of The Female Body in Western Culture (1986), is professor of romance and comparative literatures at Harvard University.

JUDITH D. SUTHER is professor of comparative literature at the University of North Carolina at Charlotte. She is the author of *Raissa Maritain: Pilgrim*, *Poet, Exile* (1990). Her monograph on the life and work of Kay Sage, *Kay Sage, Solitary Surrealist*, is scheduled for publication in 1994.

LISA TICKNER is professor of art history at Middlesex University and the author of *The Spectacle of Women: Imagery* of the Suffrage Campaign 1907–14 (1988).

ANNE M. WAGNER is professor of modern art at the University of California, Berkeley, and the author of *Jean-Baptiste Carpeaux: Sculptor of the Second Empire* (1986). Her essay in this volume is part of a larger study of gender within twentieth-century American art practices. Page numbers in *italic* refer to the illustrations

Abstract Expressionism 145, 189-205 passim, 223 Académie Colarossi 16 Adams, Henry 8 Adjani, Isabelle 28, 26 Albee, Edward 224 Allendy, Dr. René 161 Apollinaire, Guillaume 31, 33, 40-1, 42, 52 Aragon, Louis 14 Artaud, Antonin 52 BALLA, Giacomo 44 Balzac, Honoré de 21, 22 Barr, Alfred 48 Beauvoir, Simone de 8, 10, Bell, Angelica see Garnett, Angelica Bell, Clive 65, 66, 71, 72, 77, 81, 83-4 Bell, Quentin 76 Bell, Vanessa 8, 11, 65-80 passim, 83; 64, 73, 74, 77, 81 Bellow, Saul 159 Benstock, Shari 8, 52 Bernhardt, Sarah 25 Beuret, Rose 24, 26 Bloomsbury group 44, 86, 65-80 passim Blot, Eugène 27 Bochner, Jay 41 Boucher, Alfred 16 Bourdelle, Emile Antoine 17, 20, 24 Bradley, William Aspenwall 167 Braque, Georges 34, 40 Brasillach, Robert 58 Brassaï 161 Breton, André 33, 45, 100, 101, 102, 106, 108, 139, 140-1, 143, 152 Breton, Jacqueline 143 Breton, Simone 33 Brumant, Alice Didier 215 Buñuel, Luis 155 CAGE, John 201

Calas, Nicolas 143 Camden Town Group 73 Campbell, Kenneth Hallyburton 92–3 Campbell, Mary 88 Canova, Antonio 15 Cardoza y Aragón, Luís 135 Carpenter, Humphrey 8 Carrier-Belleuse, Albert-Ernest 16 Carrington, Dora 65, 71, 76 Carrington, Leonora 10,

97-117 passim, 140; 96, 99, 103, 104, 111, 115

Index

Castelli, Leo 190-1 Céline 58 Cellini, Benvenuto 15 Cendrars, Blaise 40-1, 42, 43-4 Césaire, Aimé 219 Cézanne, Paul 34, 35, 75 Chadwick, Whitney 140 Chagall, Bella and Marc 55 Chevreul, Henri 32, 35, 38 Chirico, Giorgio de 145, 146, 148 Claudel, Camille 8, 9, 15-29 *passim*; 14, 25, 26, 29 Claudel, Louis-Prosper 16, 27 Claudel, Louis 16, 27 Claudel, Paul 16, 27 Cocteau, Jean 52 Connolly, Cyril 65 Cope, Arthur 69 Crane, Hart 206 Crevel, René 45 Cubism 31, 34, 35, 36-7, 40, 43, 55 Cunard, Nancy 54 DADA 40, 44-6 Dalí, Salvador 145, 146 Dante 19, 202, 205 Daudet, Alphonse 19 De Angelis, Paul 104, 105 De Kooning, Willem 194, 196 Dearborn, Mary 160 Delacroix, Eugène 19, 20 Delaunay, Robert 8, 11, 31-48 passim, 55; 30, 35, 38, 47 Delaunay, Sonia 8, 9, 11, 31-48 passim, 55; 30, 37, 43, 47, 49 Delteil, Joseph 45 Diaghilev, Serge 44 Díaz, Porfirio 123 Dick, Kenneth 164 Dickinson, Violet 85 D'Offay, Anthony 67-8 Donatello 15, 19 Donati, Enrico 142 Drieu la Rochelle, Pierre 54, 58, 62 Druks, Renata 159 Dubuffet, Jean 152 Duchamp, Marcel 41 Duckworth, George 69, 80, 92 Duckworth, Gerald 92 Dufy, Raoul 46 Duhamel, Marcel 139, 141, 150, 152, 153 Durrell, Lawrence 157, 159, 164, 166, 167 ÉCOLE DES BEAUX-ARTS, Paris, 16 Emerson, Ralph Waldo 158

Ernst, Jimmy 107, 116

Ernst, Marie-Berthe 107, 112–13

Ernst, Max 9, 10, 97-117 passim, 140; 96, 99, 109,

II7

Exter, Alexandra 35

FALKENBERG, Paul 231 Fauves, 35, 73 Fitzgerald, F. Scott 141 Fitzgerald, Zelda 8, 10 Ford, Charles-Henri 143 Forster, E. M. 68 Fraenkel, Michael 157 Francastel, Pierre 48 Freud, Sigmund 15-16, 164 Friedman, B. H. 223, 239, 240 Friedrich, Caspar David 108 Fry, Roger 66, 67, 68, 75, 76, 77, 79, 81 Futurism 40, 42, 44 GABLIK, Suzi 191 Gabo, Miriam 144 Gabo, Naum 144 García Marquez, Gabriel 218 Garland, Judy 196, 201, 202 Garnett, Angelica 77-8, 81; 81 Garnett, David 77, 78 Gaudier-Brzeska, Henri 76 Gauguin, Paul 35, 124 Geffroy, Gustave 19, 26 Gide, André 18 Ginsburg, Allen 197 Giotto 124 Glissant, Edouard 216 Goddard, Paulette 133; 133 Goll, Claire and Ivan 55 Goncharova, Natalia 35. 41-2 Goncourt brothers 19 Gorky, Maxim 52, 193 Grant, Duncan 8, 11, 65 80 passim, 83; 64, 73, 78 Gray, Cleve 225 Greenberg, Clement 226, 229, 230-1 Greer, Germaine 66 Grimm, Jacob 109 Guggenheim, Peggy 98-9, 107, 115, 139, 143, 226, 235, 238 Guiler, Hugh 155, 160, 161-2, 169, 170 HAMMETT, Dashiell 8, 11, 173-87 *passim*; *172*, *176* Hamnett, Nina 70 Hare, David 143 Hélion, Jean 143, 144

Hélion, Jean 143, 144 Hellman, Lillian 8, 11, 173–87 *passim*; 172, 187 Hellman, Max 187 Hemingway, Ernest 9 Hess, Thomas 193 Hofmann, Hans 234 Holroyd, Michael 79 Hosmer, Harriet 26 Hugo, Victor 17, 19 Huston, Nancy 10–11 Huysmans, Joris-Karl 25–6

IMPRESSIONISM 32

JACKSON, Harry 228, 233 Jacob, Max 52 Jason, Philip 156 Jeramec, Colette 54 John, Augustus 70, 72, 76, 78 John, Gwen 69, 76 Johns, Jasper 8, 9, 189-206 passim; 188, 203 Johnson, Nunnally 178 Johnson, Ray 201 Jolas, Eugène 164 osephson, Matthew 141 Judd, Don 225-6 Jung, C. G. 164 KAHANE, Jack 164 Kahlo, Frida 8, 11, 12,

119-35 patsim; 118, 125, 127, 128, 131, 13, 134 127, 128, 131, 133, 134 Kahn, Gustave 27 Kahn, Simone 54 Kaprow, Allan 195 Keynes, Maynard 77 Killoh, Ellen Peck 167 Kiligman, Ruth 238 Kline, Franz 192, 193, 194 Kober, Arthur 175 Kokoschka, Oskar 109 Krasner, Lee 10, 33, 223-44 passim; 222, 231, 237, 241, 243 Kris, Ernst 229 Kurz, Otto 229

LACOUTURE, Jean 53 Lamba, Jacqueline 108 Laurencen, Marie 33 Lawrence, D. H. 66, 83, 155, 156, 158, 159, 162, 165 Levy, Julien 139, 142, 144 Lewis, Wyndham 66, 68, 71, 73, 76, 78 Lloyd, Constance 69 MACCARTHY, Desmond 71, 84 McCarthy, Joe 11, 194

McCarthy, Joe 11, 194 Magic Realism 218 Mahler, Alma 109 Mailer, Norman 159 G3 passim; 70, 56, 59 Malraux, Clara 10, 51-63 passim; 70, 63 Mansfield, June 155-6, 161, 162-3, 164, 165 Mansfield, Katherine 68, 83, 84 Marcello 26 Marín, Lupe 130 Marinetti, Filippo 71 Martin, Jay 159, 164 Martin, Knox 195-6 Marx, Roger 19 Matisse, Henri 35 Matisse, Pierre 142, 144, 147, 150, 151 Matta (Roberto Echaurren) 140, 143 Michelangelo 15, 19 Milford, Nancy 8 Miller, Eve 164 Miller, Henry 8, 11, 155-70 passim; 154 Miller, June see Mansfield, June Millett, Kate 164, 170 Mirbeau, Octave 19, 25-6 Mitchell, Claudine 24 Modotti, Tina 119, 124, 131 Monet, Claude 19 Monnier, Adrienne 62 Montherlant, Henri de 58 Moralt, Dr. Marie 73 More, Hermon 137 Morhardt, Mathias 19, 26, 27 Morisot, Berthe 8 Morphet, Richard 67-8 Mortimer, Raymond 67 Musée d'Art Moderne, Paris 48, 150 Museum of Decorative Arts, Paris 16-17 Museum of Modern Art, New York 47-8, 150-1, 200, 231, 232, 236 NAIFEH, Steven 226-8, 230 Namuth, Hans 231, 240 Négritude 213, 219 Neo-Impressionism 32, 34-5 New York School 193 Newman, Barnett, 193 Nicolson, Harold 84-5, 86, 87, 90, 93, 95; 89 Nin, Anaïs 8, 11, 155-70 passim; 154, 168, 171 Nin, Joaquin 162 Nizan, Henriette 54 Nizan, Paul 54 Nuytten, Bruno 28

OCAMPO, Victoria 62 O'Connor, Francis 240 O'Hara, Frank 197, 206 O'Keeffe, Georgia 8 Olivier, Fernande 33 Osborn, Richard 135 Osborn, Alfonso A. 236 O'Toole, Patricia 8 Ovid 18

PAULHAN, Jean 54 Perlès, Alfred 157, 161, 163, 165 Phidias 19 Picasso, Pablo 34, 40, 42, 138, 191 Plessix, Francine du 225 Pole, Rupert 169 Pollock, Charles 226 Pollock, Jackson 10, 193, 194, 223-44 passim; 222, 235, 241 Posada, José Guadalupe 124, 130; 131 Post-Impressionism 66, 71, 74 Potter, Jeffrey 226-7, 229 Priccin, Stéphanie 216 Prusak, Salomea 14 RANK, Dr. Otto 161, 162, 164, 167 Rauschenberg, Robert 8, 9, 189-206 passim; 188, 193, 201, 207 Rayonism 42 Read, Herbert 104 Rebel Art Centre, London Reed, Christopher 79 Reed, John 241-2; 243 Rimbaud, Arthur 51 Rivera, Diego 11, 119-35 passim; 118, 131, 133, 134 Rodin, Auguste 9, 15-29 passim; 14, 21, 23 Rollinat, Maurice 25-6 Rops, Félicien 25-6 Rose, Barbara 232 Rose, Countess Berthe-Félicie de 32 Rose, Phyllis 8 Rosemont, Franklin 101 Rosenbaum, S. P. 68 Rosenberg, Harold 223, 224, 239 Rothenstein, John 66-7 Rothko, Mark 193

Rousseau, Douanier 124 Rubens, Peter Paul 20 Rutter, Frank 71 SACKVILLE-WEST, Vita 8, 11, 12, 83-95 passim; 82, 80 Sage, Henry Manning 139 Sage, Kay 10, 11, 137-53 passim; 136, 149 St. Aubyn, Gwen 88 Saint-Exupéry, Antoine de \$8 Salon des Artistes Français 19 Sanchez, Eduardo 161 Sartre, Jean-Paul 8 Satie, Eric 52 Schneede, Uwe 109 Schnellock, Emil 160 Schwarz-Bart, André 8, 11, 209-21 passim; 208 Schwarz-Bart, Simone 8, 11, 209-21 passim; 208, 220 Segonzac, André Dunover de 68 Shone, Richard 67, 76 Sickert, Walter Richard 73 Smith, Gregory White 226-8, 230 Snyder, Bob 159 Soby, James Thrall 150 Soupault, Philippe 45 Spalding, Frances 68, 77 Steichen, Edward 21 Stein, Gertrude 9, 33 Stephen, Adrian 77 Stephen, Sir Leslie 65, 78-9, 80, 92 Stephen, Thoby 70 Stieglitz, Alfred 8 Strachey, Lady 69 Strachey, Lytton 67, 72, 74, 77, 79, 81 Strachey, Marjorie 71, 72 Strachey, Pernel 71, 74 Strachey, Pippa 71, 72 Stravinsky, Igor 41 Stuhlmann, Gunter 170 Suleiman, Susan Rubin 52, 140 Surrealism 11, 52, 54, 55, 56, 97-115 passim, 124, 138-51 passim Sweeney, James Johnson

Symons, Arthur 20 TABAK, May Natalie 239-40 Taeuber-Arp, Sophie 33 Tanguy, Yves 9, 10, 11, 137-53 passim; 136, 146 Tanning, Dorothea 117 Tate Gallery, London 67 Thoreau, Henry David 159 Tonks, Henry 68, 70 Trefusis, Violet 84-5 Triolet, Elsa 54 Turnbaugh, Douglas 79 Twombly, Cy 194, 197, 200, 202 Tzara, Tristan 33, 45-6 UHDE, Wilhelm 35, 36 VARNHAGEN, Rahel 62-3 Varo, Remedios 100-1 Viviano, Catherine 144 Vorticism 80 WAGNER, Anne 12, 20, 21-2 Waldberg, Patrick 138, 141, 142, 150, 151 Warhol, Andy 138 Warner, Marina 105, 113 Watney, Simon 67-8, 79 Waugh, Evelyn 8 Weil, Susan 194, 201 Weisz, Csiki 100 Weston, Edward 119 Whitman, Walt 159 Whitney Museum of American Art, New York 137 Wiesel, Elie 219 Williams, Raymond 70 Wolfe, Tom 159 Women's Caucus for Art 235 Woolf, Leonard 12, 72, 83, 84, 85-6, 89-90, 91, 93-4, 95; 90 Woolf, Virginia 8, 11, 12, 61, 65, 66, 67, 68, 69, 71-2, 74-6, 78-9, 81, 83-95 passim; 82, 90 Wright, Frank Lloyd 100 YEATS, W. B. 65 ZOGBAUM, Wilfred 241, 242; 241 Zola, Émile 25-6

137